Social Formation and Symbolic Landscape

SOCIAL FORMATION AND SYMBOLIC LANDSCAPE

Denis E. Cosgrove

The University of Wisconsin Press

The University of Wisconsin Press
2537 Daniels Street
Madison, Wisconsin 53718

3 Henrietta Street
London WC2E 8LU, England

1 3 5 4 2

Printed in the United States of America

First published in 1984 by Croom Helm Ltd

Library of Congress Cataloging-in-Publication Data
Cosgrove, Denis E.
Social formation and symbolic landscape / Denis E. Cosgrove.
332 pp. cm.
Originally published: London: Croom Helm, c1984, in series: Croom Helm
historical geography series. With new introd.
Includes bibliographical references and index.
ISBN 0-299-15514-5 (pbk.)
1. Landscape assessment—History. 2. Human ecology. 3. Social history.
4. Land use—History. I. Title.
GF90.C67 1998
304.2—dc21 97-48823

CONTENTS

Plates

Figures

Introductory Essay
for the Paperback Edition

In late 1996, during the discussions which led to the re-publication of *Social Formation and Symbolic Landscape*, the deaths were reported of the American landscape essayist John Brinckerhoff Jackson and of the British landscape architect and writer Geoffrey Jellicoe. Both Jackson and Jellicoe were figures of huge significance in twentieth-century English-language landscape writing. They have deeply influenced my own thinking about landscape, and I count myself fortunate in having met them and heard each of them speaking on landscape. In their different ways, both were acutely sensitive to the complexities and ambiguities, as well as to the expressive power, that actual landscapes embody. Each recognised and honoured in his writings and designs a desire to sustain what I refer to in this book as an unalienated, insider's apprehension of the land—of nature and the sense of place—together with a more critical, socially-conscious, outsider's perspective: what I call the landscape 'way of seeing'. Reading *Social Formation and Symbolic Landscape* today, it is obvious to me how far it draws upon J.B. Jackson's unique capacity to interpret landscapes iconographically and intelligently while remaining true to the everyday experience of landscape as the setting for life and work. Jackson's essays deepened my own love and understanding of landscapes, particularly American ones, although I cannot claim to match Jackson's evocations of mood, texture and colour (Jackson, 1970, 1980, 1984). More evident perhaps is the influence of his consistent demonstration that landscapes emerge from specific geographical, social and cultural circumstances; that landscape is embedded in the practical uses of the physical world as nature and territory, while its intellectual shaping in America (where his work was concentrated) has drawn upon deep resources of myth and memory offered by both Western Classical and Judeo-Christian cultural traditions.

Myth and memory were perhaps even more central to Geoffrey Jellicoe's landscape writings, which similarly concentrated in Europe and the USA, although he drew also, and with marvellous syncretism, on the varied landscape traditions of Asia. His designs incorporate his sensitivities to myth and memory alongside an uncompromising faith in Modernism. A few months after the death of President John F. Kennedy in 1963, for example, Jellicoe was commissioned to landscape an acre of land beside the River Thames at Runneymede which had been donated by Parliament on the part of the British nation to the United States as a commemorative monument to the late President (Jellicoe, 1966). This now matured landscape is less than a mile from where I presently work. Jellicoe's design incorporates a serpentine path of uneven stone sets climbing away from the river terrace, forming a Pilgrim's Progress which leads uphill through a tangle of second-growth woodland to end at a great block of white limestone inscribed with the dead President's name, his dates and words taken from his inauguration speech. Each November a New England maple sheds its red leaves over the monument, recalling both Kennedy's native Massachusetts and the date of his blood sacrifice. To the west of the stone, the acre of ground opens into English meadowland, marked only by a path, with a ha-ha along its border. A key structural feature in the English garden tradition, the ha-ha, a sunken ditch preventing livestock from entering garden space, allows uninterrupted vision over the landscape, occluding the boundaries of property and land use. At Runneymede the view is across the watermeadow site of the Magna Carta's signing: an iconic landscape of English liberties and the rule of law. The geographical, historical and ideological references woven into Jellicoe's design are multiple and layered. In speaking and writing about this design, as about his other work, Jellicoe himself always stressed the appeal to 'archetypal' forms and rhythms shared between human consciousness and the natural world, a *mythos* which he believed that true landscape always contained and expressed. When I take students to visit the site, I tend to downplay ideas of archetypes, but rather, drawing upon the approach developed in this book, I try to connect the Kennedy site with immediately adjacent ones: a memorial to lost Royal Air Force pilots whose final resting place is unknown stands on the top of Cooper's Hill, itself the subject of one of the earliest 'prospect' or 'landskip' poems written in seventeenth-century England (Turner, 1979). The classic landscape view from Cooper's Hill is towards Windsor Castle with its Great Park, one of the most complex, contested and symbolic landscapes in England. My

approach is not to ignore or to deny Jellicoe's emphasis on the phenomenology of landscape and on those visceral experiences of natural forms, at once individual and yet widely shared and communicated, which he sought to draw down in his design. But I do emphasise that myth and memory in Jellicoe's landscape work relate to complex historical and social discourses, even if Jellicoe himself was unconscious of them.

Both J.B. Jackson's contextual and democratic and Jellicoe's mythological and Classicist insights into landscape aesthetics and memory remain vital features of my own landscape readings, but I recognise more clearly now how uncomfortably they sit alongside the dominantly historicist tenor of my argument in *Social Formation*. Thus I acknowledge more readily today their need to be incorporated into any genuinely convincing interpretation of specific landscapes.

Social Formation and Symbolic Landscape is not principally about the interpretation of specific landscapes; it is rather an historical sketch of *ideas* about landscape as they have evolved and changed in Europe and North America since the fifteenth century. Nonetheless, if the historical explanations the book offers are to be convincing they should speak to specific landscapes such as those which Jackson and Jellicoe discussed and designed. Reading the book in preparation for writing this introduction, I was surprised how little reference I made in it fifteen years ago to Jackson's and Jellicoe's works. They would be much more present were I to be writing it today. This signals perhaps as eloquently as anything else the contingencies of the moment when the book was initially conceived and written. Reprinting it now allows me an opportunity to reflect on those contingencies, and to highlight the ways in which my own thinking about landscape has evolved since the book was published. Many of these changes in my thinking are responses to others whose own work was stimulated by reading *Social Formation*. It also allows me to acknowledge much more openly than I felt possible in the early 1980s those aspects of landscape which Jackson and Jellicoe emphasised, and which inevitably must modify the powerful insights social theory brings to understanding landscape.

My primary intention in 1984 was to press landscape studies, especially in Geography, towards what seemed to me specific new directions: to locate landscape interpretation within a critical historiography, to theorise the *idea* of landscape within a broadly Marxian understanding of culture and society, and thus to extend the treatment of landscape beyond what seemed to me a prevailing narrow focus on design and taste. This *idea of landscape* I developed is sum-

marised in a statement which has been more widely quoted than any other in the book:

> the landscape idea represents a way of seeing—a way in which some Europeans have represented to themselves and to others the world about them and their relationships with it, and through which they have commented on social relations. Landscape is a way of seeing that has its own history, but a history that can be understood only as part of a wider history of economy and society; that has its own assumptions and consequences, but assumptions and consequences whose origins and implications extend well beyond the use and perception of land; that has its own techniques of expression, but techniques which it shares with other areas of cultural practice.

This thesis, that landscape constitutes a discourse through which identifiable social groups historically have framed themselves and their relations with both the land and with other human groups, and that this discourse is closely related epistemically and technically to ways of seeing, remains both the book's strength and, from today's perspective, its principal weakness. It is the foundation upon which a subsequent critical literature has built substantively and theoretically, widening and deepening our historical understanding of landscape meanings. Subsequent developments in landscape thought and interpretation have equally disclosed the weaknesses, partiality and limitations of the thesis. Nonetheless, the basic argument of *Social Formation* is so clear and the organisation of the text so tightly woven around it, that tinkering with it for a second edition would obscure rather than enhance both its clarity and the book's coherence. To present all the modifications and subsequent insights with which I myself would now wish to embroider the argument would mean a new and different book. I have therefore decided to leave the main text unaltered, to stand or fall on its original merits.

In the space allowed by a single prefatory chapter, I cannot do justice to the range and quality of writing about landscape that has appeared since 1984, nor even to the many ways that the thesis offered here has been both extended and criticised. I am naturally delighted that it has attracted such attention, both within my own discipline and beyond, in Anthropology, Archaeology, Art History and Landscape Architecture, and also that, through the book's translation into Italian with a thoughtful commentary by Clara Copeta, it has engaged with traditions of landscape design and interpretation very different from

those of the anglophone world (Cosgrove, 1990). But progress comes more from criticism than from praise, so I shall restrict myself here to the issues and writings that have most effectively challenged and extended the original text and have most influenced my own thinking about landscape since this book was first written. I structure my comments around the two phrases that make up the book's title. 'Social Formation' allows me to comment upon the social and historical theories which structure my approach to landscape. 'Symbolic Landscape' gives me an opportunity to comment upon the methods by which actual landscapes and their representations are approached in the book, and to return finally to those issues of myth, memory and meaning which invade landsapes' material existence and which I have associated with the work of Jackson and Jellicoe.

Social Formation

In parochially disciplinary terms, *Social Formation and Symbolic Landscape* was a contribution to a late 1970s and early 1980s debate within anglophone Human Geography, at that time negotiating the early stages of what we can see with hindsight was a profound collapse of long-established scholarly assumptions about disciplinary coherence, scientific method and verification, objectivity and the politics of knowledge. Of course, the collapse of confidence in the grand theories, or 'master narratives', which have driven the Western scientific project since the Enlightenment has by no means been confined to the discipline of Geography, and it has progressed considerably since 1984. In all fields of learning, the past fifteen years have forced us to recognise that no single, coherent set of theories, concepts and methods—regardless of their moral or political appeal—can hope to provide a certain and progressive path towards truth. This insight offers challenges to a thesis which relies upon a dominant narrative, in this case Marxian, while liberating thought; it allows historical explanation to remain powerful while embracing other motivations for action and other sources of meaning in human relations with the material world.

The title *Social Formation and Symbolic Landscape* immediately positions the book theoretically. 'Social formation' is a Marxist formulation, discussed in detail early in the book and promoted as a conceptual escape from the tendency within Marxism to subordinate both material and imaginative cultural expressions to the imperatives of

political economy, itself conceived largely in terms of production. Much of the theoretical discussion in the book turns upon a historiographic debate which was engaging the attention of British Marxist historians at the time it was written: the issue of a 'transition from feudalism to capitalism'. Conceptually, feudalism and capitalism are intended to denote types of social organisation whose legal, political and cultural expressions are rooted in the collective organisation of material production. In the book, it is to the different ways in which *land* has been socially appropriated, primarily for use values under feudalism and for exchange values under capitalism, that I attempt to connect the appearance, expressions and meanings associated with the landscape idea in the West. Today, I am much more conscious of the frailties of this formulation. The focus on 'social formation' rather than 'mode of production', as I argue in the text, was of course intended to avoid economic determinism. But, as Marxism's critics have not failed to point out, once the chains of causality anchoring consciousness and value to collective production of material goods are broken, as they are in a 'humanist' Marxism, the theory loses much of its effective explanatory edge. Furthermore, a number of historical and theoretical insights, from psychoanalysis, feminism, and post-colonial studies for example, have reconfigured the emphasis on class as the foundation of social action within strictly Marxian historiography, while sharing its critical and progressive intent of examining the nature and origins of contemporary social worlds and seeking to ameliorate their injustices. I shall comment briefly on those criticisms of the social formation model which seem most relevant to the treatment of landscape in the book.

Historiographically, debate over 'the transition to capitalism' has largely been superseded by a concern to understand the evolution of 'Modern' societies more broadly conceived, societies which share certain socio-economic, demographic, political, cultural and spatial features, but which are also historically and geographically varied. Their emergence is regarded as much more than a simple outcome of the world-historical evolution of market capitalism. In the aftermath of a self-consciously twentieth-century 'Modern*ism*', with its particular forms of Fordist industry and mass production and its *avant-garde* cultural expressions and ideological 'master narratives', it is possible to rethink the history of European societies. Since the Renaissance, and with increasing velocity since the eighteenth-century Enlightenment, the societies discussed in this book have experienced their present and narrated their past as an interconnected nexus of material (demo-

graphic, technological, socio-economic, environmental) and cultural (intellectual, scientific, political, legal, artistic) changes, transforming them internally and projecting their influence with growing external effects across the globe. Thus, for example, Peter Burke's comparative sets of 'biases' in Renaissance culture, which I claim in the text reflect the 'capitalist transition' in the Italian city states, may with perhaps less violence to their complexity and historical specificity be regarded as evidence of a much less overdetermined movement of social modernisation. A crucial aspect of such modernisation is the historical consciousness of 'being Modern'. This itself is a characteristic strand of European humanist thought as it developed through the fifteenth and sixteenth centuries and influenced progressive values in the years that followed. 'Being Modern' altered relations with the land in more complex ways than merely through changing forms of ownership: for example a growing secularism and a Protestant belief in personal salvation through works may have played as significant a role in altering attitudes to the exploitation of land or mineral resources as capitalist ownership (Merchant, 1980).

Humanist values were promoted by Europeans until very recently as a universal and progressive achievement, to be adopted with time and 'development' by all peoples, an element in the construction of a Modern global identity. Central to this progressive narrative of human achievement has been the figure of the individual European male, conceived as a universal subject, exercising rational self-consciousness within a largely disembodied mind, and endowed with a will to power: thus the sovereign subject of history. Effectively, if invisibly, that subject is the hero (or anti-hero) of *Social Formation*. I attribute the origins of the landscape idea to the experience of bourgeois citizens in the Italian city states in relation to land, and to the humanist culture generated out of their experience, paying specific attention to the spatialities connected to new technologies of vision and representation (linear perspective). The account pays little technical attention to the significance of alternative perspective constructions shown by Svetlana Alpers (1983), Walter Gibson (1989) and others to have been so significant in sixteenth- and seventeenth-century Flemish and Dutch landscape representation. Important contributions to the history of seeing in the West have emphasised the complexities of its evolution since the time of Leon Battista Alberti and Filippo Brunelleschi. Martin Jay (1992), for example, has identified a number of 'scopic regimes' in the development of Modernity with complex connections to social and technical change, while Timothy Mitchell (1989) has elaborated Martin Heidegger's

insight that modern societies characteristically represent the world to themselves as a picture and has related this to the West's 'picturing' of other societies and their landscapes. Such work offers fertile extensions and elaborations of the land and landscape thesis offered here.

An obvious consequence of exploring more fully than in *Social Formation* the culture-historical and political implications of the disembodied eye and its subject centredness is to highlight the almost complete absence in the text of gender and of desire as aspects of an embodied viewing subject and of landscape discourse more generally. Not only are the viewers of landscape in *Social Formation,* from Alberti through Andrea Palladio and his patrons, the Venetian, Flemish, Dutch and English landscape artists, Thomas Jefferson and Hector St-Jean de Crèvecoeur, William Kent, John Ruskin and Richard Long uniformly male, but they appear and communicate to us as *eyes,* largely disconnected from any other corporeal or sensual aspects of their being. The detachment from the land entailed by the landscape way of seeing is the critical focus of the work, to be sure, but detachment from their own bodies tends to be a consequence of the proffered reading here. Yet we know that sensuality and desire are powerful motivating aspects of imagination, mobilised in complex ways in relation to the vision which they often direct, and cannot be ignored in responses to landscapes. Such complexities of vision are often explicit in Ruskin's writing, and they are readily apparent in many of the landscape images painted by Giorgione, Titian, Claude Lorrain, Nicholas Poussin or J.M.W. Turner. Although it has been largely through gender theory that the importance of subject embodiment for shaping human spatialities and environmental experience has been signalled, the significance of its occlusion in this book goes beyond issues of gender politics. It has the effect of at once inflating the significance of individuals' statements on landscape by rendering them ciphers for a universalised experience, while silencing whole aspects of their authors' personal, unavoidably embodied, experience of the material world. By the same token, the text is silent on the gendering of the landscape itself as the object of seeing, or as some writers would have it, of 'the gaze'. Gendering the object of study is a recurrent feature of landscape representation, and, it has been claimed, of attitudes towards nature and environment more generally in Modernity (Merchant, 1980). While I would resist the claim made in some feminist studies that the landscape idea inevitably constructs gendered landscapes as the passive, feminised objects of a rapacious and voyeuristic male gaze (Rose, 1993), the absence of any recognition in my discus-

sion of *villagiatura* and *poesia,* for example, of the sexual desires and power relations involved in the associated landscape representations significantly narrows the interpretation. Through pursuit of the metaphorical associations of body and landscape—briefly touched upon here in my discussion of Renaissance metaphysics, but not explored in the sensuous and gendered terms that have been exposed by more recent writing (Mitchell, 1994; Nash, 1996)—not only has the history of landscape representation been enriched, but critical questions about the relationships between landscape, environmental exploitation and modernity have been addressed.

A similarly significant absence in the book, connected to my emphasis on class relations and their connections to property, has been revealed through the post-colonial decentering of the European subject which has been so carefully examined in the years since 1984. Although relatively little attention is paid in my own narrative to landscapes beyond Europe, we have come increasingly to recognise that the implications of Columbian and post-Columbian contacts have shaped culture and landscape as profoundly in Europe as they have in the regions beyond it. Seeking to apply the ideas developed in *Social Formation* to a monographic study of the sixteenth-century Venetian landscape in *The Palladian Landscape* (1993), I was unable to avoid the significance of 'the New World' on the changing landscape and its representations, even in a region not directly involved in exploration or colonisation: ideologically in terms of utopian landscape visions, and practically in terms of newly introduced crops such as sweet corn. The same Venetian nobles who were designing new landscapes on their expanding *terraferma* estates and penning neo-platonic celebrations of natural beauty in their villas were also collecting, classifying, cultivating and disseminating exotic plants brought back from newly discovered, transoceanic worlds of colonial conquest (Tafuri, 1989; Cosgrove, 1993). Simon Schama (1995) and Anne Jensen Adams (1994) have revealed similar processes operating on seventeenth-century Dutch landscapes, and Seymour and Daniels (forthcoming) on those of eighteenth-century England. Changes in the working landscape and in landscape painting and gardening were consistently connected into the cultural and economic circuits of the European colonial project, and may often be read as a cipher of the complex interchanges it entailed. A chapter in this book is devoted to European colonisation of American land, and while it may be an exaggeration to claim, as does W.J.T. Mitchell (1994, p. 10), that landscape was 'the dreamwork of imperialism', my discussion of the Jeffersonian landscape

would have benefitted from the insights of later writers into the colo-
nising aspects of the landscape way of seeing. This would have sug-
gested greater emphasis on the imperial power relations implicit in the
US land survey system, and on the complex and hybrid consequences
of the growing global commerce in plants and species introduced for
domestication in the European designed landscape from the seven-
teenth century.

A positive, although perhaps not always intended, consequence of
de-centering and embodying the universal subject who, in *Social For-
mation* produces and consumes property as landscape, is to refocus
attention on aesthetics. While the book betrays a proper caution when
applying the class-based interpretation arising from the concept of
social formation, and acknowledges the significance of individual
imagination and pleasure in landscape, it never seriously grapples with
the aesthetic and emotional qualities of landscapes. Landscape's sen-
suous appeal, which is often much more than merely visual, dominated
philosophical aesthetic debates in eighteenth-century England. It
accounts for the popularity of Jay Appleton's thesis, in *The Experience
of Landscape* (1996), also recently republished, that there is a bio-
logical foundation to landscape aesthetics. Stephen Daniels (1988,
1989, 1993), who has closely examined the ways that literary and
philosophical debates on landscape mediated individual taste and
highly political class discourse in Georgian England, has written per-
suasively of 'the duplicity of landscape', offering a carefully nuanced
account of its appeal as subjective experience and pleasure and,
simultaneously, its role as social expression of authority and owner-
ship. Much of the strength of Daniels' interpretations of English land-
scape designs and debates in the Georgian and Regency decades comes
from granting individual aesthetic sensibilities, thus refusing to univer-
salise the subject, while grounding his studies of specific landscapes in
detailed knowledge of the historical and geographical circumstances in
which they were created.

The final problem worth commenting upon which arises from the
'transition to capitalism' model of *Social Formation and Symbolic Land-
scape* is one of historical narrative. In the book I claim that landscape
as an active concern for progressive art died in the second half of the
nineteenth century, after the last flourish of Romanticism, and that
its ideological function of harmonising social-environmental relations
through visual pleasure was appropriated by the discipline of
Geography. Re-reading these claims, it seems that they derive more
from theoretical imperatives associated with the book's thesis than

from historical actualities: capitalist modes of productive organisation had come so completely to dominate European societies, I argued, that the moral power of landscape had to be exhausted. My interpretation of the impacts of photography on landscape representation seemed, when I was writing the book, to offer convenient technical support for this claim. I do not now believe that much of this stands up to either theoretical or historical scrutiny. My claim that Romanticism was itself little more than an ideological expression of capitalist social relations and urban industrialism exemplifies the constraints that the book's theoretical model tends to impose on a much more richly textured feature of modernising European societies. To interpret the intense Enlightenment debates over human nature and origins, the 'rights of Man', liberty and constitutional organisation that accompanied the collapse of Europe's *anciens regimes* as little more than ideological legitimations designed to ease the final stages of transition to capitalist market economies, is to oversimplify matters dangerously. If nothing else, it ignores the active role played by the imaginative creation of new identities, which often drew upon landscape images like the oak tree (Daniels, 1988; Warnke, 1993), in shaping territorial and political structures such as the nation state, in which capitalist production has been obliged to operate for much of the past two centuries. Relations between landscape and Romantic nationalism have a complex history which extends over most of that period and has been a focus of some of the most exciting work by students of landscape since 1984, especially among cultural geographers. The emergence of Geography as a scholarly discipline in many European countries was itself very much an expression of Romantic nationalism (Hooson, 1994), and geography's iconic elevation of specific national landscapes may be read as an extension of the moral discourse to which landscape art had already been coupled during the eighteenth century (Green, 1990; Daniels, 1993; Matless, 1989, 1990, 1991; Cosgrove, Roscoe and Rycroft, 1996; Bassin, 1997). Contrary to the claim that Geography replaced landscape art however, Romantic nationalism found intense artistic expression through landscape representations in precisely those *fin-de-siècle* years of the nineteenth century when the text requires that landscape art lose its appeal.

I shall return below to the matter of landscape and identity. At this point I am more concerned with the historical claims made in the final pages of *Social Formation and Symbolic Landscape*. The book effectively closes its history of landscape precisely at the moment when 'Modernism' emerges as a self-conscious cultural and artistic project. It is true

that among the consistent and declared intentions of the twentieth-century *avant-garde* were the challenge to mimetic representation and the divorce of artwork from any dependence on literary and icono-graphic allusion or figurative expression. But to claim that therefore landscape lost its ability to articulate progressive thought about social and environmental relations is to take the Modern Movement's own claims at face value. It neglects, for example, the influence that J.M.W. Turner's artistic experiments with colour and light, which grew out of an intense concern with landscape (as Ruskin recognised), had upon Impressionist and Post-impressionist work in the closing years of the nineteenth century. The art of the final years of the nine-teenth and the early years of the twentieth centuries includes some of the most enduring of Europe's landscape images, many of them explor-ing the spatialities and environmental relations of modern life (Clark, 1984; Green, 1990). Further, a great cultural insight of the years since this book was written has been that, far from signaling the end of history and creating a timeless, universal artistic formalism, Modern-ism itself was but a passing moment in cultural evolution, its claims and modes of expression as historically contingent as any other. As the late Peter Fuller (1988) recognised, one aspect of postmodern culture has been a strong revival in recent years of landscape as a vital subject of artistic exploration. This reflects in part a revival of interest in the referential capacities of art, but now with a much freer attitude to-wards references and iconographic meanings. It is apparent too that the Modern movement's attitudes to landscape were themselves ambiguous rather than consistently hostile (Wrede and Adams, 1991; Matless, 1992a, 1992b). This is not to deny that there have been con-textual shifts in the technologies and structures of production and con-sumption which are intimately connected to the emergence of postmodern cultural expressions (Harvey, 1989), but these are insuffi-cient in themselves to support the claim of necessary links between landscape representation and capitalist alienation from the land.

Our understanding of twentieth-century Modernism itself as a broad cultural movement and of the discourses of landscape within it has thus been greatly expanded since *Social Formation and Symbolic Landscape* was published. Alongside their well-recorded embrace of functionalism, of mechanistic metaphors and images, and of abstract form, many Modernist enthusiasts also had a deep concern for the visi-ble landscape. Geoffrey Jellicoe himself is a fine example of this, but he was by no means alone (Wrede and Adams, 1991). Studies of twentieth-century British, German, Italian and Soviet culture reveal

the insistent appeal of a landscape aesthetics, often placing the new experiences and visual perspectives produced by modern technology, such as speed and the aerial view, in quite explicit dialogue with the picturesque tradition inherited from eighteenth-century theory and practice. To give just two examples: British debates over planning and controlling the impacts of a modern industrial state and post-war reconstruction at mid-century turned in very considerable measure on maintaining continuity in the appearance of the land, not merely for aesthetic ends but out of a sustained and widely-held belief that orderly landscape was both cause and consequence of a morally ordered, civic society seeking to negotiate the changes wrought by modern living (Matless, 1994; Rycroft and Cosgrove, 1995; Brace, 1997). In these debates, eighteenth-century English parkland often acted as a template for a resolutely progressive landscape design code. And Stalinist Russia, despite a triumphalist rhetoric of the onward march of Modern Socialism to communist victory over a subordinated nature, and the inscription of technological reason across a waywardly picturesque landscape, actively encouraged conventional landscape representations by Socialist Realist painters as the official image of Russian country-side (Bassin, 1997; McCannon, 1995). German National Socialism and Italian Futurism negotiated in similar but diverse ways equally complex paths between Modernist aesthetics and appeals to the spiritual power of landscape (Groening and Wolschke-Buhlmahn, 1985; Rollins, 1995; Zanetto, Vallerani and Soriani, 1996).

The place of technology within Modernity is central—practically, mythically and rhetorically. But only a superficial reading of cultural history would suggest that the mechanistic and inorganic aspects of technology have actually resulted in a lessened appeal of landscape. Photography, which I deal with in these pages only in its impacts on nineteenth-century landscape, has been central to the promotion and recording of landscape during the twentieth century. The appeal and aesthetics of the western United States as landscape, for example (Bowden, 1992; Daniels, 1993), owes as much to photography as to the paintings of Thomas Cole, Asher Durand and Albert Bierstadt (in one of whose most sublime landscape paintings a tripod camera plays the role of the traditional eye-witness). And this is due not merely to the work of art photographers such as Ansel Adams (Snyder, 1994) or Alex MacLean (Corner and MacLean, 1996) but to the much more demotic medium of film. In Hollywood movies—not only Westerns—and more recently television, advertising and video, landscapes have played a vital role, not merely as the setting for human action, but

often as a main protagonist. Twentieth-century technologies of vision and representation have been coupled with other technical achievements, transforming, but not extinguishing, the appeal of landscape and its power to articulate moral and social concerns. Among the most obvious is the internal combustion engine, which allows high-speed movement across smooth, uninterrupted ribbons of road and produces new ways of entering, experiencing and seeing landscape. The builders of Germany's system of *Autobahnen* in the 1930s recognised this potential, planning routes and designing the curves of their roads in order to open new vistas across German landscapes and offer novel ways of experiencing them (Rollins, 1995). With powered flight the kinetics of speed were complemented by a qualitatively different order of distance perspective over land. The dream of the bird's-eye view, pictured imaginatively in the 'world landscapes' of the sixteenth century (Gibson, 1989; Cosgrove, 1993b), was thus realised in practice. It not only opened new relations of distanciated viewing—reaching an apogee in the 1968 photograph of the earth rising over the lunar surface in a parody of one of the picturesque landscape's most recurrent compositions (Cosgrove, 1994)—but revealed a new temporality in landscape, through the archaeological marks of past occupance visible on its surface only from the air.

The landscapes produced and experienced through the interaction of technology and land in the twentieth century have become the subject of intense interest in the years since the first appearance of *Social Formation and Symbolic Landscape*. The continued relevance of terms such as the 'Sublime', inherited from the landscape discourse of earlier centuries and applied for example to the landscapes of hydro-electric power generation (Nye, 1994) or nuclear weapons testing, suggests that the strong claim in the book for a break in the late nineteenth century in the discourse of landscape cannot really be sustained.

Symbolic Landscape

A feature of this twentieth-century landscape interaction of land, technology and vision is the ever more seamless elision of experience and representation. Introducing *The Iconography of Landscape* (1988, p. 8), Stephen Daniels and I claimed that from today's perspective landscape resembles 'a flickering text displayed on a screen whose meaning can be created, extended, altered, elaborated and finally obliterated by the merest touch of a button.' Such 'virtual landscapes' represent the furthest extension so far of the idea of landscape as a distanced way of

seeing developed in this book: moving beyond even symbolic landscape, in some representations to landscape *simulacra* (Baudrillard, 1988; Clarke and Dole, 1994). This further extension and elaboration of the symbolic qualities of landscape, apparent in so much postmodern commentary, demands some reflection of the meanings given to 'symbolic landscape' in this book.

If an entire chapter is devoted to exegesis of the phrase 'social formation', 'symbolic landscape' is nowhere precisely defined. I was astonished to find that it does not even appear in the index, and the theory of symbolism underlying the work is left unclear. No reference is made to semiotic or other communicative theories of symbolism, to iconographic or other methods of symbolic hermeneutics of interpretation, to the relations between symbol and myth, nor to forms of symbolic interaction. References to 'ideology' and 'hegemony' indicate attention to the social constitution and uses of symbolic discourse, and in fact the symbolic is generally treated theoretically as a veneer or veil, drawn with greater or lesser effect across material and social relations. A subordinate discourse is also evident in my brief discussion of animistic myth connected to the natural world and seasonal rhythms. Methodologically, the symbolic here, and in my subsequent work on landscape (Cosgrove and Daniels 1988; Cosgrove 1993a, 1993b, 1994, 1995; Atkinson and Cosgrove, 1997), is treated iconically, through a Warburgian approach which emphasises the contextual interpretation of pictorial symbols. This seems particularly suitable to the idea of landscape as a way of seeing, interpreted largely through the medium of visual images, and emerging in the same Renaissance historical and cultural context as the Renaissance artistic culture which concerned those who developed this approach in Art History: Aby Warburg, Erwin Panofsky and Ernst Gombrich. I found it a particularly effective approach in my detailed examination of changing material landscapes and their representation in sixteenth-century northern Italy: the 'Palladian landscape' (1993), in which 'vision' acted as a powerful *Leitmotif* of landscape interpretation.

This approach stands in some distinction to the more literary-based methodology adopted by some other recent writers of critical landscape interpretation. James and Nancy Duncan (1988), for example, have revealed the theoretical resilience of 'text' as a metaphor for landscape, drawing upon the insights of literary theory and criticism. This has had the effect of moving attention away from the purely visible landscape, in order to emphasise relations of power and subordination that are effected in and through the organisation of space but which

are often deliberately obscured to the eye. In an historical analysis of the royal landscapes of the Kingdom of Kandy in Sri Lanka before European colonial rule, James Duncan (1990) extends and applies the insight that the various tropes used in rhetoric and recognised in literary hermeneutics, such as metaphor, metonymy and simile, are significant not only in understanding literary representations of landscape (Lawson-Peebles, 1988; Lewis, 1988) but in their material construction and their communication of social meanings. Relations between landscape and text have been fundamental to understanding the inscription of meaning on newly-discovered lands during the course of European colonial expansion, in large measure itself a process of naming, as work on Australia and South Africa has revealed (Carter, 1987, 1996; Brunn, 1994; Foster, 1996). I have found particularly stimulating the idea of combining the text metaphor for landscape with the visual and iconographic emphasis developed in *Social Formation and Symbolic Landscape*. This yields the idea of treating landscape as theatre (Cosgrove and Daniels, 1993), a connection historically warranted perhaps in the European cultural tradition by the close connection between many significant landscape artists and theatre design. Antonio Canaletto, Gianlorenzo Bernini, Inigo Jones, Philippe de Loutherbourg and Louis Daguerre were all engaged in designing stage sets for theatrical performance. Such conceptual elaborations of the relation between landscape and symbolic discourse which have followed the publication of this book indicate the theoretical fertility, while perhaps highlighting the initial imprecision, of the idea of symbolic landscape.

The disconnection of landscape from productive social relations with the material earth implied by treating landscape symbolically—as image, text or theatre for example—and taken to its extreme in the idea of 'virtual landscape', has attracted criticism from a number of writers since the publication of this book (Price and Lewis, 1993; Mitchell, 1994). A dominant concern among them has been to sustain the sense of landscape as a material geographical object, encompassing both human agency and the material environment, acknowledging its symbolic attributes without reducing it to a mere social construction. The environmental and communitarian foundations of landscape were of course central to the geographical concepts of landscape discussed early in the text. Recent recovery of Carl Sauer's work and thought by late twentieth-century American environmentalists, some of whom, like Barry Lopez (1986), have written brilliantly evocative landscape interpretations, and the continued fertility of cultural geography as an

environmental discourse within the American academy have led to a lively debate on landscape within Cultural Geography (Price and Lewis, 1993; Foote et al., 1994) in recent years, in which the etymology and meanings of landscape have been intensely re-examined. Kenneth Olwig (1996), for example, has challenged the argument developed in *Social Formation* that landscape as a way of see-ing, a symbolic construction, largely replaced landscape as a direct human experience and expression of collective social order within a specific geographical and environmental context. 'It is not enough', he claims, 'to study landscape as a scenic text. A more *substantive* understanding of the landscape is required . . . [recognizing] the historical and contemporary importance of community, culture, law and custom in shaping human geographical existence—in both idea and practice' (Olwig, 1996, p. 645). He emphasises the continued significance of landscape as a context for socio-political identity and community action across much of contemporary northern Europe.

Such a claim is undoubtedly a welcome caveat against the wilder excesses of a post-structuralist treatment of landscapes as little more than simulacra, disconnected from any link with the material earth and actual social practice, and it is properly urged by those concerned with the implications of current landscape study for practical environmental intervention. But such semantic studies tend themselves to become caught in purely linguistic circuits, and it may be that the argument for the continued social relevance of landscape as an expression of environmental relations beyond the purely visual is more effectively made by such landscape studies as Simon Schama's 'excavation below our conventional sight-level to recover the veins of myth and memory that lie beneath the surface' (Schama, 1995, p. 14). This too is con-ducted largely via the interpretation of expressive media through which relations with the material world have been imagined and represented: texts, paintings, designed gardens and parks, city plans, sculptures and photographs. The intention is not to construct a unitary historical structure of meanings and environmental relations through landscape, but, as Schama's title (*Landscape and Memory*) implies, to reveal the power of social memory—mythic unreason—in shaping individual and social identities through its treatment of an inescapable human presence in the natural world.

Structuring his approach to landscape around the elemental themes of wood, water and rock, Schama seeks to reveal how human com-munities have drawn imaginatively upon dominant features of their living environment to shape distinct identities. Recognising the thrust

of the anthropological insight that identity is constructed more through the experience of others than through autonomous self-consciousness, Schama acknowledges the exotic appeal of imaginative landscapes located beyond the insiders' world of the known and the everyday. Thus, for example, he describes the complex evolution of Roman experiences and images of the wooded and impermanently farmed territories beyond the imperial *limes* defined by the Rhine and Danube, the landscape described by Cornelius Tacitus in his *Germania*. The inhabitants of these forests who had conspired to defeat the might of Rome through their strategic use of the landscape of the Teutoburger Wald were regarded perjoratively as savage and uncouth peoples who failed to cultivate the land, and, simultaneously, as upholders of liberty, leading an exemplary life of egalitarian collectivity close to nature. Their life and landscape offered an implicit rebuke to imperial urban decadence and overexploited *latifundiae* of Mediterranean Italy. Tacitus' text later provided an ideological justification for the significance of a landscape of *Wald und Fels* within German Romantic nationalism. So powerfully was the myth activated in fascist Germany that an SS detachment in the closing days of World War Two devoted precious time and resources to a fruitless search for the earliest manuscript of *Germania,* supposedly secreted in an Italian villa near Ancona (Schama, 1995, pp. 75–81).

In Schama's account water flows in rivers of myth rather than standing deep and luminous, or sparkling on the surfaces of lakes or the sea. It is a natural element, drawn upon and wonderfully elaborated historically to irrigate landscapes of social power and authority: for example by Bernini in the Piazza Navona at Rome, signaling Papal claims over universal space by bringing the continental rivers of the globe—Danube, Nile, Amazon and Ganges—to a confluence at the heart of the Eternal City, or by Le Nôtre at Versailles, where the principal axis strikes west to end in the great fountain of Apollo's chariot disappearing into the lake of Ocean. Schama's third landscape element is rock, the most resistant to change and flow, and in this sense imaginatively the most enduring. Carving bodily form in stone is the closest we can come to giving material immortality to a human life, and Schama's account takes us from gender wars over the faces to be carved at Mount Rushmore to the conquest of the mountains as a way of gaining simultaneously the grand perspective of the 'world landscape' and the contemplative depths of the world's soul.

I emphasise Schama's book because it deals so effectively with the mythic dimensions of landscape which have increasingly dominated

my own attention since writing *Social Formation and Symbolic Landscape*. It does so without losing touch with either the materiality or the social and historical specificities of landscape. In this sense Schama echoes J.B. Jackson's landscape voice. Jackson too wrote one of his most evocative landscape essays on the sacred power of stone. He emphasized the significance of the long-held belief that, like other natural elements, stone is not dead and inert, but rather 'a concentration of power and life' (1984, p. 108). He points to the frequency with which stone has been connected not merely with the telluric depths of earth, but with the crystalline cosmos and the stars, whence it owes its origins. He finds therefore a power in 'mythic lithology' expressed in stone's use in memorial and monumental landscapes (Mosse, 1990; Johnston, 1994, 1995; Heffernan, 1995; Atkinson and Cosgrove, 1997). He would have approved, I think, of Geoffrey Jellicoe's great stone slab at Runneymede, serving alongside the maple and the meadowland 'the essential function of landscape . . . to combine the monumental, the landmark, with the transitory', evidence of what John Ruskin once called 'man's acquiescence in the statutes of the land that gave him birth.' It is this rather than the narrow focus on human dominance over other people and over nature, or on human destruction of natural environments, that I believe the best landscape writing discloses. In their different ways Jellicoe, Jackson and Schama all acknowledge the still active power of myth as a shaping force of meaning in landscape (see also Warnke, 1993).

Environmentalist criticism of modern social formations is an obvious absence in *Social Formation and Symbolic Landscape*. The social theory upon which the text draws in large measure failed to evolve a coherent theory of the natural world or of social relations with it (Harvey, 1996). But I am not sure I would even today give great prominence to environmentalism. Any sensitivity to the history of landscape and its representations in the Western tradition forces the recognition that human history is one of constant environmental modification, manipulation, destruction and creation, both material and imaginative. And guiding, if rarely driving, this process is the belief—deposited deep in myth and memory—that the good, the true and the beautiful, as well as the threatening, the awesome and the disgusting, are inscribed in the contours of the land.

In *Social Formation and Symbolic Landscape*, land, especially cultivated, productive land, is the principal material foundation of the idea of landscape. It is also the great absence in Simon Schama's treatment of landscape. The forest, water and rock which structure his text are

of course resources for production as much as for myth, but historically in the regions both books discuss they have been, and remain, much less important in sustaining collective human existence than cultivated land. Whether as use value or as exchange value it is the cultivated earth that provides food for the overwhelming majority of individuals and communities, and it is thus in land that perhaps the most deeply rooted myths are to be discovered. Indeed, the most powerful of them concern *rootedness*, ideas of home and belonging, of locality and identity, and of the social and environmental dangers of change and modernisation. For this reason, and despite the many ways that I might change this account with the benefit of a decade's hindsight, I still believe that the thesis presented in this book has something to say about the relations between land and human life as they are expressed in landscape.

London, February 1997

I would like to thank members of the 'Landsape Surgery' at Royal Holloway: Anne Boddington, Orly Derzie, Jeremy Foster, Paul Kelsch, Keith Lilley, and Luciana Martins for their incisive comments on the drafts of this chapter, and Helen Watkins for her assistance in obtaining illustrations and permissions.

References

Adams, A.J. (1994) 'Competing Communities in the "Great Bog of Europe": Identity and Seventeenth-Century Dutch Landscape' in Mitchell (ed.), *Landscape and Power,* pp. 35–76

Alpers, S. (1983) *The Art of Describing: Dutch Art in the Seventeenth Century.* London, John Murray

Appleton, J. (1996) *The Experience of Landscape.* Rev. ed., Chichester, Wiley

Atkinson, D. and Cosgrove, D. (1997) 'Embodied Identities: City, Nation and Empire at the Vittorio-Emanuele Monument in Rome', Royal Holloway, University of London, Imperial Cities Research Paper

Bassin, M. (1997) 'The Greening of Utopia: Nature and Landscape Aesthetics in Stalinist Art' (forthcoming)

Baudrillard, J. (1988) *America* (Trans. Chris Turner). London, Verso

Béguin, F. (1995) *Le Paysage.* Paris, Dominoes-Flammarion

Bowden, M. (ed.) (1992) 'The Invention of American Tradition', *Journal of Historical Geography 18(1),* 3–138

Brace, C. (1997) 'Finding England Everywhere: Representations of the Cotswolds 1880–1950'. Ph.D. diss., Cheltenham & Gloucester College of Higher Education

Brunn, D. (1994) ' "Our Wattled Cot": Mercantile and Domestic Space in Thomas Pringle's African Landscapes' in Mitchell (ed.), *Landscape and Power,* pp. 127–74

Carter, P. (1987) *The Road to Botany Bay: An Essay in Spatial History.* London, Faber and Faber

Carter, P. (1996) *The Lie of the Land.* London, Faber and Faber

Charlesworth, A. (1994) 'Contesting Places of Memory: the Case of Auschwitz', *Society and Space 12,* 579–93

Clark, T.J. (1986) *The Painting of Modern Life: Paris in the Art of Manet and His Followers.* New York, Knopf

Clarke, D. and Dole, M. (1994) 'The Perfection of Geography as an Aesthetic of Disappearance', *Ecumene, 1(4),* 317–23

Corner, J. (1992) 'Representation and Landscape: Drawing and Making in the Landscape Medium', *Word and Image*, 8(3), 243–75

Corner, J. and MacLean, A. (1996) *Taking Measures across the American Landscape*. New Haven and London, Yale University Press

Cosgrove, D. (1990) *Realtà sociali e paesaggio simbolico* (a cura di Clara Copeta). Milan, Unicopli

Cosgrove, D. (1993a) *The Palladian Landscape: Geographical Change and Its Cultural Expressions in Sixteenth-Century Italy*. University Park, Pennsylvania State University Press

Cosgrove, D. (1993b) 'Landscape and Myths, Gods and Humans' in B. Bender (ed.), *Landscape: Politics and Problems*. Oxford, Berg, pp. 281–305

Cosgrove, D. (1994) 'Contested Global Visions: One-World, Whole-Earth and the Apollo Space Photographs', *Annals, Association of American Geographers*, 84(2), 270–94

Cosgrove, D. (1995) 'Habitable Earth: Wilderness, Empire and Race in America' in D. Rothenberg (ed.), *Wild Ideas*. Minneapolis, University of Minnesota Press, pp. 27–41

Cosgrove, D. and Daniels, S. (eds.) (1988) *The Iconography of Landscape: Essays on the Symbolic Representation, Design and Use of Past Environments*. Cambridge, Cambridge University Press

Cosgrove, D. and Daniels, S. (1993) 'Spectacle and Text: Landscape Metaphors in Cultural Geography' in J. Duncan and D. Ley (eds.), *Place/Culture/Representation*. London, Routledge, pp. 57–77

Cosgrove, D., Roscoe, B. and Rycroft, S. (1996) 'Landscape and Identity at Ladybower Reservoir and Rutland Water', *Transactions, Institute of British Geographers*, 21(3), 534–51

Daniels, S. (1988) 'The Political Iconography of Woodland in Later Georgian England' in Cosgrove and Daniels (eds.), *The Iconography of Landscape*, pp. 43–82

Daniels, S. (1989) 'Marxism, Culture and the Duplicity of Landscape' in R. Peet and N. Thrift (eds.), *New Models in Geography: The Political-Economy Perspective*. London, Unwin-Hyman, pp. 196–220

Daniels, S. (1993) *Fields of Vision: Landscape, Imagery and National Identity in England and the United States*. Cambridge, Polity

Duncan, J. (1990) *The City as Text: The Politics of Landscape Interpretation in the Kandyan Kingdom*. Cambridge, Cambridge University Press

Duncan, J and Duncan, N. (1988) '(Re)-Reading Landscape', *Environment and Planning D: Society and Space*, 6(2), 117–26

Foote, K., Hugill, P., Mathewson, K. and Smith, J. (1994) *Re-Reading Cultural Geography*. Austin, University of Texas Press

Foster, J. (1996) 'Landscape Phenomenology and the Imagination of a New South Africa on Parktown Ridge', *African Studies, 55(2)*, 93–126

Fuller, P. (1988) 'The Geography of Mother Nature' in Cosgrove and Daniels (eds.), *The Iconography of Landscape*, pp. 11–31

Gibson, W.S. (1989) *'Mirror of the Earth': The World Landscape in Sixteenth-Century Flemish Painting*. Princeton, N.J., Princeton University Press

Green, N. (1990) *The Spectacle of Nature: Landscape and Bourgeois Culture in Nineteenth-Century France*. Manchester, Manchester University Press

Groening, G. and Wolschke-Buhlmahn, J. (1985) 'Die Landespflege als Instrument national-sozialistischer Eroberungspolitik', *Arch +, 81*, 46–59

Harvey, D. (1989) *The Condition of Postmodernity: An Enquiry into the Origins of Cultural Change*. Oxford, Blackwell

Harvey D. (1996) *Justice, Nature and the Geography of Difference*. London, Blackwell

Heffernan, M. (1995) 'Forever England: The Western Front and the Politics of Remembrance in Britain', *Ecumene, 2(3)*, 293–324

Hooson, D. (ed.) (1994) *Geography and National Identity*. Oxford, Blackwell

Jackson, J.B. (1970) *Landscapes: Selected Writings of J.B. Jackson*, ed. E. Zube. Amherst, University of Massachusetts Press

Jackson, J.B. (1980) *The Necessity for Ruins and Other Topics*. Amherst, University of Massachusetts Press

Jackson, J.B. (1984) 'Stone and Its Substitutes' in idem, *Discovering the Vernacular Landscape*. New Haven and London, Yale University Press

Jay, M. (1992) 'Scopic Regimes of Modernity' in S. Lash and J. Friedman (eds.), *Modernity and Identity*. Oxford, Blackwell, pp. 178–95

Jellicoe, G.A. (1966) *Studies in Landscape Design*, vol. 2. London, Oxford University Press

Johnston, N. (1994) 'Sculpting Heroic Histories: Celebrating the Centenary of the 1798 Rebellion in Ireland', *Transactions of the Institute of British Geographers, 19(1)*, 78–93

Johnston, N. (1995) 'Cast in Stone: Monuments, Geography and Nationalism', *Society and Space, 13*, 51–66

Lawson-Peebles, R. (1988) *Landscape and Written Expression in Revolutionary America: The World Turned Upside Down*. Cambridge, Cambridge University Press

Lewis, G.M. (1988) 'Rhetoric of the Western Interior: Modes of Environmental Description in American Promotional Literature of the Nineteenth Century', in Cosgrove and Daniels (eds.), *The Iconography of Landscape*, pp. 179–93

Lopez, B. (1986) *Arctic Dreams: Imagination and Desire in a Northern Landscape*. New York, Scribners

Lowenthal, D. (1985) *The Past is a Foreign Country*. Cambridge, Cambridge University Press

Matless, D. (1989) 'Ordering the Land: The "Preservation" of the English Countryside 1918–1939'. Ph.D. diss., Nottingham University

Matless, D. (1990) 'Definitions of England, 1918–1989: Preservation, Modernism and the Nature of the Nation', *Built Environment, 16(3)*, 179–91

Matless, D. (1991) 'Nature, the Modern and the Mystic: Tales from Early Twentieth-Century Geography', *Transactions of the Institute of British Geographers, n.s. 16(3)*, 272–86

Matless, D. (1992a) 'A Modern Stream: Water, Landscape, Modernisation and Geography', *Environment and Planning D: Society and Space, 10*, 569–88

Matless, D. (1992b) 'Regional Surveys and Local Knowledges: The Geographical Imagination in Britain, 1918–39', *Transactions of the Institute of British Geographers, n.s. 17(4)*, 464–81

Matless, D. (1994) 'Moral Geography in Broadland', *Ecumene, 1(3)*, 127–56

McCannon, J. (1995) 'To Storm the Arctic: Soviet Polar Exploration and Public Visions of Nature in the USSR 1932–39', *Ecumene, 2(1)*, 15–32

Merchant, C. (1980) *The Death of Nature: Women, Ecology and the Scientific Revolution*. San Francisco, Harper and Row

Mitchell, T. (1989) 'The World as Exhibition', *Comparative Studies in Society and History, 31*, 217–36

Mitchell, W.J.T. (ed.) (1994) *Landscape and Power*. Chicago and London, University of Chicago Press

Mosse, G. (1990) *Fallen Soldiers: Reshaping the Memory of the World Wars*. Oxford University Press, Oxford

Nash, C. (1996) 'Reclaiming Vision: Looking at Landscape and the Body', *Gender, Place and Culture, 3*, 149–69

Nye, D. (1994) *American Technological Sublime*. Cambridge, Mass., MIT Press

Olwig, K. (1996) 'Recovering the Substantive Meaning of Landscape', *Annals, Association of American Geographers, 86(4)*, 630–53

Price, M. and Lewis, M. (1993) 'The Reinvention of Cultural Geography', *Annals, Association of American Geographers, 83(1)*, 1–17

Rollins, W.H. (1995) 'Whose Landscape? Technology, Fascism, and Environmentalism on the National Socialist *Autobahn*', *Annals, Association of American Geographers, 85(3)*, 494–520

Rose, G. (1993) *Feminism and Geography: The Limits of Geographical Knowledge*. Cambridge, Polity

Rycroft, S. and Cosgrove, D. (1995) 'Mapping the Modern Nation: The National Land Use Survey 1932–34', *History Workshop Journal, 40*, 91–105

Schama, S. (1995) *Landscape and Memory*. New York, Alfred A. Knopf

Seymour, S., Daniels, D. and Watkins C. (forthcoming) 'Estate and Empire: Sir George Cornewall's Management of Moccas, Herefordshire and La Taste, Grenada', *Journal of Historical Geography*

Snyder, J. (1994) 'Territorial photography' in Mitchell (1988), pp. 175–202

Tafuri, M. (1989) *Venice and the Renaissance* (Trans. Jessica Levine). Cambridge, Mass., MIT Press

Turner, J.G. (1979) *The Politics of Landscape: Rural Scenery and Society in English Poetry, 1630–1660*. Oxford, Basil Blackwell

Warnke, M. (1993) *The Political Landscape*. London, Reaktion

Wrede, S. and Adams, W.H. (eds.) (1991) *Denatured Visions: Landscape and Culture in the Twentieth Century*. New York, Museum of Modern Art

Zanetto, G., Vallerani, F. and Soriani, S. (1996) *Nature, Environment, Landscape: European Attitudes and Discourse in the Modern Period: The Italian Case, 1920–1970*. Università di Padova, Quaderni del Dipartimento di Geografia

Acknowledgments

Acknowledgment for permission to reproduce plates and figures is gratefully made to the following: Ditta O. Böhm, Venice (Plates 1 and 2); National Gallery of Art, Washington (Plates 3 and 4); Kunsthistorisches Museum, Vienna (Plate 7); Collection/Rijksmuseum Amsterdam (Plate 8); Ashmolean Museum, Oxford (Plate 9); Museum of Fine Arts, Boston (Plate 10); Scottish National Portrait Gallery, Edinburgh (Plate 11); British Architectural Library, RIBA, London (Plate 13); The Tate Gallery, London (Plate 14); City of Aberdeen Art Gallery and Museums Collections (Plate 16); Academic Press Inc. (London) Ltd (Figure 4.2); US Department of Commerce, Coasts and Geodetic Survey (Figure 6.1); Messrs Faber and Faber Ltd (Figure 9.1). Other photographs by the author, and figures by A. Tarver based on author's sketches.

Why should we, in the compass of a pale
Keep law and form and due proportion
Showing, as in a model, our firm estate
When our sea-walled garden, the whole land
Is full of weeds; her fairest flowers chok'd up
Her fruit trees all unprun'd, and her wholesome herbs
Swarming with caterpillars?

<div align="right">(Richard II, Act 3, Scene 4)</div>

Introduction

This book is about the idea of landscape, its origins and development as a cultural concept in the West since the Renaissance. During that period many Europeans came to see the external world and nature in novel ways, ways that corresponded to new approaches to production on the land. Many studies exist of the changing European use of the earth, the moulding of land by human labour into visibly distinct regions we call landscapes. Others have examined how Europeans have represented their world as a source of aesthetic enjoyment – as landscape. The intention here is to replicate neither of these approaches, but to draw upon, and inform, both of them within a thesis which relates ideas about the cultural significance of landscape to ways in which land is materially appropriated and used.

The argument here is that the landscape idea represents a way of seeing – a way in which some Europeans have represented to themselves and to others the world about them and their relationships with it, and through which they have commented on social relations. Landscape is a way of seeing that has its own history, but a history that can be understood only as part of a wider history of economy and society; that has its own assumptions and consequences, but assumptions and consequences whose origins and implications extend well beyond the use and perception of land; that has its own techniques of expression, but techniques which it shares with other areas of cultural practice. The landscape idea emerged as a dimension of European elite consciousness at an identifiable period in the evolution of European societies: it was refined and elaborated over a long period during which it expressed and supported a range of political, social and moral assumptions and became accepted as a significant aspect of taste. That significance declined, again during a period of major social change, in the late nineteenth century.

1

Landscape today is pre-eminently the domain either of scientific study and land planning, or of personal and private pleasure. It no longer carries the burden of social or moral significance attached to it during the time of its most active cultural evolution.

In exploring the history of this way of seeing I have made use of the growing body of contemporary theory concerning the relationships between cultural production and material practice. A cultural concept like the landscape idea does not emerge unprompted from the minds of individuals or human groups. To be sure, individuals can and do find original ways of articulating and expressing the idea, and collectively human consciousness may appear to refine or extend that idea without obvious links to collective material practices. But historically and theoretically it is unsatisfactory to treat the landscape way of seeing in a vacuum, outside the context of a real historical world of productive human relations, and those between people and the world they inhabit to subsist. In seeking the material foundations for the landscape idea the obvious point of departure is the human use of the earth, the relationships between society and the land. This is the stuff of historical geography as traditionally practised, and such relationships form a theme of study throughout the book. The evolution of European land practices offers important historical parallels with the period of landscape's cultural ascendancy.

Between 1400 and 1900 much of Europe and the society it founded in North America were progressing towards a characteristic form of social and economic organisation which we term capitalist. Purchase and sale in the market-place of an ever-increasing range of goods and services, including the land itself, determined their social allocation. Labour itself became a commodity, released from the bonds of custom and allegiance which had formerly tied the labourer both socially and spatially. In developing a capitalist mode of production, Europeans established and achieved a dominance over a global economy and a global division of labour which remains a critical determinant of our present social and economic geography. The European transition from societies dominated by feudal social relations and their associated cultural assumptions, to capitalist centrality in a world-wide system of production and exchange is a phenomenon of central historical importance in making sense of our own world. We understand a great deal about many of the fundamental features of the change: its associated demographic trends, alterations in agricultural and commodity production, the political reorganisation of peoples and territories, and the changing

relations between individuals, groups and classes. Whatever the specific focus of historical attention, it is the internal reorganisation and outward expansion of European societies, gathering pace throughout the period, which insistently compels historical enquiry and demands historical understanding. In response to that insistence historians have developed a range of theories which seek to identify the underlying causes of long-term change. Whether basing their explanations on demography, technological innovation, environmental alteration, class conflict or the evolution of human ideas, it is the phenomenon of parallel changes in so many spheres along a single trajectory which forms the common feature of their discourse.

We may regard capitalism in many, not always contradictory, ways: it may be the materially liberating and progressive force implied by the term 'modernisation', or an alienating and exploitive method of maximising the surplus value of human labour and resources. Alternatively, we may see it as an inevitable stage in a structured historical process upon which we are called to make no moral judgements. Whatever our interpretation of the value of such a system of human relationships, it remains the case that the rise of capitalist production has been the basis of European ascendancy. To claim that the transition to capitalism began in the fifteenth century, when the structures of feudalism were clearly weakening in the countries of western and southern Europe, and that it ended in the nineteenth, when those lands lying around the rim of the north Atlantic presented examples of well-established capitalist states, offers therefore a useful shorthand for capturing an essential unity within the historical process while implying no absolute significance for the bracketing dates. Many of the features we associate with the transition (for example, the growth of long-distance trade based on urban centres of mobile capital accumulation, or the breakdown of the manorial system of agricultural production) predate the beginning of the period in certain parts of Europe – by centuries in the case of upper Italy. And by 1900 in Britain the features of pure market capitalism – if such purity ever existed – were distinctly blurred by the intervention of the state in critical areas of production and reproduction: housing, health and education; while in parts of eastern and central Europe those forces that were to give birth to a form of socialist production in the twentieth century were already gaining a powerful momentum. Between these dates the transition itself was differently inflected and paced in the regions of Europe: a 'second feudalism' has been hypothesised in certain eastern and Mediter-

ranean regions of the continent (Wallerstein, 1974). To speak then of 1400-1900 as the period of the capitalist transition is really only to set a context for formulating historical questions, to indicate a theoretical direction rather than to provide answers to those questions or verification of theory. But it is a context which requires us to examine the evidence in an integrated way rather than in terms of discrete and self-contained historical issues. Whether we are following the course of English constitutional debates in the seventeeth century, or of Venetian and Genoese maritime trade; explaining the pattern of migration from the Rhineland to the middle American colonies or the response of French peasants to the corvée; exploring the changing structure of the European family or the development of the modern penal system, it is in the context of a fundamental shift in the ways that human beings collectively used their environments and led their lives that we can offer structure and coherence to historical understanding and place our detailed knowledge within a wider perspective.

This perspective offers to historical geography the opportunity to raise its sights from the static reconstruction of past geographies or the detailed but essentially discrete study of field systems, settlement patterns or population distributions and to see these materials and issues as part and parcel of a broader history. The emergence of European capitalism involved radical changes in the social organisation of space at different scales. Europe's position in the global pattern of human affairs changed from being one of a number of cores of high population density, urbanisation and sophisticated technology (Braudel, 1973) to become the centre of what Emmanuel Wallerstein (1974) has termed the 'world system', operating like the metropolis within an urban system with a dependent and hierarchically-organised hinterland of surrounding peripheral and semi-peripheral regions. Within Europe, and North America, a progressive differentiation occurred between on the one hand regions of advancing population growth, in-migration, agricultural transformation, industrial production and urban development, and on the other stagnant or declining regions in which these processes operated more slowly or were reversed. Space was reorganised as nodes were linked and boundaries redrawn to reflect the altered conditions of different regions at all scales. The self-contained universes of manor and parish which we take as the model of the spatial order of feudalism gave way over time to the integrated and structured space economy of the nation state with its urban hierarchy and specialised agricultural

and industrial regions. Its geography is fundamentally different from that of the pre-capitalist space economy and the changing spatial order at all its scales is intimately involved as both effect and cause with the social and economic transition observed by historians.

It is not only spatial order which engages attention in historical geography, nor is this the only geographical dimension of the transition to capitalism. One of the most respected English historical geographers has long insisted upon the significance of that other great geographical theme: the relationship between society and the physical environment, between man and the land. H.C. Darby (1951) noted the significance of three key aspects of the transformation of European land: the clearance of woodland, the drainage of marshland and the reclamation of wasteland and heathland. All of these were ways of creating productive agricultural land. Changes in the way that humans organise to produce their material lives quite obviously result from and give rise to changes in relationships with their physical surroundings. The techniques by which Europeans used the land, altering and exploiting the natural world, underwent accelerating change during the period under discussion (Pounds, 1979). Some of these changes have been the subject of detailed examination in historical geography: the reclamation of the fenlands around the North Sea at the core of the emerging world system, the introduction of new crops from the Americas and of different ways of cultivating traditional ones, the increased productivity of pastoral farming and the enclosure of arable lands, the exhaustion of timber resources in seventeenth-century England and France, and the exploitation of mineral resources. All of these activities predate to a greater or lesser extent the exact period specified here, but within that period they achieved a new scale and pace. The single most telling example of this is of course the subjugation of the whole continent of North America to European modes of material production, its inclusion within the European agricultural economy, the wholesale exploitation of its natural resources of wildlife, timber and mineral deposits, its integration by canal and railroads and its colonisation by farmhouses, towns and cities. We speak often of industrial and agricultural revolutions. They involve fundamental reorganisation of society's relationship with the environment and resources so that, like spatial organisation, the man-environment theme in geography is also elucidated by the context of the capitalist transition.

But this transition was not merely one of human activity. Equally

implicated in it was a transformation in the ways people reflected upon what they did and what they were. When we speak of the seventeenth-century scientific revolution, of the Reformation, of the rise of individualism or secularism, of Renaissance humanism or the work ethic, we acknowledge the importance of changes in the ways Europeans thought about and signified themselves and their world. Geographers are increasingly aware that the relationship between societies and their environment as it is lived is as much a product of consciousness as of material realities. Clarence Glacken (1967) has outlined some of the changing attitudes of Europeans to their environment and to their place in it before 1800. He stresses the increased emphasis on the individual in the modern period, first as microcosm of the natural order and increasingly as its controller, the decline of theology as the source of explanation of the features of the natural world, and the developing assurance among Europeans of their ability to transform and improve a manipulable nature.

The world that Europeans conceived and the place that they imagined themselves to hold within it changed as their material conditions were transformed. But the relationship between consciousness and social existence is fraught with theoretical difficulties. Over the long term the change in both tends to be in the same direction, but struggle between conflicting cultural assumptions is a part of the general struggle towards new ways of life, and it is precisely the relationship between environmental thought and attitudes to land on the one hand, and the transition to capitalist forms of material production on the other, that gives meaning to each and which lies at the root of the landscape idea. An example may serve to illustrate this at the global scale. Figures A and B are representations of the world produced by English cartographers seeking to illustrate the œcumene. The first is a simplified sketch of the map of the world produced in the fourteenth century and hanging in Hereford cathedral. This *mappa mundi* is circular, centred on the holy city of Jerusalem and shows the world island of Europe, Asia and Africa enclosed in a ring of ocean. Parts of its outline and content we would recognise today as representing geographical reality, others we would dismiss as myth and fancy. Equal significance is attributed to the celestial and terrestrial spheres; both are considered to be properly part of the reality in which human life is lived. The second map represents the world as it was no doubt presented to the schoolchildren of Hereford in the early part of this

6

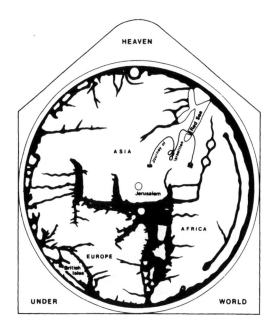

Figure A: Medieval World Picture. Simplified sketch based on the *mappa mundi* at Hereford Cathedral

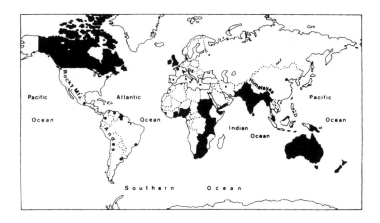

Figure B: Imperial World Picture. Mercator projection of the globe showing British imperial possessions, simplified from a school atlas of the late nineteenth century

century. It is enclosed within a rectangular frame, distorting the sphere of the globe according to known and accepted rules of cartographic projection. It includes all the land masses and seas with a locational accuracy which we would regard as superior to the former example. Earth space would be filled with colours and bounding lines showing nation states and imperial possessions and the names of significant landforms and human settlements. Each may represent the world as known and imagined at the time of its production. However, each structures the geography it depicts according to a set of beliefs about the way the world should be, and presents this construction as truth. Both are moral statements: the first explicitly so in its concern to depict the order of divine creation and the place of the human world within it; the second implicitly in presenting the proper order of a British-dominated globe and the relative place of the nations within it. In other terms, both are ideological statements. To understand the meanings of the two maps and the differences between them requires not only a knowledge of the evolution of cartography as a technique for representing spatial relations, a technique whose history is closely related to that of landscape painting (Harvey, 1980; Rees, 1980), but also an understanding of the objective and subjective changes in spatial organisation and environmental relations between the dates at which they were drawn. The first map reflects a material world set within the hierarchy of creation and centres it in the *axis mundi* of Christendom, offering a geography of the natural order homologous to the social order of feudalism; the second presents a secular world focused on a core imperialist state and its dependencies, offering an image of a stable political geography whose claimed objectivity and scientific accuracy of construction legitimate the global structure of British imperial rule. It is one of the tasks of historical geography to make intelligible the changes in the spatial order and environmental relations, both real and imagined, which account for two such different configurations. Each was considered truthful at the time of its making, each would have been regarded as myth by the intended audience of the other. The idea of a transition from feudalism to capitalism offers an anchor which makes their differences intelligible in the light of other historical processes.

The Hereford map and the map of the British empire, for all their differences, are similar in their intention to make the world visible, to present geography to the eye. We accept geographical reality because we can see it. To *see* something is both to observe it and to grasp it

8

intellectually. The way people see their world is a vital clue to the way they understand that world and their relationships with it. Between 1400 and 1900 Europeans changed markedly in the ways that they saw. One indicator of the change in their vision is the idea of landscape.

Landscape has two distinct, but in important ways related, usages. Between the early fifteenth century and the late nineteenth century, at first in Italy and Flanders and then throughout western Europe the idea of landscape came to denote the artistic and literary representation of the visible world, the scenery (literally that which is *seen*) which is viewed by a spectator. It implied a particular sensibility, a way of experiencing and expressing feelings towards the external world, natural and man-made, an articulation of a human relationship with it. That sensibility was closely connected to a growing dependency on the faculty of sight as the medium through which truth was to be attained: 'seeing is believing'. Significant technical innovations for representing this truth included single-point perspective and the invention of aids to sight like the microscope, telescope and camera, whose origin and development, as I shall show, can be understood historically by reference to patterns of social and productive organisation we recognise as capitalist. Landscape's second usage is in contemporary geography and related environmental studies. Here it denotes the integration of natural and human phemonena which can be empirically verified and analysed by the methods of scientific enquiry over a delimited portion of the earth's surface. Geographical studies of landscape until very recently denied the existence of common ground between the object of their investigations and the sensibility implied by the artistic usage of landscape. In fact they are intimately connected both historically and in terms of a common way of appropriating the world through the objectivity accorded to the faculty of sight and its related technique of pictorial representation. It is in this relationship that the idea of landscape and its history can direct our attention towards the active role of cultural production in the transition to capitalism, a role that often remains neglected in historical geography.

To substantiate this claim requires initially that we clarify the idea of landscape and the usages to which the word has been put. This is the purpose of Chapter 1. It identifies certain contradictions within the meanings of landscape which require historical rather than logical resolution. It is necessary also to examine more fully the difficulties associated with employing the theoretical constructs implied by the

framework of capitalist transition and with forging a relationship in theory between changes in productive relations and changes in human consciousness, particularly when dealing with a geographical area as large and as varied as western and southern Europe over half a millennium. Consideration of these issues forms the material of the second chapter. Having established a theoretical context in which to place the landscape idea and a theoretical understanding of change in different areas of social life we can proceed to exemplify the argument by reference to specific historical societies and their cultural products. This is done in a series of essays focused on different areas at different historical periods. The initial discussion concerns Italy, where the first developments of the landscape idea took place, where the techniques for representing it were pioneered during the late fourteenth and early fifteenth centuries, and where social relations of a capitalist nature were already advanced. This leads to a more detailed consideration of the case of Venice in the sixteenth century, a dominant centre of merchant capitalism and the location of some of the most expressive early landscape art in painting, poetry, architecture and gardening. Venetian themes and motifs ·in landscape were to be borrowed and reinterpreted in later periods in many other parts of Europe and America. The Venetians share this significance with certain Flemish, Dutch and Roman landscapists whose work is summarised in Chapter 5.

The discovery and settlement of North American – in its initial stages very much an Italian intellectual achievement – and particularly the emergence of the United States as an attempt to fulfil certain European aspirations, allows us to observe a particular variant on European culture. A consistent desire to break with European conventions, to create a new and more perfect society and a unique attempt to establish a mode of social relations which was neither feudal nor capitalist, give special significance to the landscape idea in the early American context. Seventeenth- and eighteenth-century England places us at the centre of European economic and social change and provides an outstanding example of the ideological use of the landscape idea. The advent of industrial capitalism in Britain at the turn of the nineteenth century and the responses to it provide the context for the most sophisticated development of the landscape idea. In the hands of a writer like John Ruskin the relations between landscape as a way of seeing and the social relations of production became an explicit object of study and the landscape idea was asked to carry the burden of a fully-articulated body of social theory. At the

moment when a perception of the true nature of that relationship seemed possible, however, it became too broad in its implications to be contained within the landscape idea. The intellectual division of art and science and the technological innovation of photography spelled the death of landscape as it had traditionally been conceived and as a subject of central cultural concern. At this time the science of geography began to appropriate landscape as its special area of scientific concern while in photographs and tourist viewpoints landscape took on the properties of a generalised commodity whose connections with the means of its production were once more mystified. The last chapter therefore comments briefly on the landscape idea in our own century.

While the examples chosen for detailed consideration here have a certain chronological and geographical coherence, they are by no means the only ones available. Significant innovations in painting and designing landscape occurred in absolutist France during the Baroque period, for example. Wilderness landscape took on a singular moral force in the heady and self-conscious atmosphere of a westward-moving American republic. But their consideration here is brief. However, I believe that detailed examination of these examples would serve to confirm the general thesis even while opening new avenues and prospects across its topography.

The landscape idea is still with us. Indeed within geography its significance has increased in the last decade. There has been an attempt to re-establish the severed links between geography and the study of artistic and literary expression. At the same time some geographers have attempted to remove from the landscape idea the close association with the exceptional and the exclusive by referring study to the landscapes of ordinary life (Meinig, ed., 1979; Gold and Burgess, eds., 1982). My wish to write this book derives in large measure from the feeling that in landscape we are dealing with an ideologically-charged and very complex cultural product, one that will not easily yield to fashionable changes in geographical methodology. But it is with that methodology that I will begin. However, before turning to examine landscape in contemporary geography there are a number of debts incurred in the writing of this book which demand acknowledgement. Robin Butlin, Stephen Daniels and Cole Harris read earlier drafts and their comments and advice saved me from at least a few blunders while providing some important ideas. Students on a course at Lougborough dealing with the issues discussed here offered a critical audience, as did Trevor Pringle and the participants

11

in seminars at London, Cambridge and Southampton. Anne Tarver produced respectable maps and diagrams from inadequate sketches, and David Walker and Christopher Roper introduced me to the mysteries of word processing. Isobel, Emily and Isla gave both encouragement and enormous forbearance as two summers disappeared to the whirr of floppy disks and bouts of near despair. My editor at Croom Helm, Peter Sowden, remained good-humoured about the non-appearance of drafts. To all of them I owe a word of very special thanks.

1

The Idea of Landscape

In geographical usage landscape is an imprecise and ambiguous concept whose meaning has defied the many attempts to define it with the specificity generally expected of a science. While landscape obviously refers to the surface of the earth, or a part thereof, and thus to the chosen field of geographical enquiry, it incorporates far more than merely the visual and functional arrangement of natural and human phenomena which the discipline can identify, classify, map and analyse. Landscape shares but extends the meaning of 'area' or 'region', both concepts which have been claimed as its geographical equivalents. As a term widely employed in painting and imaginative literature as well as in environmental design and planning, landscape carries multiple layers of meaning. Commenting on the poet Gerard Manley Hopkins's neologism, *inscape*, W.A.M. Peters has commented that the suffix 'scape' 'posits the presence of a unifying principle which enables us to consider part of the countryside or sea as a unit and as an individual, but so that this part is perceived to carry the typical properties of the actually undivided whole' (Peters, 1948, p. 2).

That unifying principle derives from the active engagement of a human subject with the material object. In other words landscape denotes the external world mediated through subjective human experience in a way that neither region nor area immediately suggest. Landscape is not merely the world we see, it is a construction, a composition of that world. Landscape is a way of seeing the world. For all its apparent objectivity and foundation in the historical record the landscape described in *The Making of the English Landscape* possesses an affective meaning, it represents W.G. Hoskins's (1955) way of seeing England. It is this which informs his interpretation of

13

how people in the past saw and remade the land. In Yi-Fu Tuan's words (1971, p. 183), the landscape 'is somewhat analogous to the interior of the house, in that its totality reveals purposes and ends that have directed human energy'. Human subjectivity provides the totality or holism, the synthetic quality, of landscape to which Peters, Tuan and others refer. Painting and literature have in the past developed certain techniques and conventions to represent and comment upon the holism of landscape and in so doing they have stressed the individuality of subjectivity, a dimension of meaning which geographical science naturally has found difficult to incorporate into its landscape studies.

A similar difficulty is raised by a second and related aspect of the meaning of landscape. The frequent association in geographical writing of landscape with studies of the impact of human agency in altering the physical environment serves to remind us that landscape is a *social* product, the consequence of a collective human transformation of nature. The elision of landscape with wilderness or nature untainted by human intervention is a recent idea generally involving a rejection of the evidence of human action (Graber, 1976). The artistic use of landscape stresses a personal, private, and essentially *visual* experience. In Hopkins's lines,

The world is charged with the grandeur of God.
 It will flame out, like shining from shook foil;
 It gathers to a greatness, like the ooze of oil
Crushed. Why do men then now not reck his rod?
Generations have trod, have trod, have trod;
 And all is seared with trade; bleared, smeared with toil;
 And wears man's smudge and shares man's smell: the soil
Is bare now, nor can foot feel, being shod.
 (Hopkins, *God's Grandeur*, 1877; 1953, p. 27)

the poet regards the collective human labour which transforms nature, as a metaphor of sin, and celebrates a personal vision of natural beauty – of 'inscape' as the recognition of divine majesty. Such a rejection of a humanised earth is not characteristic of the entire history of the landscape idea, but it reveals sharply the tension between individual enjoyment of the external scene and the collective making of that scene which we can trace historically.

The unities and tensions of subject and object, and of personal and

14

social, produce problems for those geographers who would wish to derive from landscape a specialised scientific concept. Such an attempt requires by its nature the removal of ambiguity, so that scientific understanding may proceed. So with characteristic logic Richard Hartshorne (1939) argued for landscape's exclusion from the geographical vocabulary unless its meaning was so refined as to expunge all subjective and personal connotations. But the usage of landscape resists the imposition of such logic and for this reason, as well as the greater willingness in contemporary geography to challenge the possibility and indeed the value of modelling the discipline upon the natural sciences, landscape for all its ambiguities retains currency in geographical writing. Indeed it is in part precisely the dual ambiguity which purchases landscape's continued value in a geography which aims to comprehend terrestrial space as both subject and object of human agency, in a geography which finds its aims and methods more closely aligned to those of the humanities and their hermeneutic modes of understanding than with the natural sciences. To accept the ambiguity and severally-layered meanings of landscape does not excuse us from careful examination of them and of their origins. Rather it obliges us to pay rather greater attention to them than we have done in the past, for it is in the origins of landscape as a way of seeing the world that we discover its links to broader historical structures and processes and are able to locate landscape study within a progressive debate about society and culture. Therefore in this chapter I shall explore the nature of landscape's dual ambiguity in greater depth, and suggest that landscape represents an historically specific way of experiencing the world, developed by, and meaningful to, certain social groups. Landscape, I shall argue, is an ideological concept. It represents a way in which certain classes of people have signified themselves and their world through their imagined relationship with nature, and through which they have underlined and communicated their own social role and that of others with respect to external nature. Geography until very recently has adopted the landscape idea in an unexamined way, implicitly accepting many of its ideological assumptions. Consequently it has not placed the landscape concept within an adequate form of historical or social explanation (Relph, 1981). To do so requires not so much a redefinition of landscape as an examination of geography's own purposes in studying landscape, a critical recognition of the contexts in which the landscape idea has intellectually evolved and a sensitivity to the range and subtlety of

human creativity in making and experiencing the environment.

Geography and Landscape Morphology

Geographical writers on landscape have identified the origins of the present English word in German and Middle English terms which denoted an identifiable tract of land, an area of known dimensions like the fields and woods of a manor or parish (Dickinson, 1939; Jackson, 1964; Mikesell, 1968; Stilgoe, 1982). It was to this areal meaning of landscape that early twentieth-century geographers like Carl Sauer (1925, 1941) and Richard Hartshorne (1939), both strongly influenced by German geographical writings, attempted to return the concept. In general, studies of the origins, evolution and forms of selected tracts of territory or landscapes have sought to produce a synthesis of the elements that compose the chosen area, suggesting that the various components lock together to produce characteristic and observable relationships of form. Their approach combines two methods. Morphology breaks the observed unity into constituent parts and subjects each to detailed examination, the better to understand individual and collective contributions to the reconstructed whole. Detailed examination is very commonly genetic, posing questions of origin and evolution. One of the clearest outlines of 'genetic morphology' is Carl Sauer's *The Morphology of Landscape* (1925). Genetic morphology found favour in historical, cultural and physical geography, all of which have employed the landscape concept extensively. Despite the genetic treatment of individual forms, however, the processes of development and change in the whole are arrested at a particular historical moment so that the areal synthesis can be established and a timeless unity of form composed. Under the morphological method landscape becomes a static, determinate object of scientific enquiry. Its compositional elements and their relationships become susceptible to objective identification, classification and measurement, and while the scientific status of genetic morphology as method may be disputed, the rigorous exclusion of subjectivity in the interests of its scientific aims is not.

In common English usage, however, landscape has a meaning beyond that of a land area of measurable proportions and properties. This meaning was given originally by painters' use of the term. Before a reference dated 1725 the OED defines landscape as 'A view or prospect of natural inland scenery, such as can be taken in at a

16

glance from one point of view'. A further definition, supported by a reference from 1603, more than a century earlier, confirms the origin of this meaning: 'a picture representing natural inland scenery as distinct from a sea picture, a portrait etc.' In this sense landscape is the area subtended to the eye and vision of an observer who will, at least in theory, paint it. It is to be composed for its aesthetic content and may excite a psychological response. Observed in this painterly way, landscapes could be beautiful, sublime, tame, monotonous, despoiled. They engaged a subjective response in those who observed or experienced them. Landscape was therefore invested from outside with human meaning. Eighteenth-century English philosophers and writers on aesthetics, drawing upon prevailing psychological theory, fiercely debated the nature and origins of the affective bonds between the conscious subject and its visible natural surroundings. Their efforts, which were occasioned by the artistic and literary usage of landscape, have been continued in some measure in geography from von Humboldt (1848) to Vaughan Cornish (1928) and most recently Jay Appleton (1975) and Edward Relph (1976, 1981). Even those geographical writers who have been eager to develop landscape as a strictly scientific term have found it necessary to recognise the subjective meaning implied by artistic and poetic usage of landscape. Carl Sauer (1925), for example, acknowledges after his exposure of scientific morphology, that there remains an aspect of meaning in landscape which lies 'beyond science', the understanding of which cannot be reduced to formal processes. Like the French geographer Paul Vidal de la Blache, Sauer recognised that the affective dimension of landscape indicated a harmony between human life and the milieu in which it is lived. In his geographical writing he sought to capture something of this harmony in language and literary structure but stopped well short of the mysticism with which some German geographers like Ewald Banse (1924) and G. Hard (1965) have invested the concept of *Landschaft*. To regard landscape as both object and subject has important consequences for a discipline seeking to theorise according to determinate rules of scientific procedure the relationships between human beings and their environment as those relationships give rise to characteristically differentiated areas. Morphological analysis, with its concentration on empirically defined forms and their integration, can operate only at a surface level of meaning, a level equivalent to the *primary* level of interpretation referred to by the art historian Erwin Panofsky (1970) when identifying the meaning of a painting as its formal pictorial

17

representation. Below this lie deeper meanings which are culturally and historically specific and which do not necessarily have a direct empirical warranty. Formal morphology remains unconvincing as an account of *landscape* to the extent that it ignores such symbolic dimensions – the symbolic and cultural meaning invested in these forms by those who have produced and sustained them, and that communicated to those who come into contact with them: the meaning, for example, of the church spire riding over fields of hay or ripening wheat, damp stubble or sodden ploughland – a telling symbol even to the most casual observer.

The affective aspect of landscape is equally implicated in the second ambiguity we have noted, between individual and social. To speak of landscape beauty or quality is to adopt the role of observer rather than participant. The painter's use of landscape implies, precisely, observation by an individual, in critical respects removed from it. The landscape drawn, painted or photographed, placed on a wall or reproduced in a book, is addressed to an individual viewer who responds in a personal way, and can elect to remain before the scene or to turn away. The same is true for the relationship we have towards the real world once we perceive it as landscape. Another way of putting this is that in landscape we are offered an important element of personal *control* over the external world. The individualist aspects of this 'landscape relationship' were important to those eighteenth-century thinkers who drew strongly on theories of individual psychology to develop their ideas of the 'sublime' and 'beautiful' in nature. Similarly, contemporary research into landscape evaluation for planning purposes relies upon personal responses, generally elicited by some form of interview, which are then aggregated to produce a common or social measure of landscape quality. Specific geographical consideration of the affective qualities of landscape has also concentrated on the individual. Vaughan Cornish's 'aesthetic geography', and Jay Appleton's 'habitat theory' are both predicated on the assumption that the experience of landscape is that of individual perception and response to an individual scene.

But the affective bond between human beings and the external world is not merely, perhaps not even primarily, an individual or personal thing. For geography, in fact, the personal relationship is of minor importance when compared with the collective investment of meaning in places by those who make and keep them. David

Lowenthal (1962-3) has indicated the profound difference between the external, individual observer and the insider-participant in a telling example from William James of the different responses to a pioneer forest clearing in Appalachia between a sophisticated traveller and the responsible landholder. For the former the clearing was a chaotic and visually offensive scar of the pristine majesty of the forest. For the latter it was a record of pioneering effort and a symbol of his family's and the nation's future. The place was invested with a personal and social meaning that had little to do with its visual form. James concludes that 'the spectator's judgement is sure to miss the root of the matter and to possess no truth'. To apply the term *landscape* to their surroundings seems inappropriate to those who occupy and work in a place as insiders. Herein is a clue to the status of the iandscape concept. The visible forms and their harmonious integration to the eye may indeed be a constituent part of people's relationship with the surroundings of their daily lives, but such considerations are subservient to other aspects of a working life with family and community. The composition of their landscape is much more integrated and inclusive with the diurnal course of life's events – with birth, death, festival, tragedy – all the occurrences that lock together human time and place. For the insider there is no clear separation of self from scene, subject from object. There is, rather, a fused, unsophisticated and social meaning embodied in the milieu (Sack, 1980). The insider does not enjoy the privilege of being able to walk away from the scene as we can walk away from a framed picture or from a tourist viewpoint. He is, in Relph's (1976) terms, an 'existential insider' for whom what we may call landscape is a dimension of existence, collectively produced, lived and maintained. In this context, as Relph and Buttimer have argued, 'place' seems a more appropriate term. The element of control which we noted in the relationship implied by the landscape idea is missing, although communities may use a variety of symbolic and ritualistic means in attempting to wrest a degree of control over their physical world. For the insider the external world is unmediated by aesthetic conventions and the collective coexists with the individual. This second ambiguity in landscape, between personal and social, like its objective and subjective qualities, makes it difficult to employ the term as a category within a rigorously scientific enquiry, for in attempting to do so we risk denying the integrity of the insider's experience, prising it apart and subjecting it to the cold blades of classification and analysis.

The two sets of ambiguities discussed here are not of course

unconnected. Landscape is object and subject both personally and socially. However, they can be clarified if, rather than merely noting their origins in the artistic use of landscape, we explore those origins in their historical context. When we do so we come to recognise that in adopting the concept of landscape geographers and others have unconsciously taken over an historically produced and ideologically – dyed view of the external world whose implications raise many of the philosophical and methodological problems confronted but not necessarily resolved in contemporary human geography.

Landscape and Perspective

The idea of painting or imaginatively describing scenes from nature, whether wild or humanised, as the main subject of an artistic composition has a very specific history in Europe. Landscape painting first emerged as a recognised genre in the most economically advanced, densest settled and most highly urbanised regions of fifteenth-century Europe: in Flanders and upper Italy. It reached its fullest expression in the Dutch and Italian schools of the seventeenth century and in the French and English schools of the following two centuries. With the rise of modernist and other forms of non-representational art in the past 100 years landscape has lost much of its claim to be an important preoccupation of progressive artists. Referring to the origins of landscape, J.B. Jackson (1979) has pointed out the historical parallels between its emergence in European painting and the development of the modern theatre as a formal art wherein human actions are presented in direct relationship with a designed and controlled environment: 'scenes' composed of regulated space and illusory settings. In the same renaissance period descriptive geography, particularly of the newly-discovered parts of the globe, undertook to reveal to Europeans the varied terrestrial scene and the relationship between peoples and the lands they occupied. In all these activities Europeans emphasised visual relationships and the control of space in which an illusion of order could be sustained. The boundary between reality and fantasy was not clearly defined; in the theatre, for example, it is consciously obscured. In landscape painting, landforms, trees and buildings could be altered in position and scale, introduced or removed in order to structure and compose an apparently realistic and accurate scene. Cartographers could combine a detailed and carefully observed map of a city with motifs

of its patron saints or classical gods intended to convey its commercial or political topography. All these parallel developments suggest an attempt on the part of Europeans to clarify a new conception of space as a coherent visual structure into which the actions of human life could be inserted in a controlled and orderly fashion.

The terms control and order are significant. Kenneth Clark (1956) has written that a form of landscape painting which he calls 'realist', in the sense that the artist attempts faithfully to record the forms of the external world for their own sake, appeared for the first time in fifteenth-century Flanders and northern Italy. He claims that it related to 'some change in the action of the human mind which demanded a new nexus of unity, enclosed space', a change which was conditioned by a scientific way of thinking about the world and an 'increased control of nature by man' (Clark, 1956, p. 29). Jackson (1979, p. 3) also refers to 'a widespread belief that the relationship between people and their surroundings could be so expertly controlled and designed as to make the comparison [between the intensity of family bonds and those of humans with their environment] appropriate'. Landscape painting at this time achieved the visual control of space and of the human actions which occur within it. In examining the ideas and techniques by which this was achieved we can recognise a critical and lasting difference within the history of landscape representation between the two areas of its initial elaboration. In Flanders, painters like Van Eyck in the early years of the fifteenth century were among the first to produce works which render in astonishing detail and accuracy the secular life of towns and villages against a carefully recorded physical setting. These scenes formed the background to paintings whose dominant theme remained sacred. But through its history Flemish landscape painting was characterised more by close empiricism than by intellectual theory, a fact of some significance for later English landscape art which drew equally from Flemish and Italian models. But it is in Italy that we can identify an *idea* of landscape, the notion of a particular artistic genre which could be allocated a determinate place within an artistic theory dominated by techniques for controlling visual space. Pre-eminently spatial control was achieved through a technique of perspective, a technique which renaissance artists regarded as their most significant discovery and the means for realistic representation of the world. Perspective was regarded not merely as a technique, a visual device, but as a truth itself, the discovery of an objective property of

space rather than solely of vision. It regulated the space of their pictures and of the theatre, representing as reality that which is observed by the eye of the spectator conceived as the static centre of the visible world (Berger, 1972). The eye was regarded as the point of convergence of an infinite number of rays which tied it to the external world. Reality was frozen at a specific moment, removed from the flux of time and change, and rendered the property of the observer.

The specific discovery of renaissance artists was linear or single point perspective. Linear perspective, originally demonstrated in a famous Florentine experiment by Filippo Brunelleschi, presupposes a single eye looking, without movement, at a vanishing point of orthogonal rays. It was described in detail and its theory constructed by Leon Battista Alberti, one of the most influential theorists of the Italian Renaissance. Alberti has also been claimed as one of the earliest apologists for landscape as a distinct genre of painting (Gombrich, 1966). His treatise on art, *Della Pittura* (1435-6), opens with a discourse on the techniques for constructing a visual triangle from the eye which will allow the painter to represent things as they really are. This work became the standard authority for subsequent treatises on accurate perspective representation and its influence remained pervasive well into the eighteenth century. It was regarded as of key importance by Sir Joshua Reynolds, the foremost English authority on artistic theory during the period when the nature and purpose of landscape painting was most seriously debated. That J.M.W. Turner, an outstanding and innovative landscapist of the early nineteenth century, held the position of Professor of Perspective at the Royal Academy indicates the durability of the hold which renaissance theory maintained over early modern painting. It was only the challenge by various of the 'modern' movements in our own time, particularly Cubism, which stressed the relative nature of vision as revealed by the camera and of space as theorised in physics which fully and effectively disposed of the dominance of perspective as the central convention for realist representation of nature.

E.H. Gombrich has argued that Alberti provided a theoretical foundation for landscape before landscape paintings as such had been produced in Italy. The earliest occurrence of the term *paesaggio* applied to pictures dates from 1521. The most memorable reference is to Giorgione's *La Tempesta*, described as 'a small landscape (*paesetto*), on canvas, with a thunderstorm, a gipsy and a soldier' (quoted in Gombrich, 1966, p. 109). Originally it was applied to

Flemish genre pieces purchased by Italian collectors primarily for their depiction of scenery rather than for the human or religious events they described. Their scenery was unfamiliar, even fantastic, to Italian eyes in form, colour and atmosphere. Italian connoisseurs had developed, partly through the theories of Alberti and his successors, a consciously 'aesthetic' attitude to painting and prints, prizing them more for their technical artistic achievements than for their function or subject matter. In this of course they were laying the foundation for a market in art works wherein value was determined by aesthetic attributes, a point of some significance for relating the view of the world promoted by landscape to the economic relations of sixteenth-century Italy. Art was becoming a commodity whose value could be realised in exchange. For this to be so its products had to hold their appeal to any individual viewer and to sustain it in different contexts and places. This had not been the case for a medieval fresco or altar triptych, for example, paid for by a patron, perhaps representing himself and his family, and designed to stand in a particular chapel. The new aesthetic attitude was based on the notion that painting had a certain psychological effect on the person contemplating it, regardless of location or context. It was a personal experience between painting and spectator.

Alberti has a memorable passage in his *Ten Books on Architecture* (1450) where he discusses the decoration of buildings and rooms:

> Both Painting and Poetry vary in kind. The type that portrays the great deeds of great men, worthy of memory, differs from that which describes the habits of private citizens, and again from that depicting the life of the peasants. The first, which is majestic in character, should be used for public buildings and the dwellings of the great, while the last mentioned would be suitable for gardens, for it is the most pleasing of all.
>
> Our minds are cheered beyond measure by the sight of paintings depicting the delightful countryside, harbours, fishing, hunting, swimming, the games of shepherds – flowers and verdure. (Quoted in Gombrich, 1966, p. 111)

Alberti is recommending a strict hierarchy of both subject matter and location for works of art. At its peak is *storia*, epic or heroic history whose elevating character is suitable in places of power and authority. Painting representing the life of ordinary citizens – that is the propertied and enfranchised patricians – is suitable for urban

23

residences, private houses and palaces. At the base of the hierarchy is the world of the countryside and the life of the peasants. When Alberti claims that landscapes are appropriate for gardens he is referring neither to urban gardens nor to a real world of peasant labour so much as to the world of patrician villas set in country estates and used for summer recreation and relaxation away from the cities. Thus the activities to be depicted are leisure pursuits: fishing, hunting, swimming or relaxed views over the countryside and coast. The peasantry, beasts of labour and objects of ridicule in poetry or farce, are to shown 'at their games'. They form decorative additions to a sylvan setting which cheers beyond measure the soul of the world-weary citizen.

Landscapes painted in Italy at this time demonstrate in practice Alberti's theory. Paolo Ucello's *Hunt in the Forest*, for example, shows wealthy patricians relaxing in a traditional upper-class country sport. It is a tightly-controlled exercise in linear perspective. Commenting on space composition – 'the bone and marrow of the art of landscape' – in Umbrian painting of the time, Bernard Berenson fully grasps the sense of power they convey: 'in such pictures how freely one breathes – as if a load had just been lifted from one's breast; how refreshed, how noble, how potent one feels' (Berenson, 1952, p. 121).

We shall have occasion later to examine Alberti's attitudes to different kinds of landscape. For the moment it is sufficient to note that there is no suggestion that these paintings should represent landscape as a place of ordinary life in which the daily world of the insider, at work or at leisure, is sympathetically portrayed. Landscape painting is intended to serve the purpose of reflecting back to the powerful viewer, at ease in his villa, the image of a controlled and well-ordered, productive and relaxed world wherein serious matters are laid aside.

Renaissance theatre parallels this hierarchy in the relationship established between stage set and action. Sebastiano Serlio was one of a number of renaissance architects who designed permanent stage sets for wealthy patrons. They were of three kinds, for tragedy, comedy and farce. Tragedy's required a perspective view of an imaginary classical city, replete with emblems of Roman imperial authority where the 'great deeds of great men' could be acted out. Comedy took place in a palace courtyard or domestic interior. Farce merited a bucolic scene in which peasants could engage in buffooneries within the amused purview of relaxing patrician

gentlemen and where, as in *A Midsummer Night's Dream*, a perfect love could flourish among the verdant groves. In both painting and theatre perspective was employed to control space and to direct it towards the external spectator. This spectator participates only vicariously, as imagined hero in the city, sympathetic confidant under the pergola, or amused observer of a rural life to which thankfully he does not belong. The people who occupy the landscape and cheer the citizens by their antics do not themselves participate as subjects responsible for their world; they are puppets controlled by the artist through the same techniques as nature itself is controlled.

Perspective, then, was a device for controlling the world of things, of objects which could be possessed. It was related to a cosmology in the Renaissance which regarded creation as ordained by fixed geometrical rules. The painter or architect could understand and apply these rules and thereby emulate the creative act. Leonardo da Vinci, referring to the painting of landscape, makes it clear that in landscape the artist can wrest control over nature, he has creative power:

> So if he desires valleys or wishes to discover vast tracts of lands from mountain peaks and look at the sea on the distant horizon beyond them, it is in his power; and so if he wants to look up to the high mountains from low valleys and from the high mountains towards the deep valleys and the coastline. In fact, whatever exists in the universe, either potentially or actually or in the imagination, he has it first in his mind and then in his hands, and these [images] are of such excellence, that they present the same proportioned harmony to a single glance as belongs to the things themselves . . . (Quoted in Gombrich, 1966, p. 112)

Here perspective, proportion and landscape are united within a single claim for the role of the individual artist as a controlling creator. There is a suggestion, too, of the unity of artistic creation with the objective understanding of nature which blossomed later into the empirical sciences. Leonardo himself never divorced artistic creation from what we would now regard as the scientific exploration of nature. What united them was a belief in a harmonious and proportioned order running equally through macrocosm and microcosm and reproduced technically in painting through perspective control of the picture's space. The relationship between art and science in the evolution of the landscape idea has important

consequences for geography's use of landscape, as we shall see. Indeed the emergence of geography as a distinct intellectual discipline, many of whose proponents have employed the landscape concept, coincides historically with the decline of landscape in art as well as the abandoning of perspective as painters explored new ways of representing light, atmosphere and the complexities of vision. These relationships are examined in the final chapter. For the moment it is sufficient that we recognise that the separation of subject and object, insider and outsider, the personal and the social are already apparent at the birth of the landscape idea.

Perspective as a convention of realist vision has two consequences which relate to the idea of control discussed above. While it is possible to hint at the passage of time in realist landscape painting – indeed there have been fixed conventions for doing so, for example by depicting ruins in the scene or suggesting evidence of human mortality, as in the elegiac 'Et in Arcadia Ego' – an important effect of linear perspective is to arrest the flow of history at a specific moment, freezing that moment as a universal reality. Secondly, perspective, in structuring and directing universal reality at a single spectator, acknowledges only one, external subject for the object it represents. Thus a landscape painted in accordance with pictorial rules, or nature observed by an eye trained to look at it as landscape, is in important respects far from being realistic. It is composed, regulated and offered as a static image for individual appreciation, or better, appropriation. For in an important, if not always literal, sense the spectator *owns* the view because all of its components are structured and directed towards his eyes only. The claim of realism is in fact ideological. It offers a view of the world directed at the experience of one individual at a given moment in time when the arrangement of the constituent forms is pleasing, uplifting or in some other way linked to the observer's psychological state; it then represents this view as universally valid by claiming for it the status of reality. The experience of the insider, the landscape as subject, and the collective life within it are all implicitly denied. Subjectivity is rendered the property of the artist and the viewer – those who control the landscape – not those who belong to it.

It is not surprising, therefore, that when humans are represented in landscape paintings they are more often than not either at repose or, if at work, distant and scarcely noticeable figures. Their position is determined by the pictorial structure and for the most part human figures seem to be in but not of their surroundings. If they become

too dominant the work ceases to be a landscape. In landscape subject and object are always potentially separable by the mere act of the spectator's turning his back on the painting or scene. This is the clue to the double ambiguity with which our discussion opened. Perspective locates the subject *outside* the landscape and stresses the unchanging objectivity of what is observed therein. Collective human experience is reduced in significance compared with the individuality of the observer. But by claiming realism, paintings of landscape and the idea of landscape itself offer the *illusion* of an affinity with the insider's world, the world we do experience as a collective product of people subjectively engaged with their milieu. Hence landscape's ambiguities derive directly from its ideological origins.

There is, of course, more to the painting of a landscape than merely linear perspective and associated claims to realist reproduction of the external world. All painting is in large measure a work of imagination, and in landscape the sky as light source, water as a symbol of rebirth or purity, the curving and undulating forms of natural topography, all appeal to that imagination and at the same time make the rigid application of linear perspective particularly difficult. But it is significant that the landscape idea and the techniques of linear perspective emerge in a particular historical period as conventions that reinforce ideas of individualism, subjective control of an objective environment and the separation of personal experience from the flux of collective historical experience. The reasons for the emergence of this view are to be found in the changing social organisation and experience of early modern Europe and it is to them that the main essays in this book are directed. As that social organisation develops so the view of the world implied by the landscape idea undergoes elaborations and mutations, responding to determinate contexts and specific tensions. But its essential features remain relatively constant and they have been incorporated into the landscape concept employed in geography. Indeed in some respects geography's concept of landscape may be regarded as the formalising of a view of the world first developed in painting and the arts into a systematic body of knowledge claiming the general validity of a science. To justify this claim we need to consider briefly geography's visual bias.

Landscape and Visual Bias in Geography

Since its establishment as a recognised academic discipline at the end

of the nineteenth century, geography has consistently sought a concept capable of denoting the specificity and individuality of areas on the earth's surface over which a 'unity in diversity of phenomena' may be recognised and studied. Even the protagonists of a strictly nomothetic, law-based and deductive geographical method modelled on positivist scientific assumptions have acknowledged that geographical laws and spatial theories may only be tested and exemplified in the context of really existing areas. Writers with philosophical positions as far apart as Fred Schaefer (1953) and Derek Gregory (1978) concur that it is to the elucidation of areal relations of terrestrial phenomena and events that geography ultimately aspires. Landscape is only one of a number of terms developed in the discipline to specify this goal. In Anglo-Saxon geography *region* has generally been preferred, and some have borrowed the French term *pays*. But for each of these a holism is implied, a dimension which is not captured by the mere enumeration of constituent parts. The significance of *landscape* as the defining term for this areal concept lies in its open admission of visual bias in the search for geographical synthesis and that in recent years it has been employed as a geographical concept by writers seeking to challenge the orthodoxy of scientific method in geography, to incorporate into the discipline an open acceptance of subjective modes of study.

However, all these areal concepts have within geography a visual foundation. Consider Vidal de la Blache's geographical description of the Pays de la Beauce:

The Beauce is not a purely territorial unit; it is the expression of a type of land and of existence of which the idea exists very clearly in the minds of its people. It would be a delusion to search for other limits than these; and we should not be surprised if the name appears sporadically elsewhere, thrown up by the nature of the place. Thus we find it appearing to stray towards the confines of Perche or into the plain of Hurepoix. But there will always remain the *pays*, the Beauce par excellence, because there is one area which demonstrates most clearly and precisely its characteristics: that area which spreads its uninterrupted uniformity from Etampes to Pithiviers, Artenay, Patay and Auneau. The rare small streams which cut into the margins of the Beauce leave no trace on this convex, shield-like land except for imperceptible dry notches, or by the appearance of *rouches* or lines of marsh. The life of the plains dominates, to the exclusion of that variety which the

life of the valley always brings. Life is concentrated, in large villages, gathered around wells which can only reach water at great depths; villages are deprived of that skirt of trees and gardens through which the Picardy village stretches itself. The chalk, always near the surface, provides building stone for both houses and roads. The Beauce farmer, grandly housed, travels in his cart along the straight highways stretching to the horizon. The image of an abundant and copious life attaches itself to his *pays* and it enters into his habits and his needs . . . (Vidal de la Blache, 1903, pp. 147-9)

Vidal here evokes both a powerful visual image of the landscape and a sense of the functional rhythms of its daily life. We can sense the basis of the description in direct experience, sharpened by carefully reflective scholarship, and it retains validity for anyone who has crossed this area south of Paris even today, some 80 years after it was written. Above all Vidal's synthesis is pictorial. It emphasises form and pattern as they appear to the eye. This is true not only for the physical objects in the landscape, but also for the mode of life which he presents as integrated so neatly into its milieu. It is evoked by the image of the farmer, his house, village and cart. Even the security of his life is stressed by a strongly visual image.

The same visual emphasis is found in Carl Sauer's description of the characteristic landscape of the north European heath, offered as an example of the generic type of landscape that geography seeks to develop from its study of uniquely occurring examples, rather than as a description of one particular area:

The sky is dull, ordinarily partly overcast, the horizon is indistinct and rarely more than a half-dozen miles distant, though seen from a height. The upland is gently and irregularly rolling and descends to broad, flat basins. There are no long slopes and no symmetrical patterns of surface forms. Watercourses are short, with clear, brownish water, and perennial. The brooks end in irregular swamps, with indistinct borders. Coarse grasses and rushes form marginal strips along the water bodies. The upland is covered with heather, furze and bracken. Clumps of juniper abound, especially along the steeper, drier slopes. Cart tracks lie along the lower ridges, exposing loose sand in the wheel tracks, and here and there

a rusty cemented base shows beneath the sand. Small flocks of sheep are scattered widely over the land. The almost complete absence of the works of man is notable. There are no fields or other enclosed tracts. The only buildings are sheep sheds, situated usually at a distance of several miles from one another, at convenient intersections of cart tracks. (Sauer, 1925, pp. 323-4)

Here, too, the strength of the geographical description lies in the visual image it succeeds in evoking, employing the resources of language to indicate relationships between various phenomena and processes, both natural and human, which give rise to a landscape type. We are reminded of a heathland landscape by the German romantic landscape painter, Caspar David Friedrich. The synthetic understanding, of which Sauer gives this example, even if rarely successfully achieved by geographers, has been a declared aim in much of their work. It has recently been restated in powerful terms by Cole Harris (1978). But it is rare to find geographical writers acknowledging explicitly the pictorial foundation of their landscape concept.

The long recognition by geographers of the importance of the map as both a primary analytical tool and the main embodiment of their results and conclusions also testifies to a visual foundation of geographical synthesis (Rees, 1980; Thrower, 1972). Of course, many of the cartographic representations of spatial relationships produced by contemporary geographical science bear little obvious affinity with the world we observe around us with the naive, unaided eye. But even the most schematic trend surfaces or abstract distance decay models claims to be transformable into the world of visible realities, assuming that we are able to operate the appropriate transformation rules. It is not, I think, without significance that students taught the basis of central place theory or urban land rent curves more easily remember the pattern of hierarchically-organised hexagons or of concentric circles than the theoretically more important concepts of threshold, range and economic rent. A common protest familiar to every teacher of these theories is that the patterns they yield do not correspond to the patterns known from experience or from the topographic map. This reservation reflects the empiricism and visual underpinnings of the geographical imagination. No geometrician or economist would find the visual pattern of his or her evidence more significant than the algebraic formulation of the theorems, or the equation yielded by the intersection of the demand

curves. William Bunge (1966, p. xiv), making the case for a purely theoretical, mathematically-based geography, noted that 'geography is the only predictive science whose inner logic is literally visible'. Geographers appear to require that the demonstration of their theories be supplied by the visual evidence of the world around them. Theirs finally is the argument of the eye. It is not then surprising that they have searched for a concept which captures this geographical objective.

To be sure, geographical writers have not been entirely unaware of their visual bias, some indeed have revelled in it. Among German scholars for example there has been over many years a debate between the 'purists' who would rigorously exclude from geographical consideration all non-material and non-visible phenomena and processes in order to concentrate on the morphology of forms, and those following Hettner who would incorporate chronological and ecological considerations in order to give landscape geography explanatory status (Holt-Jensen, 1981; Geipel, 1978). The same argument was echoed among Anglo-Saxon writers discussing landscape in pre-war geography: Hartshorne, Sauer and Dickinson, all of them drawing heavily on German sources. One consequence of this was that landscape geographers felt it necessary actually to distinguish between their approach and that of the painter, poet or connoisseur of the aesthetics of the external scene. Marwyn Mikesell for example, taking his cue from the French geographer Jean Bruhnes, states:

> The perspective of the geographer is not that of an individual observer located at a particular point on the ground. The geographer's work entails map interpretation as well as direct observation, and he makes no distinction between foreground and background. The landscape of the geographer is thus very different from that of the painter, poet, or novelist. By means of survey, sampling, or detailed inventory, he achieves the comprehensive but synthetic perspective of the helicopter pilot or balloonist armed with maps, photographs, and a pair of binoculars. (Mikesell, 1968, p. 578)

The geographer's is still a 'perspective', it is still exclusively visual, but it is subtly different from the artist's. Mikesell draws the distinction at the level of technique rather than of purpose. But Constable's detailed inventories of cloud formations and weather

conditions, the highly sophisticated classifications of geological types, vegetation and building forms supplied to nineteenth-century landscape painters by John Ruskin, or the close analysis of topographic maps by contempory 'land artists', would hardly suggest that if they were 'armed' with the same techniques Mikesell claims for the geographical arsenal, landscape artists would despise them. If a more profound distinction exists between the two, then Mikesell leaves it implicit. It may be that he assumes the painter, poet or novelist to be more open and engaged in revealing a subjectivity or exploring a moral dimension that the geographer should be at pains to exclude in the interests of scientific objectivity. If this is so it is left implicit. As we shall see, more recent geographical writing has declared itself open to the embrace of subjective and moral discourse.

This may be because science demands structured explanation of the forms and events which it observes, and the understanding and elucidation of processes. Since the mid-nineteenth-century contributions of Darwin and Comte, science has been systematically separated from the arts as a mode of understanding. Certainly Sauer's discussions of landscape are unyielding in their requirement that geography be at root a positive science, and neither Hartshorne nor his critics disagreed. But landscape does not lend itself easily to the strictures of the scientific method. Its unity and coherence are, as we have seen, deeply rooted in a way of seeing, and this remains true whether the view is from the ground, from the air or of the map. All of them are understood to be structured by the rules of vision, by a form of perspective. Once we elect to offer explanation of either an historical, a functional or an ecological kind we are forced to abandon the static visual model in a search for process. But it is process that landscape as an ideological concept formally denies. Thus, for example, when historical geographers have attempted to incorporate historical change into landscape study they have been forced into unconvincing methodological gymnastics, using devices like cross-sections, sequent occupance or thematic change through time, or else have abandoned altogether the synoptic overview of area to concentrate upon social processes which yield a specific spatial form. The same may be said for geomorphology which has largely neglected morphological analysis for detailed investigation of the processes of landform development and earth-surface sculpturing.

Yet while the requirement of science ultimately undermines the purely visual basis upon which the landscape idea finally rests, science in some ways is itself the extension of the way of seeing the

world from which landscape and perspective emerged. A disinterested and objective, scientific geography is the apotheosis of the outsider's view of the world. It embodies in formal rules the perspective of one who can consider spatial organisation the objective outcome of objective processes, and who can separate himself literally and theoretically from the object of study. It is the opposite of the insider's experience, of one engaged by necessity in making and living in a landscape. The claims of scientific understanding reinforce the notion that the objects of its study are universally real and true. Thus to claim scientific treatment of landscape in geography is to extend the claim of realism for the outsider's view, to devalue that of the insider and thereby to underwrite the ideological position that landscape proclaims.

Like landscape painting, Mikesell's geographical landscape lacks a subject within. The subject of landscape in art is the spectator or the artist, participating as creator or controller through the medium of perspective. Mikesell and others who make a claim for a specifically geographical concept of landscape further exclude the subject, for the geographer is supposed precisely to retire from the landscape he offers in order to ensure its objective status. He hides consciously behind his battery of surveys, maps and aerial photographs. And his landscape lacks its own subject. No people appear before the eyes of the helicopter pilot or balloonist other than as indistinguishable ants moving as statistical averages across distance space. Lacking in these ways subject or subjects, we may ask whence the proclaimed unity of the geographical landscape derives? It would appear to be produced by the same techniques as that of a painting: from the formal bounding or framing of the scene, from the arrangement of physical forms, from the classification of types of human activity and even from the evocation of mood through atmosphere, light and colour, as we saw in Vidal's and Sauer's descriptions. When fully deployed these methods can produce geographical descriptions highly suggestive of landscape paintings as such, challenging the validity of the laboured distinction between the geographical and aesthetic landscapes.

Landscape and Humanistic Geography

Over the past decade the view of geography as a positive science has been challenged by writers favouring a 'humanistic' approach to

understanding relations between humans and their world. Landscape has re-emerged in their writings as an important term because its affective meaning seems to allow for an escape from the outsider's position and for the incorporation of sensitivity to human engagement with particular places and areas. Humanistic geography seeks to recover the geographical imagination so well illustrated in the writings of Vidal and others, but subsequently lost in scientific geography, and to introduce moral discourse into geography (Ley and Samuels, 1978). Significantly the writings often claimed to reveal such sensitivity, those of Vidal or the historian Fernand Braudel, reveal a strong *historical* sense, and it is this rather that any formal method which seems to account for their success in evoking the nuances and complexities of human relations in society and place which give rise to characteristic areas, or landscapes. Yet, as Harris (1978) has pointed out, the historical sense is weakly developed in humanistic geography, and this accounts for many of the difficulties that contemporary humanism has encountered in working with landscape in geography.

Despite frequent homage paid to French regionalism of the early twentieth century, humanistic geography is very much an American product, a reaction to the enthusiasm with which positivist method was embraced by north American geographers in the post-war period, and generated most strongly by social geographers. And in appealing to the landscape idea American geographers have had at least one important model to turn to within their own scholarly tradition: the writings of J.B. Jackson. As a recent collection of essays on *The Interpretation of Ordinary Landscapes* (Meinig, ed., 1979) makes clear, humanistic study of landscape owes to him and to his journal *Landscape* a particular debt. Jackson has always eschewed disciplinary labels and both in his own writings and through the editorial policy of his journal opened out the concept of landscape in ways which seem to democratise it, liberating both spectator and participant, by writing from the inside and pointing to the symbolic meanings which arise from social life in particular geographical settings. Jackson senses that the origins of landscape indicate a new and detached mode of seeing, something more than a shift in artistic and literary taste. Of the Renaissance he comments, '[it] is plain that landscape was necessary because it indicated something hitherto unknown or undefined: a detached manner of viewing the world as an object, as distinct from man'. This allowed for an aesthetic perspective on the external world in which nature could become the whole subject of a picture and

from which certain classes of human affairs, the practical as opposed to the contemplative, could be excluded. Jackson notes that this exclusion made possible an examination of the external world in terms which we would now call 'scientific': identification, classification and analysis of discrete objects conceived apart from human intention. He exposes the common historical origins of both landscape as art and landscape as object of scientific investigation.

Recognising something of the historical origins of the landscape idea and refusing to submit his imagination and sensitivity to the constraints of sophisticated disciplinary definition have enabled Jackson in papers on the American landscape to provide a series of evocative, memorable and penetrating vignettes which are both visually acute and yet receptive to the meaning of the milieu for those who occupy it. In the architecture of the highway strip, its billboards, fast-food franchises, motels, gas stations and auto-repair yards; in the main streets of small mid-western towns; in the domestic back yards of Arizona ranch houses, Jackson can sense and communicate the daily significance and practical uses of what he still chooses to call the landscape. He can indicate its relationship to the ways that its makers have signified themselves and their worlds, for example in considering the American house archetypically over three generations, and address at once both its visual coherence and its social purposes.

Of landscape as a formal term Jackson has admitted that 'the concept continues to elude me', and gives the reason as his refusal to treat it as a scenic or ecological entity and his determination to accept it as a political or cultural phenomenon, changing in the course of its history. Donald Meinig (1979, pp. 288-9) lists the key features of Jackson's landscape idea: landscape is anchored in *human life*, not something to look at but to live in, and to live in socially. Landscape is a *unity* of people and environment which opposes in its reality the false dichotomy of man and nature which Jackson regards as a Victorian aberration. Landscape is to be judged as a *place for living and working* in terms of those who actually do live and work there. All landscapes are *symbolic*, they express 'a persistent desire to make the earth over in the image of some heaven', and they undergo *change* because they are expressions of society, itself making history through time. Finally Meinig lists two structural elements which Jackson regards as central to landscape study. These are the *individual dwelling* as the primary landscape element and the prototype of the larger world in a culture; and a primary attention to the *vernacular* in landscape. In these last items Jackson's democratic and populist

35

leanings are apparent. In assessing Jackson's landscape studies Meinig recognises their stimulating and suggestive qualities but argues that they lack the intellectual detachment necessary for more critical and theoretical understanding:

> All is assertion and argument, nothing is documented or formally demonstrated; much is observed, nothing is measured. Jackson is a stimulating thinker, he is not a professional scholar. His writings are never supported by the usual research apparatus. (Meinig, 1979, p. 229)

These comments return us to the central problem raised by the origins of landscape in the renaissance humanist tradition. Landscape is indeed the view of the outsider, a term of order and control, whether that control is technical, political or intellectual. In the rich sense that Jackson's practice has given it perhaps landscape is simply as unreachable by the formal apparatus of scholarly or intellectual control as it is by the armoury of techniques and tools with which Mikesell would distance the scientific geographer.

This issue is taken up by another contributor to Meinig's collection. Marwyn Samuels (1979) is representative of the new geographical humanism in his search for ways of incorporating human meaning into the purposes of geographical understanding and in his desire to develop a clear methodology for landscape study. He recognises that the separation of subjective and objective ways of knowing bears critically on the study of landscape. He proposes therefore to incorporate both into an approach drawing upon the traditions of other humanities which examine the expressions of human creativity in art and artifice, specifically biography. Samuels insists upon the 'authorship' of landscape, the fact that it is not the unconscious outcome of impersonal forces but the responsibility of real people. At the same time the individuals who create landscapes operate in determinate contexts. Samuels's conclusion is that we should concentrate upon the evidence, direct and indirect, that individuals have left as explanation, rationalisation, or description of their intentions. New York, for example, he claims is the creation of great men like the Roebling Brothers, Louis Sullivan, certain patrician families like the Rockefellers and Harrimans, and above all of Robert Moses, chairman of the Triborough Commission in the early years of the century. All of them operated in the context of

developing American industrialism, a changing urban economic base
and the prevailing ideas of the progressive movement.
Samuels is not unaware of the philosophical and methodological
issues which his proposed approach raises. He draws attention
specifically to the problem of appealing to idealist or materialist
modes of explanation – the former regarding human ideas as the
autonomous force of human actions, the latter seeking to ground
those actions ultimately in the conditions of human existence in the
material world. He comments that 'if the logic of landscape biography
renders this distinction moot, the method of that biography must
account for the relationships among these two worlds' (ibid., 1979,
p. 69). But his response to this issue is to evade it by defining
overlapping categories of landscape: landscapes of 'impression' (more
about than *in* the landscape) and landscapes of 'expression' (whose
authors are identified *in* their landscape). This is an evasion because
it simply restates the opposition between subject and object, insider
and outsider – the central contradictions of the landscape idea – in
altered form. Indeed it relocates the opposition within the landscape
itself rather than in the ways we set about understanding it.

Considered as an attempt to give a formal academic structure and
method to Jackson's informal penetration of the layers of meaning in
landscape, Samuels's humanism offers a means of viewing it as an
insider while sustaining a degree of scholarly detachment. But this is
attained only at the expense of disregarding the social dimensions of
landscape and adopting assumptions of voluntarist individualism. The
idea of context hints at a more social and structured explanation and
Samuels does suggest that the method of landscape biography derives
from historiographical sources. But these are weakly developed ideas
and for the most part the dynamic and historical aspects of landscape,
the account of its changes under succeeding 'authors', plural as well
as individual, in time as well as space, are ignored.
They are less absent in Edward Relph's (1981) analysis of
humanistic geography and landscape. Relph is aware of links between
the landscape idea, the evolution of scientific method and renaissance
humanism. But in seeking to couple humanism with Cartesian
science as pure intellectual categories revealing themselves in
alienated or placeless landscapes, Relph rejects one side of the
dialectic between thought and action in the real historical world.
Thus, whereas Samuels ultimately rests his understanding on the
landscape authorship of 'great men', Relph locates his in moral self-

reflection. The outsider is to become an insider through personal regeneration, and moral fervour becomes a substitute for historical analysis.

The treatment of landscape in humanistic geography, despite its shortcomings, demonstrates that the issues raised by landscape and its meanings point to the heart of social and historical theory: issues of individual and collective action, of objective and subjective knowing, of idealist and materialist explanation. If traditional geographical studies of landscape stressed the outsider's view and concentrated on the morphology of external forms, recent geographical humanism seeks to reverse this by establishing the identity and experience of the insider. But in neither case is the picture frame broken and the landscape inserted to the historical process. The reason for this is that, as I have indicated, landscape is itself a way of seeing, taken on board by geography with its ideological assumptions fundamentally unaltered. To understand how this has happened we need to trace the history of the landscape way of seeing and controlling the world. I have already noted something of its origins in the Italian Renaissance. I have suggested that it underwent significant change in the nineteenth century, as the landscape vision based on linear perspective, guarantor of realism, was challenged in the arts and simultaneously elevated to the status of an object for investigation by geographical science, a status only now undergoing critical scrutiny.

The intervening period is one during which landscape underwent certain mutations, but remained dominated by techniques of composition which served to underwrite the image of a world unchanging and stable in the relationships between humans and nature. It was equally a period when the rigid separation we accept between art and science remained unformulated. To trace the evolution of the landscape idea through this period is to follow a theme in the history of ideas. That demands a framework for locating ideas in a more inclusive historical context than Relph, for example, offers. The historical theory of a transition from feudalism into capitalism offers such a context because it is one which highlights a radical alteration in material relations between human beings and the land. In this alone it offers a critical challenge to the landscape idea which posits a stable union of man and nature. Once we have observed how the landscape idea relates to this transition we may clarify the difficulties it poses for geography.

2

Landscape and Social Formation: Theoretical Considerations

In the introduction I claimed that the idea of landscape achieved prominence during the long period of transition in European societies between feudalism and capitalism. Feudalism and capitalism are both very general terms. Without careful definition of context they do not provide a sharp theoretical edge or allow us to specify except in the most general terms their relationship with cultural products like landscape. In Marxist thinking each denotes a mode of production, a particular way in which humans come together socially to produce their individual and collective existence. A mode of production is above all a theoretical description of a set of economic and social relations. It is in effect a model or ideal type, and as such it is not something we should expect to find existing in pure form in any specific historical society. In pure market capitalism, for example, the model states that all production and the social relations relating to it are geared towards commodities bought and sold in a market where value is determined solely in the act of exchange by the meeting of supply and demand. We know that this has never been the case in any historical society. Even in nineteenth-century England, the case study for Marx's construction of a theory of capitalism, people produced and exchanged certain goods and services reciprocally within their communities and without recourse to the market, the prices of some goods were still determined by custom or state intervention at a local or national level, and forms of collective control still existed over remaining pieces of common land.

So in concrete historical terms we need to recognise that while the broad relations of a given society may be dominated by a particular mode of production whose theoretical model is a valuable descriptor, there will always exist both the remnants of formerly dominant modes

39

and the anticipations of future ones. Further, we should realise that the model of a mode of production will be altered in practice by those geographically specific features of our differentiated world to which other forms of historical explanation often give prominence: relief, climate, vegetation and soils, demographic characteristics and ethnicity. It is these specifics of history and geography which variously inflect the dominant mode of production, producing what Marxists refer to as social and economic formations, social formations for short. If we are to construct our understanding of the landscape idea around the notion of a transition between dominant modes of production in European social life we need to clarify these terms and their meaning in the European context.

Also, the whole idea of the transition within European social formations raises the questions of why and how such changes occurred. For some readers of Marx and Engels their work suggests a unilinear and inevitable historical process characterised by distinct stages, each dominated by a mode of production: primitive communism to ancient slave-owning to feudalism, capitalism and ultimately socialism and communism (Hobsbawm, 1965). We have enough evidence, however, from archaeology, the anthropology of non-European societies and from the history of other complex civilisations to recognise that such a neat historical evolution is an absurdity, one that allows us to evade the need to explain in concrete terms how European societies actually transformed themselves. A number of competing theories exist to explain the European capitalist transition and they are briefly reviewed in this chapter.

Perhaps inevitably, given the supremacy that capitalism accords to economic relations conceived as the production and exchange of material goods, most of these theories stress economic change narrowly conceived. They underplay the realm of culture. This arises in part from the idea, developed with some textual authority from Marx, that historical change occurs primarily in the *base* of social life, that is in material productive relations, and only secondarily and in a dependent fashion in the *superstructure* of that society, that is in its political, legal, religious, cultural and artistic life (Williams, 1977).

A recent re-emphasis in the writings of some historians on the centrality of class tensions and struggles as the motor force of historical change acts against this deterministic argument. They attach greater significance to the ways people see their objective situation, to the significance of ideology, struggle between classes in the realm of cultural production and the production of symbolic

meanings as active forces in historical change. The theoretical discussion of relations between material necessity and human agency returns us to issues which in the last chapter I claimed the humanist interpreters of landscape had neglected. The final part of this chapter will therefore review the debate about the role of culture in the transition and suggest reasons why landscape may be located as a significant cultural phenomenon within it.

Modes of Production

Since the landscape idea denotes a view of the land and its social meaning, the discussion of modes of production and of the capitalist transition here will focus upon land and the social appropriation of land under feudalism and capitalism. It is obvious that there exists a far broader discussion of such issues as class, labour, the state and so on under different modes of production. As we shall see in the later specific studies, such issues are often raised under the guise of landscape representations. For the moment, however, it is sufficient to our purposes to concentrate on the very different ways in which nature and land take on meaning under feudalism and capitalism.

Feudalism

Feudalism is a form of social organisation based in land as the primary means of production, a system of social relations founded upon territory held in fee (Anderson, 1974a). Marxists speak of feudalism as a 'natural economy'. By this they mean that neither those who produce, nor the tools with which they produce, nor the natural environment in and from which they produce, their means of existence and life, nor indeed the products of their labour, are regarded as commodities for purchase and sale in the market-place. The producer is in fact united with his means of production, primarily therefore to the soil. The serf is in theory bound to the earth he works by the bonds of custom and law. He does not however own it in the sense in which we commonly think of *property*, because he cannot sell or purchase his or another piece or pieces of land, nor can he exercise an absolute and individual authority over it or its use. He is enmeshed in a system of relations that extends both within and between social classes, and he is geographically tied to a specific locality, a manor or parish.

Land in fact is held communally so that the individual agrarian

41

worker is engaged in a series of duties, obligations and customs with his fellows. Collectively they parcel up and allocate the land, determine its use and that of certain communally-held means of working it: seeds or plough team or harvest cart. The individual has the right to the product of his plots or strips and of personally-owned tools, livestock and dwelling. There is a tension built into the system of within-class relations between whatever individual desires or aspirations the producer and his family may have and the collective will of his community. One would not expect all persons of an ascribed status, for example serfs, to be equally poor or prosperous, or to have identical aspirations, values and experiences.

Vertically, the primary producers owe obligations in custom and law to a superior class, legally defined, of lords. In principle there exists a reciprocity whereby the military protection a lord can offer is exchanged against a part of the product from the collectively-held land. In fact of course this is a huge protection racket. Surplus labour is extracted from the serf under legal obligation, backed if and when necessary by force of arms, and appropriated by lords. Lords also directly control pieces of land, the demesne, whose size may vary over time depending upon circumstances like population density, which is worked by the direct labour of serfs or peasants under their authority. The two or three days of labour required on the demesne also represent surplus extraction, as do the host of other customs and controls exercised by lords: the administration of lay justice, provision of mills, wine or oil presses, etc. Feudal lords themselves hold their land in fief to progressively higher authorities, their feudal superiors. Their control over land and labour is dependent upon an obligation to provide military service to the next magnate up the hierarchy. Sovereignty is thus parcelled out and ownership contingent always upon a complex system of interlocking obligations. At the top of the pyramid in theory is the sovereign who has a military call upon nobles but only indirect authority over the population as a whole. Thus both property and the state which we understand today as the parameters of control over land are meaningless concepts in feudalism.

The system is held together ultimately by judicial authority backed by military force, and given oral legitimacy by shared custom and, explicitly in medieval Europe, by a universal church, itself a major landlord through episcopal and monastic holdings organised along feudal lines, and a recipient of part of the surplus through the tithes owed to its diocesan priests.

In feudalism, then, production is for use rather than exchange.

But this does not preclude in practice the existence of markets or of money. Both are necessary for the transfer of products between differently favoured environmental areas and for the exchange of necessities against the products of craftsmen and luxuries. But such markets are strictly controlled both in location and in the prices to be obtained. The freedom and mobility required by merchants and craftsmen to pursue their activities represent a structural opposition to the notions of fixed status, contingent ownership and reciprocal exchange of production against protection. Therefore the market must be constrained to operate only at fixed locations and determined times, controlled as far as possible by the feudal ruling class. Primarily it is contained and controlled within the city, whose enclosing wall is not only a physical boundary between the built environment and the countryside, but between different worlds of production, exchange and social relations.

Clearly the ideal type represented by this description of feudalism is realised only under very variable forms. But for the moment we can perhaps note its inbuilt contradictions: between the interests of serfs and peasants in holding as much as possible of their product to themselves, and those of the landlords in maximising the extraction of that product; between production for use on the land or in the noble's castle or palace, and production for the market in the town, however constrained that market may be; and between the centripetal forces of the crown's interests and the centrifugal forces of the lesser nobles' as they affect the national territory. It is these tensions which give feudalism an internal dynamic as a mode of production (Brenner, 1977).

Capitalism

In a feudal system the transfer of surplus labour, represented by feudal obligations or direct labour, must be forced out of the dependent classes by juridical or institutional means because the members of those classes are not alienated from their means of production. The essence of the capitalist mode of production is that surplus labour is extracted by purely economic means through the operation of the market mechanism. In theory the capitalist market is completely self-regulating, that is prices are determined by the intersection of supply and demand without any external legal constraints on its operation. The market dominates all aspects of life so that all production is for exchange in the market-place. Purchase of a commodity on the market confers absolute right of property over

that commodity to the individual. The right of property is enshrined in law and the value of property determined in the process of exchange without reference to its actual or potential use. This is what is meant by referring to capitalism as a system of production for exchange rather than use. All goods and the means of producing them are thus commodities, including both human labour and the earth itself, which becomes landed property.

Through the operation of the market mechanism society is stratified into two theoretical classes, the owners of that property which constitutes the means of production, termed by Marx the bourgeoisie, and those who own nothing but their own labour power, the proletariat. This latter group must sell that labour to the former in order to gain the means of survival. Its members are thus alienated from themselves because, lacking any control over the means of production or the mechanisms of exchange, they are reduced to instruments of labour whose value is itself determined in the capitalist market-place. Their surplus labour is thus extracted and realised in the profits of the bourgeois capitalist class. The operation of the system requires freedom of occupation and movement by both labour and capital in order to respond to the exigencies of the market-place. Thus the ties to the land and to tools which characterise feudalism are broken.

The bourgeoisie employ the means of production which they own for the purposes of realising profit in exchange. Profit is necessary for continued investment and expanded production because the inter-action of supply and demand in a self-regulating market is inherently competitive. This means that continued production is always threatened by competitors who can undercut a producer by providing the commodity more cheaply. The system thus has an internal dynamic towards expansion of production, leading to crises of over-production, towards innovation in production techniques and commodities, reduced wages and expanded markets as producers attempt to sustain profits. Capital works through commodities to increase itself in an ever-expanding system of production and exchange.

As the locus of the market, the city becomes the key geographical location in the space economy (Lefebvre, 1970). As innovation leads to factory production, so the city takes on an ever greater significance. Land and agriculture become capitalised in commodity production, they are merely space-extensive industries dependent on the life of the urban market-place. A land market allocates land to owners and

the larger market determines its use and value. Regionally at first and increasingly at a national and global scale, space is integrated as the market penetrates all spheres and areas of production, resulting in concentrations in space which parallel the social concentration of capital into fewer and fewer hands.

Just as feudalism contains inbuilt oppositions and contradictions so does the capitalist mode of production. Production is social while appropriation of the product is individual; competition forces down prices leading to both over-production and insecurity in the activities of producers. Increasing numbers of small producers are forced into the ranks of dispossessed labour as their limited capital is lost to more efficient competitors. The working class struggles to maintain and increase wages or otherwise wrest a greater proportion of its surplus labour while the owners of capital seek to maximise its extraction. The class antagonism which is structural to capitalism would, according to Marx, result in the overthrow of the entire system by the organised proletariat who in doing so would socialise the means of production for the common benefit of all people, thus ushering in a new socialist mode of production (Marx and Engels, 1888).

As with feudalism, the theoretical outline of capitalism as a mode of production is never realised in pure form in real historical societies. In sketching it I have not discussed central issues to which Marx and later writers found it necessary to turn in the analysis of capitalism in practice: the role of the state, the trajectory followed by the constant restructuring and revolutionising of the means of production, or the processes of class formation and capital accumulation over time. But even in outline the model does offer us certain essential features which we can recognise underlying the crucial differences between European societies in the later middle ages when still dominated by feudal relations, and those of the nineteenth century and our own, dominated by capitalist ones.

Social Formation and the Transition

The outline of these two modes of production appears to support a purely economic interpretation of history, concerned with the production of material goods, thereby reducing human and social life to the level of material survival. On the one hand it ignores legal, political, moral, cultural and aesthetic questions other than as

45

epiphenomena of productive relations. On the other it implies that the operation of a given mode of production is *sui generis*, that human beings have little or no control over the social forces and structures within which they are doomed to live out their lives. In other words it is deterministic. Moreover the sketch seems to imply that these modes of production stand in some predetermined historical relationship one to another. It may be that we recognise the internal conflicts within feudalism as a mode of production and see that they would ultimately lead to its collapse. But there is no inherent reason why they should do so, and certainly not at a predictable moment in its history. Again, in the European case it is suggested that out of the ruin of feudal societies emerged those dominated by capitalism. Without even turning to the historical record we can see that logically there is no reason why feudalism should be followed in time by capitalism. All these problems suggest the need for a rather more sophisticated theoretical positon as we turn to the historical record itself.

The concept of a social formation represents a recognition on the part of Marxist thinkers that in the case of really-existing historical societies people do not experience their lives in terms of separate spheres of existence: basic economic necessities and social relations grounded in them, overlain by less significant religious, political, or cultural structures and activities. Nor do they act as if this were the case. All these spheres of existence which we separate conceptually are in fact unified in the consciousness and actions of a social order. The concept of a social formation is intended to acknowledge this fact, while at the same time recognising that, as Marx said, 'it is not the consciousness of men that determines their being, but on the contrary their social being that determines their consciousness' (Marx and Engels, 1973, p. 503). The theoretical problems of relating forms of consciousness to forms of social existence are formidable and as the landscape idea is precisely a form of consciousness we shall refer to them again later in the chapter. For the present we should recognise that a social formation is intended to denote the unity among the aspects of social existence, and one specific to a geographical area. Thus Britain and the United States are both capitalist countries, but they differ markedly in their political systems, the cultural predilections of their populations, their assumptions about the relations between the individual and the state, their educational systems and dietary habits, to note but a few examples.

A social formation is also intended to refer to the existence of

subsidiary modes of production within the dominance of the defining mode. Thus in Carolingian France, often taken as the prototype of a feudal society, slavery still existed on certain manors – a throwback to a classical mode of production – while in the fairs of Champagne prices for certain commodities were responsive to fluctuations in supply and demand, anticipating capitalist relations. We could also find examples there of labour mobility or of private ownership. In sum, while a given society may be characterised by the dominance of one mode of production there will always exist within it the remnants of former modes and the elements of others which may come to dominate it in the future, and over long periods of transition the picture will be even more complex. This means that the precise historical changes which occur will be variously paced and inflected in different social formations even though dominated by the same mode of production. We know, for example, that feudal relations were weakening in upper Italy far earlier than in England or France; we know too that it was in the latter countries rather than the former that capitalism first came to dominate social and economic relations.

Finally we cannot ignore the existence of different environmental contexts and of the geographical diffusion of ideas. It would be facile to expect the same geographical forms of manor and open fields which we associate with feudalism in northern France or midland England to occur in the accidented uplands and narrow pasture valleys of the Alps or Pyrenees or in the Scottish glens. The production of wheat or small grains imposes different constraints upon human labour and demands different patterns of technological innovation than does that of rice or tree fruits, vines or animal fodder. Climatic constraints on agricultural production vary, just as do those of topography and soil fertility. To ignore these facts is simply naive. One of the great and dangerous illusions bequeathed the Soviet Union by the legacy of Stalin's interpretation of Marxism has been the notion that under the socialist mode of production all the environmental constraints which bourgeois science had invented would fall away and that the great steppelands and rivers of Siberia would yield readily to the triumphant march of organised socialist labour. Also, people and their ideas are mobile. One of the themes of this study is the influence of Italian theories and styles of landscape, developed under specific historical and social conditions, on very different societies at different times. Their acceptance and application has to be understood in terms of the conditions prevailing in the receiving society, but their origin and arrival there requires an

understanding of geographical processes of cultural transfer and diffusion.

Theories of the Capitalist Transition

The recognition that over the course of the five centuries between 1400 and 1900 European societies shifted from feudal to capitalist economic relations is not the privileged insight of Marxist historiography, although to use such terms is to make a gesture towards historical materialism in explaining the shift which use of a term like 'modernisation' would not. In general we can identify three theories developed among historians to explain the transition, each having different perspectives and emphases within it (for a contrasting summary, see Holton, 1981). These are the *ecological* or *demographic* thesis, associated with the work of the economic historian M.M. Postan (1949-50, 1972); the *commercialisation* or *mercantile* thesis originating in the writings of Henri Pirenne (Havinghurst, 1958) but more fully formulated by Paul Sweezy (1978); and the varieties of *structural* and *class conflict* thesis promoted by some Marxist historians, among others by Rodney Hilton (1978) and Maurice Dobb (1963), and recently reformulated by R. Brenner (1977). To distinguish these theses is not to suggest that their authors have ignored the significance of factors given prominence in rival explanations but to indicate what each author regards as the 'prime mover' in the transition. The outlines of each are summarised briefly below.

The Ecological/Demographic Model

This model places particular emphasis on population dynamics and their impact on social and environmental relations. Specifically it concentrates on the population rise that has been identified in all parts of Europe in the years following the first millennium, and the subsequent collapse of the 1300s associated with the first epidemics of bubonic plague. Between 1000 and 1350 a securely established system of feudal states and territories which had emerged from the strife and uncertainties of the Roman imperial collapse allowed for the continental expansion of production. New fields and pastures were exploited in former woodlands, marshland and wasteland; the German-speaking peoples pushed far into East Elbia; towns flourished under the guild system of manufacture and the population of Europe rose steadily to a peak in the early years of the fourteenth

century. But according to this Malthusian argument the population was increasing beyond the capacity of the land to sustain it under the prevailing technology and organisation of production. More and more poor and marginal lands were cultivated by people increasingly weakened by inadequate diet; shortage and famine began to occur with increased frequency. Into this precarious situation was thrust the unpredictable horror of plague epidemic and the population of Europe collapsed in the mid-fourteenth century: nearly halved in Italy, France, England and Spain. The immediate consequences included a retreat from newer and more marginal settlements and lands, a greater freedom among the surviving population to move to more favoured areas, and in the longer term a redress in favour of the peasantry of the balance between the power of landlords to control them and the latter's powers to determine the terms of their service. Rents were increasingly commuted to monetary payment thus declining in real terms as money devalued, and there was a shift to the towns. In the general slackening of feudal ties new forms of labour contract, innovations in productive techniques to offset expensive labour and greater opportunities to accumulate capital all shifted the European economies towards more capitalistic forms of organisation, setting in motion a long decline of feudalism and the emergence of capitalism.

This interpretation places the emphasis on natural environmental constraints as they operate within a given level of social and technological development. A Malthusian relationship between population and resources, a relationship ultimately beyond the capacities of human beings to control, breaks the feudal integument and releases forces which while latent could not find expression within the existing social pattern.

The Commercial/Mercantile Model

While the demographic model emphasises a natural process, the theory of development favoured by Sweezy stresses the roles of the city, of trade and of money – all inherently capitalist forms existing as 'foreign bodies' within feudal societies and destined ultimately to dissolve their structures. Following the pioneering work of Henri Pirenne who argued that long-distance trade in the Mediterranean had been effectively cut off by the Arab invasions of the sixth century and that only with its revival 400 years later could mercantile activity stimulate economic growth in the West, Sweezy argued that the revival of trade, at first in the Italian and Provençal cities, and later in

Flanders and the Rhineland, was the prime mover in the decline of European feudalism and the origins of capitalism. Trade was external to and inconsistent with the productive relations and social organisation of feudalism.

Long distance trade, organised by merchant middlemen from the cities, circulated money which entered the feudal economy in increasing amounts and acted as a solvent of former barter arrangements. As the cities grew, both from trade and artisanal production of luxuries for the feudal nobility, themselves paid for in money, so they acted as poles of attraction to rural serfs who could gain in them freedom from bondage and higher incomes from the production of commodities. Thus they produced a greater mobility of labour while the increased need for money stimulated the commutation of feudal rents and dues. Investment flowed from the cities into the rural areas as merchants backlinked into rural manufacturers escaping guild restrictions (in textiles, for example) and rewarding efficiency and innovation. Sweezy thus takes Marx's comments on the solvent agency of money and the critical role of the city as the keys to the general erosion of feudalism and the establishment of capitalistic relationships, first in the towns and later in their agricultural hinterlands, but he regards money and the city as external elements, antagonistic to the feudal order.

F. Braudel (1982) has recently and powerfully restated the argument for long-distance trade as the initial factor in the evolution of European capitalism. He points out the stupendous profits to be made in the Asian spice trade, English woollen trade and later the Atlantic trades in gold, silver, tobacco and human labour. Profits up to 400 per cent on investment allowed for massive accumulation and concentration of capital in Europe. Further, such trade had considerable impact on consumption among ruling elites and urban middle classes, driving Europe into rapid changes in fashions of diet, dress and habitation which themselves increased the rate of innovation, change, circulation and accumulation. This urban-mercantile economy, Braudel argues, operated over, and with little reference to, the static economy of subsistence agriculture in which population and food supply were in constant unstable equilibrium, and over the economy of local urban markets where primary surpluses were exchanged more for use than for profit.

The Structural/Class Conflict Models

While denying neither the significance of conjunctural events like the

50

Black Death nor the solvent power of money, historians like Hilton, Dobb and Brenner have argued that to regard either as the prime mover in the decline of feudalism and the emergence of capitalism is to seek a deterministic solution in forces external to the operation of the feudal mode itself. They point out that Marx argued that a mode of production contains within it the dynamics of its own transformation, that it is in the agency of human beings that change occurs, and that it is through class struggle that internal contradictions are exposed and finally resolved in a net social advance. They therefore seek an answer to the question of the transition within the structures of feudalism. They stress the necessary antagonism between a peasantry which aims to increase the productive surplus of its labour in those spheres under its own control and for its own appropriation, that is on the plots and strips of land under collective cultivation, and a landlord class bent on maximising the extraction of the surplus by increasing the productivity of demesne lands or raising the various exactions, dues and corvées to which it is legally entitled. Hilton and Dobb emphasise the overexploitation that this implied and the overextraction of the surplus which by the fourteenth century was reducing the reproductive capacity of peasant labour, leaving it open to such devastating effects from the plague. In the post-plague period the balance of power shifted decisively to the peasantry who in a series of partially successful revolts succeeded in wresting privileges from the feudal nobility which allowed for the monetisation of rents, mobility of labour and, via control over a greater proportion of the surplus, the accumulation of capital through petty commodity production and the rise of entrepreneurial skill among some of the wealthier peasantry: new men. The emphasis here is squarely on the internal dymanics of feudalism and the conflict between its classes.

The supporters of all three models recognise that the process of change was variable under different social formations and in different parts of Europe. They acknowledge, too, the critical importance for capital accumulation of the price revolution in the later sixteenth century consequent on the arrival in Europe of American bullion which pushed prices ahead of wages and concentrated capital into fewer hands (Vilar 1956) and what Eric Hobsbawm has called the crisis of the seventeenth century. In explaining the variable pattern of capitalist development and the problem which has often been noted that there is a 200 year gap between the decisive collapse of feudalism and the distinctive emergence of capitalist-dominated economies in the seventeenth century, Brenner (1976, 1977) has

called into focus the variable outcome of the peasant-landlord struggles of the fifteenth century. He argues that in England and the Low Countries a peculiar stand-off of forces was critical to the emergence of agrarian and later industrial capitalism. While in eastern Europe, for example in Poland and Germany east of the Elbe, the landlords successfully resisted peasant demands and reconstituted a very tight form of feudal control at this time – a second feudalism which lasted into the nineteenth century – in continental western Europe, notably in France and the Rhineland, the peasantry achieved a decisive victory in the sphere of land ownership rights, giving them legally unfettered proprietorship. These different outcomes he accounts for by reference to the differing relations between the state and the nobility in the various areas. In England alone the spoils were divided. The peasantry gained legal freedom from feudal status but the landlord class retained control over land, expropriating peasant proprietors and farming increasingly via capitalist tenancies. This he argues explains the origins of the first fully capitalist social formation in England, where accumulation occurred initially in agriculture and where a large, increasingly landless agrarian proletariat could be recruited for rural proto-industries and later urban manufacturing.

Explaining the gap between the decline of feudalism, tightly defined, and the rise of capitalist social formations, some historians have pressed the case for a period of peasant proprietorship in parts of western Europe characterised by a form of social production on the land which was neither feudal nor capitalist, but individualist, domestic and autarkic (Huggett, 1975). The peasant, it is argued, owning the means of production is not forced to sell his labour in order to survive and produces for use rather than exchange. Maintaining a greater degree of control over the surplus than is possible under feudalism, the peasant enters the market for agricultural produce and petty commodities more by choice than by economic necessity. Of course the existence of the state as an agent of redistribution means that a burden of taxation to be paid in cash renders necessary some engagement with the market, and we know that in practice peasant indebtedness, exploited by larger landowners and the merchant bourgeoisie, meant a less rosy picture than the idea of an independent mode of production might suggest. However, those who support this argument see in this transitional mode the possibility for capital accumulation in both commodity production and merchant trading as the basis for the eventual emergence from it of fully capitalist relations of production. Whether or not such an

independent mode of production is theoretically valid is of less importance here than the fact that a belief in its existence has particular significance in the case of American relations with the land during the early years of settlement and expansion, as we shall discuss in Chapter 6.

The independent mode of production model has little to say about the role of the state – a contradiction particularly apparent when it is applied to the American republic. The time lag often identified between 1450 and 1650 as the interval between the decline of feudalism and the emergence of capitalism is of course the period when Europe came to be dominated by strong, centralised monarchies. It is the era of absolutism. Perry Anderson (1974b) has argued that to identify the end of feudalism with the disappearance of a number of its medieval forms: rents in labour and kind, fragmented sovereignty and very restricted markets and urbanisation, is to ignore the variety of the social formations possible under feudalism as a dominant mode. He makes the case for regarding absolutism as a reformulated feudalism in which the state takes on far greater prominence. Power, rather than being diffused widely down a hierarchy of territorial lords and nobles, becomes concentrated at the summit, in the person of the monarch as the embodiment of the state: '*l'Etat c'est moi*'. Feudal rent is extracted increasingly by means of legally enforced taxes backed by centralised military force. The ruling class replaces its traditional military role by offices of state which, together with payment of standing armies, consume the greater part of the surplus so extracted. The state makes alliances with merchant capital but attempts to control merchant operations through state-chartered companies and a mercantilist policy preventing the emergence of a self-regulating market in labour and commodities which would undermine its essentially feudal social relations. For Anderson then, feudalism, albeit reformulated, continued to dominate European social formations into the eighteenth century. But the accumulation of capital by merchants and commodity producers made possible under absolutism led eventually to a bourgeoisie powerful enough to overthrow the feudal state and establish capitalist relations of production in the revolutions of the seventeenth century in England and the eighteenth and nineteenth centuries in continental Europe.

Inevitably this summary of the main arguments concerning the dynamics of the European transition to capitalism glosses over a large

number of detailed arguments and local variations. Without taking these fully into account it is impossible to offer a firm conclusion here about the prime mover of change and it would be arrogant to do so on the basis of such a sketch. But it is important to emphasise that much of the struggle which accompanied the transition centred upon land, its ownership, use and social significance. This is not surprising since land was the fundamental material prerequisite for production in a pre-capitalist and pre-industrial society. While recognising the importance of mercantile activity, urban artisanal production, conjunctural events and the constraints of differently productive physical environments, the truth of Marx's statement that 'the natural unity of labour with its material prerequisites must be broken if capital is to come into existence' remains. And the most significant of those material prerequisites was land.

Cultural Production and Material Production

Even if we are willing to admit the active role of human consciousness in pressing forward the change from feudal to capitalist relations in European formations, we may still fail to grasp the full complexity and richness of the historical processes unless we are willing to regard it as a cultural as much as an economic and political struggle. The tendency among historians of capitalist development is to focus upon economic indicators: wage rates, levels of accumulation and so on, or the most manifest of social struggles: clear evidence of protest and revolt and among subdominant classes, peasants in the fourteenth century or bourgeoisie in the eighteenth and nineteenth centuries. There are obvious exceptions to this, for example E.P. Thompson's (1963, 1975) writings on the culture of the agricultural and urban working classes of England, or Eugene Genovese's (1972) study of black experience of American slavery. Outside the broadly Marxist camp a theoretical challenge to the concentration on the economic and its immediate political manifestations is of course from the Weberian tradition, most obviously Max Weber's own thesis (1958) concerning the religious struggles of the Reformation and its aftermath. In offering the Calvinist or Puritan ethics of extreme protestantism with their emphasis on hard work, thrift and self-denial as an ideal type for the cultural prerequisites of capitalist accumulation, Weber strongly emphasised the role of human consciousness in the historical process. In doing so he, like

Thompson (1978) more recently, raises a central issue for any materialist thesis: the relative significance of what are often conceived as levels of decreasing importance within the structure of a social formation, the economic, the political, the ideological and the cultural or symbolic activities of its people. If we are to locate the idea of landscape as a way of seeing the world, a produci of human consciousness and culture, within the materialist framework of the capitalist transition, we are obliged to consider this problem of Marxist cultural theory.

In a number of passages and letters Marx and Engels attempted to deal with the relationships between the social relations of production and the realm of social consciousness, shared ideals, values and beliefs – in short, of culture. The best known of these passages is the following:

> In the social production of their existence, men invariably enter into definite relations, which are independent of their will, namely relations of production appropriate to a given stage in the development of their material forces for production. The totality of these relations of production constitutes the economic structure of society, the real foundation, on which arises a legal and political superstructure and to which correspond definite forms of social consciousncss. The mode of production of material life conditions the general processes of social, political and intellectual life. It is not the consciousness of men that determines their social relations, but their social relations that determine their conscious-ness. (Marx and Engels, 1973, p. 503)

Throughout this passage, until the last sentence, Marx is careful to use words like 'conditions' and 'general processes', and both he and Engels were frequently at pains to point out the error of attempts to construct a strict causality between the economic and the cultural. But in opposing German idealist philosophy which regarded history as the progression of a consciousness working through men and women and specifically in his inversion of the Hegelian position in the final sentence of this passage, Marx undoubtedly provided the authority for the architectural analogy of an economic base upon which the cultural may be theoretically constructed in an absolute and determinate manner. In such a theory cultural products like literature, painting, poetry and drama – and landscape – and the aesthetic and moral values with which these are concerned, become

mere outgrowths of material productive activity, to be understood only by direct reference to the mode of production which happens to dominate the society in which they are produced. Notions of artistic tradition or innovation within the sphere of artistic activity, and certainly sensitivity or imagination are, by and large, dismissed as bourgeois mystifications of the real purposes of culture which are regarded as ideological. The art historian Nicos Hadjinicolau (1974) is representative of the more extreme versions of this interpretation. Rejecting conventional art history as either formalistic or biographical and thus idealist, he regards the task of such a discipline as the exposure of class meanings and statements in art and the classification of works of art as either progressive or reactionary. Ruling class or oppositional class interests merely find expression in the production and exchange of art works, and little more can be said of them.

The debates between proponents of such 'vulgar' Marxism and those who would recognise a more active role in human creativity and imagination and their products, has recently been engaged within a wide range of disciplines. For our purposes the most relevant are those within the humanities: history, art history and the study of literature, although by the nature of such discourse the dividing line between the humanities and social sciences like anthropology, sociology and geography where similar debates go on, is increasingly blurred. Two common threads may be detected in the re-evaluation of cultural production along materialist lines. The first concerns a re-emphasis on the Marxist notion of 'totality' and on dialectics as the principle method of Marxist materialism. The second is the analysis of the meaning of 'material production'.

Within the apparently seamless habit of any social formation the economy conceived as the production of material goods, and culture conceived as the production of symbols and meaning, coexist and continuously reproduce social relations through the action of living human beings. Economy and culture, structural necessities and human actions, interpenetrate and relate dialectically, each structuring the other as it is structured by the other. Thus each must be given equal weight in social and historical explanation. The production of meaning, of symbols, and their material expression is complex. It includes historically and geographically specific symbolic systems, for example the hierarchy of the medieval heavens wherein the Trinity sit enthroned, commanding serried ranks of archangels, cherubim and seraphim, greater and lesser saints. Such an order

56

replicates that of the universal church on earth, with its Pope – Vicar of Christ – cardinals, archbishops, bishops, parochial priests and laity. This symbolic structure, obviously homologous to the ranked structure of feudal classes, may be regarded as an ideological legitimation of that social order. At the same time it is through faith in the certainty of the celestial order that much of the temporal order is reproduced, that a moral law exists with which the grosser abuses of class power may be challenged and the temporal order itself questioned. Culture as ideology must be broadened to incorporate culture as an active force in the reproduction and change of social relations.

But symbolic production may also relate to transhistorical and transcultural, unalienated human experiences and concerns, those that derive from our shared human physiology, our experience of birth, death, childhood, sexual experience and so on. If we do not accept this it becomes difficult to understand how cultural and artistic products of one culture or social formation can speak to people from another. Natural symbols and animistic references abound, even in our own sophisticated culture. In the construction of human landscapes the anthropomorphism of environmental symbolism and of sacred geometry has been recognised and its cross-cultural replication noted by writers like Mircea Eliade (1959), Paul Wheatley (1971) and Yi-Fu Tuan (1974).

In discussing the issue of the cross-cultural appeal of symbolic products, Peter Fuller (1980) has drawn attention to the materiality of biological existence and its mediation through the psychoanalytic reality of human experience. Our bodily construction, physical and sexual potential, our experience of birth, early growth and maternal relationships, our knowledge of the certainty of death, are all shared material human experiences, regardless of historical time and social formation. They produce psychological tensions to which, according to Fuller, it has always been one of the functions of what we now call art to respond. In his words, 'the aesthetic is an historically specific structuring of certain elements of human experience and potentiality which pertain to that underlying condition of our biological being and which can be occluded or displaced but never entirely extinguished by ideology' (Fuller, 1980, p. 193). While in no way pointing towards a crude biological or atavistic explanation of aesthetic experience, this represents a challenge to simple interpretations of symbolic production as ideological legitimation or subversion. Transhistorical symbols and those which are apparently more specific in time and space

cannot neatly be separated. They interpenetrate and may, like the neolithic dolmen, the Mayan ziggurat, or medieval cathedral, require vast expenditure of human labour in their production. They make a nonsense of the idea of 'levels' within a social formation. As E.P. Thompson (1978, p. 288) claims of his study of eighteenth-century England, 'the law did not keep politely to a "level" but was at every bloody level'; in property relations, philosophical writings, the ideology of the courts, religious practice and political discourse. It was in fact 'an arena for class struggle, within which alternative notions of the law were fought out'. Referring to the anthropology of non-western societies, Marshall Sahlins (1976, p. 132) makes the same point: 'if economics is the "ultimate determinant", it is a determined determinant [which] does not exist outside the always concrete, historically changing complex of concrete mediations, including the most spiritual ones.' At the theoretical level the dialectic of material conditions and human consciousness, of material production and symbolic production can only be declared; solely in the practice of historical reconstruction and interpretation, based on empirical evidence but informed by theory, can it be revealed.

The second advance made in recent cultural theory concerns the specific production of cultural artefacts, and stresses the need to recognise such works as material products rather than something non-material erected on a base which provides the 'necessities' of human survival. Cultural works are material in two senses: First, they demand the interaction of material artefacts – pen, paper, ink, printing press, canvas, oil or brush – with human labour – writing, sketching, editing, painting, chiselling. In the case of landscape design this should be particularly apparent since in making a park or garden vast undertakings of earth movement, planting, pruning and maintenance are often required. That such works are scarcely if ever mentioned in discussions of landscape or garden history bears testimony to the mystification of so much cultural history. Second, cultural products represent a mediation through the consciousness and physical activity of their makers of human and social life in the material world. In Raymond Williams's (1981, pp. 98-9) words, mediation 'is a positive process in social reality, rather than a process added to it by way of projection, disguise or interpretation'. That these processes operate through symbolic codes or languages more or less formally developed, learned from the past and specific to particular media of cultural production makes them no less material. Those codes are at once 'a specific cultural technology and a specific

form of practical consciousness' and thus a unified and material social process. Part of our contemporary difficulty in recognising this unity, and of our tendency to separate the symbolic from the material springs from the fact that in our own society and time symbolic production is located predominantly in the production of material commodities for exchange – as are painting, music and literature (Sahlins, 1976). We regard such production as practical or utilitarian for the most part and are therefore confused – we are intended to be so – when the painting of a soup can is, through a clever inversion of our cultural assumptions, presented to us as 'art'. Failing to recognise the symbolic constitution of material production in our own society, we are at a loss to explain its significance in others where we are at least aware of its existence. Thus when we see that the English revolution of the seventeenth century was acted out in the language and codes of Christian belief, we disallow that the language itself is an active material production, but rather eliminate it from that 'level' and reintroduce it as 'ideology' or false consciousness, 'phantoms formed in the brains of men, sublimates of their material life process' (Sahlins, 1976, p. 136).

This is a consequence in large measure of our tendency to seek for functional explanations, via verifiable cause-effect chains, of causal thinking. It has been pointed out that Marx himself, for all his proclamation of dialectical thinking, did not remain unaffected by the categories and structures of nineteenth-century scientific thought, particularly when he came to analyse the mode of production most closely related to it: industrial capitalism (Williams, 1977, p. 92). Victorian natural science and the then emerging social sciences completed an historical process whose intellectual origins may be found in renaissance and particularly Cartesian philosophy and the scientific revolution of the seventeenth century whereby the world was conceived to be composed of discrete objects which, while interacting with each other, themselves remain unaltered and isolable. Relationships between objects are therefore understood as qualitatively distinct from the objects themselves, and may be established sequentially, A causing B causing C and so on while the characteristics of A, B and C remain bound by the definition given them at the outset. Other forms of logic are characteristic of both earlier European and contemporary non-western societies, as well as of childhood and much practical, unsophisticated thinking among western peoples. Such forms are dialectical and use a form of symbolic or *analogical* logic in which symbols and their referents are

not distinguished as different modes of existence but rather as fused together and capable of mutual alteration. In analogical thinking the identity or character of things lies primarily in the relationships they embody, and they cannot be understood outside those relationships – including of course relationships with sentient subjects. Nature is saturated by mind and, contrary to sophisticated causal thinking which would see this as a problem to be overcome, analogical thought accepts it as a reality to be embraced. In most non-western medical theory, and indeed in Hippocratic European medicine before the eighteenth century, theories of the elements united the human body, human soul and natural world in such a way that health and disease ran through all three and a change in any one would implicate changes in the others. The natural order embraced and permeated the human order, socially and individually, and the embrace was reciprocated.

The change from such a conception of existence and its relations to the acceptance of atomism and causality as common-sense logic was not unrelated to the formation of new social and environmental relations in an emerging capitalist order. The fascination with alchemy and 'black arts' in the seventeenth century may be interpreted as the application of traditional analogical thinking to the mystery of new economic relations. Alchemy proposes that through the intervention of magic, base metals may be transformed into gold and thus unnaturally increase in value. In pre-capitalist economies use-value requires that money operates to lubricate the exchange of equivalents in the form C-M-C1, where C is a commodity, M is money and C1 is another commodity of equivalent use value. Under capitalist exchange-values money is fertile, it operates through the exchange of commodities to increase itself in the form M-C-M1. In pre-capitalist, analogical thought such fertility is a characteristic only of living things, for it to occur in a non-living thing like metal or money requires magical intervention. Michael Taussig (1980) has shown how similar disjunctures between analogical thought and capitalist economic relations lead to otherwise inexplicable practices among South American Indians working on plantations or in mines as wage labourers.

The tensions between analogical thought and causal logic as they affect the understanding and representation of nature and landscape became critically important in the nineteenth century as I shall discuss in the last part of this book. For now it is sufficient that we recognise analogical thinking as more characteristic of human

relations with the environment, both historically in Europe and geographically over much of the globe today than causal logic, and that the suppression of the former in favour of the latter is in large measure ideological, and accounts for the difficulty we have in attributing equal significance to human consciousness and symbolism as to material conditions within historical and social explanation.

Landscape as Cultural Production
During the Capitalist Transition

The historical origins of capitalism lie in the dissolution of existing relations between human beings and the material conditions of their lives, relations often termed 'natural'. These are the dissolution of the relation of human beings to the earth as the natural basis of production; of those in which humans appear as proprietors of the instruments of production; of ownership as a means of consumption of prior significance to production; and of the labourer as living labour power, part of the objective conditions of production. The relationship between human beings and the land, both objectively and subjectively, is implicated in all these and we should therefore expect it to undergo radical change during the period of the capitalist transition.

In feudalism the value of land lay in its use for the production and reproduction of human life. Control over it ensured human survival, but ownership did not imply property. Ownership was collective and contingent. Land was not a saleable commodity, but control over it was a measure of *status*. Monarch, noble, and even the classes of serf and peasant were defined by lineage in terms of status in relation to land. Its value to these different classes lay always in the land's potential as product: directly in the case of the peasant community, indirectly in the case of higher orders as the numbers of bodies it could sustain and whose surplus labour it could support. It is scarcely surprising that students of landscape history and its representation in painting and literature have noted the concentration in medieval times, and into the eighteenth century, on a productive, humanised earth, initially the garden: enclosed, and fertile, the incubator of domesticated plants, yielding the luxuries of specialised foods like soft fruits, olives and vines and the necessities of health in medicinal herbs and plants. Such gardens may be highly stylised and symbolically organised, the references may be courtly and aristocratic,

61

but, paradoxically to our eyes, such symbolism indicates their value to human use, reflecting a cosmic order so that herbs would be arranged according to their medicinal qualities and 'signatures', the whole design based upon systems of analogy.

Land as status did of course allow for its representation as a reflection of aristocratic taste, consumption and display. But this is scarcely landscape in the sense of a representation of land in and for itself, as property from whose production is to be realised a profit. Under capitalism the situation is radically altered. In an economy based on free labour and private ownership of the means of production, land is a commodity whose value lies in exchange. It is property defined by *contract*, and we know from the writers of social history how fierce were the battles to establish the notion of untrammelled personal property in land over the still powerful conception of common ownership and access to it, for example in the English eighteenth century. Clearly even in capitalism the value of land still relates in part to its productivity in sustaining human life. Thus 'improved' land commands a higher price on the market than unimproved land. But the productive value of the land is alienated by appearing as exchange value; at the end of the day land is a form of capital. Indeed in capitalism improvement may be entirely unrelated to the capacity of the land in ensuring human life. Today the highest value of all is set upon land at the heart of the great metropolitan urban areas, at 'peak land value intersections', and that land is allocated to use by the dominant institutions of capitalist production and exchange: banks, insurance companies and the head offices of giant corporations. The highest value non-urban land lies for decades uncultivated on the fringe of the metropolis while its exchange value appreciates in anticipation of urban expansion. A whole school of geographical location theory is founded on the principles of land value as exchange and land use as its reflection (Harvey, 1974).

Where ownership of land is individual and absolute as property, we might expect its representation in art and literature to be different from that in a natural economy and society. Indeed art and literature will themselves have different roles, purposes and languages. They, too, are conceived more as property having exchange value and being produced for the market. John Berger (1972, pp. 83-108) has shown that oil painting is the bourgeois medium of painting *par excellence* because of the substantiality and realism that its fine finish allows. With its introduction in Flemish and Italian pictures during the

fifteenth century the subject matter of art underwent a transformation. Objects of ownership: dress, furniture, domestic animals and so on were painted with such realism that we feel able almost to pluck them from the canvas, and they surround their owners as indicators of their worth. The relationship between oil painting, easel work, framing and an emerging market for art is significant for landscape, as we shall see in the discussion of Italian work. Oils were the favoured medium for rendering landscape well into the last century, and the landscape they represented, together with its human implications, was a constituent element of the changing social meaning of art. Land as a subject for art has no favoured status under capitalism. It is merely one form of property, thus as significant, but not necessarily more so, as any other material subject: still life, portrait, animal picture or event.

But, as was hinted above with reference to English struggles over property rights, the period of the capitalist transition in Europe is precisely one in which the status of land was uncertain. Its redefinition, from use value to exchange value, was a long and hard-fought process. It was played out in numerous struggles between feudal aristocrat and capitalist bourgeois, between bourgeois landlord and peasant. For a long period land was *the* arena for social struggle: it was both status and property. To the extent that wealthy bourgeois aimed in the sixteenth to nineteenth centuries to gain social prestige in social formations still powerfully influenced by feudal relations and values, they aped the manners and tastes of the still significant landed nobility. Thus they sought property in land as a means of status definition and affirmation. To the extent that older landowning families adjusted to the growing significance of market relations, so they began to regard their land as alienable property; failing to adjust they might fall back upon older notions of paternalism and *noblesse oblige* with respect to the design and representation of land and of labour on it. But increasingly land was seen through new eyes: as a form of capital, as property, and both classes bent themselves to extinguish remaining feudal and collective rights on the part of the peasantry. Land was bought and sold on the market-place, but not infrequently new owners sought to legitimate their rights and those of their children in traditional terms of blood and lineage: marrying into older families, buying or inventing titles and thereby relating to an older form of social ranking. The process of change was experienced subjectively and was furthered as much in poetry and literature as it was in parliamentary enactment or the courts of law. The process

may be observed in sixteenth-century Italy or in seventeenth- and eighteenth-century France and England. In English literature something of its expression has been documented by Raymond Williams (1973).

It is the main thesis of this book that in this dual significance of land during the struggles to redefine it in terms of capitalist relations is the key to the modern landscape idea and its development. It is this which provides the resolution to the ambiguities of meaning discussed in the last chapter. In a natural economy the relationship between human beings and land is dominantly that of the insider, an unalienated relationship based on use values and interpreted analogically. In a capitalist economy it is a relationship between owner and commodity, an alienated relationship wherein man stands as outsider and interprets nature causally. Culturally, a degree of alienation is achieved by compositional techniques – particularly linear perspective, the formal structure of the pastoral in poetry and drama and the conventional language of landscape appreciation. The idea of landscape holds both types of relationship in an unstable unity, forever threatening to lapse into either the unreflexive subjectivism of the insider where the feeling for the land is incommunicable through the artificial languages of art; or the objectification of land as property pure and simple, the outsider's view, where alienation is complete and a statistical weighting can be placed upon the 'landscape value' of a piece of land which can be entered into a cost/benefit analysis against the value that the land might have as an industrial site. The origin of the landscape idea in the West and its artistic expressions have served in part to promote ideologically an acceptance of the property relationship while sustaining the image of an unalienated one, of land as use. The history of the landscape idea is one of artistic and literary exploration of the tensions within it until, with the hegemonic establishment of urban industrial capitalism and the bourgeois culture of property, landscape lost its artistic and moral force and became a residual in cultural production regarded either as an element of purely individual subjectivity or the scientifically-defined object of academic study, particularly in geography. The ambiguity in landscape between individual and social meaning may be understood as an alternative way of articulating the same tensions, but at the level of human relationships, of self and community, rather than human life and land. The intention of the chapters that follow will be to explore the validity of this thesis in the context of specific historical social

formations arranged roughly in chronological order through the period of the transition.

Specific Tensions and Enduring Features in Landscape and Culture

While the context of change from feudalism to capitalism provides a broad canvas upon which to sketch a history of the landscape idea in materialist terms, we need always to bear in mind both specific contexts and enduring experiences which, when considering landscape's individual representations, may cut across or modify in various ways the overall pattern of development and change, making it more subtle and nuanced in reality than it appears in theory. Three general points are worth making here. First, there are traditions and concerns specific to any particular field of cultural production, be it painting, poetry or gardening, and to individual practitioners in those fields. Second, there are specific tensions in any society in place and time which will find expression in individual works or groups of works; and third, there are, as we have noted, irrepressible human experiences cutting across history and geography which find expression under all social and economic circumstances. Each of these merits a short commentary in terms of landscape before we turn to individual case studies.

It is a cliché of art history that art comes from art, that is that the subject matter, techniques, iconography and design of a work of art or a school can best be understood by searching for origins in the 'influences' and traditions within the field to which their maker responded. These are learned, incorporated and then perhaps extended, distorted, struggled against and eventually overturned for something new. It is characteristic of European cultural production since the Renaissance that such traditions are overturned and that the tempo of such change accelerates the closer we approach our own day, a marked contrast to many earlier European cultures, to folk cultures and to those beyond European influence. J.M.W. Turner, in early works, accepted picturesque conventions as they had been developed in late-eighteenth-century England, he acknowledged the authority of academicians and employed many of Claude Lorrain's techniques and themes in landscape. Over time he transformed and extended both the techniques and the subject matter of landscape,

65

producing revolutionary experiments with light and colour. In turn his ideas and techniques influenced and were extended by later nineteenth-century impressionists in their landscapes. Of course, to locate all our discussion of cultural production within these terms is to present a closed history and to disregard the fact that all artists live in a changing and active material world and are responsive to it. Closing cultural history within the boundaries of its own discourse simply mystifies cultural production, but it would be foolish to disregard such issues altogether, to deny the significance of conventions and to blind ourselves to internal struggles and explorations within a given field of human activity. It would be equally foolish to ignore specific influences like the local topography, vegetation and climate upon a landscape artist. John Berger (1980) has demonstrated the importance of his life in the Jura to the making of Gustave Courbet's landscapes; the same could be said of the Alpine foothills in the case of Titian.

There are within any social formation at any given historical moment specific social and political or religious tensions and struggles being played out by individuals and groups. Landscape has frequently been deployed as a medium for commenting on them. An example is the situation in Britain during the Napoleonic wars. Rising prices for agricultural products and patriotic fervour seeking to promote national unity against a possible French invasion help account for the popularity in British landscape painting and gardening in the early years of the nineteenth century of peaceful, productive farming scenes characterised by amicable social relations between landowners and cheerful, well-fed labourers. This marked a temporary reversal of the trend towards wild, unpopulated scenes of romantic nature (Rosenthal, 1982; Barrell, 1980). Such cross-currents in the larger-scale flow of development of the landscape idea cannot be discounted and may often explain instances which otherwise seem regressive.

The third aspect of the landscape idea which challenges in some measure the broad-brush treatment of its history during the capitalist transition relates to those irreducibly human experiences of our own organic life and that of the external world. The cyclical patterns of nature: seasonal weather, the recurrence in plant and animal life of birth, death and rebirth, are enduring. They are a dimension of the life experience of each human individual and every human society. It is not difficult to appreciate how human life processes are read into those of the natural world, for they are in large measure the same and

afford a means of expressing an unalienated relationship with the physical milieu. At this level relations between humans and the land can survive fundamental alterations in productive organisation, although the particular forms of their expression will undoubtedly be affected by such alterations. In quite distinct formations this animism is carried through to collective social life and its meaning. It is found, for example, in the structure of Virgil's poetic development, in the *Eclogues*, *Georgics* and *Aeneid*, generally thought to have been written in that order. Virgil was regarded by literate Europeans from Chaucer's time to the nineteenth century as the model classical landscape poet. His work provided the ideal structure, motifs and language for the European pastoral and elegy and thus became a source of inspiration for painters too (Olwig, in press).

The three Virgilian works represent a progress from the *Pastoral* which posits a 'natural' relationship between humans and their physical surroundings at the birth and infancy of society; through the *Georgical* society of individual farmers who intervene in nature, making it respond more certainly to the rhythms and needs of human life but nevertheless relating to it as husbandmen rather than as exploiters; to the urban society of the *Aeneid* where Virgil celebrates the birth of Rome, sustained initially in the labour of the fields but over time introducing commerce, competition and war. The progress from nature to culture is the progress of society from innocence to experience, from free sharing to individual acquisition, from ploughshares to the swords which ultimately mean the death of society and a return to the wilderness of untamed nature. Each stage carries within itself the seeds of destruction and replacement by the succeeding stage in an endlessly recurring cycle which projects into nature the experiences of individual human life.

Such an interpretation posits a homology between individual history, collective social history and the history of poetry – of cultural production itself. All are equally implicated in the same flow of cyclical cosmic time which allows for understanding by analogy and symbolic association rather than by causal explanation. It is grounded in a shared and inalienable biological experience, and in terms of pre-capitalist modes of understanding it can easily be displaced to an expression of social interpretation.

The significance of these three aspects of cultural production as they affect the expression of the landscape idea will be appreciated as we trace its broad history in the studies that follow. They serve to alter the particular hues of landscape's expression, to inflect the

course of development but not, I believe, to alter the general course of landscape's response and contribution to the changing social relations of a transforming Europe.

3

Landscape in Renaissance Italy:
City, Country and Social Formation

In the renaissance city states of northern and central Italy landscape as a way of seeing was developed with particular theoretical clarity. The Italian *paesaggio*, more commonly *bel paesaggio*, denotes precisely that appreciation of the beauty of the external world that can be captured in painting or poetry which the English 'landscape' conveys (Sereni, 1974). While with hindsight we may see the genre paintings of Flemish artists like Van Eyck as the first realist landscapes, E.H. Gombrich (1966) has shown that it was Italian connoisseurs who called them *paesaggio*, and while critical of their undisciplined mass of detail, appreciated their realism in conveying a sense of the real external world. I have suggested already the intimacy of the link between the landscape idea and the technique of linear perspective as a way of controlling space and claimed that both can be regarded as ideologically related to that control over both the natural environment and society which we associate with emerging capitalism. Italy forms an obvious starting point for examining the evolution of the landscape idea because it was here that the theory of landscape first developed.

There are two further reasons for devoting the first of these case studies to renaissance Italy. First the role of the Italian city states in the emergence of European capitalism is a central one. It is well known that a significant number of the principal techniques of the capitalist market economy – bills of exchange, joint-stock companies and double-entry bookkeeping are the most frequently cited examples – were developed in the commercial cities of late-medieval Italy, and that their fiscal strategies were highly sophisticated (Whaley, 1969). Cloth merchants in cities like Florence, Lucca and Milan had developed a putting-out system of domestic manufacture on a large scale by the fifteenth century, thereby backlinking

merchant capital into manufacturing. But Italy's role in promoting a new order is problematic, particularly in the light of the apparent 'arrest' of Italian capitalism in the sixteenth century when the region began its drift away from the mainstream of European development and found its location increasingly peripheral or semi-peripheral to the core of the European economy, a core which was firmly located around the southern North Sea by the end of the eighteenth century (Coles, 1952; Cipolla, 1952). The second reason for an initial concentration on Italy is that Italian tastes in landscape and their representation in literature, painting and garden design had a profound influence on later European landscape, both in image and in reality. Italy was a place of pilgrimage for early modern Europeans, especially Englishmen and Germans, who embraced and elaborated its taste in landscape for their own times. I shall later discuss the specific example of Palladian landscape, originating in the land dominions of sixteenth-century Venice and enormously influential as a source of ideas and motifs for the making of landscape in eighteenth-century northern Europe and America.

In this chapter, therefore, I examine first the nature of the Italian social formation in the fifteenth and sixteenth centuries, laying special emphasis on its unique combination of surviving feudal relations in much of the rural area with a powerful urban-based commercial capitalism. While commercial, political and cultural life was concentrated in the cities, their relationship with the surrounding countryside was central to their existence. The struggle between the representatives of an urban bourgeoisie, which was also landowning, and long-established rural feudal magnates bears strongly upon our understanding of renaissance humanism which provided the intellectual programme of which the landscape idea is one expression. The struggle was engaged principally in the city because of its overall economic dominance. But the more general relationship between city and country in northern and central Italy is equally important to an understanding of the meaning of renaissance landscape. After all perspective is an urban viewpoint, eminently suited to the representation of architectonic masses, the regular pattern of streets, open spaces and buildings which make up the city. The first landscape is the city itself, and it is an urban viewpoint that is subsequently turned outward towards a subservient countryside making of it also a landscape. The city is the birthplace of both capitalism and landscape and thus I shall examine those ideas developed by Italian humanists and architects for ideal urban landscapes as well as the representa-

70

tions of rural landscape in the Renaissance.

Italy and Emerging Capitalism

The most striking feature of medieval central and northern Italy when compared with the rest of the continent is the number and size of its cities. In 1300 there were 22 cities north of Rome with populations greater than 20,000, and scores of smaller centres which could claim urban status in respect of their regular markets, autonomous civic institutions and political or juridical control over the surrounding countryside or *contado* (Whaley, 1969). These cities had been the particular beneficiaries of Italy's participation in the demographic boom which characterised Europe between 1000 and 1350, an expansion which added perhaps two million people to Italy's seven million at the millennium. Some cities, notably Milan, Venice, Genoa and Florence had reached populations of nearly 100,000 and even relatively small centres like Padua, Verona and Pavia recorded over 30,000 inhabitants. The ratio of urban to rural population in these city states was not infrequently of the order of 2:5, 5:7, or 5:8 (Jones, 1966). They were centres of both local and long-distance merchant trading, of manufacture – particularly of woollen textiles and metallurgy – and of intense political and intellectual life. Most significantly, when compared to the cities of France or England, they were independent, autonomous political entities, free from the controlling authority of a dominantly rural-based feudal aristocracy. This is not to suggest that landed interests had no place in the city. To be sure, the relationship of the city to land ownership, management and agricultural production was a central dimension of its existence and in many respects of its administrative organisation and evolution. But from the early twelfth century the cities of northern and central Italy had broken decisively with their nominal feudal overlords – Emperor or Pope – by declaring and sustaining their existence as free communes whose population owed allegiance to their city alone, even to their district within it (*campanilismo*). The Italian cities had been able to defend this claim through their strength in mobilising both manpower and the financial and technical resources to defeat any attempt on the part of the Emperor to subjugate them, as the defeat of Frederick II's Italian campaign by the Lombard League in 1240 provides testimony (Hyde, 1973).

71

Historians still disagree about the reasons for the precocious revival of urban-based merchant activity in upper Italy. The cessation of invasion from the north, the relative decline of Arab power in the Mediterranean, Italy's position as a point of entry for luxury Asiatic produce into western Europe and the continuity of urban institutions, however weakened, from the days of the Roman empire have all been adduced to explain the phenomenon (Anderson, 1974a). No doubt all played a part and were materially assisted by the existence of the Papacy in Rome whose claims to political and territorial authority clashed with those of the German emperor and weakened imperial attempts to impose a rigid feudal hierarchy over Italian space. This allowed the necessary freedom for merchants to operate in the interstices of a weakly developed feudalism. Original communes were declared by alliances of important merchant families with middle-ranking landowners who had gained the right of succession over their fiefs under the *Constitutio de Feudis* declared by Emperor Corad II in 1037, the effect of which was to make them effectively outright owners of their land, burdened only with a permanent rent but free to sell or otherwise alienate land if they so wished (Hyde, 1973). This alliance of urban merchant interest and landownership is an important feature of the commune and underlies its ability to organise and exploit the surrounding rural *contado* as a kind of collective feudal dependency. By the thirteenth century in Italy, rather than the cities finding their place in the gaps left within an overall feudalised rural fabric, they dominated the rural economy so that the remaining large feudatories, the descendents of families granted large domains by Charlemagne, survived in rural enclaves between or on the margins of urban-controlled *contadi*. Families like the Visconti of Milan, the Este of Mantua and the Malatesta of Rimini remained powerful, particularly well represented in the north-east, and a potential threat to urban autonomy, but a relatively minor one during the three centuries of expansion between the mid-eleventh and mid-fourteenth centuries.

Relations in the Cities

In the cities themselves it is not easy to identify common characteristics among those who formed the original communes and who later claimed the status of noble citizenship against the demands for urban political participation from the newer merchant and wealthy artisan inhabitants, the *popolo*. Lauro Martines (1980) recognises eight characteristics of the early communes: they were economically

prosperous; they owned rural land and sustained social contact in the rural areas; they exercised certain feudal claims over tolls, customs and episcopal incomes; they frequently invested in commercial or maritime activity; they had a traditional association with ecclesiastics in governing the city when it had been under the political authority of its bishop; they used intermarriage to forge connections with families of more ancient blood lineage; they were *milites* rather than *pedites*, that is they had the established right of recourse to arms and horses for mounted combat; and they were sworn members of family or clan associations which disposed of fortified houses in the city. The communes of the twelfth century, then, were by no means purely representative of urban property or commercial interests, nor were they a unitary grouping of a recognisable or recognised class. Different groupings of families competed constantly for control and left the marks of social tension in the urban morphology: in its fortified tower houses and connecting archways and passages that united one quarter of the city against another. The instability of rival consular communes and the social cleavage that emerged between them and the ranks of the 'new men', the *popolo*, rising to wealth on the demographic and economic tide of the later twelfth century, led to the call for external mediation and rule by an impartial *podesta*. Very frequently these invited chief administrative officers of the city were members of the oldest feudal nobility with large rural holdings, as also were those invited to administer the military affairs of the city, the *capitani*, making them obvious but ominous choices.

The class tension between nobility and *popolo* was not assuaged by podestarial rule and, often with the collusion of individual members of the former, the *popolo* wrested power in a series of dramatic revolts in the early thirteenth century. New republican constitutions were devised whereby authority was jointly exercised by *popolo* and *nobilità*, widening urban suffrage but basing it still on property thereby excluding lesser artisans, labourers and agricultural workers who formed the majority of the population. It was the *popolo's* influence in the city communes that accounts for their 'modern' features: the maturity of their financial, accounting and taxation systems, their municipal functions controlling aspects of urban life such as housing construction, fortification, sanitation and public offices. It was under the *popolo's* influence that civic building and communal *palazzi* proceeded apace. It was they who promoted the *stilnovo* – vernacular Italian poetry – and the idea that nobility was not a function of blood

but of behaviour and ideas and that *virtù* was the potential of all citizens and not merely of the aristocracy (Martines, 1980). While it is not possible to distinguish nobility and *popolo* into a landed feudal class and a commercial and manufacturing class both living in the city, it is through the influence of the latter that commercial and economic considerations came to dominate urban perceptions and distinguish Italian cities as the locus of an early capitalistic culture emphasising secular considerations and the primacy of wealth and property as the basis of status.

However, individuals still identified themselves primarily through their participation in the collective life of the city, and it was in the guild, the parish and the commune that personal life found its moral sanction and its outward expression. The contradiction between wealth and property which were personal and yet the basis for participation in civic life which was collective and which declared a sacred legitimacy was an active one. As Martines (1980, pp. 92-3) states with reference to the literature of the period, 'the result was, in verse as in life, a nervous union of contradictions: of moral austerity and earthly wealth, economic intrepidity and religious fear, rapacious greed and frenzies of generosity, and a tight shuttling back and forth between sin and prayer', a very different situation from that of the seventeenth-century Calvinist merchant whose individualistic religious ideology gave moral sanction to both private wealth and personal status as one of God's Elect.

Despite the overlapping economic interests of nobility and *popolo* they continued to regard each other with suspicion as separate classes. Whether expressed in terms of support for Empire or Papacy or Guelf/Ghibbeline faction they remained rivals for control of the burgeoning cities, even supporting rival *podeste*. Their constant internal feuding together with the external conflict generated with neighbouring cities over territory and trade tended to highlight the latent potential for a solution through dictatorship. During the early years of the fourteenth century this was realised in increasing numbers of city states by the emergence of a *signorie*. Significantly these individual rulers, many of whom extended their power over groups of cities, were drawn disproportionately from families whose origins lay in the old established feudal group whose power had originally been diminished by the rising urban communes whose destinies they now controlled, families like the da Romano and Visconti who disputed the dominance of the line of cities from Milan to Padua during the 1300s (Martines, 1980; Jones, 1965). This is

74

not to claim that the *signorie* represented a reversal of urban-rural relations or a take-over of the city by the interests of the *contado*. The passage to power was generally through the exercise of podestarial functions or through having been the military leader of a guild, popolano or noble faction within the city. Thus the *signorie* had long been actively involved in the *vita civile*. But the values of men like Ezzelino da Romano were feudal in that they placed a premium on military skill, rank and homage rather than upon wealth gained through commercial acumen. The tension between these values and those of the *popolo* and even the urban nobility in cities which still maintained their communal constitutions helps explain in part the evolution of renaissance humanism.

Two of the largest and wealthiest communes maintained their republican institutions intact long beyond this period and were centres of significant renaissance cultural developments: Florence until the early sixteenth century, and Venice where the original patriciate, crystallised in the early years of the thirteenth century, had never relinquished power to the *popolo* and where there was no *contado* and no significant land ownership before the early fifteenth century.

The *signorie* gained power in the years immediately preceding the plague of 1348 and its recurrences which halved the population in both city and countryside. The impact of this demographic disaster was long lasting (Herlihy, 1965). Very few cities had recovered their pre-plague population totals by the mid-sixteenth century. But the Italian economy – its trade, manufacture and agricultural production – does appear to have weathered the crisis rather better than other regions of western Europe. The cites of upper Italy remained a focus of the most advanced merchant trading on the continent, although in a sense they were living off their fat. Innovation and entrepreneurial skill are less apparent from these years and 'over the long term, there was a deceleration in the peninsula's productive capacities, a weakening in trade investment and in the upper-class grasp on business initiative, and a decline, at the same social level, in direct personal commitment to trade' (Martines, 1980, p. 170). To this decline some historians have attributed the demand for cultural products as a form of investment (Lopez, 1953).

Under the *signorie* and even in the still nominally republican states of Venice and Florence there is wide evidence of increasing rigidity in the social structure, accelerating investment of urban capital in land and property and a concentration of wealth into fewer hands.

New men more rarely entered the scene, became citizens or were able to amass the wealth and status necessary to meet the increasingly rigid rules governing access to power in the communes. In Florence, for example, by the latter part of the fifteenth century, the merchant patriciate was crystallising into a nobility and no new families were let into the group, and the same is true of other Tuscan cities and those of the Venetian *terraferma* (Ventura, 1964). In 1496, 63 per cent of the population of Bologna owned no land, and in the Padovano the Carrarese family owned 25 per cent of the *contado* by 1400 while 50 years later the peasantry possessed a mere 3 per cent of the fertile zone adjacent to the city (Jones, 1966, p. 416). With the invasions of Italy at the turn of the sixteenth century and its subsequent dominance by the Hapsburg monarchies this pattern was reinforced while the vitality of Italy's emergent capitalism gave way to a stagnation and what some historians have called a 'second feudalism'.

The reasons for this reversal are still not fully understood but certainly related to it was a greater involvement in political and cultural life as an end in itself, a response perhaps to the more stratified and rigid social pattern that the *signorie* had introduced into the cities. It is this pattern of social civic life that gave birth to the values which we associate with renaissance humanism. Before examining it in more detail we need to say something of the rural world with which these urban communes were so intimately linked.

Relations on the Land

The source of migration to the growing medieval communes was the rural communities. The manor, that cornerstone of early feudal land exploitation in north-western Europe, had been established in upper Italy under Lombard and Carolingian rule on both lay and ecclesiastical lands. But here it was a weak institution and short-lived: 'even in the Lombard and Carolingian periods, when manorialism was at its height, the prevailing tendency on Italian estates was towards indirect modes of exploitation' (Jones, 1966, p. 397). By the late tenth century great collective works of improvement, clearance, drainage and irrigation were being undertaken, dominantly on monastic land, and there were parallel individual initiatives consequent upon a rapidly expanding population. By this time cultivated land was increasingly held from the original feudal landlords under *libelli*: a form of lease which specified a fixed rent and allowed the lessee freedom of movement and alienation by sale. The great *libellari* who amassed large holdings under these leases also had urban

property and frequently resided in the city. Here they formed a core of the noble groups who declared the original communes. The bridge between city and country was thus established from very early on.

In the case of those directly working the land, bondage and other forms of feudal legal control over the extraction of labour services were actively suppressed by the communes as they extended power over the *contadi*, often in concert with peasants themselves. These latter themselves increasingly held their land leasehold: either *in affito*, by payment of a fixed rent over a determinate period; or *in mezzadria*, that is sharecropping within the terms of a contract which stipulated the proportions of both inputs and outputs to be supplied by the peasant himself and the proprietor (Giorgetti, 1974). Generally rent was paid in the form of high-value, marketable commodities like wheat, wine or oil to be sold for consumption in the city. This shift to economic rather than juridical and political means of extracting the agricultural labour surplus does not mean that the communes allied with peasants against landlords. Indeed when there was a direct clash between the two, the communes generally favoured the latter group, and peasants who came to the city were not granted its freedom as a matter of course (Jones, 1968). The main concern of the urban commune was to assure food supply and to assert political authority over the surrounding rural lands, and it preferred peaceful redemption and purchase of freedom by serfs to coercion. Above all it was concerned to safeguard property rights and to separate land ownership from lordship. The cities suppressed or emasculated nascent rural communes and consistently extended juridical and fiscal authority over the *contado*, becoming in effect collective seigneurs. In 1314, for example, 62 per cent of San Gimignano's landowners lived in the city, owning 84 per cent of the land in the *contado*.

Leases, whether of *livello* or *mezzadria*, can be regarded as transitional between a feudal and a fully capitalistic mode of agricultural exploitation. They were associated with the building up of *poderi*, estates let commercially but with restrictions placed on the direct producer which effectively prevented freedom of movement and tied the peasant to his land. In Tuscany where *mezzadria* was widespread the detailed conditions of the labour contract specified that the producer reside on his land, contract to farm no other land, neither alienate nor quit without notice, rotate, plough, sow and harvest at fixed times and improve both the earth and its fixed infrastructure like ditches and terraces. In the words of the time he was to *ben lavorare* or lose the tenancy (Jones, 1968). Since in

principle half the capital was to come from the tenant and since few peasants could fulfil this obligation without borrowing, debt became the main weapon of coercion. The leases thus produced a 'proletarianisation of the peasantry' with large numbers of landless cottars unable to meet the terms of lease and obliged to work as labourers or artisans living in villages and working on the remaining large estates or casually on the dispersed family farms of larger *mezzadri*.

The city state, then, could be regarded as a market centre for both land and its produce, surrounded by a politically dependent countryside wherein the agricultural surplus was extracted increasingly by semi-capitalist commercial rather than politico-juridical, feudal means. This centrality is reflected in the geography of cultivation in the *contado*. While there were considerable regional and local variations responding to the highly differentiated physical environment of mountain, hill and plain and the problems of drainage and irrigation which Italy's combination of climate and relief produces, we can generalise a Von-Thünen type model of zones of slackening intensity of production away from the city. The most intensively farmed land often lay within the city walls or in gardens scattered among the buildings of the swollen thirteenth-century suburbs. In ecclesiastical and lay city gardens were cultivated the best vines, low cut and trellised, soft fruit, herbs and horticultural crops. Beyond these, and extending for up to six miles from the city was a zone of intensive intercropping. The *coltura promiscua* was a pattern of cultivation within an irregular reticulation of small fields (*a pigola*) where the ploughland, generally in wheat, was planted also with trees either in rows along its edges or individually placed across the entire surface. These trees supported high vines and themselves served a multiplicity of uses. They could be fruit or nut trees, or mulberries associated with sericulture. More often they were used for forage in a system where, particularly in late summer, animal feed was scarce. The elm was the most widespread support tree used for this purpose and it supplied also wood for fuel and construction. In the Milanese, poplars supplied industrial wood and could survive the waterlogged soils of the Po valley. This intensive form of cultivation was closely associated with *mezzadria* and its scattered settlement pattern with roads leading from the city into a dense patchwork of small fields and farm buildings. Contracts of *mezzadria* frequently stipulated the planting of vines, mulberries and other commercial crops to provide a

saleable return to the urban lessor as well as a self-sufficient unit of cultivation for the *contadino*. The resulting pattern gave the impression of well-regulated and highly productive farming. As Emilio Sereni points out:

> The variety, the density, the good order of tree and bush cultivation on the hillslope landscapes of the Renaissance surprised travellers and foreign observers. It was an unusual spectacle at this period, even in the most favoured lands of the Mediterranean, let alone those of the cold north, for it frequently clothed the entire relief of the hillsides in a delicate embroidery. (Sereni, 1974, p. 223)

It appeared to be the result of systematic planning. In fact it was the outcome of myriad individual decisions made by urban landowners and their sharecroppers and drafted into the leases between them.

The apparent stability and good order of the *coltura promiscua* was often deceptive. In the hill regions there were acute problems of soil erosion on steep slopes, a result of deforestation. Stone and earth terraces were extensively used, but the rectangular fields, ploughlines, pathways and lines of trees were frequently oriented downslope, increasing runoff and soil loss. Agronomic writers like Crescenzi in the fourteenth century and later Tanaglia and Gallo reiterated classical advice to cultivate along the contour (*a cavalcapoggio* and *a giropoggio*) but this was expensive, required more collective operation and ran the risk of damaging the vines, commercially significant to the urban landowner, through standing water. Downslope arrangements were often specified in leases regardless of their environmental consequences and systematic change was not introduced until the eighteenth century.

Hillslope farming dominated in central Italy because of malarial danger in the plains. In Lombardy vine support trees stood over pastureland in areas that had been systematically drained and irrigated. In the emerging centralised signorial states like Milan under the Sforza and Visconti or in the Venetian *terraferma*, large-scale works of improvement were undertaken. Construction of the Martesina and other canals during the fourteenth and fifteenth centuries produced irrigated fields and water meadows that broke through the problem of animal fodder, allowed for regular rotation and manuring and made Lombardy the most advanced agricultural region in Europe in the fifteenth century (Braudel, 1972, pt. 1). It

was here that Italian agricultural and hydrological science was most advanced and where land surveying, using mathematical methods akin to those of perspective, emerged – although in the renaissance period smaller schemes were also instigated in Tuscany and the Papal States.

Beyond the intensive zone lay more extensive patterns of land use, less commented upon by visitors and less frequently noticed by city dwellers because less fully integrated into urban commercial life. More strictly feudal organisation often survived here on large ecclesiastical and older aristocratic estates, particularly in poorer upland regions, although even traditional transhumant pastoralism was increasingly reorganised along commercial lines. Open fields ploughed for grains, communally grazed and then bare-fallowed before cross-ploughing the following autumn replaced the enclosed fields of the suburban zone. Large areas of waste, marsh and woodland remained. Marginal land, cultivated during the peak period of prosperity and population growth, was abandoned in the crisis of the 1340s, as elsewhere in Europe, despite attempts by communal authorities to prevent it. But by the early 1400s land prices were rising and restrictions again being imposed on woodland clearance. Overall the disruption of the fourteenth century was temporary in Italy and gains in productivity in the renaissance period generally balanced losses from abandoned land and poor cultivation practices, suggesting intensified extraction of labour power.

Arrested Capitalism in Renaissance Italy

The evolving geography of individual city states characterised by early developments in merchant capitalism and a strong, urban-centred linkage with the commercialised countryside accounts in large measure for the arrest of capitalist development in renaissance Italy and its inability to move decisively towards a full market society. In the less urbanised and less commercially advanced regions of western Europe: in France, Spain and England the transition to capitalism was by way of centralised monarchism in the absolutist state.

In Italy no such centralisation emerged. It had been systemtically precluded by the early development of urban merchant capital and the localised penetration of commercial relations into the countryside, allying urban and landed interests. Collective opposition on the part of the communes to external imposition of a unitary feudal state by

the German emperors had been effective in preventing it in the thirteenth century and had received support from the Papacy. But neither the single authority of Rome nor the inherently competitive communes could unify upper Italy. Signorial rule produced some large territorial political entities, Florence and Milan for example, and Venice ruled a large part of the north-east by the fifteenth century, but none was comparable in scale or power to the emerging states across the Alps. In some senses the *signorie* could be regarded as localised absolutism (Anderson, 1974b). They resisted guild pretensions, suppressed the political power of the *popolo* in the interests of the nobility, extended central taxation and created state bureaucracies whose offices were held by nobles and favourites. A passion for statecraft and an alignment of nobility with blood and lineage characterise the values of the renaissance city state and represent in part a resurgence of feudal interest in the land as the urban nobility scorned contact with the 'mechanical arts': manual activities. Only 'holy agriculture' was deemed worthy of the concerns of a noble whose main activity was the cultivation of statecraft and the 'liberal arts'. But feudal forms carried little legitimacy in the communes and the traditional nobility could not call upon the loyalty of a disciplined, seigneurialised countryside in dealing with urban interest groups.

Urban guilds, for example, still exercised rights to restrict new techniques and labour relations in manufacturing across the whole urban-rural continuum and thus blocked advances which in other parts of Europe often took place outside the restrictive atmosphere of the older cities. The small scale of political territories precluded the exploitation of a national market while also keeping them militarily weak in the face of the large and technically advanced armies which invaded Italy at the beginning of the sixteenth century. It is then in the very nature of the early advance of urban mercantile capitalism in Italy and its social and locational expression that the reasons for the arrest of future development are to be discovered.

Nowhere is this clearer than in the organisation of agriculture, and the situation in the rural areas is instructive not only because they became a main area of investment in the Renaissance along with urban property and government loan stock but because they were the subject of a new cultural expression: landscape. In a study of the Medici estate of Altopascio outside Florence in the renaissance period, Frank McArdle (1978) has shown how their management became increasingly enmeshed with state political interests and how

the division of the single estate unit into tiny family units leased to
mezzadri, while it held the peasantry as a debt-ridden proletariat,
allowed for no specialisation of labour but duplicated inefficient
production of a single commercial crop, in this case wheat. The
system he claims represents a hybrid mode of production, one with
marked advances of a capitalistic nature over the seigneurial regime,
but an organisation which inherited a legacy that prevented these
capitalist elements from blossoming into the dominant economic
system. With Italian capital during the fifteenth and sixteenth
centuries flowing into land and into *mezzadria*, the dominant form of
land leasing, the situation McArdle describes is representative of
many parts of upper Italy.

Social Formation and Humanist Culture

The social formation of renaissance Italy was stretched between
feudalism and capitalism and consequently incorporated an un-
resolved tension between country and city, nobility and *popolo*, birth
and worth. Its dominant culture reveals a related set of tensions.
Fifteenth-century humanism, its most significant expression, has
elements which may be regarded as secular, individualist and
rational: distinctly modern to our eyes. Yet it was grounded in a
cosmology that was strongly medieval, appealed to collective civic
ideals and was directed towards the interests of the ruling patriciate.
Its rationalism and objectivity were based on a mode of analogical
rather than causal thinking, making explanation by means of symbolic
correspondence rather than through empirically verifiable relation-
ships. Emerging initially in the communes at the time of the *popolo's*
ascendancy, humanist culture became increasingly appropriated as an
ideology of the *signorie* as they came to dominate the life of the cities.
While some of the major humanist intellectuals even of the fifteenth
century and the high Renaissance – Alberti, Fontana, Guicciarini,
Leonardo, Macchiavelli, Pomponazzi and Valla – came from the
professional and merchant classes, their ideas legitimated noble
autocratic or oligarchic rather than bourgeois republican rule. These
humanists adopted the role of 'organic intellectuals' whose appeals to
higher values and apparent freedom from the class divisions of their
society mask their task of providing a symbolic system through which
the self-consciousness of the ruling class was elaborated and
articulated to itself and to subordinate groups.

We have noted already the tension within the communes' civic culture between individualist and collective values and between earthly wealth and moral austerity. Humanism in the Renaissance mediated these tensions. It did so largely by aligning a celebration of the individual with an image of power and authority to be exercised in the interests of the state: the city (Martines, 1980). In so doing it allowed the conspicuous display of wealth, for example in patronage of the arts or in monumental architecture, to signify the dignity and worthiness (*virtù*) of the natural leaders of men thus giving them a moral legitimacy. Those features with which we associate renaissance humanism: the enthronement of reason, study of classical literature, writing of history, love of eloquence and rhetoric, were directed at contemporary society; in modern parlance they were 'relevant'. Humanists found employment as tutors, advisors, courtiers, professors. They groomed the sons of the nobility to become leaders of men, as their successors have done to our own day. Naturally the values to which they appealed were rarely articulated in crude terms of authority and control. They were declared as universal values, grounded in objective understanding of the world, but of their real implications there can be little doubt.

Of the complex intellectual culture of renaissance humanism and its varied pursuits one theme will serve as an example of the tensions with which it dealt, a theme closely related to ideas of landscape and a view of the world focused on the individual. This is the notion of man as a microcosm of the created order of nature. One of the characteristic features of medieval scholastic philosophy had been that of the division of creation into a spiritual and a temporal plane, each hierarchically ordered. In the former, ranked choirs of angels and the saints found each their appointed place below God. In the latter, ranked below human life, were descending orders of animals, plants and inanimate objects. The realities of the feudal social order became the categories of the natural order of things. The highest of temporal beings, man, with his immortal soul aspired to the spiritual plane and, through contemplating that of which he could have no empirical knowledge, could reach it by transcendence. The speculations of early renaissance humanists, particularly those of the Florentine Academy, drew upon Platonic philosophy to reformulate this cosmology (Cassirer, 1963). They argued that the organisation of the temporal world reflected directly that of the spiritual through a series of 'correspondences'. Reason, implanted in the human mind, allowed man, as student of the temporal plane, to understand

something of the spiritual. Man was a microcosm of creation: his body contained its proportions and harmonies. Leonardo da Vinci expressed the idea succinctly:

> Man has been called by the ancients a lesser world and indeed the term is well applied, being that if man is composed of earth, air and fire, this body of earth is similar. While man has within him bones as a stay and framework for the flesh, the world has stones which are the support of earth. While man has within him a pool of blood wherein the lungs as he breathes expand and contract, so the body of the earth has its ocean, which also rises and falls every six hours with the breathing of the world; as from the said pool of blood proceed the veins which spread their branches through the human body, so the ocean fills the body of the earth with an infinite number of veins of water . . . man and the earth are very much alike. (Richter, 1952, p. 45)

Leonardo's well-known diagram of the human body contained within the perfect figures of circle and square reveal that this was more than analogy, it was a coherent theory. What human reason could reveal were the actual principles whereby God had created the world and man in a consistent and orderly way. The overriding principle was proportion. Proportion and balance produced a harmony which underlay the form and motion of all creation. It was through measurement and mathematics, creations of intellectual reasoning, that the proportion and harmony of the universe could best be apprehended. The cosmos was represented as a circle, the most perfect geometrical figure, of which God formed the centre and periphery, rendering all parts congruent. From the geometry of the circle could be derived systems of numerical proportion discoverable in all phenomena. These could be constructed theoretically by mathematics, demonstrated in geometry, and apprehended sensually by the eye, ear and emotions. Here was the rational and consistent way in which the supreme artist worked and by which he intended to guide humans in continuing and improving creation (Wittkower, 1962). L.B. Alberti (1965, pp. 196-7) makes clear the link within this theory between reason and emotion:

> The rule of these proportions is best gathered from those things which we find in nature herself to be most compleat and admirable, and indeed I am every day more and more convinced

of the truth of Pythagoras' saying, that Nature is sure to act consistently and with a constant analogy in all her operations. From this I conclude that the same numbers, by means of which the agreement of sounds affects our ears with delight, are the very same which please our eyes and mind.

Beauty, then, is an objective category, it inheres in unity and completeness, wherein nothing may be added or subtracted without destroying the whole. Because the human individual is made up of the same elements and proportioned harmony as creation itself, reason and emotions are inseparable. The dignity of man, in mind and body, is celebrated in a way which allows for the individual to be emphasised without denying him an ordained place in the established order of things.

By appropriating the universal principles the individual could reveal his human dignity in creative activity. In architecture, painting and design and in the measured cadences of eloquent speech the humanist demonstrated his individual worth while employing rules which made his work recognisable and effective over the emotions of fellow human beings. The perspective construction of renaissance paintings, the severe classical proportions of its architecture and the elegant masculinity of its human statuary and sculpture, all testify to these conceptions of man, space and time. The theory was all-inclusive, objective and authorised by reference to classical sources: Plato's *Timaeus* or Vitruvius' *Architecture*. It was of course both male and class biased. Women, artisans, peasants and other such lowly human forms were deemed unworthy subjects for this human dignity – it is the preserve of the *citizen*, and over time increasingly of the noble citizen, and most especially of the Prince.

The idea of power and authority is never far removed from the writings of renaissance humanists or from their understanding of man's place in the world and his relationship with it. Marcello Ficino comes close to revealing the critical link with political necessities:

But the arts of this type, although they mould the matter of the universe and command the animals, and thus imitate God, the creator of nature, are nevertheless inferior to those arts which imitating the heavenly kingdom undertake the responsibility of human government. Single animals scarcely suffice for the care of themselves or briefly of their offspring. But man alone so abounds in perfection that he rules himself first, which no beasts do, then

governs his family, administers the state, rules peoples and commands the entire world. And as though born for ruling he is entirely impatient of servitude. (Quoted in Martines, 1980, p. 216)

This statement has a particular poignancy when we remember that the peasants, the *contadini*, were frequently referred to as 'beasts', animals fit only for the labour of the fields. If man is impatient of servitude but born to rule peoples, then some people must not be men.

But if this cosmology could be bent towards class power and aligned particularly with the interests of a nobility which was distancing itself from the taint of productive labour, it was also deeply embedded in the practices of bourgeois life. Michael Baxandall's (1972) research has revealed how familiar with the mathematics of proportion merchants, bankers and urban landowners were. Their daily affairs required the gauging of volumes, the calculation of proportional divisions of risks and profits in joint mercantile ventures or the survey of land areas, fields and crop yields on their *poderi*. Their children attended mathematics lessons up to 14 years at the *abbaco*, schools whose name indicates their main activity. Along with gauging, the 'universal arithmetic tool of literate Italian commercial people in the Renaissance was the Rule of Three, also known as the Golden Rule and the Merchant's Key' (Baxandall, 1972, p. 95), a simple way of calculating proportions and ratios. It was exactly the principle employed by theorists like Alberti to construct the geometric ratios which governed universal harmony, 'the secret argument and discourse implanted in the mind itself' (Alberti, 1965, p. 194) which made for beauty and harmony in nature and in art. Erudite appeals to hermetic and cabalistic theories of numbers obscure what were fairly basic techniques of capitalist life, but reveal their appropriation as ideology for a specialised group of humanists and their patrons.

This tension was inherent throughout the humanist programme. The dignity of man towards which it was directed could hardly be claimed a function of birth or blood, such claims had little legitimacy among men like the Medici whose wealth derived from commerce. At the same time it could not be open to all in the capitalist sense of status being allocated by success in the market-place alone. In fact humanists like Alberti counselled against educating youth simply in the commercial arts and skills necessary for a banker or merchant. Humanist education was the prerequisite for achieving human dignity

and its exercise was in political discourse and authority rather than in bourgeois business or feudal warfare. In assessing the tensions which penetrated the whole culture which we term Renaissance, Peter Burke (1974a, p. 246) has described that culture as a pattern of biases along axes which stretch from characteristically humanist to characteristically feudal attitudes:

VALUES

HUMANIST	FEUDAL
Natural	Supernatural
Dignity of Man	Misery of Man
Achievement	Birth
Letters	Arms
Thrift	Splendour
Active Life	Contemplative Life
Virtù	*Fortuna*
Reason	Faith

In the humanist column we observe some of the assumptions characteristically associated with contemporary capitalist society: the emphasis on achievement rather than birth, on reason rather than faith and in natural rather than supernatural phenomena. But precisely in calling these 'biases' Burke acknowledges the struggle within humanist culture between different groups within the city, nobility and *popolo*.

Humanism was open to appropriation by either of these groups. In fact, over the course of the fifteenth century and particularly in the later Renaissance the biases were shifted decisively towards the interests of a congealing aristocracy, towards birth rather than achievement, arms rather than letters, splendour rather than thrift. In this shift we see a cultural articulation of Italy's regression and the arrest of its transition into capitalism.

City and Country as Landscape

One of the reasons why we can legitimately use painting and architecture as indicators of social values in renaissance Italy is that they were produced for patrons who made explicit their demands on the artist. A market for art where the painter produced work for sale

did not emerge until well into the sixteenth century in Italy and even then disposed of only a small proportion of artistic productions. In general contracts were drawn up between patron and artist detailing subject matter, materials and costs as well as completion date and the particular studio painters or masons to be involved. The patron could therefore specify the ways in which his view of himself and his world was to be revealed and celebrated. In painting during the course of the fifteenth century there was increasing emphasis placed on the design and brush skills of the artist rather than the proportion of expensive materials like aquamarine and gold leaf as indicators of the wealth, prestige and taste of the patron. This had two consequences. The first was that it gave the artist increased freedom to display technical virtuosity and imagination in his work and thus claim the status of a professional man – more equal to the patron – than could the artisan. From this position he could take a more active role in determining taste and could pretend an autonomy for his art, and by implication all 'art', which increasingly occluded its social and economic context. The second consequence was that painted backgrounds, traditionally that part of the painting filled with large areas of expensive and symbolically significant colour, began to be used as the space for demonstrating the painter's technical and imaginative skill. Backgrounds were increasingly occupied with scenes from daily life – 'figures, buildings, castles, cities, mountains, hills, plains, rocks, costumes, animals, birds and beasts of every kind' as a contract for Ghirlandaio specifies (quoted in Baxandall, 1972, p. 18). In a contract for a picture of *St Augustine and the Child* at Perugia, Pinturricchio undertook 'to paint the empty part of the pictures – or more precisely on the ground behind the figures – countryside and skies and all other grounds to where colour is put: except for the frames, to which gold is to be applied' (quoted in Baxandall, 1972, p. 17). The main subject matter remained dominantly religious but the increased demand for artistic virtuosity gave scope for painting from nature and reducing the relative significance of the sacred content. This shift has always been regarded as one of the preconditions for the emergence of landscape as a genre and it relates to the changing social conditions in which the painter was operating. Background could over time become the main subject matter.

But there is a broader context in which this change must be seen. That the background should be filled with subjects 'from nature' continues a tradition of painting *il vero* (realism) which dates back to

the early fourteenth century. Rather than a purely symbolic style where meaning beyond that of the conventional religious iconography came from colour and scale conventions, *il vero* implied realism in the creation of illusory space, into which moulded and anatomically correct figures are placed firmly on the ground, foreshortened and illuminated by light from an identifiable source. This style, associated particularly with Giotto and contemporary with *stilnovo* in the poetry of Petrarch and Dante, has been seen by Marxist art historians like Hauser and Antal as an indication of bourgeois or *popolano* demand for rational and secular representation of religious themes. If the mysteries and miracles of Christian belief could be located in everyday settings, their authors revealed as men and women not unlike the burgers of Padua or Siena, then their symbolic power could be appropriate to express or legitimate the lifestyle, experience and authority of those burgers. To speak, however, of a bourgeois art *tout court* is misleading. We have seen that there was no clear distinction, certainly in Giotto's time, between bourgeois and nobility in the cities. Class division became more strictly delineated over time, but in this earlier period when the *popolo* was commanding a greater say in the government of the commune it is legitimate to see values associated with merchants, guild masters and bankers beginning to penetrate cultural production as they came to wield more of the economic and political patronage under which cultural production took place.

In Siena, for example, the *popolo* had gained access to communal councils in 1233. By 1257 they controlled one half of the seats and offices of the council. A particularly strong civic pride is evidenced in both the morphology of the city and its cultural representation. Siena is often cited as one of the earliest examples of city planning because of the frequent archival records of debates on the regulation of urban buildings and spaces not merely for functional requirements but for purely aesthetic and prestige motives. Public open spaces were designed for visual effect, notably the piazza of 1346 whose regular fenestration, building style and height were determined by council decree. The early-fourteenth-century cathedral was immensely ambitious, rivalling Florence's, as was the *palazzo pubblico*, the subject of long debate and careful planning as symbol of Sienese communal status. The building, constructed over half a century between 1297 and 1344 is a monument to civic pride, its tower overtops that of the cathedral and it is decorated internally with a work of artistic propaganda which has been taken as the paradigmatic illustration of

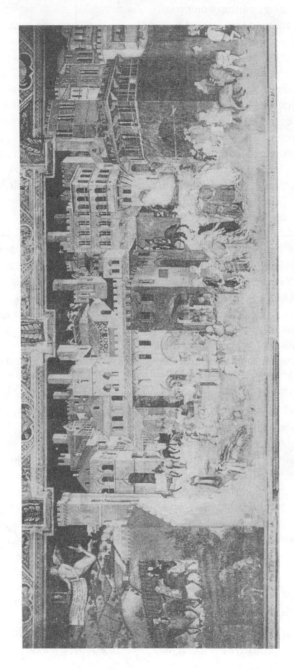

Plate 1. Ambrogio Lorenzetti: *Good Government in Town and Country* (detail; Museo Palazzo Pubblico, Siena)

the medieval city commune and the most dramatic graphic expression of the *vita civile*, the urban and urbane vision of integrated city and country life in the period of a *popolo's* ascendancy. Ambrogio Lorenzetti's cycle of frescos known as *The Effects of Good Government in Town and Country* (Plate 1) presents an image of Siena and its tributary *contado*. The city is pictured as a living organism, a complex of tightly-grouped buildings and human activities. Citizens are shown trading, disputing, dancing and visiting. They are characterised by an elegance of expression, dress and bodily movement. Nobility and *popolo* cannot be distinguished but are integrated into a pictorial unity of colour and movement by activity across the picture surface rather than by the formal composition of picture space or architecture. But a distinction is made between citizens and *contadini*. The dominion of Siena over its territory is explicit. The city stands atop a hill surrounded by the zones of decreasing agricultural intensity. The reticulated and productive fields of the immediate vicinity give way to more extensive open hills and valleys with the occasional *fattoria*, or large estate centre with its workers. *Contadini* are in the city, bringing their pigs, lambs, grain and wood for delivery and sale – almost as tribute. But they are readily identified by their stolid and awkward expressions and gestures, their diminutive stature and dull, uniformly brown costumes. Citizens ride out hawking or hunting on horseback in the half-mown fields, already suggesting that the conscious acknowledgement of the countryside is as a playground as much as an economic base for city life. Quite clearly good government is city government. Other paintings of the communes from the same period by such painters as Duccio, Fabriano or Simone Martini reveal a similar stress on the dominating and civilised precinct which is the city set over a subject territory. But the city itself is not seen in these fourteenth-century paintings as a landscape, a visually ordered, structured and unified space. In Lorenzetti's or Duccio's city we are located inside the living commune and it is still possible to imagine contending parishes and guilds within the complex active unity of people and urban space. In Rees's (1980, p. 66) words:

> Paintings of towns . . . show not so much what the towns looked like as what it felt like to be in them. We get an impression of towns, not as they might have looked to a detached observer from a fixed vantage point, but as they might have impressed a pedestrian walking along the streets and seeing the buildings

from many different sides.

Humanism and the Ideal City

If we contrast these paintings with the image of the city offered to us in Perugino's *Christ Giving St Peter the Keys to the Kingdom of Heaven* (Plate 2), or Pinturricchio's *Funeral of San Bernadino* the difference is striking. No longer is the city an organic and promiscuous collectivity of buildings, spaces and human activities, nor does it stand as a point of domination in the working countryside (although examples of that convention can be found still at this period). Here the city is *landscape*, a formal geometrical and monumental order – a product of the eye. It is the concrete realisation of that harmony, proportion and unity which Alberti and others spelled out in the humanist programme of individual and cosmos. In the background is represented a rural scene, devoid of the evidence of human life. Its hills and trees reflect the same formal arrangement as the city itself. The people of the city, or rather *in* the city – for nothing suggests that they have any greater attachment to it than has the viewer – group themselves in dignified poses. Their gestures are dramatic and self-conscious, not the movements and activities of humans going about their civic affairs but expressions of human dignity and aristocratic poise. These paintings depict the most significant symbolic landscape of the Renaissance: the humanist space of an ideal city.

Humanism, with its stress on the individual as a microcosm of a universe constructed according to fixed mathematical relationships, provided a philosophical framework within which the artistic technique of linear perspective developed around 1420 could easily be integrated. Writers and architects like Alberti, Filarete and Francesco di Giorgio Martini combined painting, architecture and social theory and married ideas with techniques in a series of imaginative plans for unitary cities (Argan, 1969; Rosenau, 1959). In so doing they drew upon the one extant architectural treatise of classical antiquity to lend historical authority to their ideas. The work of Vitruvius Pollio had been known and studied before the fifteenth century but his suggestion of a city planned in the form of a perfect circle, centralised upon a focal open space whence highways radiate as spokes oriented in relation to wind directions seemed to offer a direct realisation of the cosmic scheme in the ground plan of a city. A wide variety of realisations of the scheme was possible and much has been written on the various alternative designs produced during the

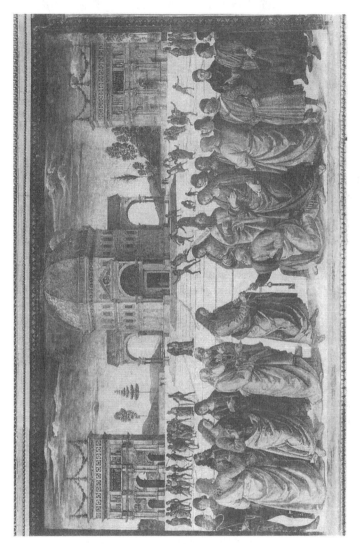

Plate 2. Pietro Perugino: *Christ Giving St Peter the Keys to the Kingdom of Heaven* (Vatican, Sistine Chapel)

Renaissance. All, however, have certain properties in common. The ideal city is conceived as a unitary space, an architectural totality, a changeless and perfect form. It is delineated by a fortified wall, circular or polygonal in shape. At the centre is a large open space surrounded by key administrative buildings: the prince's palace, the justice building, the main church, generally referred to in classical terms as a temple, and often a prison, treasury and military garrison. Significantly the market square is rarely discussed in detail and often relegated to a subsidiary open space away from the centre. The dimensions of the central piazza and its architecture are rigorously controlled and strictly proportioned. Road patterns are determined by centre and periphery, either orthogonally or in gridiron pattern. They are designed to provide visual corridors giving prospects on key urban buildings or monuments. The entire conception is visual, either imagined from above as a visual unity of plan or on the ground as a series of integrated perspectives to and from principle buildings located at the vanishing point. Individual structures are to be designed according to the rules of the classical orders, thus each is rendered a microcosm of the same geometrical principles which govern the harmony of the whole city and which are displayed in the physical and intellectual properties of its citizens. The ideal city is designed for the exercise of administration and justice, for the civic life, rather than for production or exchange. It is purely ideological.

The morphological features of ideal cities reveal sharply the integration of proportional theory with its cosmological implications and political ideology. They are social as well as architectural utopias, designed to regulate and determine relationships between classes in an environment where neither merchant nor landed aristocrat dominates, but where a class of noble administrators rules by virtue of its members' superior reason rather than their exercise of economic power or inherited privilege. Filarete, for example, ossifies the social order of his imagined city by proposing different classical orders for the buildings of each social order: Doric for gentlemen, Corinthian for the merchant and Ionic for the artisan. In *De Re Aedificatoria* Alberti produced the first ideal city model and, it is often claimed, the least rigid and formalised plan. But the social assumptions and sense of social and spatial control are explicit throughout his discussion. He begins by making reference to the 'natural' division of men who are differentiated according to the same distinction that obtains between humans and beasts, namely the

power of reason. Some men are more gifted in reason than others, fortune will often ensure that these are also gifted in worldly wealth. By nature such men are meant to rule their fellows and thus they require different buildings from the commonality. The ideal city is an expression of their *virtù* and reason and their houses reflect these qualities. The house of the gentleman will be 'remote from the concourse of the vulgar and from the noise of trades' (Alberti, 1965, p. 89). It will be a 'small city'. At its centre will be a courtyard, the articulating open space for the rooms and apartments which surround it. These are functionally arranged to meet the needs of a hierarchy of residents: master, wife, children, extended family relatives, guests and servants. Public rooms, private bedrooms, functional spaces for cooking, storage and stabling are all systematically distributed and each is of determinate proportions in plan and elevation, those proportions which inhere in the human body and are inscribed in the city as a whole. They are repeated in the classical exterior elevation of the house so that the harmony of interal space and society can be read off from the outside, and the individual house contribute to the order and regularity of the whole urban landscape.

The gentleman's house, that of a ruler of men, needs protection. Only one entrance, guarded by a porter, is to be made. A similar fear that the social order may not be quite as stable as its 'natural' foundation might suggest is evidenced in Alberti's recommendations for public buildings like the law courts which should have multiple exits to provide escape routes in times of public insurrection. Indeed themes of control and potential social unrest recur throughout the discussion. The city is to be defensible not only against external elements but equally against its own vulgar rabble. This can be achieved in different ways according to the nature of the polity. If an individual tyrant rules, 'the whole should be contrived so that every Place which in any way commands the Town, should be in the Hands of the Prince'. His palace, at the heart of the city should have prospects out along the streets and itself be visible from all parts of the city displaying his authority to all. Nearby should be the fortress which 'should be sure to have even and direct Streets by which the Garrison may march to attack an Enemy, or in case of Sedition or Treachery, their own Citizens and Inhabitants' (Alberti, 1965, p. 86). In the case of oligarchic rule Alberti (1965, p. 83) suggests dividing the city into two concentric circles separating the social classses:

. . . the richer Sort, desiring a more open Space and more Room,

95

will easily consent to being shut out of the inner Circle and will be very willing to leave the Middle of the Town, to Cooks, Victuallers and other such Trades; and all the Scoundrel Rabble belonging to *Terence's* Parasites, Cooks, Bakers, Butchers and the like, will be less dangerous there than if they were not to live separate from the nobler Citizens.

How this is to be integrated with the centralising of public buildings is unclear, but superficially the passage reads like an apologia for the social morphology of the capitalist city, here determined by fiat rather than the intersection of bid-rent curves.

We can regard this ideal city theorising as a discussion of landscape because it treats urban space according to the same visual and social conventions and principles which organised the subject matter and filled the expanding backgrounds of renaissance paintings before the term *paesaggio* was consciously applied. The ideal city unites power with imagination 'and the ensuing vision of space was domineering, moved by a faith in man's ability to control the spatial continuum' (Martines, 1980, p. 272). In paintings, especially after the 1420s in the central Italian schools, religious events are portrayed as taking place in architectural settings which are not merely classical but quite distinctly urban. Annunciations by Crivelli, Baldovinetti, Piero della Francesca, the Master of the Barberini Panels and Fra Filippo Lippi; Vecchietta's *San Bernadino Preaching* and Raphael's *Sposalizio* all depict sacred themes in the context of the ideal city where the theoretical space of chequerboard pavements, columns, arches and pediments provides not only easily recognised perspectives and vanishing points but a fitting stage for stylised citizens to perform, striking the dignified poses of men of *virtù* and reason. The individual, as patron, or artist or viewer is encouraged to stamp his authority across the most crowded scenes and upon the most sacred events through his control of the picture space by proportion and linear perspective. The city is the theatre of reason and harmony.

If the urban views of Lorenzetti are in some respects bourgeois the ideal city is not. It is dominant in painting and architectural theory up to the end of the fifteenth century. Thereafter the relationship between ideal city theory and painting is less close. Architectural treatises of the second generation of planners – Serlio, Sanmichele and Vincenzo Scamozzi – are more rigid than earlier ones. In Italian painting a distinctly pastoral rejection of the city emerged in the early 1600s. But between 1420 and the invasions of

Italy painting and urbanism were closely aligned and the conception and representation of space seems to be poised between a purely aristocratic vision of the world where rank and status are regarded as natural and assured by birth, and a bourgeois one where they were economically determined. As a humanist conception the early ideal city plans seem to mediate these positions by stressing supposedly universal values of reason and natural order. But they are drifting towards the location of real power in a crystallising aristocracy, towards an articulation of absolutist principles. We can see this revealed in the small city state of Urbino where the court of a relatively minor potentate, Count Frederico da Montefeltro, became in the years between 1466 and 1472 a gathering place for a number of the most significant renaissance humanists, painters, and writers. Most notable in this context is Piero della Francesca whose *Flagellation* is a perfect example of setting a sacred scene in the perspective of an ideal city and from whose studio at Urbino perfectly symmetrical and utterly unpeopled illustrations of perspective within ideal cities emerged. The Sienese architect Francesco di Giorgio (a major ideal city theorist and designer of urban fortifications) also worked here, as later did Castiglione, author of the classic renaissance handbook on courtly behaviour, *The Courtier*. It was Castiglione who referred to Montefeltro's palace at Urbino as 'a city in the form of a palace', and Luciano Laurana's design fulfils precisely the prospectus drawn up by Alberti for the palace of an individual princely ruler. Its mass and height overwhelm the huddle of houses in the small hilltop town, covering a vast proportion of the urban area. From the palace extensive views over the city and surrounding *contado* are framed by delicately-wrought window lights set in perfectly proportioned rooms resembling the perspectives illustrated in contemporary architectural paintings. Internal organisation around the great courtyard produces a series of spaces that still give the visitor an extraordinary impression of calm and ordered perfection. Decoration accords with the humanist programme: an endless celebration of classical themes: reason, music and rhetoric. But alongside these, combined with panelled views of imaginary urban scenes, is the ubiquitous logo of the duke: *Fe Dux*. Montefeltro was from an old aristocratic family whose genealogy was closely linked with other such dynasties, the Malatesta, Sforza and Gonzaga (Rotondi, 1969). Humanism and the ideal city are being appropriated as early as the 1460s at Urbino to underwrite the ascendancy of strongly aristocratic and feudal values. The emphasis on military

achievement and machines of war in the internal decoration of the palace is merely one further indication of this.

Humanism and the Countryside

One of the best known portraits of Duke Frederico da Montefeltro is a profile whose background is occupied by a view over a river valley, the watercourse winding among cultivated fields dotted with trees in the *coltura promiscua* of Marche. Taken together with the rural views from the palace this serves to remind us of the ideal city's place in relation to the surrounding countryside. Architectural theorists assumed that their city would stand over a subject territory, but in their works the functional integration of city and country so clear in Lorenzetti's frescos is replaced by an urbanisation of the countryside – an extension of urban authority by means of the principles of reason and proportion developed in the city. Filarete's floats like a perfect disk, a symbol of order imposed on a caricatured rural topography. Alberti claims to 'take it to be a great Happiness to any City, to be able to cultivate a good handsome Part of its Territory' for the sake of self-sufficiency and for its protection against external aggression – a total subjection of rural to urban interests (Alberti, 1965, p. 68). The city, he claims, should stand on an eminence, avoiding unhealthy lowlands but equally commanding prospects over its subject lands. From its gates wide roads should radiate as directly as possible to provide easy movement for troops and for day return visits by its citizens to their estates. The country villa merits detailed attention by Alberti, as later from his successors. He suggests a spatial organisation according to the same urbanistic principles which govern the design of the town house. But here the attention is focused on comfort and luxury. Less formal than the city dwelling, the villa is above all a pleasure house, a belvedere, in which the patrician may relax away from the responsibilities of city government. This is not entirely to ignore the organisation of agricultural production. Alberti lavishes attention on the proper storage of estate produce: wine, oil and grain. Most production would be in the hands of *mezzadri* and *livelli* and the villa acted in this respect as a collection point for the surplus paid in the form of produce. Functionally it is therefore indeed an urban location.

In effect the ideal city theorists had little to say about the countryside as such. Like most humanists and urban dwellers they were content with disparaging truisms such as the claim that the city produces

good men, the villa good beasts.

The contradictions implicated in the humanist abstraction of man as a creature of intellect and reason, divorced from the social tensions of the Italian city are revealed with a particular clarity in their attachment to the garden. The Florentine Academy met in the gardens of suburban villas, modelled upon the enclosed worlds described by classical writers like Pliny (Masson, 1966). Early in the Renaissance Petrarch had written of his love of horticulture and of the garden as a fitting place for humanist contemplation. Alberti, Filarete and Martini, all ideal city theorists, also discussed the layout and content of villa gardens, emphasising the selection and arrangement of plants, flowers and herbs for sensuous enjoyment of their colour and smell. Drawing upon medieval practice in the medicinal and symbolic value of plants, they incorporated a rigid geometry of pathways, beds and topiary to reveal here also the ideals of human control and cosmic harmonies – a visual order founded upon the unity of eye and mind. Both Laurana, architect of Urbino, and Aenius Sylvius, later Pope Pius II and re-designer of Pienza along ideal city lines, created gardens as an integral part of their urbanistic conceptions. In both cases the garden is, characteristically, a secret precinct, a fantasy place where both the political or commercial activities of the city and the productive work of the countryside may be avoided and where labour, other than the occasional therapeutic pruning of vines or planting of fruit trees, is intellectual and contemplative. The labour required to sustain the control over organic nature that the garden represents is not a matter of discussion. In fact, of course, enormous expenditure of surplus labour has to be employed to maintain this image of a perfect middle landscape, of a location suspended between countryside and city and thus disengaged from the interests of both. But the results of this labour are appropriated in the culture of the garden (*villagiatura*) as the product of the rational mind reflecting larger harmonies passing directly between nature and the individual and unmediated by anything so gross as the daily intervention of work. In the garden the humanist escapes a confrontation with productive social relations by substituting the image of a realised harmony between man and nature – the essence of the humanist ideology.

The same image of a self-sustaining union between an inherently productive nature and the rational human mind is apparent in renaissance landscape as it emerged in the background of late fifteenth-century paintings. As A.R. Turner (1963, p. 193) puts it,

with apparently uncritical acceptance of the ideology of the image he is discussing.

Renaissance landscape, whatever its particular form, exists to serve mankind. Its fields and groves are carefully groomed and only rarely give way to wild ravines, spectacular vistas or deserted places. This domesticated world gives sustenance to the physical and spiritual yearnings of the men who inhabit it. In the broadest sense, landscape is humanized.

We know from Alberti that the place for landscape paintings was the villa or garden and we may regard one of its primary roles as providing the impression that the villa garden, generally enclosed or at most providing carefully selected views over distant fields, was but a fragment of a larger but similarly constituted rural world. But while the controlling techniques of proportion and perspective could render the garden space as rational as that of the city, they clearly faced difficulties in depicting open country. Here few shapes are angular, few lines straight, and distance is distorted and outlines obscured by atmosphere and the refraction of light.

Certain conventions were developed to overcome these difficulties. The most characteristic was to adopt a viewpoint high above the scene to be depicted and to articulate space around a linear feature like a road or river. The obverse of the Montefeltro portraits by Piero della Francesca or the *Martyrdom of St Sebastian* by Pollaiuolo are examples of this technique. It allows the picture space to be organised around the fundamental principle of a single convergence point and, in removing the sky, gives the painter greater control over light and atmosphere. Space composition is dependent upon the manipulation of linear perspective techniques rather than upon those of aerial perspective and luminosity. It is later painters like Leonardo da Vinci and the Venetians, Giorgione and Giovanni Bellini who use the sky and the effects of natural light as a way of creating the realist illusion of space. In landscapes of the Umbrian and Florentine schools of the mid-fifteenth century space is composed to distance the scene and to allow a 'pleasing sense of recognition' without detailed description. This removes any need to confront the realities of the life and work which sustains such a 'humanised scene' (Clark, 1956, p. 37). In these landscapes, fragments of classical architecture serve to remind us of their intellectual and social provenance, generally they are unquestionably views out from the city, so that the real locus of the authority which gives them meaning is not in doubt.

Landscape is the perspective of an ideal citizen contemplating the good order of the immediate zone of intensively cultivated land, most of which he and his fellow citizens own. This way of organising and depicting landscape in paint, as an extension of urban space into a gardened countryside, *bel paesaggio*, is associated particularly with the central Italian schools of art. No doubt many of the painters had little direct contact with the erudite intellectual world of humanism and their work responded to the demands for filling the backgrounds of traditional subjects with new objects and skills. Subject matter and medium no doubt required new resolutions. But only certain subjects and certain skills were acceptable to patrons, among them were 'natural' scenery and the illusion of real space. With writers like Alberti, and later Leonardo, we observe the convergence of both the skill of the practical painter and the intellectual activity of the academician and humanist seeking patronage in the courts of signorial princes who, like Lorenzo di Medici, had by the end of the fifteenth century themselves received their education in the humanist academies. An alliance of humanist culture and political power wherein each came to underwrite the other reached its apogee in Rome and Florence under the Medici, in the activities of Leonardo, Raphael and Michelangelo. But in this later phase of the Italian Renaissance it is Venice – exceptional in its political and economic structure and late in its adoption of renaissance humanism – that the idea and art of landscape opens new imaginative frontiers and is associated with a body of techniques in architecture, painting and gardening which would later prove of profound long-term significance to the western landscape tradition.

4

Venice, the Veneto and Sixteenth-century Landscape

During the early Italian Renaissance humanists like Cusanus, Pico and Alberti had encouraged the substitution of a more planar, mathematically proportioned cosmos for the vertically-ascending orders of the medieval conception. A more secular cosmos suited the fluid social and urban context in which they lived and it found clearest graphic expression in linear perspective as the basis of space composition. Close association between the techniques of perspective construction and those of land survey and cartography has been noted (Rees, 1980; Harvey, 1980; F.M.L. Thompson, 1968). By the end of the century the world of the humanists, of the merchants and navigators, was expanding at a hitherto unimaginable scale. Routes around Africa, and to India, above all west across the Atlantic, revealed a new world, to be appropriated imaginatively as well as commercially. Over the course of the following decades map makers like Ortelius and Mercator, whose work could now be printed, checked for accuracy and widely disseminated, were to devise ways of representing this enlarged terrestrial space. Copernicus and Galileo would reveal that for all its new-found immensity, the world of humans was but a dependent sphere in a vast system whose controlling centre lay unconquerable distances away in the sun, the focus of space and source of light that flooded the human landscape. The spiritual focus of the terrestrial world, Rome, not only saw its authority challenged by reformation, but was itself sacked by invading armies.

The simultaneous uncertainty and soaring potential of the new space that Europeans occupied at the turn of the sixteenth century was captured in some landscapes of the high Renaissance, in Leonardo's *Virgin of the Rocks*, for example, and behind the

ambiguous *Mona Lisa*, even more dramatically in the disturbing panoramas of Altdorfer and Ortelius's friend Pieter Bruegel, in *The Tower of Babel*, *The Battle of Alexander* and *The Return of The Herd*. But in terms of the later development of the landscape idea the most significant landscapes produced in Italy came from a city whose participation in expanding long distance trade, in merchant capitalism, navigation, printing and cartography was the foundation of its prestige, and yet which in the sixteenth century was caught in a tension precisely between continued participation in expanding trade and commerce and a recline into the less risky and easier life of aristocratic agrarian exploitation. That city was Venice.

In 1500, 100,000 people lived on the lagoon islands of Venice, the wealthiest city in Italy and the foremost merchant trading capital of western Europe. Since defeating its Genoese competitors at the end of the fourteenth century Venice had established itself as the dominant entrepôt for trade between Europe, the Levant and Asia and had built a maritime empire along the coasts and islands of the eastern Mediterranean (the *stato da mar*) and a land territory on the mainland of north-east Italy (*terraferma*). While, as we shall see, Venice was in certain key respects unique as an Italian city state, particularly in its relationship with land and agriculture, its economic development represents the greatest achievement of Italian mercantile capitalism in early modern Europe, and the achievement of its painters, architects, and urbanists one of the most enduring contributions to the European landscape idea. In the early sixteenth century Venice itself was redesigned as a consciously symbolic landscape while on the *terraferma* rural landscapes were created which would provide a vocabulary later in those lands which succeeded to Venetian commercial prominence: England and the USA.

Venice and Landscape

Art historians make a distinction between Venetian and Florentine schools of renaissance painting which is summarised by the terms *colore* and *disegno*. By the latter is implied an interest in the formal structure of the painting, the accurate rendering of realist space, the human figure and artefacts, and the construction of an intellectual argument within the design of the work. *Disegno* is seen as characteristic of the Florentine school. *Colore* denotes a greater

emphasis on skill in handling painterly materials: the various media, brushwork, finish, and the controlled use of colour and light. It is regarded as a characteristic of Venetian painters' decorative rather than intellectual approach to painting. To translate these two terms as colour and design and to claim that Florence produced an intellectual art while Venice's was sensuous would be to overstate the distinction, but it would suggest something of the differences that renaissance commentators, like Vasari, themselves observed. Why Venetians should have excelled in the rendering of light and colour while Florentine artists stressed invention and design is a question to which no satisfactory answer has yet been given. The radiance and reflective qualities of a city laced with canals and set in open, mirror-like expanses of water is as frequently dulled with cloud as the Tuscan hills are rendered brilliant under summer skies. A tradition of mosaic decoration and Byzantine architectural fantasy may be more closely related to the distinction. Whatever the reason, this traditional virtuosity in the use of light and colour gives to Venetian landscape painting and architectural townscape a resonance that echoes through later European landscape.

When we look at a landscape painted by Giovanni Bellini, or Giorgione, Titian or Jacopo da Bassano, we soon realise that it is light and colour that unify the picture space, control the relative significance of elements presented to the eye, and govern the mood of quiet contemplation, the impression of harmony between human life and the environment in which it is lived. This is very different from the linear perspective which organises the landscapes of Peiro della Francesca and Paolo Uccello with their sharp-edged and precisely-delineated forms receding correctly to the vanishing point. Light and atmosphere, according to John Berger (1972), lie at the heart of landscape painting and he argues that because the sky cannot be appropriated as property or rendered pictorially as such in the way that the land and what it bears can be, then landscape painting remains relatively unaffected by new property relations of an emerging capitalism. This may be so in a narrow sense, but the sky and its effects are a powerful symbol in themselves, generally of the divine or otherworldly, and thus of moral issues which related closely to prevailing social relations. Also, light effects can be deployed to compose space and illuminate or disguise features of the landscape below it (Barrell, 1980). The technique developed to compose and structure the space of air as opposed to that of objects was aerial perspective: the blurring of outline, the blueing of distant natural

forms and the altering of light and shadow hues as they fall on objects (*chiaroscuro*). Aerial perspective was studied in detail by Leonardo; the possibilities of its use, he argued, made painting a superior art to sculpture and poetry (Blunt, 1973). It was employed in masterly fashion by Venetian painters and architects.

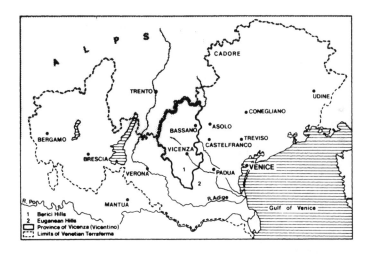

Figure 4.1: The Venetian *Terraferma*. Venetian possessions on the Italian mainland in the sixteenth century

Many of the Venetian landscapes are recognisably of the *terraferma*, that great finger of land which points towards the heart of the Po basin and which the Venetians had conquered and annexed in the early years of the fifteenth century (Figure 4.1). The heart of this area was the immediate hinterland of Venice: in the hills, plains and lower Alpine slopes of the Padovano, Trevigiano, Vicentino and Veronese. This is where Bellini's madonnas sit and where the *Asolani*, Pietro Bembo's pastoral lyrics are set. Castelfranco was the birthplace of Giorgione, Conegliano that of Cima, and to his alpine home of Cadore it was the countryside through which Titian passed on his annual trips from Venice. In their landscapes recur images of the rounded forms of the Berici and Euganean hills, softened into blue across the distances of the plain, and of the dark line of dolomitic Alps along the horizon, so often sharpened in the drama of an electric storm. Each of these painters owes a debt to the physical

105

environment of his youth. But the mood of Venetian sixteenth-century landscapes signifies more than merely a mastery with colour and tone and a personal engagement with the luminous lands of the *terraferma*; it expresses a new and highly profitable relationship between Venice and its landed territories, a new dimension of Venetian patrician experience.

For during the later fifteenth and particularly in the sixteenth century the *terraferma* came increasingly to provide the food needs of the metropolis and it offered a secure investment for capital and a novel form of status acquisition. In emphasising landed investment Venice reflected a trend then occurring in all the Italian cities. Interest in landscape as a subject of painting and poetry, paralleled by villa-building and decoration, should perhaps not surprise us in such circumstances. But its particular character and the exact nature of the relationship require more detailed considerations. And to emphasise the use of rich colour, of chiaroscuro and aerial perspective as techniques in the Venetian artistic and architectural traditions should not blind us to the Venetian humanism and platonism, nor to the emphasis Venetians placed on the design of their city along the lines of an imagined classical ideal. In Venice as elsewhere the landscape idea grew out of distinct social, economic and political experience. Some knowledge of the particularities of that experience is essential for understanding the Venetian senses of landscape and its later attraction to other Europeans.

Republican Venice

Unlike the other city communes of northern Italy Venice was not the centre of a rural *contado*. Established by mainland refugees on islands in the tidal lagoon, Venice was a confederacy which became centred at Rialto under the rule of an elected Doge and which as late as the early 1300s still drew its frontiers around the *dogado*, the lagunar islands and the narrow strip of coastline enclosing them. This separation from land which was elsewhere one of the main bases of urban economy and society is both cause and consequence of other unique aspects of Venice within medieval and early modern Italy. Venice was unquestionably a merchant capitalist city, generating wealth from its engagement in Europe's long-distance trade in the eastern Mediterranean and beyond (Lane, 1973). This required not only sophisticated marine technology, both commercial and military,

and highly developed financial institutions to underwrite credit lines and spread risks, but also a freedom from the restrictions imposed by the feudal order on commercial life. Venice was inserted as a non-feudal island between the quite different but equally non-capitalist formations of western Europe and the Islamic East. In sustaining this position the lack of any threat from remaining feudatories in a subject *contado* and the ability to negotiate an autonomy between Empire and Papacy were critical advantages. At the same time, easy access across the *terraferma* to Lombardy and via the Alpine routes to southern Germany, to the forests of Istria and Friuli and to other commercial centres of Italy provided raw materials, manpower and trade potential for Venetian enterprise to exploit.

The lack of a subject rural territory also meant that landownership as a source of wealth and investment was insignificant in Venice until the fifteenth century. The urban patriciate was overwhelmingly mercantile in interests and while guilds were numerous they were composed of craftsmen and artisans who never wielded sufficient economic power to challenge the dominant merchant oligarchy as a well-organised *popolo*. The political crisis of the last years of the 1290s which led to the closure of the Great Council membership was in part a struggle between newer and older commercial wealth. But it was a political rather than an economic struggle and was resolved by simultaneously widening the membership of the ruling group while restricting future access to authority in Venice. The *Serrar del Consiglio* of 1297 swamped the older families who had threatened autocratic despotism and incorporated new wealth into an oligarchy whose privileges were henceforth protected from dilution. While the Venetian patriciate contained considerable variations in wealth (Finlay, 1980) and was by no means free from internal factionalism, the tension between nobility and *popolo* which allowed for signorial take-over elsewhere in Italy was avoided in Venice.

Venetians themselves emphasised the stability of their institutions and stressed its republican virtues by comparison with signorial despotism elsewhere. Venice, they claimed, survived and prospered because its government achieved a balance between monarchy in the person of the elected Doge, aristocracy in the 300 senators from among whom he was chosen, and popular republicanism in the two-thousand-strong Great Council (Bouwsma, 1968). This was the foundation of the so-called 'myth of Venice' as a perfect constitutional form. The republic in the fifteenth century governed a commercial empire by sea and land. But it was an empire without

geographical, linguistic or ethnic homogeneity. It was a creation of commerce, dependent for its whole existence upon the urban centre and so given meaning by the city of Venice itself. For a long time the relationship between Venice and its dominions was that of the conquering city state and a conquered, exploited empire, not one of a capital and its provinces. The reason for this was the continued dominance of profitable maritime merchant trading as a source of patrician investment under more or less monopoly conditions. Consequently no change was made in the city's republican constitution to take account of its external possessions, and it remained firmly geared to the rule of the city as an autonomous entity. On the *terraferma* local urban statutes were confirmed, their ruling groups simply encoded and enclosed to resemble that of Venice, and Venetian governors and administrators added as a top level in the structure. Political development was thus arrested in the interests of preserving the commercial hegemony of the centre.

Nevertheless fifteenth-century conquest of the *terraferma* generated conflicts within Venice and between Venice and its Italian neighbours. Doge Mocenigo emphasised at the time of original landward expansion that landed interests should not distract Venice from its historical mission in sea trading. The perceived tension between Venice's sea and land engagements was given acute emphasis in the opening years of the sixteenth century when, fearing that the city's intention was imperial domination of the whole peninsular, the Papacy combined with France, Spain and the Empire in the League of Cambrai to thwart Venetian aims. In 1509 the League's armies advanced rapidly across the *terraferma* and Venetians feared the conquest of the city itself. By judicious manoeuvring to exploit the internal divisions within the League the Venetians succeeded in saving the city and retaining their land empire, despite a decade of devastation from marauding armies. But the shock of the war and the rapidly diffused knowledge of the Portuguese and Spanish navigations in the Atlantic caused considerable concern and debate among the Venetian politicians and writers about future relations between Venice and its maritime and dry land possessions. Doges, diarists and senators engaged in a sustained debate about the unique mission of their city and its ordained place in history. This was the mode of discourse in which the adjustment to changing external circumstances was sustained. They emphasised both the geographical centrality and the physical isolation of Venice within Italy – an island wedded to the sea. Equally they claimed that the marriage of Venice

to the sea was a precondition of its sustained republicanism in the face of signorial rule and foreign occupation elsewhere in Italy. Geographically and constitutionally Venice was blessed with a liberty which had governed its historical continuity.

It was in the writing of history that Venetian humanism flourished most strongly. Despite the close link with Padua, whose university had been the centre for some of the earliest humanist scholarship and which was the only recognised institution of higher learning for the Venetian patriciate, and despite the existence in the city of the Aldine Press which made Venice the leading publishing centre of Italy by 1500, philosophical and speculative intellectual activity was more limited in Venice than in Florence. The penetration of the state and its agencies into so many aspects of social life in Venice perhaps accounts for this. But history could serve to celebrate the state, and writers like Sabellico and Giustianini in the late fifteenth century, and later Gasparo Contarini and Paolo Paruta, used historical writing to justify rhetorically the permanence and perfection of Venetian institutions. Their emphasis was always upon the uniqueness of Venice and they developed the idea that their city was the heir to Roman virtue and Roman grandeur. D.C. Chambers (1970) has called the renaissance period the 'imperial age' of Venice when to the traditional state iconography of St Mark the evangelist as patron of the city were added the classical gods Neptune and Mercury – the gods of navigation and commerce. The sixteenth-century myth of Venice was at once geographical and historical, and it found expression in the constitution of Venice as a symbolic landscape.

Republican Venice as Landscape

Cartography

We gain a sense of the humanist vision of Venice from its late-fifteenth-century cartography. At this date urban maps depicting bird's eye views of individual cities following the rules of linear perspective were popular among wealthy Italian collectors. The Duke of Mantua, for example, made a large collection of them in the final years of the century. In 1500 a woodcut bird's eye view of Venice of quite extraordinary size and detail was made by Jacopo de Barbari. It has long been interpreted as a highly accurate record of the urban

scene, detailing individual buildings, canals and streets. But it is as strongly influenced by the myth of Venice as by a spirit of scientific objectivity and realism. Schultz's (1978) detailed analysis of its grid has revealed severe distortion away from the centre of the map which allows exaggerated emphasis to be placed upon the central functional and symbolic nodes of urban life: San Marco, the administrative and ceremonial heart of the city; Rialto, the commercial and financial centre; and the Arsenal, the military-industrial focus. It is these three centres that were being embellished through the sixteenth century in a programme of architectural development organised by J. Sansovino and which came to articulate the patrician image of Venice as an ideal city.

Barbaro's is a symbolic landscape. Venice floats at the centre of the open lagoon. The line of the *lido* which separates the lagoon from the open sea is distorted to enclose a circular aquatic space guarded to the north by the line of the Alps. Neptune rides at the centre in the basin of San Marco and above Venice sits Mercury, protecting this 'emporium'. Both of these classical Gods declare the purpose of the map: to present an image of Venice as the centre of commerce and the mistress of the seas. The map stands in the tradition of *mappae mundi*: synoptic and paradigmatic images of the created world which aided the contemplation of divine wisdom. Such *mappae mundi* were produced by Venetian cartographers during the late medieval period and one had long decorated the public loggia at Rialto. But the moralised geography of the medieval maps is here combined with practical cartographic representation of topographical reality, the necessary tool of the maritime merchant. The combination reminds us of the union of faith and reason, of empirical knowledge and cosmological belief within an analogical mode of explanation which underlay humanism and gave it moral and ideological force. Barbari's map

is the commonwealth of Venice rather than the physical city: Venice the premier trading and maritime power of Europe. Her physical features are exhibited as the material manifestations of the state, just as the figures of Mercury and Neptune are the incarnations of her numen. Jacopo's print is a visual metaphor of the Venetian state, like the familiar symbols of Venice, the winged lion of St Mark and the female figure holding the scales and sword of Justice, which represented the divinely protected and justly governed republic. (Schultz, 1978, p. 468)

The map presents Venice as an ideal city, but differs from the ideal city plans of Martini or the tight, controlled spaces of Piero's urban portraits. By representing a real and recognisable city as the ideal it celebrates a myth of Venice as having already achieved that perfection to which humanist writers and architects elsewhere only aspired. It could hardly have achieved this by recreating the perfect geometrical form of Alberti's intellectual conception, but the humanist references are there in the Latin inscriptions, classical gods and Vitruvian winds which encircle the margins. Depicting a confident commercial republic, supported by the ideological references of humanism, Barbari's map is the cartographic expression of a whole political culture designed to celebrate the Venetian myth. Ritual and ceremonial reinforced this image in daily life for Venetians of all classes. Edward Muir (1981) has examined in detail the expressions of state culture in annual festivals like the Doge's 'marriage with the sea', *carnevale* and the procession in St Mark's Square. A ritual geography exploited the symbolic value of the rhythms of everyday life – going to and returning from the sea, the cycle of the seasons or of birth and death – within the context of Venetian legends to legitimate the institutions of the state.

Townscape Painting

The same purposes informed contemporary townscape paintings by Gentile Bellini, Victor Carpaccio and Giovanni Mansueti. Their townscapes form the background to devotional pictures often painted for the *Scuole Grande* of Venice and may be compared with Lorenzetti's views of Siena in their creation of a bustling, congested commercial city. The *Scuole Grande* were unique Venetian institutions, independent lay confraternities commanding large amounts of money and devoted by statute to the promotion of the material and moral welfare of their members. Membership was not limited by class or income and while the patriciate was not excluded from membership it was forbidden from engaging in their administration (Howard, 1980). Nevertheless they were closely integrated with the state. Their constitutions were modelled on the Council and Senate, they were expected to participate in public ceremonial and their leaders were drawn from wealthy non-patrician families. They mediated the social and moral order of the city's rulers to otherwise disenfranchised social groups. The cycles of paintings which decorated their halls depicted the lives and miracles associated with

111

their saintly patrons or other suitably pious themes like the legend of St Ursula, often miracles believed to have taken place in Venice itself as those performed by the fragment of the true cross for the Scuole Grande of San Giovanni Evangelistica. These sacred events are shown occurring almost casually against the background of an active city. In their construction perspective is less rigid as a device to hold the picture space than in contemporary Florentine painting and buildings, dress and boats are highly decorative, picked out in rich colour. But if there are strong elements of the more traditional, informal and perhaps bourgeois representation of the city, a closer inspection of the human figures who occupy this space reveals the theatrical poses and elegant self-consciousness which appear in ideal city paintings elsewhere. Even the gondoliers are highly stylised and sumptuously attired, scarcely the transport labourers of a working city. Among the congestion and behind the pious events lies the image of social order and state authority.

In later cycles individual patrons or the leading members of scuole appear in rigid ranks removed from the events of city life and observing the religious spectacle. They possess a more characteristically renaissance organisation of the picture and the people appearing in the landscape. It has long been recognised that many of the features that characterise intellectual humanism and renaissance painting developed late in Venice. The reason for this may be associated with the sustained commercial involvement of the Venetian patriciate, its republicanism and its pietistic form of religious practice. Religious institutions had long been securely under the control of the state to the dismay of many Popes and 'a traditional religious faith worked, paradoxically to licence commercial and political ruthlessness, and there was no reason to discard what had always worked' (Bouwsma, 1968, p. 72).

Venice in the Sixteenth Century: Townscape and Landscape

In the years following the upheavals, real and perceived, of the Cambrai crisis, the loss of Constantinople to the Turks and the opening of the Portuguese and Spanish Atlantic trade routes there was a marked shift in attitude among the Venetian ruling class. While the city made a remarkable recovery from the devastation of the war and while profits from the spice trade did not decline before the end of the century, a weakening of Venice's maritime commercial position

was increasingly evident. The balance of payments moved into deficit, the public debt increased and, at the end of the century, inflation, bank failures and Turkish penetration of the eastern Mediterranean combined to produce a genuine economic crisis (Lane, 1973). Long before that, however, there was a sense of unease among the patriciate evident in declining innovation (for example, in marine technology) and declining willingness to invest in high-risk, long-distance trade. The obverse of this investment coin was the increased flow of capital into land, either in city real estate or in agricultural estates on the *terraferma*. The notion that Venice became a rentier economy during the sixteenth century has been challenged (Woolf, 1968), but despite short-lived booms in manufacturing the trend in that direction seems to have been apparent to Venetians themselves, commented upon by diarists and publicists. The Venetian patriciate became more self-conscious of status and class, adopted latinised names, spent long periods in *villagiatura* and indulged an enthusiasm for classical humanism and Neoplatonic literature. These changes are evident in a more idealised urban scene, an altered attitude to land, and changing social and economic relations in the countryside.

Architectural Interventions in the Townscape

The Barbari map became a model for many subsequent perspective maps of Venice. They reveal an increasingly consistent representation of the city as a visual unity, a landscape, and a willingness to distort reality into the symbolic form of the ideal city, an image that corresponds far more closely than Barbari's to the second and more formal generation of ideal city plans, many of which were published in Venice. In these maps the *lido* and coastline are increasingly distorted towards a circular shape, the urban area compressed to a more compact than linear form and in some cases the circular map is segmented by orthogonals focusing on the Piazza San Marco, the centre of the city. G.B. Ramusio, maker of one such map, published imaginatively idealised plans of recently-discovered cities in the New World, notably Hochelaga (Montreal) and Tenochtitlan (Mexico City). Both are represented as symmetrical, centralised ideal cities, standing isolated in circumambient waters. To have discovered the image of Venice in the potentially perfect new found land was to reinforce the belief in its ordained perfection (Cosgrove, 1982a).

Perhaps the most striking of all the sixteenth-century images of Venice as an ideal city is the set of proposals drawn up by Alvise Cornaro for improving the city's defences. Cornaro was a leading

humanist from one of the most important Venetian families. The loggia of his estate villa at Padua was the earliest purely classical Vitruvian building on the *terraferma*, and he was closely involved with newly-established state land reclamation and water protection agencies (the *Provveditore ai beni inculti* and the *Provveditore alle acque* respectively). In 1565 he presented a plan for surrounding Venice with a circular rampart complete with bastions and draining large areas of the lagoon for cultivation of grain to supply the city. His plan is a perfect illustration of the union of engineering technology, state intervention and humanist idealism. The practical control of nature would yield a perfect geometrical form, a realisation of cosmic principles and thus a justification of their validity and relevance to the world of affairs. Cornaro's plan remained a parchment landscape. But the symbol of ideal Venice was realised in imperial architectural vocabulary through a programme of building in the century between 1480 and 1580. It concentrated on the three nodes emphasised on the Barbari map: San Marco, Rialto and the Arsenal. It was given a strong classical Roman reference in the grandiose architecture of Jacopo Sansovino and Andrea Palladio (Tafuri, 1980; Howard, 1980).

At the administrative heart of Venice (Figure 4.2) a collection of buildings representing mixed government surrounded the enormous open space of the Piazza San Marco and the equally impressive Piazzetta opening on to the lagoon. At the head of the Piazza stood the basilica of San Marco, housing the remains of the Evangelist, the foundation of Venetian iconography. His symbol of the winged lion topped the column at the entrance to the Piazzetta and recurs in all parts of the Piazza complex. San Marco was not the cathedral of Venice: the bishop's seat was an insignificant church located on the margins of the city beyond the Arsenal. The Basilica was the Doge's private chapel with its own ceremonials and liturgy appropriate to its role as a symbol of state. Connected to the building was the seat of Monarchy, the Doge's Palace. A classical wing was added in 1483 but the main façade was rebuilt after a disastrous fire in 1577 despite a strong plea from some leading patricians for complete rebuilding along classical lines. These two elements pre-existed the humanist organisation of the central area. But largely under the supervision of Jacopo Sansovino, official architect of the city, the ambience of this whole complex of buildings and spaces was transformed during the 1500s to recreate that of a Roman forum. Along the north and south sides of the main Piazza continuous columnated loggias of 1513 and

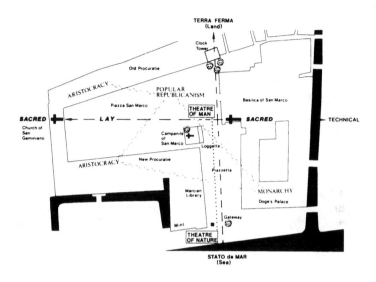

Figure 4.2: Symbolic Structure of the Piazza San Marco
(Reprinted with permission from *The Journal of Historical Geography*, Vol. 8, No. 2, p. 150. Copyright: Academic Press Inc. (London) Ltd)

1590 provided strong classical lines defining the central open space. They were built for the *procuratie*, representing the aristocracy. Between them the regulated space of the Piazza represented a place of discourse, an open-air theatre for the celebration of republican virtues and the location of the city's most solemn rituals. Two further groups of structures completed the whole. The *orologio* or clock tower constructed in 1496 stands over the entrance to the *merceria*, the main retail street of the city leading to the Rialto. Regulating public time under the authority of St Mark's lion, its simple rectangular geometry also contributes to regulating public space and provides a visual anchor for the sight-line which leads thence to the open water of the lagoon, the entrance to Venice. This axis is specified by the standards raised before the Basilica and the two columns at the water's edge. To complete the secondary open space through which this axis runs, Sansovino designed a loggia for the free-standing *campanile* of San Marco, an informal meeting place for members of the Grand

115

Council; a building to house the Marcian Library facing the Doge's Palace; and, connected to it, the Mint. Through these interventions and the clearance of various stalls and other temporary structures which had previously cluttered the area, Sansovino's created two coherent spaces which intersect in front of the Basilica, locking all the structures into a single visual and symbolic unit, one which we recognise today as a masterpiece of urban design.

The waters of the lagoon in the Basin of San Marco form an integral part of the urban landscape design. Andrea Palladio's church of San Giorgio Maggiore occupies a strategic island across the open stretch of water, turning it into a shimmering extension of urban space. Its significance was consciously explored in the sixteenth century in its use as the location for floating *teatri del mondo*, circular constructions rendering in three dimensions the classical fantasies of humanist cosmology. These were the setting for dramatic productions designed by patricians like Luigi Cornaro and Daniele Barbaro. Placing such intellectual statements of cosmic harmony in the 'theatre of nature', as the lagoon was sometimes called, revealed the unity of human reasons and the created natural order. This was the organising principle of the Piazza San Marco: a concrete visual symbol at the heart of the city of Venice's republican perfection, realised in mixed government, articulated through imperial Roman architecture and legitimated in the rationalist theories of humanism. Public interventions in urban space were authorised by the Senate and its committees and despite often heated debate over the merits of classicism there was broad agreement of the symbolic meaning and significance of the townscape of San Marco (Tafuri, 1980).

The Rialto was the commercial centre of Venice, the location of the markets, warehouses and financial institutions upon which the city's prosperity was founded. If, in Tafuri's (1980) terms, San Marco was the locus of Wisdom and Eloquence, Rialto was the place of Function. Humanist patricians supported plans by ideal city theorists like Fra Giocondo and later Palladio to reorganise the market area after the fire of 1514 along the lines of classical spatial geometry. With regular open spaces and gridiron streets lined by Tuscan loggias, Rialto would have corresponded to the secondary square in an ideal city plan. But rather as the commercial demand for land and the complexity of ownership later frustrated plans by Christopher Wren and John Evelyn for the rebuilding of the City of London after the fire of 1666, the grandiose schemes of humanist architects were blocked by the need at Rialto to maintain business as usual, so that its

medieval morphology remained unaltered and a more piecemeal programme, better suited to the wisdom of commerce, was adopted. Sansovino's *fabbriche nuove*, (1554), the central marketing warehouse at Rialto, was a joint speculative venture financed by private capital rather than the state. Its simplicity of design and freedom from heavy imperial ornamentation distinguish it from the form and symbolism of San Marco. The failure to impose a formal classical solution here is suggestive of the status distinction which was emerging in Venice in the mid-sixteenth century between the liberal arts of learning and government and those lesser arts of trade, commerce and industry.

The Arsenal on the other hand was unquestionably the place of Technique, of Vulcan. It was an enormous complex of shipbuilding and repair yards, of ordnance workshops, rope and sail factories. Its workers were paid and housed by the state and upon them depended the military security of Venice. Until the late fifteenth century the Arsenal had been open to access from the canals and pathways around it, more a specialised district of the city than a unitary location. But in 1539 it was surrounded by order of the Senate with a ten-foot high blind wall and left accessible only via one, elaborately decorated, classical gateway. Tafuri suggests that this was not merely a security device but a way of hiding the despised mechanical arts from more refined eyes. Nor should we ignore the impact of this hidden seat of technical power as an instrument of state intimidation, remembering Alberti's words about military control of the city.

These various sixteenth-century interventions into the townscape of Venice also included private initiatives. The great renaissance palaces built along the Grand Canal and the villas and gardens of the Giudecca and other surrounding islands all reveal an appropriation of prime sites and a larger share of urban space for the purposes of display by the wealthiest patrician families: the Gritti, Contarini, Loredan and others (Howard, 1980). While in these buildings, as in public constructions, there was a sharp eye for the investment value of land, the overall impression of sixteenth-century Venice as a built environment is of a desire to see the city as a visual whole, a landscape whose form reflected social and political perfection. Venice was *the* ideal city, the rightful heir to ancient Rome, having a privileged history and thus no great need for radically restructuring urban space along theoretical lines. Neo-Vitruvian architecture, integrated into the existing urban morphology, merely confirmed what was already known and celebrated in writing by humanist historians and in action through public ritual.

Venice and the Terraferma: Land and Landscape

Those who floated schemes for more extensive alteration of the existing patterns of Venetian urban space along ideal city lines were associated with the more conservative and older aristocratic families (the *Longhi*) who in the political life of renaissance Venice were opposed by the *Curti* or *Giovanni*, smaller and more recently-established family clans, whose members feared that the concentration of public policy in the hands of the small and secretive Council of Ten represented a threat to Venice's republican liberty (Finlay, 1980). They called for a return to more open government and for a revival of the city's commitment to trade and maritime commerce. One of their main concerns was the shift of investment into land on the *terraferma*. Two of their opponents already mentioned, Luigi Cornaro and Daniele Barbaro, possessed extensive estates in the Padovano and Trevigiano respectively. The former was an active apologist for extending state interest into the *terraferma* through drainage and reclamation. There was a close link between landed interest, political conservatism and humanist thought in this period and while in the struggle for political reformation and the continuity of urban form the *Giovanni* seem to have had the advantage, they were unsuccessful in turning the tide of Venetian investment in land. Of the 1400 villas on the Venetian *terraferma* now listed as of historic interest, 14 date from the fourteenth century, 84 from the fifteenth and fully 250 from the sixteenth century. Venetian land investment did not begin after the Cambrai crisis – it had been emerging over a long period and received a stimulus, for example, from the sale of former Scaliger and Carrarese lands after their dispossession in the early fifteenth century. But it achieved a new momentum in the following century and has been interpreted by some historians as evidence of a fundamental shift of the Venetian economy from a mercantile to a rentier basis (Pullen, ed., 1968). The evidence is inconclusive for even in the 1420s the *terraferma* had provided nearly 30 per cent of state incomes and the proportion did not rise significantly until the early seventeenth century. Levels of investment in maritime trade did not slacken significantly until the late sixteenth century and the proportion of state investment in land remained a low proportion of its total outgoings during the century. Nevertheless public interest in land improvement was increasing.

In 1558 a state office was established to supervise the reclamation

of uncultivated land, irrigation and drainage (*Magistratura ai beni inculti*) and in 1574 a similar office to co-ordinate the development of communal land (*Magistratura ai beni communale*). During the period between 1550 and 1650 over 200,000 *campi* of land on the *terraferma* were reclaimed for agriculture. Again we are considering an economy in transition between a still strong merchant capitalism and a growing willingness to spread investment into land and property rather than to direct it towards a manufacturing base to secure the articles of trade. Other than a brief boom in woollen manufacture and the well-established luxury manufactures like silks and glass, industry was not a favoured destination for Venetian capital.

Land investment, either public in the form of drainage, reclamation and hydraulic regulation, or private in the form of estate farming was a response to a number of factors. Acquisition and sale of ecclesiastical and common lands helped fund a burgeoning public debt at the expense of the church and the rural peasantry. Self-sufficiency in grain in the face of Turkish threats to traditional eastern Mediterranean granaries was a critical determinant of policy in a city of over 100,000, and tax revenues accrued from newly-farmed estates. An ideology of agriculture promoted by the publication and wide dissemination of treatises on husbandry is evident throughout the sixteenth century. Alvise Cornaro for example in *La Vita Sobria* sang the praises of 'holy agriculture', contrasting its easily-secured revenues and elegant lifestyle with the risky returns and personal dangers of seafaring trading. The tone of his writing is self-indulgent, aristocratic and shows an eye for landscape beauty not unconnected with the sense of exploitation and control:

> My dwelling, which is in Padua . . . is arranged for both summer and winter with all the resources of architecture, and also has gardens by running streams. In the spring I go for a while to my place in the most beautiful part of the Euganean Hills, where I have fountains and gardens and a comfortable dwelling; and there I amuse myself with some easy and pleasant hunting such as is suitable to my age. (Cornaro, 1935, p. 47)

If land holding was an investment it brought with it aristocratic attitudes and a disdain for work, particularly for the work of the *contadini* whose land was being expropriated by patrician landowners by means of debt leasing. For all the discussion of good husbandry

there is little evidence of agricultural improvement in terms of new techniques of farming: rotations, seed improvement, breeding and so on (Sartori, 1981). Increased revenue came from more intensive exploitation of the peasantry through tighter lease terms and the introduction of cheaper peasant foodstuffs like maize while wheat and rice were grown for the urban market. The ideology of 'holy agriculture' stressed the pleasures of *villagiatura* rather than the responsibilities of the landowner to the land and its workers.

Villagiatura was a tradition of long standing in Venice, particularly on the less densely populated islands of the lagoon. The Barbari map shows extensive *delizie*, villas and gardens, on the Giudecca south of the city. These were places of summer retreat where patricians discoursed with humanist scholars and artists whom they patronised. In this setting during the last decades of the fifteenth century a strongly aristocratic and courtly culture was developed. It became the model for villa lifestyle among wealthy patricians along the Brenta and on the *terraferma*. Pietro Bembo, for example, described his island villa in 1476 as a natural theatre with a variety of decoration and green ornamentation. From the portico and loggia of the house led an axial pathway banked by hedges and flanked by ordered plantings of vineyards and fruit trees leading on to a wilder grove in which was hidden a pavilion of bushes. The intention was to allow boundaries to fade one into the other and suggest the unobserved passage from culture into nature. The villa garden in the Veneto, unlike the formal parterres and geometry of its Florentine equivalent, emphasised informal transition but still, in Lionello Puppi's (1972, p. 87) words 'tended to disassociate the logic of daily life, worldly involvement, and the passions – whose terrain was the city – from the serenity of meditation and of the pure, elevated intellectual processes, which required a refuge set apart, seen inevitably in a happy, tranquil state of nature'.

The favoured medium of this villa culture was *poesia*. Lyrical poetry, often accompanied by music and drawing inspiration from Petrarch, Virgil and Plato, became a fashion among a group of young patricians led by Pietro Bembo. Bembo had close links with the Florentine Academy and its Neoplatonic philosophy – erudite, idealist and heavily symbolic. Along with others of his class, including Aldo Maurizio, founder of the Aldine Press, he set up the Neakademia in 1500 to study Greek texts. The language of his poetry, however, was a refined Tuscan modelled upon Petrarch and Boccaccio whom he

regarded as having developed a pure Italian suitable for the elevated uses of lyrical poetry. The setting of his compositions was the villa garden, a place of ease and contentment where a friendly and subdued nature provided for human needs with a minimum of pastoral intervention. The poems of *Gli Asolani* (1505) are set in the palace garden at Asolo, a small town in the Alpine foothills above Treviso and the court of the exiled queen of Cyprus, Caterina Cornaro. Here the pretence of refined manners and courtly lifestyle was assiduously pursued. The poems present a dialogue on ideal love in which the poet celebrates his lady and through total self-abnegation in the service of her purity and beauty manifests a divine form of love infusing all things and placing humans in harmony with the celestial order. Language, gesture and movement are all highly stylised, sustaining a social utopia which is deemed the fitting place for the truly noble spirit.

Such a state is accessibly only to those willing (and able) to devote their whole lives to its service. Divine and all-encompassing love was contrasted to vulgar love, the sensual, particular and irrational love of beasts and ordinary mortals, a contrast made explicit in Titian's *Sacred and Profane Love* where two Venuses sit against contrasting landscapes, one clothed, the other naked. The social implications are fairly obvious and some writers even went so far as to define tight gradations of love, each appropriate to a particular class of humans. Perfect love was attainable only by the very highest social groups. It is not surprising that Bembo was later to associate himself with the court at Urbino where Castiglione in 1528 produced the definitive handbook of refined, aristocratic manners and total subjugation on the part of the courtier to the wishes of the Prince. The high ideals of Platonism and Petrarchian literature hide an acute class consciousness and an association with power and authority as strong as Alberti's earlier humanism.

In Bembo's courtly, Neoplatonic humanism less emphasis was placed on the rational, proportioned and mathematical basis of universal harmony than earlier humanism with its strong civic and bourgeois spirit. The celestial harmony which pure love encountered was more felt or experienced by the individual, putting him at one with nature and other beings such as himself.

As in all utopias, that created in *Gli Asolani* is environmental as much as social. Nature is infused with love, the harmonious music of the spheres floats through the pergola and is heard across the green pastures and among the woodland glades. The setting is captured

perfectly in Sanazzaro's *Arcadia* published in Venice in 1502. It recalls a Virgilian world of pastoral ease, of youth and of timeless, verdant meadows bathed in golden sunlight, the symbol of love. Sanazzaro is acutely aware of the significance of landscape elements in creating the proper setting for Arcadian life:

> who doubts that a fountain which issues naturally out of the living rock surrounded by green plants is more pleasing to the human mind than all the other fountains, works of art made from the whitest marble and resplendent with much gold? (Quoted in Burke, 1974a, p. 156)

Beauty in all things is less a function of rules and geometry as the Florentines had claimed, than of *grazia*, the gracefulness and elegance that come with divine perfection. As a utopia, the image of arcadia denies real history and masks the true social relations upon which it is founded, it deals in a spurious nostalgia for a lost golden age. In the extraordinary literary and architectural fantasy called the *Hypnerotomachia Polifili* published by the Aldine Press in 1499 the lovers' dream is located among classical ruins and its author Colonna 'describes their decay with real feeling, and he makes them an excuse for reflections on the frailty of human life and love, and on the destructive passage of time' (Blunt, 1973, p. 42). This was the imaginative world occupied by a section of the Venetian ruling class and promoted by them as a more refined and morally-superior lifestyle than merchant commerce. But to sustain its illusory structure the realities of social and economic relations in the Venetian countryside were necessarily denied. In the reports of Venetian *rettori*, administrators of the *terraferma*, such realities are, by contrast, abundantly clear. A rural peasantry was deprived of its traditional communal rights, its control over land compromised by debt to patrician landlords, and its housing, health and diet progressively damaged (Tagliaferri, 1981).

Bembo's imaginary world was represented visually in the paintings of Venetian artists: Giovanni Bellini, Giorgione, Titian and Paolo Veronese. They were the first to capture the mood of literary arcadia in paint, and their work is the source of a central tradition of European landscape painting stretching through Claude Lorrain to English eighteenth-century and American nineteenth-century ways of perceiving and painting landscape. It is they who gave Venice a particular significance within the Italian tradition, partly through

technical developments in blending colours and using light and shade to unite surface and depth and harmonise a sense of atmosphere. However, to claim, as Clark (1956, p. 37) does, that 'there was no reason why the Venetians should have excelled in landscape, had it not been that Bellini was by nature one of the greatest landscape painters of all time' is to ignore the literary and philosophical, let alone the economic and social, milieu within which his skill was applied. While Bellini is perhaps best known for his religious subjects, particularly the madonnas sitting radiantly in landscapes flooded with glowing light and made specific by details of plants, animals, birds and topography painted with exquisite care, their piety seems informed as much by ideas of Neoplatonic love as by traditional religious sentiment. Bellini's allegorical paintings reveal his enthusiasm for Neoplatonism and one of his works is an erotic nude portrait of one of Bembo's intimates pictured against a verdant landscape of the *terraferma*. For the Duke of Ferrara he completed in 1514 a *Bacchanal*, later altered by Titian, complete with satyrs, Pan's pipes and wine-drowsy young patricians making rather less than the purest of amorous advances towards the semi-clad hostesses of the feast (Plate 3).

Bellini pioneered techniques for representing rural *terraferma* scenes which escaped the conventions of high vantage points and linear organisation of the picture space imposed by Florentine perspective. A view at ground level allows large areas of sky to provide a source of intense light bathing the picture. Human figures are painted full-face or in sharp profile, at rest and adding to the serenity of the landscape. The landscape is constructed in a series of low undulations and rounded hill forms differently highlighted or in shadow. In the background runs the line of the Alps. The varying tones give both strong recession from the picture plane and in their horizontality across the picture emphasise the mood of calm unity between human feeling and the world of nature. Space at rest and the intensity of light are the technical means for rendering beauty and holiness which is the pictorial equivalent of *grazia*: a beauty not susceptible to written rules but emerging from the celestial love which infuses all things. Captivated by the success of these devices, Turner (1963, p. 60) can claim that in Bellini's pictures 'a miracle transpires in the setting of daily life, so much a part of the landscape that it might almost pass unnoticed'. In fact this is far from the landscape of daily life but an imaginative harmony in which no vulgar

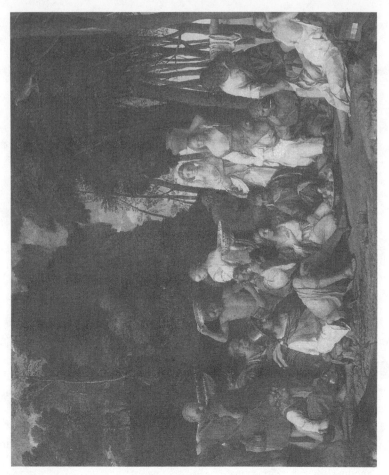

Plate 3. Giovanni Bellini: *The Feast of the Gods* (Widener Collection, © 1997 Board of Trustees, National Gallery of Art, Washington)

mezzadri or *livelli* struggle to meet their rents nor where arduous work upsets the balanced calm of man and nature. An occasional shepherd or cowherd may pass in the distance, blending unobtrusively into the golden luminosity, but the life-force of Bellini's humanised world is imagined divine love, satisfying the ideals of a nobility enjoying their rural estates as relaxation and as removed from the brute facts of productive agrarian life as they are from the bourgeois world of the city.

Giorgione, Bellini's pupil, was even more directly associated with the literary world of Bembo and the court at Asolo. His paintings achieve a subtler integration of human mood with nature. Both figures and landscape share a dream-like quality suggesting a true realisation of divine love. The well-known *Tempesta* shows a woman suckling her child and an elegantly attired shepherd or soldier looking past her. Behind and between them is a complex landscape framed by trees and in the eerie illumination of a lightning flash revealing the outlines of a *terraferma* town beyond a wooden bridge. Classical ruins complete the enigmatic scene. The haunting mood of this painting and the fact that its subject is unknown had made it one of the mysteries of Venetian landscape. But X-rays have revealed that originally in place of the soldier was a water-nymph bathing naked in the stream. Given that the nursing woman is hardly attired as a convincing gypsy this evidence supports the thesis that the scene is taken from the classical story of the infancy of Paris, suckled by a shepherd's wife, a fitting subject for a pastoral painting (Wilde, 1981). But more than the classical narrative the significance of the painting is in its evocation of a mood of total correspondence between human feeling and the forms and actions of the natural world, a pictorial *poesia*. The same is true of Giorgione's *Three Philosophers* and *The Adoration of the Magi* where a richly organic background is as much a part of the subject as the sacred event. One of the philosophers is engaged in studying signs of Christ's coming in the natural world, staring dreamily at a fig tree. The *Sleeping Venus*, in which the landscape was completed by Titian, is pure *poesia*: an image of classical divine beauty lying unobserved except by the spectator in a landscape which is carefully tended but where not the least evidence of human labour intrudes, except perhaps for the elegiac symbol of the felled tree already sprouting new life. Uniting the moods of characters and the landscape, Giorgione and Titian appealed directly to the sentiment of young patricians many of whom were already committed to the life of the rentier rather than the

merchant and some of whom later were to patronise Andrea Palladio, the architect who succeeded more than any other in realising the Venetian ideal of landscape in the reality of his designs for villas on the *terraferma*.

One sixteenth-century painter of the Venetian school stands separate from these conventions. Jacopo Bassano has been called by Bernard Berenson (1956, p. 32) 'the first Italian to paint the country as it is', without grand, effective lines or Vergilian references. Bassano's subjects are country people set in the countryside around his small town in the foothills north of Treviso. The theme is often religious and the human participants do have a sentimental appeal. The young shepherd, for example, in his *Annunciation to the Shepherds* (Plate 4) anticipates the picturesque urchins of Caravaggio's Seville. But the landscape, lacking the formal structure of Bellini's or Titian's, lacks also their luminosity. It has a dark, brooding mood and a mannerist sense of disturbing movement, highlighted by the appearance of individuals unconnected to the main narrative, sullen or impassive. In his *Rustic Scene* a sower passes behind the bright group of milkmaids, his sharp, dark features blended with the shadowy landscape. In *Christ at Emmaus*, set in an inn, the landlord, to one side, observes with apparent disinterest Christ and his disciples, more concerned about payment of the bill or clearing the table for the next customers, than he is with the sacred event. The slightly subversive aspects of Bassano's landscapes is unusual – that he was a commercial painter for the Venetian market rather than for aristocratic patrons may explain their genre style. Certainly he stands with painters like Moreland, Courbet and Van Gogh as an unusually truthful and challenging observer of the conditions of rural life.

The Palladian Landscape

These rural conditions were increasingly being determined in the sixteenth-century *terraferma* from villas which served both as functional estate centres and locations for the pursuit of *poesia*. *Poesia* and the intellectual abstractions of perspective or ideal city theory were not mutually exclusive aspects of sixteenth-century Venetian humanism. They were reconciled in the villa designs of Andrea Palladio. Palladio was closely associated with a number of aristocratic Venetians holding large landed estates, among them Cornaro and Barbaro who promoted ideal city ideas in Venice. As official architect

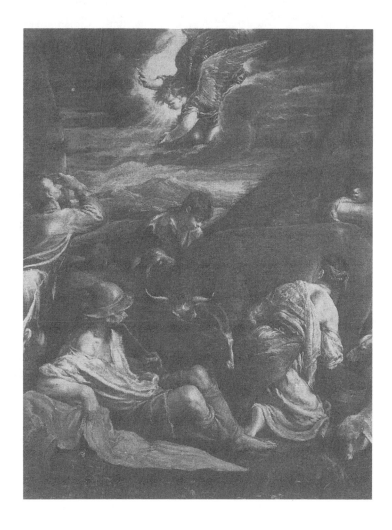

Plate 4. Jacopo Bassano: *The Annunciation to the Shepherds* (Samuel H. Kress Collection, © 1997 Board of Trustees, National Gallery of Art, Washington)

of Venice after Sansovino, he contributed to the urban scene a number of significant elements. The churches of San Giorgio Maggiore and Il Redentore are his major additions to the townscape. Both were planned to be seen at a distance, across stretches of open water and both are landmarks of considerable and imperial grandeur rising over the horizon. Their façades, oriented towards the heart of the city, and their flamboyant columnation make them essentially theatre pieces – highly scenographic eyecatchers resembling Roman triumphal monuments rather than places of humble Christian worship and thanksgiving. In this they remind us of Venice's proclaimed relationship with ancient Rome, a theme celebrated by Palladio in the triumphal arch designed for the ceremonial reception of Henry II of France on the *lido*. Palladio had studied the ruins of Rome at first hand and produced the illustrations for Barbaro's translation of Vitruvius. Rudolf Wittkower (1962) has demonstrated Palladio's use of complex harmonic proportions in the design of the Venetian churches, and certainly Palladio was no stranger to humanist cosmological theories and ideal city schemes. Indeed he had made his early reputation in urban rather than rural architecture so that his contribution to the city as landscape is the obvious point of departure because it informed much of what he later achieved in the design of the villa and its relationship with the rural landscape.

Palladio was 'discovered' by Giangiorgio Trissino, his early humanist patron and mentor when working as a mason on the latter's villa at Cricoli near the *terraferma* city of Vicenza. Trissino was a leading member of the small group of noble families who dominated the social and political life of Vicenza (Ackerman, 1966). He had attended the meetings of the Florentine Academy in the early 1500s and along with Pietro Bembo was one of those concerned with refining a purified Italian language. This was part of a broader ideological programme which redefined the Vicentine nobility as an aristocracy committed to humanist ideals and proclaiming the *virtù* of its members as a function of their *nobilità*. In the middle years of the sixteenth century, through his academy at Cricoli, Trissino trained the youthful nobility of Vicenza, attaching to the group the low-born Palladio. The curriculum consisted of classical studies, Italian language, Neoplatonic philosophy, mathematics, music, geography, history and physical fitness. It was a comprehensive humanist programme for a provincial ruling class. The aristocratic consciousness it imbued is evident in the later actions of his pupils. In 1567 as members of the city's Noble Council, modelled on Venice's, they

closed its rank to any additional entrants, a process paralleled in other *terraferma* cities (Ventura, 1964). Henceforth membership was to be hereditary and inalienable. Citizenship and thus franchise would be available only to those whose family had been resident in Vicenza for at least 100 years and which had for at least two generations back had no connections with the mechanical arts. This elite held exclusive political control over the internal affairs of Vicenza. Its members drew their wealth largely from lands in its *contado* from which they successfully excluded Venetian penetration. Within the group an inner elite dominated key committees. A total of 71 families controlled 73 per cent of the votes in Council and a mere 36 could command a majority (52 per cent). These are the families whose names appear across a map of the Vicentino as the largest and often oldest landowners, among them the Barbarani, Thiene, da Porto, Chiericati, Valmarana and Trissino.

While under the political sovereignty of Venice, Vicenza's ruling families acquiesced uneasily to their provincial status. One of Trissino's ancestors had led a faction of the nobility to align the city with the Imperial forces during the Cambrai wars and many continued to resent Venetian dominion. There is a record of appeals by rural communities for direct rule from Venice as opposed to the fiscally rapacious authority of Vicenza and despite repeated attempts by the metropolis to build permanent defences around the subject city the local nobility succeeded in defeating them all by simply refusing to vote the necessary financial contribution (Hale, 1968). The desire for independent aristocratic control perhaps explains the enthusiastic reception by the nobility of a locally-trained architect to design both civic buildings and private palaces in their city and the imperial style adopted for them.

In 1548 the Council, led by Trissino's former students, voted to accept the plan offered by the still inexperienced architect, Palladio, for rebuilding along classical lines the loggias of their council building in the heart of Vicenza. His proposal was approved in the face of competition from some of the leading north Italian architects of the day, among them Serlio, Giulio Romano and Sanmichele. Palladio's design for the building, which he renamed the Basilica, is a perfect example of urban architecture as theatre (Plate 5). It turned what was an isolated building located on an open piazza into the controlling element of a series of visually co-ordinated spaces. The design consists of two uninterrupted sets of arches, one over the other, each

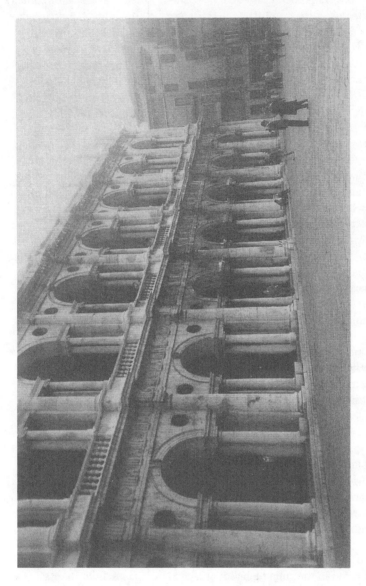

Plate 5. Andrea Palladio: Loggia of the Palazzo della Ragione (the Basilica), Vicenza

stressed by massive half-columns. These hide the heavy piers which provide the structural support for the loggias and, together with the double columns supporting each arch, translate an enormous mass into light, decorative architecture. The original building around which they are constructed was of an irregular shape but the irregularity is obscured in the measured spaces and proportioned rhythm of arches, frieze and cornice. The result is a masterpiece of architectural chiaroscuro, the columns and half-columns emphasising the shade of recesses and the reflective light of white stone. Palladio's design is a monumental interpretation of Roman architecture, an aggressive declaration of both artistic and cultural independence of Vicenza from Venice.

The impact of the loggias on the morphology of central Vicenza is also striking. The surrounding spaces are separated into three distinct piazze linked by the continuity of the loggia design which provides one side to each. The work makes for visual enclosures between each of the piazze and controls their internal dimensions through its commanding classical presence. The largest of them, the Piazza dei Signori north of the Basilica, took on the appearance of the forum in an ideal city. Its dimensions correspond to those proposed for the width and height of such squares by urban theorists and it was surrounded by buildings appropriate to such a location: the council chamber, palaces of the podesta and military captain, the parish church and prison. Later Palladio designed a second set of arched loggias along the opposite side of the square which, if completed, would have further emphasised the correspondence of central Vicenza to the classical piazza he describes in his *Four Books of Architecture*:

> Those ample spaces are left in cities . . . that there the people assemble to walk, to discourse and bargain in; they afford also great ornament, when at the head of a street, a beautiful and spacious place is found, from which the prospect of some beautiful fabrick is seen. (Palladio, 1738, p. 72)

Those who gathered in the Piazza dei Signori, however, unless they belonged to the ruling oligarchy responsible for its construction, must have felt, as we still feel there today, overwhelmed by its display of power and authority. Palladio undoubtedly achieved both a technical triumph and a radically new interpretation of classicism. But he also succeeded in articulating patrician self-sufficiency and arrogant

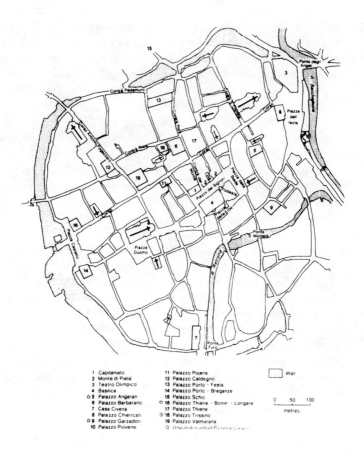

1	Capitaniato	
2	Monte di Pietà	
3	Teatro Olimpico	
4	Basilica	
☆ 5	Palazzo Angaran	
6	Palazzo Barbarano	
7	Casa Civena	
8	Palazzo Chiericati	
☆ 9	Palazzo Garzadori	
10	Palazzo Piovene	
11	Palazzo Pojana	
12	Palazzo Caldegno	
13	Palazzo Porto - Festa	
14	Palazzo Porto - Breganze	
15	Palazzo Schio	
☆ 16	Palazzo Thiene - Bonin - Longare	
17	Palazzo Thiene	
☆ 18	Palazzo Trissino	
19	Palazzo Valmarana	

☆ Disputed or unbuilt Palladian structure

Wall

0 50 100
metres

Figure 4.3: Street Plan of sixteenth-century Vicenza, showing the location of buildings designed by Andrea Palladio

power, challenging even Venice where the style of the Doge's palace remained unreconstructed Gothic.

A similarly domineering architecture was employed in the building programme of private palaces for the families of Vicentine patricians between 1550 and 1580. These palaces line the narrow streets of the city centre. They are intended to catch the eye and inform minds attuned to humanist symbols of spatial order, classical iconography and architectural proportion:

> In this panorama, where individual interventions achieved a uniquely uniform result, emerges the figure of the patron-employer, and thus also of the architect [Palladio] who interpreted the vision of the period, visualizing in their palaces and villas a proportion which renders them fitting for an idealized world of gentlemen of grand lineage, citizens of exceptional moral stature, and perhaps figures of great physical dignity. (Zorzi, 1964, p. 14)

This is precisely the image the palaces of sixteenth-century Vicenza are intended to convey. It sits uneasily, however, with the historical record of their owners: a brawling, bored and resentful, but extremely wealthy set of young aristocrats. With 300 murders reported in Vicenza during a 20-month period in 1619 and many individual accounts of patrician family vendettas, Vicenza bids fair to be seen as the Houston of the sixteenth-century *terraferma*. The palaces declare in symbolic language the legitimacy of this group's control over urban life and urban space. Wittkower (1962) has detailed also for these dozen or more palace designs Palladio's use in both plans and elevations of precise geometrical ratios which relate to harmonic scales. The erudite language of this 'frozen music' would be intelligible to the man of *virtù*, trained in the humanism of Cricoli. To others, not so privileged, the coats of arms, heraldic devices, military symbols and soaring columns spoke a cruder language of exclusion from power and authority in the city.

The palaces are grouped along the two axial streets of Vicenza, corresponding to the *decumanus* and *cardo maximus* of the original Roman plan. In this arrangement they also suggest a realisation of ideal city theory. Two of the most imposing palaces command the entrances to Vicenza at the eastern and western ends of the *decumanus*. Their internal dimensions and regular organisation around open courtyards make them urban conceptions in their own right. The Palazzo Thiene, for example, was planned to cover 3,800

sq. metres, the Palazzo Porto-Festa, 2,100. In describing them Palladio echoed Alberti, claiming that 'the city is as it were but a great house, and, on the contrary, a house is a little city'. Within these little cities the head of the family exercised an authority over the household similar to that which with his peers he held over the city.

The view of the ideal city as landscape realised by Palladio and his patrons in Vicenza is strikingly evident in the design for a permanent stage set for the Olympic Theatre. It was built for the dramatic productions of the exclusive humanist academy founded by Vicentine patricians to promote the ideals and values learned at Cricoli: 'all the sciences, and especially mathematics, which is the true grace of all appearances and of the noble and virtuous soul'. The stage set is composed of streets leading away from the spectator and narrowing in exaggerated perspective. The architecture is an imaginative and flamboyant recreation of a Roman city, heavily columnated and rich in statuary. It is not difficult to see that the distance between the exalted tragedies performed in this theatre and the self-image held by Academy members was small. Here again perspective, theatre and townscape unite visual with ideological and actual aristocratic control.

Unlike Venice, Vicenza possessed no opposing group within the patriciate to challenge the aristocratic ideology of humanist classicism. Having decisively closed off access to power from newly-rich families – those, for example, making fortunes in the booming silk trade—the field was clear for complete cultural hegemony. Denied by their provincial status the possibility of anything more than local expressions of their noble status, for example in the traditional fields of military action or great office, the Vicentine ruling class must have found in such expressive architecture an appealing substitute, particularly as it was so creatively articulated by a local architect. More practically the wealth generated on landed estates at a time of rapidly rising food prices and inflation found a secure haven in urban land and building, although the limited number of these grand architectural conceptions which was actually completed according to design suggests that they were over-ambitious, that resources ran out or that following generations were unwilling to complete their fathers' work.

In some respects the building programme in Vicenza was conservative in its appeal to a formal intellectual humanism and a mathematical perspective view of space rather than the more

informal, Neoplatonic ideas already well-established in painting and literature. In part this may be explained by Vicenza's provincialism. Certainly Trissino was treading well-worn ground in his pattern of humanist education, or rather he was providing an aristocratic gloss to received wisdom. In part, too, the city as landscape is more easily regulated according to fixed geometrical rules than the villa built in rural topography and intended for relaxation and enjoyment of beauty in *grazia* rather than in *proportionalità*. Again, the individual interests of Palladio cannot be ignored: his direct return to Roman sources and his practical rather than philosophical bent. Unlike Cornaro or Bembo or even his friend Daniele Barbaro he had to produce workable designs to sustain his livelihood. But beyond all this it is worth remembering that in appealing to Roman authority Vicenza was challenging Venice on its own symbolic grounds and, within the terms of renaissance thought, the purer the classicism the greater the status of the person employing it. Palladio's work at Vicenza could be read as an element in the struggle for autonomy from Venice, played out at a cultural level when any more direct challenge was impractical.

Palladian Villas

The wealth invested in the urban palaces of Vicenza was generated on agricultural estates in the surrounding *contado* and like their Venetian counterparts the Vicentine nobility spent a part of the year living in villas on these estates, engaged both in supervising their management and enjoying the relaxed life of the *villagiatura*. They employed the same architect to design these rural retreats as they did for their urban palaces, and the Palladian villas of the *terraferma* have been regarded by later observers as supreme achievements of the Venetian sixteenth-century landscape vision:

> here for the first time in Western Architecture landscape and building were conceived as belonging to each other. Here for the first time the chief axes of the house are continued into nature, or, alternatively, the spectator standing outside sees the house spread out like a picture closing his vista. (Pevsner, 1957, pp. 161-2)

Integrating architecture and landscape was a conscious element in Palladio's designs, as his descriptions of the villas in the *Four Books of*

Architecture reveal. It reflected also a functional integration of the house and the surrounding rural area, for the Palladian villas were built not only as belvederes for pleasure and relaxation, they also acted as management centres for active agricultural enterprise. The Godi family, for example, one of the most powerful of the Vicentine oligarchy with a large, centrally-located urban palace, had estates in three areas of the Vicentine which they had been enlarging and consolidating throughout the sixteenth century. Palladio designed a villa for them at Lugo in the Alpine foothills north of the city (Plate 6). Here in 1541 they recorded for tax purposes some 178 *campi* of land and a large number of *livelli*, debts owed to them by peasants on security of their one or two *campi* of land (Cosgrove, 1982b). The Godi were active in buying, selling and exchanging land in order to build large, consolidated land parcels which could then be irrigated and improved, perhaps for rice cultivation.

In their 1541 tax return the Godi described their villa at Lugo as 'an estate house with 14 *campi* of orchard next to the communal road, bordered on two sides by the valley of Lonedo. Valued at 1600 ducats . . . the fields valued at 22 ducats per *campo*'. This gives little indication, other than in the very high valuation, of the nature of the building. Palladio himself does it more justice in his description:

> At Lonedo, a place in the Vicentine, is the following fabrick, belonging to Signor Girolomo de Godi. It is placed upon a hill that has a beautiful prospect, and near a river that serves for a fish pond. To make this place commodious for the use of a villa, courts have been made and roads upon vaults, at no small expense. The fabrick in the middle is for the habitation of the master, and of the family. The master's rooms have their floor thirteen feet higher from the ground, and are with ceilings; over these are the granaries, and in the part underneath . . . are disposed cellars, the places to make wines, the kitchens and such other like places. . . (Palladio, 1738, p. 52)

Dating from 1542, the Godi villa is the earliest of Palladio's villa designs but it contains the germs of the elements common to all that followed. The Palladian villa plan is composed of a central residential block, flanked by colonnaded wings behind and in which are collected the spaces necessary to running an agricultural enterprise. The colonnades provide a unified façade, often curving as if to embrace the countryside in which they are set. The living areas are

Plate 6. Andrea Palladio: Villa Godi, Lonedo di Lugo, Vicenza

on the first floor *piano nobile* with a commanding view, framed by the loggias on either side. In the Godi villa as in many others gardens are laid out immediately in front of the villa and avenues of trees or statuary lead the eye out of the cultivated precinct of the garden into the fields, mediating the productive and pleasure spaces. This is the architectural equivalent of *poesia*, seen perhaps to its best advantage in the villa designed for Daniele Barbaro at Maser where the illusion of visual control complementing practical control of the landscape is reinforced by Paul Veronese's *trompe-l'oeil* arcadian scenes painted on the internal walls of the villa. In Puppi's (1972, pp. 107-8) words the intention of the villa designs

> was to control personally the progress and production of these estates, but at the same time, in the organization of their own residences with their greatly increased scale of services, they clearly accentuated by means of a deep *visual* gulf their privileged distinction. In other words the organization of the country habitat tended to give plastic and figural form to a rigorous separation of classes, juxtaposing and glorifying the *noble* dignity of the aristocratic condition ... over the *mechanical* unworthiness of the subordinate working classes.

The *urban* conception of the villas reinforces this ideological role. Palladio made consistent use of the same system of harmonic proportions in the design of façades and internal dimensions as he had in the Vicentine palaces and Venetian churches. The same intellectual humanist authority is imposed on the countryside as on the city. In the *Villa Rotonda*, the least functional of all the villas, and the most admired and copied by later 'Palladians', geometrical proportion as a principle of construction is unmistakable. The building combines the two elemental geometrical forms: the circle and cube. Of them Palladio claims: 'the most beautiful, and the most regular forms, and from which the others receive their measure, are the round and the quadrangular' (Palladio, 1738, p. 81). The Rotonda has four perfectly symmetrical sides, each fronted by a peristyle and is topped by a dome (a pure half-sphere in Palladio's drawing). The symbolic function of the dome is clear:

> it being enclosed by one termination only, in which is to be found neither beginning nor end, nor are they to be distinguished one from the other, but having its own parts similar one to another,

and all participating in the figure of the whole; in a word the extream being found in all its parts, equally distant from the middle, it is exceeding proper to demonstrate the infinite essence, the uniformity, and the justice of God. (Palladio, 1738, p. 82)

The Rotonda would thus appear to be a purely formal demonstration of beauty as rule-bound, abstract geometry, far removed from *poesia*. In fact in describing his design Palladio provides a rare written acknowledgement of conscious attention to landscape as an informal, irregular and changeable source of visual delight – of the sensibility that Bellini or Giorgione had captured in paint:

The site is as pleasant and delightful as can be found; because it is upon a small hill, of very easy access, and is watered on one side by the Bacchiglione [river] . . . and on the other it is encompassed by the most pleasant risings, which look like a very great theatre, and are all cultivated, and abound with the most excellent fruits, and most exquisite vines: and therefore, as it enjoys from every part most beautiful views, some of which are limited, some more extended, and others that terminate with the horizon; there are loggias in all the four fronts. (Palladio, 1738, p. 41).

The Palladian landscape reaches its apogee in the Villa Emo at Fanzolo, designed for a Venetian patrician, Leonardo Emo. Emo's family was heavily engaged in land reclamation, irrigation work and the introduction of new crops like maize which provided a cheap peasant staple. The villa that Palladio designed for him in the early 1560s stands in an enormous 80 acre garden. Its central residential pavilion is flanked by arcades of eleven arches on each side and approached via a wide, paved ramp and flight of steps. Internal decoration by Giovan Battista Zelotti is extravagant and the landscape view from the raised main entrance is guided out into the rich fields by lines of planting which also effectively hide from view the barracks of estate workers beyond the garden.

The Palladian landscape succeeds in uniting the two cultural streams out of which Venetian aristocratic ideology constructed its view of human life and landscape: rational humanism and aristocratic, pastoral *poesia*. Perspective and the concepts and techniques associated with it are inherent in the architectonic organisation of the villa and the determination of particular angles of vision within and beyond it. The notion of a harmonious, almost

mystical, interaction between the refined human soul and a nature drenched in the golden light of celestial love is articulated in the pure shapes of architectural space, in pastoral wall decoration and in the views from windows and loggias of a richly productive but carefully selective agrarian countryside.

Rational, mathematical ordering of space in perspective was individualist, urban and potentially democratic in that all humans are in principle capable of reason. It emerged from the experience of professional men in the relatively advanced merchant capitalist cities of communal upper Italy. The humanists who first articulated it were developing a culture quite different from that upon which a landed feudal ruling class elsewhere in Europe based its legitimacy: universal Christianity, family lineage and titles, warfare and chivalry. Humanist appeal to classical authority gave their ideas a universality supposedly outside their time and specific class interests. But as Italian capitalism faltered, as cities became the domains of petty tyrants, as foreign armies shattered the confidence of Italian oligarchies and as capital found the most secure investment in land and property, so humanism was appropriated for different ends. The poetically-inclined, Neo-platonic ideas of universal harmony were conservative: rural in bias, nostalgic, erudite and self-consciously aristocratic. They orginated in patrician villa gardens and the courts of urban princes. There is an intellectual continuity from the earlier, more bourgeois humanism and it would be wrong to insist too forcefully on the distinction between the two. Better to see them in terms of Burke's system of 'biases'. However, the emphasis became over time more attached to nobility, lineage and refined sensibility. It was revealed in townscape as an increasingly rigid codification of ideal city theory such as we observe in the work of Sanmichele or Scamozzi. In the country it parades as the love of landscape as the setting for a refined and other-worldly arcadian life. Seeing the world as landscape and developing landscape as a metaphor for human relationships with fellow men and with nature was part of a more inclusive ideology. But whether in the example of Venice, clinging in part to its mercantile and republican traditions, or in that of Vicenza, by contrast very much relapsed into the social relations of a second feudalism, the idea of landscape in renaissance Italy can best be understood in its alignment with the shifts and inflections of power and control in society. Whether objective or idealist in bias, urban or rural in realisation, the landscape idea remained above all an appropriation of the visual scene by sense and intellect rather than an active

engagement with it in the processes of organic and productive human life.

5

Seasons and Eclogues: Foundations of English and American Landscape

Intellectual humanism and the renaissance reverence for Antiquity, together with the increasingly aristocratic character of Italian ruling-class culture, ensured that the landscape idea was given a strongly theoretical and classical foundation and reference. From Horace and Virgil came ideas of a Golden Age of harmony between a leisured human life and a willingly productive nature, of pastoral youth and innocence in a bucolic woodland glade, and of the smiling landscape of holy agriculture as an emblem of a morally and socially well-ordered estate. The practice of *Santa Agricoltura* was at once a practical response in the face of declining trade, failing entrepreneurial skill and foreign domination, and a moral imperative justified by reference to Greek and Roman literary models.

The other great core area of medieval European economy, Flanders, presents another picture in the sixteenth and seventeenth centuries. It is a region that would be markedly more successful in maintaining centrality within capitalist Europe than was Italy, and the representation of landscape characteristically produced there was correspondingly different. Indeed in Flanders, and later in Holland, it is difficult to speak of the landscape 'idea', for we are not dealing with a coherent and integrated intellectual theory as we are with Italian renaissance cosmology, but rather with empirical representations of rural and urban life, realistically delineated and based upon careful, direct observation which remained for the most part resolutely non-theoretical, from the Gothic landscapes of the Limburg brothers at the turn of the fifteenth century to the rural panoramas of Van Ruysdael and Hobbema, or the townscapes of Berckheyde and Van Der Heyden in the seventeenth. However, there is one great iconographic source for northern landscape comparable

to the classical inspiration of the southern, that is the rendering of the seasons and their labours. I have already noted how certain, unalienated conditions of our lives on earth form consistent motifs for cultural production. The seasonal changes of nature, particularly marked in north-west Europe, each season having its typical and invariant agricultural tasks of ploughing, harrowing, sowing, mowing, harvesting and pruning, form an obvious structural reference in a culture dominated by the success or failure of food production on the land, an activity engaging the lives of nine out of every ten people whose conception of their world remained strongly animistic. That reference is to be found in folk-tales, in stone and wood carving in medieval churches, in stained glass, woodcuts and illustrated psalters. In the absence of a powerful revived classicism such as occurred in the South, this theme provided an iconographic thread of the Northern landscape tradition well into the last century (Rosenthal, 1982).

The landscape idea in England and America in the eighteenth and nineteenth centuries would draw upon both these continental traditions, incorporating them into an important field of cultural production and a complex ideology for increasingly capitalist societies. Before examining that process we need briefly to outline its immediate origins. This is the purpose of the present chapter: to highlight important sources for the eighteenth and nineteenth century Anglo-Saxon landscape idea, in the Low Countries and Italy during the seventeenth century.

Landscape in the Low Countries

In 1400 the region stretching inland from the North Sea coast between Dunkirk and Antwerp, south and east to include the cities of Bruges and Ghent, Roubaix and Leuven, rivalled upper Italy in the scale and significance of its trade and manufacture, particularly of textiles, the sophistication of its internal and external mercantile links, and in the richness of its cultural production. While its cities lacked the degree of formal autonomy from Imperial rule achieved by the Italian communes, the freedom Flemish towns and cities enjoyed from feudal restraints over the operation of markets and long-distance trade and the strength of their guild structures were both considerable. Indeed it was between Flanders and upper Italy that the greatest concentration of trade links and spatial interaction occurred

143

within medieval Europe. Inevitably the wealth and sophistication of these two urbanised regions rendered them vulnerable to the predations of neighbouring nation states and in the early modern period both suffered from the destructive visitations of competing armies from the centralised monarchies.

These large and wealthy Flemish cities with their significant burgher class displayed their riches and civic pride as much in secular as in religious buildings. Great Gothic cloth halls, guild halls and town halls rival cathedrals in the townscapes of Ghent and Bruges. Later in Amsterdam, Utrecht and Haarlem town halls and market squares were objects of enormous civic pride lavished with architectural care and love. It is not perhaps surprising that in the Low Countries protestantism with its emphasis on individual devotion and salvation by works found ready acceptance, just as Anabaptism and other Calvinist forms of radical protestantism were to dominate in a newly-independent United Provinces, although religious toleration reflected the practicality of a merchant nation. The same burgher class which ruled the cities patronised the arts: tapestry, stone and wood carving, and, from the fifteenth century, the new technique of oil painting and portraiture. Indeed it was in Flanders that oils were first employed, and it was partly their slow-drying qualities that allowed Flemish painters to achieve the painstaking detail that appears, for example, in the works of Jan Van Eyck and later, Pieter Bruegel, continuing a tradition which originated in manuscript illumination and Gothic tracery with its love of line rather than mass. Oil painting allowed for a degree of naturalism which satisfied the secular bourgeois desire for the representation of a recognisable and realistic world, a world in which the merchants of Antwerp or Amsterdam could recognise themselves and make visible and tangible their material success.

The countryside which lay beyond the walls of these Flemish cities, formally in feudal tenure under the lords of Berry, Brabant and Flanders, was in fact increasingly penetrated in the late medieval period by urban capital so that a new and more market-oriented agriculture was emerging, capitalist tenancies were being established in the decades following the Black Death and new techniques of farming were being invented (Huggett, 1975). Urban capital was essential to the financing of large-scale reclamation and drainage projects necessary for cultivating the marshy, floodable lands behind the sand dunes and around the great estuary of the Scheldt. On these reclaimed lands some of the earliest advances in modern farming

techniques were pioneered: floating water-meadows, rotation crops, seed drilling and improved grass cultivation, a process paralleled in Lombardy and mutually stimulated in both regions by their close trading links. Later, in seventeenth-century Holland the same process of urban trade capitalising improved agriculture was responsible for the monumental works of hydraulic engineering as great polders were drained and thousands of acres of rich agricultural land brought into being, creating in their pattern of dykes and windmills a rational landscape, like that of the Po valley and the lagoon lands near Venice where similar reclamation was undertaken.

Both town and country found their reflection in paintings from the fifteenth century onwards. In Flanders as in Italy this was initially as a subsidiary element to a dominantly religious theme. A favoured early technique was to give a view through a window to a different space from that of the main subject of the picture. Thus in Robert Campin's painting of the *Virgin and Child* we see through a casement a town scene reminiscent of the artist's own Bruges, its houses sharply delineated, with stepped gables and detailed fenestration, the streets occupied by townspeople engaged in the pursuits of everyday life – on packhorses, tiling roofs and so on. Beyond is a hilly countryside, patently not that of the environs of Bruges, but none the less finely detailed and carefully observed. Similar details appear in the background to Van Eyck or Gerard David's works. These townscapes and landscapes, painted at the same time as Brunelleschi, Piero della Francesca or Uccello were developing their perspective techniques and creating ideal townscapes, are strikingly different from Italian scenes. Rather than imposing a theoretical unified space across the picture surface and achieving depth by one-point perspective construction, these painters offer an empirical vignette, glimpsed through a hole in the wall, scenes which can be separated without violence from the main picture. In themselves they seem to accord closely with what we might actually have seen in contemporary Flemish towns and cities, although their precise detailing and disinterest in aerial perspective leaves the impression of a toytown world. To an extent they involve the spectator in an active world rather as Lorenzetti's frescos at Siena involve us, although the use of the window device achieves a separation and distance between viewer and viewed which is characteristic of the landscape idea. It is precisely the active, genre quality of Flemish townscape and landscape which separate them from the idealised versions of Italian renaissance space. Because of this naturalism and lack of theory the

Flemish and Dutch works were long regarded as inferior art to that of the Italians. Sir Joshua Reynolds remarked of Dutch paintings that

> their merit often consists in the truth of representation alone, whatever praise they deserve, whatever pleasure they give when under the eye, they make but a poor figure in description. It is to the eye only that the works of this school are addressed; it is not therefore to be wondered at, that what was intended solely for the gratification of one sense, succeeds but ill, when applied to another. (Quoted in Brown, 1972, p. 41)

Today, with our less mystified and academic taste for past art these works are more appealing.

The countryside, too, began to appear in the works of Flemish painters. As early as the late fourteenth century the Limbourg brothers had employed the theme of seasonal labours to celebrate the courtly and chivalric world that the Duc de Berry wished to project onto his estates. The extraordinary fine detailing of the works is evident from the success with which these miniatures can be reproduced as full-size posters. By using the same device of the window view Flemish painters during the following century intro-duced recognisable landscape into their paintings, picking out farmsteads and roads, fields and hedges, and employing the seasonal motifs to achieve the dual purpose of lending authenticity to the work and relating it to a familiar and conventional set of images. Over time the window opened out to a broader view and landscape in the works of late-fifteenth-century painters such as Hieronymous Bosch and Joachim Patinir combines symbolic and fantastic elements: twisted geological formation, lurid skies and sinister vegetation, into the quotidian world of agricultural labour. Both painters depicted St Jerome in a wilderness which overwhelms him and is composed on the one hand of painstakingly observed domestic elements such as farmhouses and animals, and on the other of disturbingly speculative forms which suggest a nature far beyond human control or order (Bazarov, 1981). The window may have opened out and the whole painting made a landscape, but the tension between involvement in a familiar and realistic world, captured empirically and the distance faced by the fantasy of geology, atmosphere and vegetation comments more on supernatural than natural worlds.

To stress the empiricism and lack of classical and theoretical reference in Flemish landscape is not, however, to ignore the

significance to it of scientific and intellectual advances during the sixteenth century. Just as there is a close association between the Florentine discovery of the Ptolemaic grid co-ordinates and Brunelleschian perspective which was worked out on the chequerboard of the ideal city, so in the following century in Flanders we can observe an immediate connection between map-making and landscape art, as well as a broader cosmological resonance in the great panoramas by Bruegel (Rees, 1980).

In 1533 Jemme de Fries of Leuven published the first thesis to show how the mathematics of triangulation could be used for the survey of topography and the construction of maps. He was part of a tradition of map-making in sixteenth-century Flanders stretching from Jacob Van Deventer to Gerardus Mercator and Abraham Ortelius, a tradition which would eventually push the science of cartography beyond the empirical techniques of the bird's eye view, the picture map and the itinerary map, and found a new science of survey and mathematical exactness, ultimately breaking the link between cartography and painting (Harvey, 1980). By the seventeenth century Amsterdam would have overtaken Venice as the centre of European cartography. The demand for such work was generated not only from navigators but equally from owners of property needing precise measurements of their land which could be recorded in an indisputable form if it were to be bought and sold, a very different requirement from those of a holder of feudal land not having recourse to a land market. Among the greatest of the sixteenth-century Flemish map-makers was Ortelius whose world atlas was published in 1570. Among his closest friends he numbered Pieter Bruegel the Elder, a painter whose landscapes unite the traditional motifs and techniques of Flemish painting with the conceptual perspectives made possible by the Copernican world view and the new cartography.

Pieter Bruegel, born in Breda in 1525 and later resident in Brussels, was in many ways a traditional painter, almost medieval in his fascination with the crowded scene, the grotesque, the incidental, and in his refusal to adopt classical and idealised structures, despite extensive travel in Italy. His work, particularly his landscapes, were widely popular as prints and engravings, bought by merchants, skilled craftsmen and wealthy farmers. Their secular iconoclasm certainly did not make them suitable for churches. The most characteristic landscapes are vast panoramas with grand horizons,

teeming with the details of daily life. In landscapes like *The Fall of Icarus* or *The Magpie on the Gallows:*

> all the riches of the world are spread out ... the artist's gaze masters the whole, sees the homogeneity and independence of all the forms. It catches the totality of the world, opens our insight into the structure of the cosmic system itself, as it would not be recognisable from below, and makes it possible for the beholder to relive the creative joy of the architect of the world. (Rees, 1980, p. 77)

Rees argues that Bruegel offers us in art what Mercator and Ortelius were designing, for the first time since Ptolemy, in their world maps: the realisation of the Copernican cosmos, a shift from the vertically-organised and hierarchical world view of the Middle Ages centred upon the earth, to a horizontal view from the new centre of the cosmos, the sun, across a rotating globe. The spectator stands, almighty, above the earth, mastering a landscape which stretches infinitely over plains and oceans, great estuaries and promontories, until it fades across an indistinct, convex horizon. Yet for all this breadth and power of vision over the whole round world, Bruegel sustains a Flemish involvement in the everyday and the vernacular. In part he achieves this by employing traditional motifs of hours and seasons. A series of works depicting the labours of the months perfectly captures the essence of Bruegel's landscape. *February* ('Gloomy Day'), for example, has a complex structure which incorporates five different landscapes into an integrated whole (Plate 7). In the foreground right, peasants involved in pollarding, gathering faggots or repairing laths are emblematic of the tradition of representing the seasons. Below the wood in which they work the land falls steeply to reveal a view over the thatched roofs of a Flemish village bathed in the eerie light of midwinter. Beyond, an estuary is tossed by storm as ships founder in the chill green waters which open to a horizon on the boundless sea. In the left distance are Alpine mountains clothed in snow and to the right, seen through the skeletal tracery of bare branches, stretch the geometrical fields of a flooded polderland. The whole scene is unified by the threatening evening sky and an atmosphere of bleak doom. Against this vast conception the individual peasants who gather wood, plaster their houses or clutch selfishly for warm waffles are as impassive and unconcerned about the great terrestrial drama as is the ploughman who stoically continues his labour as Icarus plummets from the skies, or the laden

Plate 7. Pieter Bruegel the Elder: *The Gloomy Day* (Kunsthistorisches Museum, Vienna)

market women who walk away from the tragedy of Christ's journey to Calvary in other Bruegel landscapes.

This majesty of conception achieved by distancing the spectator is kept in tension by Bruegel's concern for the mundane and personal, a sense of involvement which is lacking in Italian landscape based on precise compositional rules. Bruegel was not unaware of perspective theory, using it rigidly in his painting of *Children's Games*, but by calling on the iconography of the seasonal labours and referring back to a medieval involvement with the practices of ordinary mortals directly engaged with nature, his landscapes constantly challenge the landscape idea of the Italian renaissance, counterpointing insider and outsider, medieval world view with the modern, theoretical speculation with practical observation.

Seventeenth-century Holland

In the final decades of the sixteenth century the area of Flanders was riven by armed struggle between the Calvinist population, largely concentrated in the north of the region, and Habsburg Spain and its Catholic supporters. With the fall of Antwerp to the Catholic forces in 1583, many painters followed previous religious exiles north to Amsterdam and the towns which would form the independent United Provinces, the modern Netherlands. Amsterdam's population of 30,000 in 1590 increased to 90,000 by 1620 and nearly 200,000 by 1680. Cities like Haarlem, Utrecht, Alkmaar and Delft also experienced rapid expansion as the Dutch capitalised on their independence to dominate the maritime trade of the Atlantic and build a colonial empire in the East Indies via the new joint-stock enterprises, the United East India and West India Companies. A severely Calvinistic, fiercely anti-Catholic and iconoclastic religious culture and a prosperous bourgeois elite of merchants, shipowners, urban speculators and land developers ruled the United Provinces and profited from the confusion of a Europe dominated by religious strife, and from the declining power of Spain. They were challenged only by England, particularly after the restoration of the monarchy when a united Britain gradually replaced Dutch mercantile hegemony to become the powerhouse of Europe's move towards industrial and agrarian capitalism.

The age of Dutch maritime expansion was also that of large-scale transformation of the agrarian economy of Holland. Huge works of reclamation drained the inland lakes of North Holland: Purmer, Beemster and Schermer meers were drained of standing water by

means of advanced hydraulic techniques. Capital for these joint ventures was raised in the cities and a new geometry of rectangular fields and isolated farm estates was laid out across the flat lands (Wagret, 1968). While investment in land did not yield returns as high as those to be made in maritime commerce or public bonds, it was by no means negligible. Burke (1974b) calculates that the typical member of the seventeenth-century Amsterdam elite spread investment 50 per cent in city or state bonds, 32 per cent in company stock, 12 per cent in houses and urban land and 6 per cent in rural land. Thus while more entrepreneurial than Italian or Venetian wealthy families, the rich bourgeois of Holland did have a strong interest in land as investment, both urban and rural.

In the cities this investment was ploughed into speculative housing and development. The great ring canals of Amsterdam were speculative ventures with fine houses built for wealthy families along their banks serving jointly as dwellings and warehouses. Peter Burke points out that, unlike the palaces of Venice, Dutch houses rarely displayed the owner's wealth in flamboyant and costly ornamentation or architectural finery: 'in Amsterdam a house was simply a place for the nuclear family to live in and does not seem to have had the symbolic importance of the Venetian palace' (Burke, 1974, p. 88). On the other hand, civic patronage was a source of pride to Dutchmen. The Staatshuis in Amsterdam, the commissions for the South and West churches there, the town halls at Haarlem, Delft and other towns, were given to prestigious architects and paid for by public funds administered by the merchant and capitalist elites of the Provinces. They became favoured central subjects for the Dutch school of townscape painters which flourished in the seventeenth century.

Townscapes by painters such as Van Der Heyden, Berckheyde, Hobbema and De Hoogh stand in the Flemish tradition of closely-observed and accurately-detailed empiricism. They do not offer the idealised scenes of the contemporary Italian urban perspectives or the picturesque assemblages of later *vedute*. Rather they seek to give the likeness of a solidly-built, secure and materially prosperous urban world, one devoid of conflict or poverty, decorous and quietist in a manner befitting the religious and social outlook of those for whom they were painted. Their realism has been regarded by many as quintessentially bourgeois and in a community which regarded sacred icons as sacrilegious, where salvation was predetermined and the saints identified in this world by works and material prosperity, the

151

demand for representations of a familiar world, unadorned by classical reference, baroque splendour or strong poetic sentiment is understandable. They betray the same set of values in personal propriety and civic duty that made the family portrait and the militia group portrait (*schuttustuk*) so popular.

A similar context informed the painting of rural landscape. Few Dutch landowners built rural retreats of the spectacular grandeur of the Italian villas and their gardens. There were, of course, exceptions, but for the most part rural 'palaces' around The Hague, for example, had fewer than a dozen rooms and lacked great ornamentation on the exterior: pediments, columns, pilasters and statuary. The interest in the garden was frequently commercial. Contact with the tropics of the West and East Indies brought a fascination with exotic plants and their transfer to Europe. Meticulous paintings of single species and great canvases showing tropical plantations painted for the offices of the trading companies reveal an interest in the botanical character of particular specimens. Dutch skill was turned to the cultivation, crossing and improvement of particular varieties with an interest in their rarity and value exceeding that in their beauty, so that gardens were often scientific-speculative ventures characterised by great beds of tulips, hyacinths and carnations grown in the rich marine or alluvial soils of the reclaimed lands. Such beds remain a feature of the Dutch scene today. Fortunes were made and lost in bulbs and flowers, indicating a new approach to nature: one of scientific rationalism and commercial exploitation, consonant with an acquisitive, bourgeois society.

It is an intriguing fact that neither of these elements of seventeenth-century Dutch intervention into natural processes – reclamation and the cultivation of exotics, achieve prominence in the landscapes of the great Dutch masters of that time, a fact for which we have no convincing explanation. But the spirit of scientific rationalism which gave force to them did have profound implications for landscape art in other ways. Holland in the 1600s was a centre of invention and innovation in the field of optical instruments and the theory of light. It is in the theory and technology of sight that landscape as a way of seeing was most progressive. The United Provinces was a haven of toleration for new ideas, accommodating such thinkers as Descartes, John Locke and Spinoza, the last of these making his living as a lens grinder. At both ends of the spatial scale Dutch scientists extended the range of human observation through development of the telescope and the microscope. The precision of

townscape paintings suggests a microscopic attention to detail and Christopher Brown (1972) suggests that Van der Heyden may have used a magnifying glass to paint some of his townscapes. Such interests was theoretical as much as practical, Christian Huygens developed the wave theory of light and its polarisation in Holland at mid-century. Some of the painters themselves experimented with perspective distortions, for example Carel Fabritius in his *View of Delft* (1642), soon after the time when Pascal and Desargues established the geometrical truth that parallel lines converge and revealed their visual convergence to be a necessary consequence of defining points, lines and planes in terms of each other, devoid of Euclidean metrical assumptions (Ivins, 1946).

The interest in light and in new ways of seeing was propitious for artists responding to patrons' requests for an unadorned, realistic and familiar world. Such a world in the environs of Amsterdam or Haarlem was uniformally flat. To paint it as it might be recognised by a Dutch merchant or farmer from his house meant that a vast area of sky would be included within the frame. And it is to the sky that Dutch painters turned to give character and atmosphere to their landscapes. It became for them, as Constable later put it, 'the chief organ of sentiment'. Painters like Aert Van der Noyen who explored the effects of moonlight, Van Goyen who developed a monochromatic style of landscape in brown and grey tones derived from overcast skies and their reflection, and above all Jacob Van Ruisdael, all painted local Dutch scenes, many of them specific enough to be topographically recognisable and valuable to the historian or geographer, with a concern for light as the unifying element. In Van Ruisdael's *View of Haarlem* (Plate 8) a location of the dunes gives the artist a panoramic view and we do observe the geometry of reclaimed fields and their settlements, the windmills, so necessary and significant an element in the new Dutch landscape, and the activities of distant rural labourers. But it is the vast, moving cloudscape, occupying fully two-thirds of the painting which above all captures Ruisdael's interest, and our own. The light reflecting among the clouds and cast down in pools of glowing colour on the ground is what raises these pictures above pure topographical description. The unity of the landscape view is no longer intellectual but emotional and provided by light; no longer theoretical but personal. It is this which made Ruisdael's work so attractive to English romantic painters. To personalise the landscape in this way is of course to make it no less distant as an active world known from the inside, rather it is made

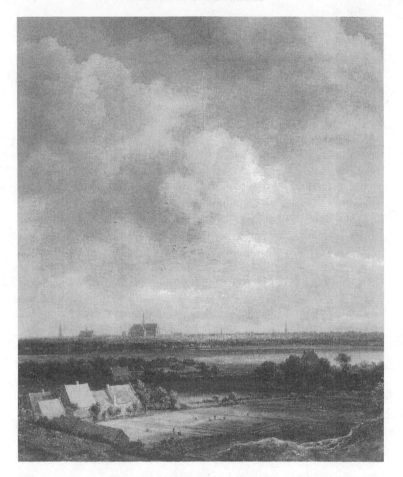

Plate 8. Jacob van Ruisdael: *View of Haarlem from the north-west with the bleaching fields in the foreground* (Collection Rijksmuseum, Amsterdam)

available to an individual patron or purchaser who can reflect his own feelings in a landscape which offers a sense of order and propriety suitable to the world of commercially-successful Holland. Such sentiments as we find in Van Ruisdael or Hobbema are not to be found in the plantation landscapes which adorned the walls of the Dutch East India Company. Here the order and control of an exploited colony are more clearly depicted in the topographical

154

detail and strong perspective composition that dominate the pictures. Not all the Dutch landscapists concerned themselves with the empirical truth of northern skies. Aelbert Cuyp was only one of a number who imposed upon a supposedly Dutch scene a warm, glowing evening light and an indistinctness of aerial perspective that was learned, not from observation on the heaths, dunes and polders, but from Italian mentors, landscapists that were to vie with the Dutch for influence on the English landscape idea in succeeding years. This Italian school is associated above all with the Frenchman, Claude Lorrain.

Landscape in Baroque Italy

Seventeenth-century Italy presents the obverse of the gilded coin that was being minted in the Low Countries. While Holland had defeated locally the power of Spain, Italy was prey to the whims of the great European monarchies, particularly the Habsburgs of Madrid and Vienna, to France and to the rapacious, counter-reformation Papacy. Venice retained republican liberty, in the face even of excommunication (Bouwsma, 1968), but commercially and industrially it was in decline, its investment flowing ever more strongly into the lands of the *terraferma*. The 1600s in Italy were a time of second feudalism and of adjustment to the new status of semi-periphery within a European world system that was firmly establishing itself along the shores of the North Sea and stretching its main arteries of commerce west and south across the Atlantic. In the south of Italy Spanish rule was one of benign neglect economically and inquisitorial repression politically and ideologically. Within this framework a new commercial class in the urban areas exploited the demands for luxuries from absentee landlords and nobles and could itself gain control over large latifundias in Apulia, Calabria and Sicily. Environmental degradation and impoverishment of the rural population paralleled the urban squalor of inflated cities like Palermo, Syracuse and above all Naples. Peasant and proletarian risings like that of Masaniello in 1647 were an expression of the increasing distance and tension between a wealthy aristocracy and an impoverished and alienated majority. Other, less dramatic forms of protest included brigandry, so that Salvator Rosa's Neapolitan landscape paintings of fierce men in the deep fastnesses of a derelict mountain countryside are not entirely

without foundation, for all their romanticism.

In the formerly advanced states of upper Italy a similarly depressing, if less pronounced state of decay was evident. Labour on the land was increasingly coerced by tight sharecropping and *affito* leases so that, as Frank McArdle (1978) has demonstrated for the Medici estate of Altopascio, workers formed effectively a rural proletariat. Here too, short-term financial gain on the part of landlords, aristocratic and ecclesiastical (through the exercise of mortmain) took precedence over environmental conservation in the long term. Thus downslope ploughing and deforestation increased problems of erosion on the hillslopes and malarial infestation in the lowland swamps. Only with the sophisticated terracing and irrigation initiatives of the mid-eighteenth century in Tuscany and Umbria did the productivity of agricultural land begin to improve again. In the Po valley improvements were made and here alone, in Savoy and the Milanese, did capitalist tenancies keep pace with, and occasionally lead, the advance of agriculture in north-west Europe. In the cities commercial enterprise was failing, rural-urban ratios were moving in favour of the countryside, and a courtly, aristocratic culture was in the ascendant. References to the 'grass-grown streets of Ferrara and Mantua' bear literal testimony to the economic stagnation of former commercial centres.

In this depressing picture one great cultural metropolis flourished. Rome of the counter-reformation and baroque periods, heavily influenced by Spanish wealth and religious fervour, became almost the paradigmatic absolutist capital. Ideal city notions or urban form, planning in the grand manner, made of its urban landscape a great theatre. Under architects like Gianlorenzo Bernini, Francesco Borromini and Pietro da Cortona, baroque Rome was turned into a city of great squares, colonnades, fountains and churches – the very centre of European high culture. It was Bernini who designed the great square of St Peter's, turning sculpture into architecture as a means of celebrating the absolute power of the individual prince, in this case the Bishop of Rome, Pope Urban VIII. In doing so, he set a pattern to be followed in military style by engineers like Vauban in fortified stellar cities like Neuf Brissach or Valletta, and by the paragons of absolutist monarchs, Louis XIV and Peter the Great in imposing capital cities: Versailles and St Petersburg. The townscape of baroque architects, especially when displaying the total authority of their patron by raising the city on untouched nature, realised in concrete form the ideology of absolutism as a reformulated feudal

order, a final attempt on the part of the nobility to sustain ancient privileges and to assert them in a militarised, centralised capital city, the focus of autocratic redistribution. This authority employed the illusionistic properties of grand perspective to focus the eye on the seat of power along great orthogonals like those leading to the Palace of Versailles or which radiate from the Piazza del Popolo in Rome. Political authority is translated into visual control and simultaneously elevated to the level of fantasy by bafflingly elaborate decoration, *trompe-l'oeils*, and the complex geometry of ground plans, curving colonnades and serpentine façades (Pevsner, 1957). This is an appropriate setting for elaborate, often courtly, ritual celebrating the divinity of the monarch. In Rome of course the ritual was primarily that of the counter-reformation mass – a total art combining ceremonial prayers in the cadences of ecclesiastical Latin, choral music, highly decorated and colourful costume, clouds of frankincense and complex patterns of movement, all in the gorgeous setting of a sculptured church interior. Power is sustained by mystification and sensuous appeal. The secular equivalent was opera, pioneered by Monteverdi, and baroque townscape is best described as operatic. The Trevi fountain in Rome is a sculptured stage set placed in the heart of the city, it perfectly articulates the ideology of a doomed aristocratic class, sustaining by appeal to the senses rather than the intellect its defences against a realist and rationalist bourgeois world order.

In the midst of this urban landscape as it was being constructed in Rome, new and immensely influential images of landscape were being produced by resident French painters: Claude Lorrain and Nicholas Poussin. While in no sense less fantastic than the baroque around them, their landscapes are far removed from it, finding a source of inspiration in views outside the city or in an imaginary past. Claude's landscapes are certainly based on detailed study of nature – of topography, vegetation and clouds – above all on the play of light across them. His chalk sketches and washes were made directly on walks in the environs of Rome, particularly in the evening or early morning when he could catch and explore the play of light and shade on slopes or branches and reproduce their detail and drama. But while this concern may anticipate the scientific attention to nature of the nineteenth-century landscapists, Claude's interests were very different from those of the contemporary Dutch painters, and there was no attempt to reproduce empirical forms in finished works. The Claudian landscape is deceptively simple. It is a view towards a light

source, framed by dark coulisses, often arching pine-like trees which catch the light in their high crowns. The central view is crossed by alternating, often interpenetrating, bands of light and shade which lead the eye effortlessly to the very depth of the picture space, the source of the flooding glow of light which bathes the whole landscape in mellow golden tones. Fleecy clouds and still water reflect and diffuse this light throughout the picture.

Claude's luminism serves a poetic function. It is rendered as a natural force which harmonises the landscape with the human condition that it sustains and reflects. That condition is best described as Arcadian, or at least Virgilian. Its classical elements are to be found in Claude's *Landscape with Ascanius shooting the stag of Silvia* (Plate 9). To the left Ascanius, a hunter in armour and toga, aims with his bow at a stag standing aristocratically to the right. Between them a still stretch of water reflects blue from the evening sky and in the middle ground a line of cattle walk quietly home. Beyond is the flat of an open strand and the sea with mountain promontories blued in aerial perspective. Above Ascanius, his companions and hounds, tower the Corinthian columns of a ruined temple and beyond the line of trees which bend with the direction of the shot are more temples and monuments. Claude's is a landscape of pastoral ease: cattle and sheep graze peacefully, unrestricted by hedge or fence, the glades are carefully tended, the woodland unthreatening. The time is a golden age, an age of innocence and pure harmony between human life and the natural surroundings in which it is lived. From the narrative we may be able to locate the scene -- in the case of Ascanius it is the Tiber and the Roman Campagna – yet the work is not intended to convey topographical accuracy. The landscape suggests above all a mood, a dream of classical innocence and warm perfection. It is the world of Giorgione's *poesia* and of Titan's pastorals, realised with a new poetic force through Claude's mastery of light. But these paintings are not without tension and potential violence. The world of innocence seems always to tremble on the edge of an experience which will destroy it. So Ascanius' arrow will kill the stag and bring about destructive war: the age of iron will follow the age of gold.

The harmony of human life and nature which Claude describes appeals, like the northern tradition of the seasons, to a common aspect of our human experience. It is a childhood dream of golden innocence, remembered with aching nostalgia. We know how brittle and transient it is, we know too that once experience has broken the harmony it can never be recovered. This shared human experience is

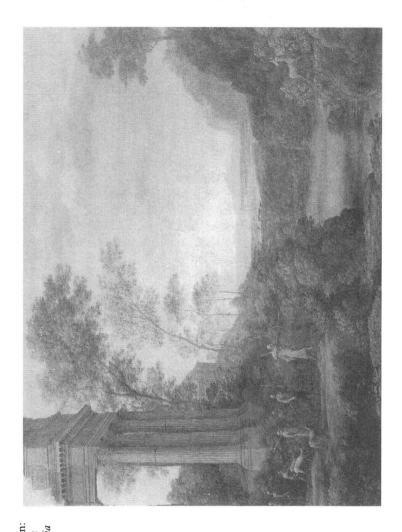

Plate 9. Claude Lorrain: *Landscape with Ascanius shooting the stag of Silvia* (Ashmolean Museum, Oxford)

realised as landscape by Claude, and also by Poussin who gave its image a more formal intellectual structure and who in *Et in Arcadia Ego* presented death at the very centre of the Virgilian dream of youth, innocence and pastoral ease by having his shepherds rest against a tomb, a *memento mori* (Panofsky, 1970).

For all that these images of environmental harmony appeal to common human experience they are not unconnected to their historical context. They partake of the same fantasy as baroque culture, but locate it outside the city and in past time. Their appeal to courtly erudition is at once intellectual and sensual. Above all they offer a vision of natural perfection in a Europe cleft by religious war and doctrinal bigotry, dominated by militarised, monarchial states and weakened by severe economic crisis and the unpredictable demographic hatchet of recurring plague. Amidst acute disharmony there is a fantasy of natural harmony, but one which gestures, appropriately, towards the most radical of changes, towards a new social order.

From the Dutch, and from these Frenchmen in Rome come quite distinct landscape images, both of them resonating against a shared human relationship with nature. Seasons and eclogues, these images are moulded together and reformulated within an English idea or landscape which has its own provenance and which is examined in Chapter 7. More immediately we shall discuss the place of the landscape idea in the event which offered to Europeans of the early modern world the most direct and potentially unmediated encounter with nature and with land, the discovery and settlement of North America.

6

America as Landscape

In the last chapter I argued that the northern tradition of Flemish and Dutch landscape was a less intellectually sophisticated, less classically influenced, empirical and naturalistic way of seeing than that developed in renaissance Italy and sustained in the seventeenth century. At the same time landscape remained a distanced way of seeing, the outsider's perspective which, for all its appeal to direct human experiences, articulated them ideologically within a period of change from land as use for the reproduction of human life to land as commodity for realising exchange value.

For many Europeans the greatest single change in the relationship between population and available land since the Black Death's radical restructuring of the population/resource ratio came with the discovery and opening for settlement of the Americas. The availability of American, particularly North American, land, whose dimensions were gradually realised during the four centuries between 1500 and 1900, altered European relationships with land both materially and culturally. For those who settled and cultivated North American land, gaining for themselves a level of material comfort and a status of citizenship unattainable by the majority of Europeans, America was a very concrete reality to be transformed from wilderness waste to a cultivated garden, to be made fertile, to be shaped by tools and practices inherited from Europe and adjusted to the conditions of the American environment. To those less directly engaged upon the land, those who imagined, explored, sought to profit from or rule and design the new continent, American land seemed to offer a chance to realise one or other of a multitude of ideals, beliefs and values: social, political, religious and environmental. In a new physical world a new human world might be created. In the years before large-scale industrialisation and urbanisation, in agrarian America up to the middle years of the

161

nineteenth century, those whose direct labour shaped American land were drawn dominantly from middling classes in England, the Rhineland, the Low Countries and northern France. By contrast, those who discovered America and those who shaped the land in their minds or on paper rather than with axe and plough were more heavily influenced by those renaissance ideas we have examined in Italy. They were Italian and Iberian merchants and navigators, Elizabethan and Jacobean courtiers and gentlemen, American patricians who, like Thomas Jefferson and Hector St Jean de Crèvecoeur, maintained close links with the most advanced ideas of French classicism and rationalism.

Out of these two sets of experiences and out of the fact that from its earliest discovery North America was integrated into the emerging European system of commercial capitalism, developed a distinctive American social formation, a formation which in the closing decades of the eighteenth century took the form of a separate political entity: the United States of America. A central feature of this social formation, so central that it occupied more legislative time in the Congress's first century than any other issue and has dominated American historiography since Frederick Jackson Turner wrote of the frontier in 1894, was land. The allocation, division, pattern of ownership and production from land is crucial to historical understanding of American social relations and American culture. Since landscape is a cultural expression of social relations with the land it can be argued that America is in some respects an articulation on a continental scale of the landscape idea, an articulation which embodies the different sets of experiences of practical shapers and theoretical designers.

The American landscape up to 1845 was, according to John R. Stilgoe (1982, p. 4), 'the tension between common and professional builders; while well-read men who understood the new theories of geography, mercantile capitalism, representative government and innovative design sometimes directed colonisation, people much less literate and far more traditional actually shaped the land'. The USA, he claims, is the landscape of common knowledge: 'neither folk nor literate but a mixture of both the "little tradition" transmitted by generations of half-literate peasants and the "great tradition" of the literate, innovative minority of scholars, rulers and merchants, and of professional surveyors and architects'. Within this context the landscape idea takes on a particularly American form, one which owes much to Europe but which is crucially inflected by the material

reality of the American wilderness and the special form of its social formation. In this chapter I begin in Europe, examining how some of those renaissance and classical ideas and values already discussed were brought to bear on discovery and early settlement, and how they fared in the reality of the new environment. Then I discuss the nature of the distinctive social formation that emerged in North America and how the landscape idea was influenced by and imposed upon it, particularly within the ideology of the new republic and the order that was cast across the continent in the rectangular survey and imposed upon the primary symbolic landscape of the nation, its capital, Washington DC. Finally, as America's place in the industrial capitalist order began to be formulated in the early nineteenth century and as social stratification of a form more closely akin to that of Europe emerged, at least in the earliest-settled parts of New England and New York, I shall consider the appearance in American art of landscape ideas and composition closely related to those of contemporary Europeans, but still displaying distinctive American characteristics.

Renaissance Landscape Ideals and American Discovery

Accordingly I am sending His Majesty a chart done with my own hands in which are designated your shores and islands from which you should begin to travel ever westward, and the lands you should touch at and how much you should deviate from the pole or from the equator and after what distance, that is, after how may miles, you should reach the most fertile land of all spices and gems, and you must not be surprised that I call the regions in which spices are found 'western' although they are usually called 'eastern', for those who sail in the other hemisphere always find these regions in the west. But if we should go overland and by the higher route we should come across these places in the east. The straight lines, therefore, drawn vertically in the chart, indicate distance from east to west, but those drawn horizontally indicate the spaces from south to north . . . From the city of Lisbon westward in a straight line to the very noble and splendid city of Quinsay 26 spaces are indicated on the chart, each of which covers 250 miles. (P. dal P. Toscanelli, quoted in Edgerton, 1975, p. 121)

The chart referred to in this letter of 1474 was drawn with a grid of latitude and longitude lines, a reticulation of earth space learned from the world map contained in Ptolemy's *Cosmografia*. That second-century work had been 'rediscovered' when it was brought to Florence in 1400 by members of one of the city's humanist academies. Their act was a springboard for Florence's rise to centrality in European cartography during the early fifteenth century, a science based increasingly on the technique of projection: representing the curved surface of the globe on flat parchment or paper. One of the projections described by Ptolemy in *Cosmografia* is 'the first instance of anybody – scientist or artist – giving instructions on how to make a picture based on a projection from a single point representing the eye of an individual human beholder' (Edgerton, 1975, p. 104). Its similarities to the principles of linear perspective then being developed practically by artists like Brunelleschi and humanists like Alberti are astonishingly close. That an intellectual interest in mapping the world existed in the same minds as the interest in reticulating picture space to give the illusion of reality is testified in the writings of many humanists, among them Pius II, the renaissance Pope singled out by Burckhardt as one of the earliest admirers of the beauty of landscape. Pius, responsible for the redesigning of Pienza along ideal city lines, wrote his own *Cosmografia* modelled upon Ptolemy. That work was read and annotated by Christopher Columbus. The passage quoted above was written to the Portuguese court by the Florentine doctor, mathematician, geographer, cartographer and optician Paolo dal Pozzo Toscanelli (1397-1482). He was an intimate of Brunelleschi and a writer on perspective. His was a wealthy Florentine merchant family fearful of the impact of Turkish advances in the Mediterranean on their trading activities and eager to discover new trading routes. His letter draws upon a knowledge of Ptolemy to justify an Atlantic navigation to the west. A few years later Toscanelli wrote directly to Columbus, encouraging his venture. What followed these speculations need not be retold here. The point that concerns us is that 'the same forces which changed the artist's view of the visible world send man to confront the unknown terrestrial world and, closing the latitude circle, to discover his own planet' (Edgerton, 1975, p. 122), a major part of which was the discovery of America.

Although unwilling to admit it, Columbus found something profoundly different from 'the very noble and splendid city of

Quinsay', that is, China. His new-found-land was discovered in those same years that Pietro Bembo and his friends were composing their lyrics at Asolo and Giorgione was demonstrating the pictorial techniques for rendering visible the arcadian world of Sanazzaro. Emerging out of ancient European myths of Atlantis and the Isles of the Blessed, America began to take on an empirical form which could be captured in the grids of renaissance cartographers. But given the utopian strain that characterises Italian patrician thought at this time, it is hardly surprising that America was also the perfect canvas upon which to project the fantasies of static perfection in which renaissance thinkers indulged. Having no history – a mere shadow on the parchment – America offered the potential for realising social utopia. Its very discovery was a triumph of human reason, its exploration and settlement would be governed in part by the social and moral ideology which accompanied renaissance reason and which we have seen developed in environmental terms by seventeenth-century Roman painters. An early illustration of this is the association of America with the society and landscape of the Golden Age.

Gold

Gold was one of the controlling images of the newly discovered continent in the sixteenth century. In a very real sense it was the discovery of gold in the Portuese and Spanish American empires that made their initial economic impact on Europe so spectacular. Finding tracer gold in Hispaniola justified Columbus' voyages despite their failure to reach the Spice Islands and China promised by Toscanelli. Columbus himself was aware of the significance of this discovery and recognised the power of gold's image, even if he veiled it in the language of heavenly salvation:

> Gold is the most precious of all commodities, gold constitutes treasure, and he who possesses it has all he needs in this world, and also the means of rescuing souls from purgatory and returning them to the enjoyment of paradise. (Quoted in Levin, 1970, p. 62)

The conquest of Mexico and, later, Peru released vast quantities of plundered precious metal, at first from native artefacts and later from mines, into the European economies through the ports of the

Mediterranean, especially Seville. While it was silver in the late sixteenth century which had the greatest impact on inflation and was responsible for the 'price revolution' at the turn of the century, gold was, as Braudel has noted, the money of princes and rich merchants. Gold rather than silver served as the most powerful image of wealth and authority. The precise role of precious metals in accelerating the European transition to capitalism is disputed, but their volume and velocity when released into circulation from the American discoveries certainly increased the general level of commodity circulation and capital accumulation throughout the continent (Braudel, 1973). In an indirect way it may also have contributed to the relative rise of north-western Europe as the core area of the world economy at the expense of the Mediterranean by stimulating increased commodity production in the former area which in the latter could import with bullion payments rather than produce internally.

But, as Columbus' report indicates, gold was more than merely an economic commodity. It implied power and possessed also a moral dimension. It is not perhaps surprising that Cosimo di Medici, prince of Florence but trained as a banker, should find in gold a suitable metaphor for his rule, proclaiming in elaborate ceremonial the return of the Golden Age. Here an elision is made between the gold that gives real economic and political power and the myth of the Golden Age as it had been learned from the humanist study of classical authors. It is typical of the relationship between material reality and cultural experience that such an elision should be based on such a concrete phenomenon as gold while obscuring the reality of the image by appealing to a purely literary convention.

The myth of the Golden Age is closely related to the Arcadian and pastoral traditions from ancient literature, as Claude was to explore in landscape painting. It is found particularly in those writers on agriculture whose works were so popular among the estate and villa owners of renaissance Italy: Hesiod, Varro and Virgil. Hesiod had posited four ages of social and environmental development, each characterised by a particular metal: those of gold, silver, bronze and iron. These ages implied a decline from primeval perfection to contemporary hardship and were linked in renaissance understanding to the idea of a senescent earth. The Golden Age itself was the primeval state of environmental perfection and human youth and innocence. The natural fertility was deemed to have been such as to meet human requirements without the need for labour: 'Earth unbidden, which gave the more freely of all her store, in that none

asked her bounty'. Such fecundity and natural abundance allowed for social perfection. All were equal because equally rich. Possession was unnecessary and the concepts of ownership and property, indeed even the words 'mine' and 'thine' were unknown, were non-existent. Neither the state, nor law, nor the evils of war blighted human bliss. In pure innocence, freedom and happiness men existed as brothers among the ever-yielding fields, orchards and flocks. However, since this dawn of human history a decline in the earth's fecundity had brought about all the evils of scarcity, labour, wealth, poverty and social division.

The attraction of the Golden Age myth to the wealthy patriciate of renaissance Florence or Venice is not difficult to imagine and in altered form it was also influential among the Italian peasantry in the sixteenth century (Ginzburg, 1980). It carried the stamp of classical authority yet could be reconciled with pre-lapsarian Christian myths. If humanist education could produce men able to penetrate the secrets of the universe, it could also assist in reclaiming the imagined state of perfection. At the same time the myth of a Golden Age and its associations of timelessness and eternal youth served as a powerful image of stable authority which could be translated into the crude spectacles of gilded floats and gold-painted youths parading the streets of Florence in celebration of Medici power (Levin, 1970).

The Golden Age myth was not confined to renaissance Italy. Like so much else of Italian culture it had become by the mid-sixteenth century part of the vocabulary of wealthy literate classes across western Europe. Its role in controlling Europeans' responses to American discovery is summarised in Harry Levin's (1970) words: 'Nothing they had previously experienced could have prepared them for their initial view of the Amerindians. However, they could draw upon a rich backlog of fabulous lore about aboriginals, namely the myth of the golden age', and that myth was as much geographical as it was social. Thus when European explorers dicovered native Americans apparently naked, friendly, producing two or three abundant crops of maize on their polycultural clearings and surrounded by a gold that they appeared not to value, it was easy for their literate observers to imagine that such people must still be living in the Golden Age. Sent out by princes who fantasised about a past utopia, navigators could return with the offer of a geographically distant but perhaps recoverable utopia. Thus in the far north of the continent, Cartier could claim of the Indians of Hochelaga: 'all these

people engage in cultivation and fishing solely to sustain themselves, they do not value worldly gods, being unacquainted with such' (Sauer, 1975, p. 90), while in the distant Caribbean a commentator looking back on the Spanish conquest could claim that the aboriginal population, by now devastated,

> had the golden age, mine and thine, the seedes of discord, were farre removed from them, the rest of the yeere from seede time, and harvest, they gave themselves to tennis, dancing, hunting and fishing: concerning judiciall courts of Justice, suits of law, and wrangling, and brawling among neighbours there is no mention at all. (Quoted in Levin, 1970, p. 63)

At the mid-point between these locations, in recording his exploration of Chesapeake tidewater for the king of France, the Italian Verrazanno provides an image of the kind of landscape in which the Golden Age would naturally be sustained, and he provided a suitable name for it: 'following always the shore, which turned somewhat toward north, we came in a distance of fifty leagues to another land that appeared much more beautiful and was full of great woods, green and of various kinds of trees' (quoted in Sauer, 1975, p. 54). The place he called Arcadia.

Pictorial illustrations of the new world confirm the image of a Golden Age landscape. The population, especially females, appear as nubile classical goddesses such as might recline in the pastoral fields of Giorgione or Titian. They work easily or play at leisure in woodland pastures or abundant crops and exotic fruits, accompanied by strange but apparently docile animals, some drawn from America's natural fauna like the turkey, others like stately stags more reminiscent of the world of Actaeon and Diana than the clearances of the Carolina Sea Islands. Simplicity, youth, innocence and ease are the dominant motifs, quite clearly grounded in an image of life and landscape drawn from Virgil's Arcadia – fecund and abundant. Obviously such a tinted view of the new world could more easily be sustained in Europe itself rather than in direct confrontation with the realities of the North American environment and it was undoubtedly embroidered to attract the continued interest of those funding exploration. Nevertheless it underwrote the seemingly futile, endless treks of men like De Soto and Coronado in their search for the fountain of youth or the gold of Cibola (Sauer, 1975). Even the governor of the first, ill-fated Roanoke colony in Virginia could

articulate his response to the reality of America in the language of the myth: 'we found the people most gentle, loving and faithful, void of all guile and treason, and such as lived after the manner of the golden rule'.

The Golden Age myth posits a classless, propertyless utopia. It is equally anti-capitalist and anti-feudal, rejecting acquisitiveness and stressing community between equals. But in its explicit evasion of the problems of human labour, production and authority it is necessarily a view from the outside. Its anthropocentricity is absolute in that the earth's only *raison d'être* is the willing service of mankind. In proposing a universal, self-generating surplus it denies change and history along with the exploitive reality which underlies power. In its complex mystification of the meaning of gold, which of course has value only as a means of personal consumption, it was particularly suited to legitimate ideas of self-sufficiency and the centralisation of specie in an independent, absolute state to which developing mercantilism in the sixteenth and seventeenth centuries was aligned because it appeared to deny the very processes by which absolute authority was established and maintained. Above all in the context of our argument here we should note that the Golden Age myth implied a vision of landscape and thus from its origins provided for America an image of fertility and abundance in the natural environment.

Wilderness

The alternative to the garden image of landscape which emerges from the Golden Age and pastoral myths is that of wilderness. Conventionally such a contrast is drawn between different responses to the American environment (Marx, 1964; Lowenthal, 1968; Tuan, 1974). For all the fancies of a primeval perfection and the occasional support offered them by tracer gold, Indian clearings or unpruned muscat vines, the reality of the American eastern seaboard as far inland as European settlers penetrated for two centuries was of forests, swamps, unexpected climatic extremes and, at least to their eyes, frighteningly savage natives and wild animals. Wilderness images do enter the reports of early navigators alongside more benign descriptions (Marx, 1964), but they emerge far more consistently from the writings of settlers, and especially from those of New England who possessed a structure of Calvinist beliefs into which such images easily fitted and a biblical vocabulary which offered them

ready articulation. Leo Marx (1964, p. 41) quotes from the diary of
William Bradford, recording his impressions as the Mayflower stood
off Cape Cod in 1620:

> Nether could they, as it were, goe up to the tope of Pisgah, to vew
> from this willdernes a more goodly cuntrie to feed their hops, for
> which way soever they turnd their eys (save upward to the
> heavens) they could have litle solace or content in respecte of any
> outward objects. For summer being done, all things stand upon
> them with a wetherbeaten face; and the whole countrie, full of
> woods and thickets, represented a wild and savage heiw. If they
> looked behind them, ther was the mighty ocean which they had
> passed, and was now as a maine bar and goulfe to separate them
> from all the civill parts of the world.

In a detailed analysis of Puritan responses over the first two
centuries based on tracts and sermons, Alan Heimert (1953) has
shown how the American environment came to take on the character
of an evil, wild temptation initially attributed to the corrupt Europe
that New Englanders had escaped.

The actions of settlers down the length of the seaboard had little if
anything to do with Golden Age fantasies or related aspects of the
literary interpretation of America in Europe. Those who cleared the
forest, removed stones from the fields, ploughed up virgin earth and
constructed houses, barns and fences, adopted practical attitudes and
quickly learned the most efficient techniques for disposing of a
wilderness. Inventions like the broad axe and later the steel plough
and barbed wire speeded up the process and pride in strength,
practicality and inventiveness was counterposed by Americans to
effete ideas of Europeans. The scene created out of this battle with
the wilderness was one of individual farmsteads and fields whose
elements refer back to European antecedents – barns, fences,
farmhouse types – but in a promiscuous mixing of European regional
styles and an overall simplification which, if materially comfortable,
offered to sophisticated European eyes a rude and unfinished
prospect (Zelinsky, 1973; Harris, 1977; Lowenthal, 1968).

The developing society in colonial North America in some
respects parallels in its contrasting elements this conflict of landscape
images: utopias sustained by those who viewed from afar and the
more practical image of a wilderness to be tamed held by those who
materially confronted the environment.

An American Social Formation

For all the signs of an emerging mercantile capitalism in the absolutist states of seventeenth-century Europe, land remained the basis of wealth and status. Access to its ownership and control was the governing issue around which class conflict occurred. Even in those social formations characterised by widespread peasant proprietorship, access to land remained critical (Huggett, 1975). In the Italian urban communes, precocious centres of merchant capitalism as they were, land and property remained the *sine qua non* of citizenship and thus of political authority. If the Golden Age and pastoral myths had a particular force in shaping elite attitudes to North America, that force derived ultimately from the open and unproblematic relationship between land and society which they posited and its relevance to economies still grounded ultimately in land and feudal rent. Within the limits imposed by such economies the only possible ways of imagining universal social perfection or even universal material satisfaction without challenging the privileges already gained by the few were either under conditions of an abundantly self-productive nature or of limitless acreages of fertile, easily-tilled land. For those more directly producing their material survival – the European peasantry – access to land in America offered the fulfilment of a very ancient dream of sufficient land, a dream which found voice in cultural products sometimes remarkably akin to those of high culture (Ginzburg, 1980).

The possibilities offered by American land underlay the consistent utopian strain in colonial ventures. We find it in the covenant of the Massachussetts Bay colony, in the Quaker scheme for Pennsylvania, the Catholic Maryland settlement and the Oglethorpe plan for Georgia with its grandiose spatial geometry and constitution written by John Locke. It recurs in the promotional literature for less idealistic settlements, the French colonisation of the St Lawrence and the plantation of Virginia. Whether America is proclaimed a 'city on a hill' or the 'land of the free' or 'God's own country', its ideological role as projected to Europeans has been to offer a solution to the central problems of a pre-capitalist society, the land question. It is this which underlies the process of European settlement and the perception of that process by those involved in it, even those today who try to interpret it.

The most influential interpretation of the historiographic signifi-

cance of land in the making of America is of course Frederick Jackson Turner's thesis that it was the receding frontier of open land that produced a new and more perfect democratic society in the United States (Turner, 1961). Debated, revised, rejected or reinstated by historians over nearly a century, the very strength of the emotional response to the thesis is indicative of how profoundly its theme is rooted in American culture. That theme has been resurrected again in recent American historical geography. Cole Harris (1977) has argued that a paring away of European social complexity occurred in North America resulting in a striking uniformity of settlement pattern, a predominance of the nuclear family and 'a relatively homogeneous and egalitarian society'. He claims that this process occurred not at the point of departure but as a result of the new relationship established between a fairly representative section of European society and *land*. 'When emigrating Europeans suddenly transformed their access to land, social change was the inevitable result' (Harris, 1977, p. 470). In Europe land was scarce and expensive and labour was abundant and cheap. In the colonial situation, particularly in North America, this relationship was reversed and consequently the colonies,

> through their most influential characteristics, cheap land and poor markets for agricultural products, favoured the establishment of the independent nuclear household and pared away most of the socio-economic hierarchy and local regional variety of European rural life. (Harris, 1977, p. 472)

This insistence on the crucial importance of land and its availability to a very large proportion of the population sustains the central image of a 'fee simple empire' as the foundation of an open and democratic society of independent family farmers, an image which can be traced back, through various inflections, to the earliest Europeans' dreams for the new found land.

Critics of this thesis regard it as a version of American populism which proclaims in the new world an open, unstratified and relatively homogeneous society, fundamentally different from the European formations from which it was drawn, based on America's profligate resources and open acres of land. They stress the institutional context of early settlements and the place of American settlement in the global transition to capitalism (Lemon, 1980). Colonial America was

172

intimately linked to Europe both structurally, in its economic subjection to the mercantilist requirements of England or France as part of the semi-periphery of the emerging world economy, and ideologically, in the liberal values of its early settlers. Yeoman capitalism, the accumulation of land as private property to achieve status (Lemon, 1980), is seen to characterise the American social formation during the colonial and early republican periods. Land ownership remained the basis of status definition and while it was indeed made available to a larger proportion of the population than was the case in any European country, nevertheless inequalities were inherent from the earliest times and certain groups, most obviously Amerindians and Blacks, were institutionally excluded from participation.

American colonial society did indeed develop a new relationship with land, one freed from feudal restraints. But it was moving along a trajectory already being described within Europe itself, at least in England. Its characteristic American expression was the individual family farm, so often pictured as log cabin or elegant clapboard house in the engravings and woodcuts of later years, isolated in prairie or woodland clearance, a metaphor for its isolation in basic self-sufficiency (Lowenthal, 1982).

Some American commentators have chosen so to emphasise this isolation and self-sufficiency as to claim for agrarian America a distinctive mode of production, neither feudal nor capitalist. But this is to accept the ideology of the fee simple empire by neglecting the propensity of American landholders to engage in trade – in the South from within a decade of the first successful settlement American farmers were completely dependent on the European market for the sale of their tobacco staple – but particularly their propensity to trade in the land itself. Land was as much a commodity as it was a civil liberty, indeed only if it was alienable in this way could it fulfil its role of granting to its proprietor the status of freeholder (Warner, 1972). Like *mezzadria* in Italy, the American agrarian economy during the colonial period may best be regarded as transitional between feudalism and capitalism. For settlers land ownership signified the achievement of a human and social status unattainable in Europe. But that status did not derive in feudal fashion from the authority it gave over the labour and product of the land. Title to land did not make one a titled person. For all its status as civil liberty, land was *property*, alienable through the market. To be a man of property is a

bourgeois conception, land title a feudal one. Thus the term 'yeoman capitalism' which signifies the transitional nature of the American situation is more convincing than reference to an independent mode of production.

It was precisely this yeoman capitalism that the land legislation of the new republic attempted to underpin and for which the Land Ordinance Act of 1785 was to be the blueprint. Thomas Jefferson, whose role in the formulation of this legislation was central, was aware of far more than the patterns of land ownership and use that had developed in colonial America. He was in close and constant contact with events and ideas in England and France (Green, 1977). In the former, changes in relations between land and society had accelerated dramatically since the sixteenth century and with them had emerged forms of ideological expression which provided a vocabulary upon which Jefferson could draw to gloss his own ideas with the more highly polished veneer of European and classical authority. In France the short-lived but influential ideas of physiocracy represent an attempt to control the forces pressing towards bourgeois revolution. They too were familiar to Jefferson and their focus on matters of land ownership and use as the foundation of state security and social improvement had considerable influence on his thinking. These European changes are considered in more detail in the following chapter. For now it is sufficient to note them while concentrating attention on the inheritance of American images in defining the Jeffersonian landscape.

The Jeffersonian Landscape

The republic which emerged from the War of Independence as a new nation inherited the ideals and images as well as the experiences generated by European settlers and colonists and moulded them into a national ideology with its own iconography. The dusky maiden, clad in feathers and tobacco leaves – a sensuous fantasy of the European imagination which so frequently had represented America – gave way during the early republican years to an image of Columbia, a classical goddess who symbolised the virtues of the young republic: independence, freedom and wisdom (Taylor, 1976). The official seal adopted by the Continental Congress was the eagle, the ancient personification of Zeus, but here an American bald eagle clutching the arrows of war and the olive branch of peace. A new and more

perfect society had come into being, but apart from the slight nod in the direction of native American fauna, its icons were borrowed from the European tradition, referring most obviously to what eighteenth-century rationalists regarded as the historical model of social perfection, republican Athens.

More practically the new republic also inherited a pressing need to formulate a land settlement policy. In 1790 nine out of every ten Americans farmed the land. Within a few years of the Declaration of Independence most of the various claims of the individual states to the territories beyond the Ohio were ceded to the federal government which took possession through Indian treaties of a vast tract between the western bank of the Ohio river and the Missouri: the Old Northwest. Over the next half century through purchases and annexations the public domain was extended to cover a further 1,500 million acres, land which would serve as the foundation of the new society Americans had determined to create. Land was the central fact of American life and ideology, its control and division was to be the preoccupation of US politics until the Civil War. Among the very first acts of the Continental Congress was the abolition of all remnants of feudal relations on the land. Remaining manorial holdings such as those inherited from original proprietors in states like Maryland and Pennsylvania were expropriated and quit rents, entail and primogeniture removed from the American legal system as causes of inequity and landlordism. Already in these actions we can observe the beginnings of a land policy directed at the construction of a particular social ideal – an ideology of individual independent freeholders.

Crèvecoeur: America as 'Prospect'

That ideology was very clearly expressed in an early classic of American writing, the *Letters from an American Farmer* published by the naturalised United States citizen Hector St Jean de Crèvecoeur in 1782. Attempting to define what was characteristic of his adopted people, he emphasises constantly the birth in America of a new man 'who must therefore entertain new ideas and form new opinions'. Such men create a new society, 'the most perfect society now existing on earth' (Crèvecoeur, 1963, p. 61) and the evidence of this is inscribed in landscape. Indeed for Crèvecoeur the truth of the American dream *is* its landscape. The European visitor is placed imaginatively on the eastern seaboard:

Here he beholds fair cities, substantial villages, extensive fields, an immense country filled with decent houses, good roads, orchards, meadows, and bridges, where a hundred years ago all was wild, woody and uncultivated! What a train of pleasing ideas this spectacle must suggest; it is a prospect which must inspire a good citizen with the most heartfelt pleasure. The difficulty consists in the manner of viewing so extensive a scene ... (Crèvecoeur, 1963, pp. 60-1)

America is a *prospect*, a word that in 1780 had a wealth of connotation (Turner, 1979), and which would suggest to an English reader at least the view over a gentleman's park, a tract of land designed for personal pleasure, as well as to be admired for its productive potential. It would also imply, as Crèvecoeur's essay intends, an ordered political state. Prospect, a word whose roots in English are the same as those of 'perspective', also carries the sense of time, of the future. What lies before the spectator's eyes also lies before him in time, it is a vision of the future. This new prospect necessitates a new way of seeing which is difficult for those to whom his letters are addressed. The reason for this, in Crèvecoeur's words, is that America 'is not composed of great men who possess everything, and a herd of people who have nothing'. Its landowners are yeomen farmers, cultivating their own land: 'some few towns excepted, we are all tillers of the earth' (Crèvecoeur, 1963, p. 61). This activity is the moral and social foundation of American perfection and Crèvecoeur continues in his letter to project the process of transformation of America from wilderness to landscape into a future when Americans will have completed the 'great circle', and subdued the continent. Crèvecoeur employs the terminology of landscape available from eighteenth-century England to underscore the American themes of productive potential and egalitarian perfection in landownership, implicitly criticising European landscapes by contrasting them with American. It is the fact of cultivation rather than appropriation which is significant, a point worth recalling when we examine contrasting views of eighteenth-century English garden design, for as he later states the original settlers – the hunters, trappers and wild men of the frontier, those most directly engaged with American nature – are not the true Americans. The virtues of the new nation are to be found, as Jefferson was later to put it, in the hearts of those who labour in the earth.

176

The Land Ordinance: American Geometry

The similarity of Crèvecoeur's views and those of Thomas Jefferson has been pointed out by Leo Marx (1964) who identified in them what he has termed the pastoral basis of American thought. Crèvecoeur wrote for a literate European readership. Jefferson, with similar transatlantic connections, was in a position directly to articulate American ideals and influence land settlement and the design of that 'extensive scene' whose future Crèvecoeur had celebrated.

Once it had brought under its control the various land claims of the individual states, the federal government established a committee in 1794 'to devise and report the most eligible means of disposing of such part of the western lands as may be obtained of the Indians by the proposed treaty of peace and for opening a land office' (quoted in Pattison, 1957). Jefferson was nominated to chair the committee, an entirely appropriate choice because more than any other single individual he had put into words the principles upon which an American agrarian society as an extension but radical transformation of European antecedents would be based. A signatory of the Declaration of Independence, a prolific writer on the nature of American democracy and a participant in designing the Constitution aimed at securing it, Jefferson also promoted the rational organisation of American institutions (for example the decimalisation of the coinage) participated centrally in designing the nation's capital and as the third president of the republic brought into the federal domain the largest single tract of land it ever acquired through his astute negotiation of the Louisiana Purchase. To focus our attention on Jefferson is not to suggest that he was responsible for singlehandedly designing republican America and its landscape but to employ him as a mouthpiece for a set of cultural norms which correlate with American yeoman capitalism.

To the congressional committee Jefferson proposed his own scheme of land survey, division and settlement, aimed at securing the kind of yeoman society outlined by Crèvecoeur. A single, rational allocation of land was to be imposed across the whole of the Old Northwest. Most critically, survey was to precede settlement, a survey based on the lines of latitude and longitude – that grid which harks back to Ptolemy's map and the spatial organisation of renaissance perspective and which had been promoted, with little success, in many American provinces before independence (Stilgoe, 1982). The land would be divided into 'hundreds', townships of ten miles square.

Jefferson was even disposed to redefine the length of the statute mile to match the meridians and allow simple subdivision. Survey lines would run north-south and east-west, and townships subdivided into lots of one mile square. At a continental scale America would resemble a vast Brunelleschi piazza. And it is important to realise how much this was a visual construction. The grid can only be appreciated fully from above or on a map. Indeed Stilgoe (1982, p. 106) comments on the difficulties that Congressmen and later surveyors and landowners had in understanding the grid, and that these were resolved by recourse to maps and other visual evidence. This was so from the earliest debates on the proposal: 'In speech after speech congressmen likened their land planning to a painting, to the making of a visual image ... Congress understood its work in visual as well as political terms.' The land policy in certain respects was the creation of a vast landscape painting which took for its theme popular democracy, a 'prospect' of which Crèvecoeur would have approved.

Township organisation and a low base land price were central to fulfilling Jefferson's social ideals. The township would be the basis of self-governing communities of independent cultivators. Like the rectangular states which, under the scheme, would come into being once 60,000 franchised settlers were established, the township would be responsible for a high proportion of its own affairs. It would organise public schools, churches and the militia. It would act as a check on the potential abuse of centralised power: the threat of absolutism was to be countered by the organised autonomy of freeholders. Low price would make American land the inheritance of all its children: a nation not of peasants but of free citizens, argiculturalists, 'the chosen people of God' because 'corruption of morals in the mass of cultivators is a phenomenon of which no age nor nation has furnished an example' (Jefferson, 1785, Query XIX).

The proposal radically attacks the still-feudal assumptions of European absolutism. The USA was to divest itself of all residual powers over land. Land would be held in fee simple, bought and sold freely, and remain forever unhampered by entail, restrictive covenants and other restraints on alienable individual property (Green, 1977). But it is equally anti-capitalist. It was drawn up in direct opposition to Alexander Hamilton's promotion of a strong central state which would sell the land to generate capital for its own investment in large blocks to facilitate the emergence of a landlord-

tenant system creating a class of capitalists capable of accumulating the capital necessary to generate a strong industrial and trading nation whose democracy would challenge the autocratic power of the European states. Jefferson distrusted the accumulation of liquid capital and fixed production plant and he spoke against the vision of America as an industrial nation, arguing that 'the young American Republic, richly endowed with land, must be mated with the pure damsel of agriculture, commerce is a vixen and manufacturing a diseased harlot beside her' (Jefferson, 1785, Query XIX). In viewing land as the only moral basis of wealth and status Jefferson turned his back on the progressive nature of industrial capitalism and revealed a decidedly pre-capitalist bias.

The details of Jefferson's plan were not accepted by his Committee. But the Land Ordinance Act of passed by Congress in May 1785 was similar enough to it to reveal the strength of Jefferson's advocacy and the appeal of his vision. The principles of prior survey, regular rectangular townships and lots and a low base price for land were all accepted. The six-mile-square townships surveyed west from the Ohio river were offered for sale by public auction, half as complete townships, half in individual lots. Although the price fluctuated over the following century there was a consistent attempt to keep it within the grasp of small farmers and throughout the nineteenth century a family could in theory set up a farm on a section, half-section or eventually quarter-section, eventually as little as 40 acres, for under $100. In all, nearly 1,000 million acres went to freeholders in this way, suggesting to many observers that Jefferson's use of those principles of rationalism and order to which humanism had appealed and which underlie the landscape idea had indeed been successfully employed to give back the land to those who worked it and thus to break the link between landscape and elite control.

In fact the attempt to create a social formation based in production on land held as property, neither feudal nor capitalist, was riven with contradictions. Land jobbers or speculators were a major impediment to its success. They bought up large amounts of land, later selling it off to smallholders at a profit, often waiting until improvements on surrounding land and developments in infrastructure and communications in the region had hugely increased its value. Small freeholders themselves treated their land as a commodity to be improved and sold profitably before moving on to another area to repeat the process. In Ohio in 1817 160 acre parcels of government land sold initially at between $2 and $12 per acre. With

improvements consisting of a rough log cabin and twelve to twenty acres cleared for cultivation they would fetch between $8 and $30 per acre. Ten to fifteen miles distance from a small town could reduce the value of a farm by 75 per cent (Jakle, 1977). In other words the principles of a market economy were rapidly established over western lands. For the state to have intervened to prevent speculation or to control the development of a land market would have compromised the central principle of freehold. Tactics like requiring residence or the building of a house within a fixed period after initial sale and reducing the minimum size of plot available were adopted but they could not overcome the reality of an open land market and its inequitable allocations which refused to acknowledge or operate according to Jefferson's moral precepts. The scheme did indeed spread a chequerboard of township and range across the continent, visible testimony to the largest scale attempt to design the landscape of a social utopia, but, in its assumption that merely by returning ownership and control to those who tilled the earth a perfect stable society would result, it was fatally flawed. It is not the relationship between human beings and the land that governs their social organisation, but ultimately their relationships with each other in the course of production. The social formation of the USA may have had distinctive traits, the yeoman farmer one of the most significant of them, but the underlying forces of the market in an emerging capitalism were ultimately more powerful than patrician ideals.

For travellers, tourists and the literati of Europe and the eastern, settled parts of the USA, the transappalachian lands could be regarded as the location of a great social experiment and a landscape, whose apperception was governed by the conventions of European taste. It remained a prospect. For Americans this meant it was always potential: they stressed the future order which would emerge from the present chaos of stump-encumbered fields and half-erected fences (Lowenthal, 1982). For Europeans the prospect suggested an already productive parkland or estate, but one subjected to certain aesthetic assumptions. These latter are treated in the following chapter. But there remains one further dimension of the republican landscape to be examined in the light of the landscape idea and its place in the American political system as an embodiment of its social formation, on which again calls to mind the heritage of renaissance rationalism. This is America's adoption of the 'great tradition' in architecture, particularly in the building of a capital for the new nation, the central symbolic landscape of the republic.

Palladian America and Washington DC

The democracy which the American revolution had brought into being could in Jefferson's eyes only be sustained by an agrarian yeomanry. It would be threatened by the centralised control of large capitalists or by the proletariat of overgrown industrial cities, those urban mobs who 'add just so much to the support of pure government, as scores do to the strength of the human body'. Jefferson's best known architectural work is therefore not surprisingly a monument to agrarian ideals. The design of Monticello, his home in Virginia, is based on his experience of French Palladianism and his admiration of Palladio's own geometry. Significantly, the temple form which he adopted had been restricted in English Palladianism to garden structures (Nichols, 1976). The patrician aspect of Jefferson's own life and character was strong: he was a rich slave-owning Virginian gentleman. But as Tafuri (1976) has shown, the aristocratic aspects of his Palladianism are modified by his manipulation of classical geometry to serve a range of practical inventions which reveal how an elitist architecture can be made to serve in a utilitarian and democratic context. The freedom with which Jefferson used the Palladian language, for example by substituting service wings for the pavilions in lateral porticoes stretching away from the main nucleus of the house, reveals a desire to strip classicism of its inaccessible aura and make of it the characteristic architecture of a free society, one nevertheless founded on enduring values. The same has been noted of his house designs at Battersea, Farmington and Poplar Forest. In designing the campus of the University of Virginia at Charlottesville, Jefferson integrated a series of individually styled pavilions, each a self-sufficient nucleus of learning, into a formal, rational conception by joining them to a continuous portico and centring the whole U-shaped mass on a domed library which followed strictly the rules of classical architectural grammar. The whole was integrated into a landscape of sloping terraced lawns, and referred to by Jefferson as an 'academic village', a pedagogical equivalent to the agrarian community. His attention to the relationship between building and landscape owed a direct debt to Palladio. Through Jefferson's influence and that of architects like B.H. Latrobe and William Buckland, Palladianism became a national style for early American public buildings (Nichols, 1976).

The prime architectural symbol, however, of American political ideals inscribed in architecture is the landscape of Washington DC,

181

Figure 6.1: Engraving of the Street Plan of Washington DC by P.C. L'Enfant (1792)

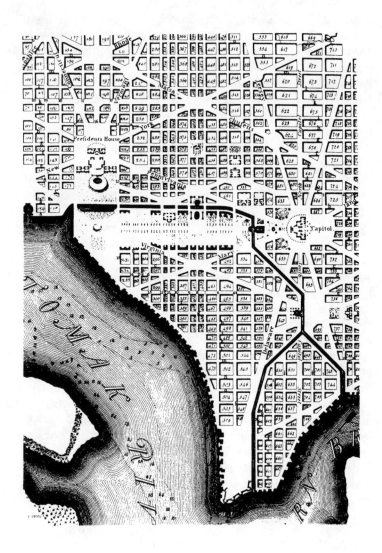

laid out across the Potomac from Monticello. Here the Palladian geometry of classical architectural form and Enlightenment rationalism, united to express the balance of freedom and order in the new

world, reached their clearest articulation, although Jefferson himself regarded the plan by the French architect L'Enfant as too grandiose for his tastes. Indeed at first sight the great axes of the Washington plan appear to owe more to the autocratic perspectives of European absolutist capitals than to democratic ideals. In fact L'Enfant combined the freedom and flexibility of building blocks developed in the simple grid of the colonial city from William Penn's plan for Philadelphia with grand radial axes derived from Le Nôtre's garden designs produced for the most absolute of absolute monarchs, Louis XIV. L'Enfant's overlay produces 15 urban nodes, representing the 15 states of the Union at the time of the plan's inception. The division between the executive and legislative arms of government is expressed by locking the White House and Capitol buildings together at the extremities of a great L formed by axes at whose intersection now rises the Washington Monument: a single white obelisk symbolising the foundation of the republic. Executive and legislature are linked directly by the diagonal of Pennsylvania Avenue, named appropriately after the 'keystone' state (Tafuri, 1976). Within the simple formalism of the plan large areas of open space and great freedom for the location and design of individual buildings make for a garden-like feel to the city, a structure of open lawns and statuesque buildings. In the heart of today's Washington it is still possible to achieve the sense of a grand formal garden replete with classical statuary – a villa garden at the controlling centre of a pastoral landscape drawn at continental scale. The major public buildings and monuments of the city have to the present century adopted classical forms – the Jefferson and Lincoln memorials, for example – accepting it as the appropriate language for the icons of the American Union. The city symbolises the enduring and transhistorical permanence of the republic's foundation. It appropriates perspective models developed in the Renaissance and refined under European despotism and absolutism and transposes them to symbols of a democratic, agrarian republicanism, making of the city a new nature, just as America itself was a new nature and a new, more natural society, and a landscape.

The Wilderness and the West

The spread of white settlement West, anticipated in the Land Ordinance, dominated the American nineteenth century. In global

terms the movement west was a dimension of the increasing scale of capitalist penetration from a north Atlantic core, dominated by markets for food and raw materials in Europe and the eastern United States. Great staples – wheat, cattle, gold – accelerated the development of continental America as pioneer wagons and railroads pushed first into the Louisiana Territory and, within a few decades, across the vast blocks of land purchased or annexed by the Republic as far as the West Coast. Included were hugely varied environments, topographically, climatically and ecologically, and with them contrasting human habitats and communities. All were uncompromisingly subjected to the demands of agricultural and industrial capital, producing an empire of continental dimensions.

Of the cultural attempts to capture the spirit and scale of this enterprise, the poetry of Walt Whitman is the most dramatic. His 'Songs' capture also some of the tensions between primeval wilderness and cultivated garden (Nash-Smith, 1950) and between high culture and popular experience that we have already noted in the American landscape idea. Whitman could hymn the praises of the Redwood Tree (1874) while celebrating also the Broad Axe (1858) that was felling it for industrial wood and new land. America was landscape, a vast panorama to be viewed in awe, and yet a localised experience: 'But each man and each woman of you I lead upon an knoll . . ./. . . pointing to landscapes of continents and the public road' (quoted in Huth, 1957, p. 3). For Whitman and for many of his contemporary poets and painters America was wilderness at a scale unimaginable in Europe and of a purity and pristine beauty that gave it a special moral power superior to Europe. At the same time Whitman points us to 'the public road' – survey track or railroad track – probably the most telling symbol in the American scene of that restless energy, mobility, expansiveness and popular access that characterise the experience both of American pioneering and settlers in the last century, and of capitalism itself (Jackson, 1970, Lowenthal, 1982).

At the time of independence American literary culture was European dominated, as we saw with Crèvecoeur and Jefferson. American writers and painters turned to European models for their themes and images (Taylor, 1976). Italy, for example, remained a place of pilgrimage for its history and classicism and, as in England, Claude offered to American painters a structure through which to see landscape. An artist like Samuel Morse could turn the *View from Apple Hill* in 1820s New York into a landscape barely distinguishable

from a prospect of the Tiber and the Roman Campagna, while George Loring Brown was referred to as 'Claude' Brown because of the parallels to the French painter's landscapes in his own way of seeing. Other native Americans like Benjamin West and John Copley actually settled in Europe, practising an academic art and seeing little future in painting an American experience.

But romantic ideas of sublimity in nature and freedom from a closed academic tradition, while a sophisticated European product as we shall see in Chapter 8, allowed American painters and writers to draw upon their European connections while discovering both a genuine response to their own primeval land and a sense of community with American popular experience and the culture that was emerging out of the making of America. This was a culture that valued the ordinary, the homespun, the vernacular (Taylor, 1976) and was powerfully influenced by moralistic and revivalist themes such as appeared in the Great Awakening of the early eighteenth century and again in the many religious communities that made the trip west to create their own utopia (Zelinsky, 1973, Sutter, 1973).

From their discovery Niagara Falls had been regarded as a spectacular American natural phenomenon, a place to marvel at, a 'sublime' experience (Huth, 1957). With time many other natural wonders joined them: Trenton Falls, Mammoth Cave in Kentucky, Grand Canyon and Yellowstone (Jakle, 1977; Graber, 1976). The idea of sublimity in nature I shall discuss more fully below, but for now it is sufficient to note that by the 1820s and 1830s the idea of romantic landscape had invested scenes of wild grandeur with a special significance. They were held by many to be places which declared the great forces of nature, the hand of the creator. In them humans could commune directly with God and feel the unity of Divine purpose and human insignificance. In the context of a religious tradition which stressed individual salvation, the idea of sublime wilderness offered a powerful opportunity for transcendence, a way of appropriating America as a distinctive experience unavailable in Europe. It gave to primeval America, particularly the vast western expanses of mountain, forest and desert, a particular moral force. Initially, among painters of the Hudson River School (Thomas Cole, Asher Durand and others) and among the New England transcendental writers (Henry Thoreau and Ralph Waldo Emerson), it was a fairly tame and relatively humanised eastern landscape in the Appalachians and New England mountains that the virtues of American nature were found and recorded (Taylor, 1976; Novak, 1980). But writers

185

like Washington Irving and James Fennimore Cooper were able to project the image west and in popular tales of Leatherstocking, Cooper locked it into an image of the pioneer, an unsophisticated, homespun American whose finest characteristics came precisely from his contact with the wilderness (Nash-Smith, 1950). Already by 1829, in a poem dedicated to Thomas Cole, William Allen Bryant could declare a special solemnity in wild, western landscape:

Lone lakes – savannas where the bison roves –
Rocks rich with summer garlands – solemn streams –
Skies where the desert eagle wheels and screams –
Spring bloom and autumn blaze of boundless groves.

(Quoted in Huth, 1957)

The west was spiritually pure, superior to a decadent Europe. While the broad axe and the steel plough might subdue it, the experience of being in it would purify human society, a theme which Frederick Jackson Turner would later take as the guiding principle of American history, an ideology that fused European romanticism and American homespun into a justification of a continental imperialism. Artists accompanied the explorers and surveyors of the American west; Albert Bierstadt, for example, whose huge canvases proclaimed the monumental environment of the Rocky Mountains' gloom and glory, finding in realist landscape the sublime themes that English artists like John Martin produced in fantasy biblical landscapes of flood and fire (Plate 10). The search for the sublime in American landscape led others, notably Frederick Edwin Church, to the tropics of Central and South America to paint volcanic eruptions and towering rain forests. Both Bierstadt and Church stand at the point where geography takes over landscape from the hands of the painter – from the US Geological Survey for whom landscapists produced topographical records came the work of William Morris Davis; and Church's tropical work was inspired by the writings and travels of the great German cosmographer and geographer, Alexander von Humboldt (Bazarov, 1981; Bunske, 1981). The significance of this I shall explore in detail in Chapter 8; it is a theme in which American experience parallels that of Europe, not surprisingly perhaps for by the end of the nineteenth century the USA was an industrial capitalist state, sharing a core location in the global economy with western Europe.

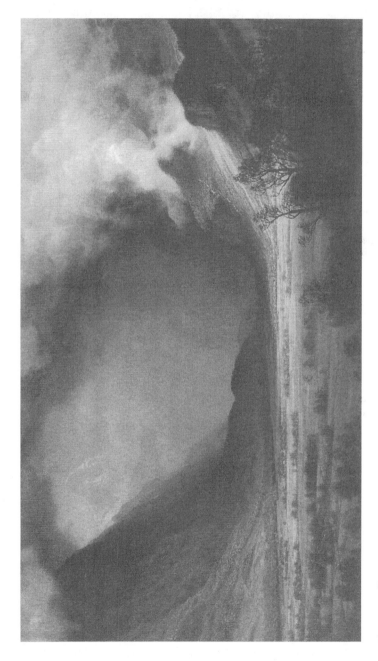

Plate 10. Albert Bierstadt: *Storm in the Mountains* (Courtesy, Museum of Fine Arts, Boston, M. and M. Karolik Collection) M. and M. Karolik Collection)

The ideas of perspective and the rational ordering of space stand at the origins of America, in the maps of Toscanelli, and at the pivot of its republican ideals, in the rectangular grid of the rural landscape and the blocks and axes of Washington. The United States represents an attempt to escape the trajectory of European social development out of feudalism and towards capitalism. But it is an attempt at the level of ideas and institutions. Rather than an escape from the transition, the American social formation of the early republic represents an example of it, a particular combination of elements of the two modes, grounded in land as the overwhelming factor of production and of social definition. Once that new land was settled American capitalist development increasingly paralleled that of Europe. It is not surprising, therefore, that the key elements of the landscape idea should also find such powerful expression in the design of American space.

7

England: Prospects, Palladianism and Paternal Landscapes

The seventeenth century in Europe was the era of the absolute state – the sovereign territorial unit organised by politico-legal coercion from a centralised and militarised summit personified by the King and focused in the elaborate ritual of the court. It was 'a redeployed and recharged apparatus of feudal domination' (Anderson, 1974b) and its most identifiable landscape expression was the rigid application to its royal capital of baroque geometry and perspective. The ritualistic and symbolic aspects of Baroque urban landscape we have already discussed, equally significant in the designs of second generation ideal city theorists like Vincenzo Scamozzi at the turn of the seventeenth century was the concern for defence and fortification. In an era of large standing armies, the *sine qua non* of state power, and of rapid advances in the technology of artillery, the complex bastions, interlocking walls, moats and earthworks occupying up to half the planned area of the city become readily explicable. John Hale (1977) has stressed the practical nature of late renaissance fortification, disputing its symbolic significance. But the two were not necessarily mutually exclusive. At a time when the practical and the symbolic were not consciously separated and when exact geometrical proportions still held cosmological significance, the military advantages of Palmanova as a defensive fort against Austrian armies or of the great avenues of Versailles as potential lines of fire against a subversive mob confirmed rather than denied their correspondence to the architecture of the created order.

In England the period of absolutism was both brief and limited. On the broadest interpretation it lasted from the later years of the Tudor ascendancy to the Civil War. The reasons for its brevity and overthrow at precisely the moment of its strongest grip elsewhere on the continent are numerous and complex, but they are closely related

to the success in England of the first bourgeois revolution and the subsequent emergence there of the first truly capitalist social formation. For this reason alone the course of development which the landscape idea followed in England between the seventeenth and nineteenth centuries is worth pursuing in some detail. In fact an ideology of landscape was very much a part of the discourse of the English ruling class throughout the period and in this chapter I shall examine how the landscape idea emerged in England out of continental roots and how it was developed over a period of rapidly expanding agrarian capitalism in the eighteenth century.

The Failure of English Absolutism

The reasons for the short duration of absolute monarchy in England include the concentration of the Crown's military interest on naval power rather than the building of a large land army, a function of England's geographical position; the ability displayed by the English parliament in limiting the fiscal autonomy of the monarch; and the small scale of the executive bureaucracy which limited the opportunity for acquiring offices on the part of members of old feudal families. But we should pay particular attention to the role of the Crown as a landowner (Anderson, 1974b). Monastic lands appropriated by Henry VIII could have offered a major source of revenue to the sovereign, free of the fetters imposed by the needs of recourse to parliament. This potential was realised in a once-and-for-all way by Henry when, in order to raise cash for his continental military ventures, he alienated the larger part of these lands to the aristocracy and gentry. By the time of his death two-thirds of the lands had passed out of the estates of the Crown, and under Elizabeth yet more was sold off. The recipients of this land were by no means all 'new men', men from outside the ranks of the feudal ruling class who had made their fortunes in trade or commerce, but a substantial number were. Even so, by the sixteenth century the English aristocracy was losing its traditional feudal *raison d'être* as a military landowning class. It was stratifying into two groups whose origins were slightly different but whose interests were not strikingly divergent: the patented peerage sustained by hereditary title through primogeniture, and a larger group of untitled gentry and the younger sons of peers which came to dominate the House of Commons. 'The idiosyncracies of the English landowning class in the epoch of Absolutism were thus to be

190

historically interlocked: it was unusually civilian in background, commercial in occupation and commoner in rank' (Anderson, 1974b, p. 127).

Because of this a relationship between landowning and commerce unthinkable in France or Spain and in a way reminiscent of that existing in the Italian medieval communes could be developed and maintained in seventeenth-century England. It was aided by the substitution of naval for land warfare in English policy which both undercut one of the main activities of a feudal aristocracy – mounted combat – and yielded a dual purpose institution: ships could be, and were, alternated between military and commercial uses. Any remaining interest of the nobility and landowning class in military affairs was not therefore antagonistic to the interests of urban merchants, indeed they were mutually supportive. The latter provided markets for the wool produced on enclosed estates, often on formerly monastic land. From this and later from the exploitation of overseas colonial possessions, English mercantile activity assured for London a dominant role in the English economy. By 1630 the city possessed an unprecedented concentration of trade and manufacture, making it the most primate of all European capitals. Already it acted as a single market for agricultural produce, influencing the pattern of agrarian development and production over a wide area of southern and midland England (Yelling, 1978).

The large landowning class, no longer coincident with the titled nobility, benefited from the expansion of mercantile activity both directly and indirectly. Marriage with the scions of merchant families brought with it the profits from colonial expansion, for example from West Indian sugar plantations. Indirectly the sophisticated financial market generated by trade could be used to raise mortgages on land, providing the liquid capital for its consolidation and for agricultural improvement, made profitable by the large urban market demanding high value products like meat and cheese. Offices in government and rack-renting of Irish properties were also sources of income and capital for English landowners. In a period when the English peasantry and copyholders were fairly lightly burdened by taxes in comparison to their continental counterparts who bore the cost of large standing armies, and when grain prices were falling, there was little fear of social disruption in the countryside. Investment in land was therefore an attractive proposition. Accordingly short-term leases to tenants holding large acreages of increasingly enclosed land farmed commercially allowed for a gradual rise of rents and profits to

the landowner while the tenant was willing to improve his ground, seed and stock, secure in the knowledge that if he did so his lease would be renewed.

Thus by the mid-seventeenth century innovations in English agriculture were proceeding apace, often learned from the areas of most advanced farming in continental Europe, Lombardy and the Low Countries. Sir Richard Weston, for example, in the early years of Charles I's reign published a detailed account of Dutch agricultural practices and himself experimented with new fodder crops and floating water meadows (Huggett, 1975). Those agricultural 'innovations' so often popularly associated with the eighteenth-century agricultural revolution – enclosure, convertible husbandry, improved pasture, replacing fallow with fodder crops, the use of legumes and temporary leys, marling, liming and manuring, and selective livestock breeding – were all being practised by progressive farmers in different parts of seventeenth-century England. Men like Townshend, Tull and Bakewell were fine publicists rather than startlingly original innovators.

In this process of commercialisation and agricultural improvement it was of course the peasants who were squeezed – the yeoman farmers or copyholders rather than the freeholders, those who lacked the capital or acreage fully to participate in the accelerated commercial agriculture practised on large tenant farms. Some of course had themselves achieved the status of substantial tenants, but the majority saw their position eroded and their land slipping from their grasp as enclosure acts forced them to bear the costs of fencing and hedging while depriving them of crucial traditional sources of communal livelihood on the disappearing commons and alienated woodlands. In this context of rising debt and falling incomes it is little wonder that for many the ideal of the yeoman farmer and his freehold as it was emerging in America held a powerful attraction.

Landscape Prospects in Seventeenth-century England

The particular character of the English social formation and the failure of absolutism is reflected in the development of the landscape idea in seventeenth-century England. There is a complex inter-penetration of absolutist spatial organisation and Italian architectural and urban theories applied to the city in an attempt to legitimate Stuart rule. At the same time this period sees the landscape idea

employed in English poetry, drama and painting in the context of a broad landowning group divided between those who sought to defend and those who sought to undermine a centralised monarchy. In Sir Philip Sidney's *New Arcadia* (1590), written a century after Sanazzaro's composition of the same name, the following lines appear:

> a pretty height . . . gives the eye lordship over a good large circuit, which according to the nature of the country, being diversified between hills and dales, woods and playnes, one place more cleare, and the other more darksome, it seems a pleasant picture of nature, with lovely lightsomes and artificiall shadows. (Quoted in Turner, 1979, p.10)

This is one of the earliest English statements of the landscape idea, written about the time when the word 'landskip' first appears in the English language. Although Sir Philip Sidney's image owes a debt to those developed earlier in Italy, the term landscape itself comes from Holland. Peter Paul Rubens was probably the most significant populariser of the genre at the English court. His portrait of Charles I presents him as St George defeating the dragon on a Thames meadow near Windsor making an obvious link between the royal park and the divine authority of the king (Rosenthal, 1982). It was late in life that Rubens took up landscape as such but his work established what was to become the central iconography of the English landscape painting up to the mid-eighteenth century: the country-house and its prospect (Adams, 1979). His painting of the Chateau de Steen, his own Flemish country house, uses the panoramic view derived from Bruegel and reveals a productive scene harking back to the labours of the seasons. But this is no longer a generalised view over distant lands, the scene is given meaning by the existence of the chateau, the estate centre to the left of the picture where the master's family walks in the grounds. A mood of rural ease, productivity and abundance suggests the classical ideal of 'holy agriculture', 'Rubens encapsulates visually the idea of a country life in which the estate is fruitful enough to send spare produce to market, where nature gives up its treasures willfully, and where one has the added pleasure of rural sports like duck shooting' (Rosenthal, 1982, p. 14). Such a landscape is a fitting image for the estates of the English landed class in the seventeenth century. At the same time it could act as a metaphor for the state of the whole nation – a nation whose rural virtues keep it uncorrupted

by the strife of the towns, particularly an overgrown London, got rich and decadent on the fruits of trade – an octopus which Elizabeth herself had tried to circumscribe and whose army of vagrants, products of the new order of commercial farming on enclosed estates, caused fear in the upholders of established order.

The estate painting encapsulates the landscape way of seeing in which painting, language and nature become transferable one with another in their subordination to the 'lordship' of the eye (Plate 11). Looking from a vantage point over an actual prospect the writer or painter 'composes' it by arranging hills and dales, open champaigns and woodlands, light and shade, so that in perspective nature takes on the illusion of a picture, itself an illusion of nature constructed for the dissociated observer. The dual inversion of nature and art allows control over both. This is a structure which becomes increasingly refined over the course of the seventeenth century, producing a genre of poetry which availed itself of classical, specifically Virgilian, allusions to 'expound the orderly variety of the earth' and articulate a self-image to the English landowning class (Turner, 1979). In its early stages we can detect something of the ideology of Stuart absolutist yearnings.

The perspective which organises the view over a rural scene, composing and arranging nature into a harmonious order, carries a dual sense. One is the pictorial technique of realist representation of space already discussed; the second is the sense in which we use the word when we tell someone to get a problem 'in perspective'. In this second sense perspective meant the correct way of seeing the social, moral and political order of the world. Thus in Denham's poem, *Coopers Hill* of 1642, the Windsor landscape which Rubens had painted takes on precisely the supposed character of the king whose palace is located in it:

> With such an easie and unforced ascent,
> Windsor her gentle bosom doth present;
> Where no stupendous cliffe, no threatening heights
> Accesse deny, no horrid steepe affrights,
> But such a Rise as doth at once invite
> A pleasure and a reverence from the sight.
> Thy Masters Embleme, in whose face I saw
> A friend-like sweetness and a King-like aw,
> Where Majestie and love so mixt appeare,
> Both gently kind, both royally severe.
>
> (Quoted in Turner, 1979, pp. 36-7)

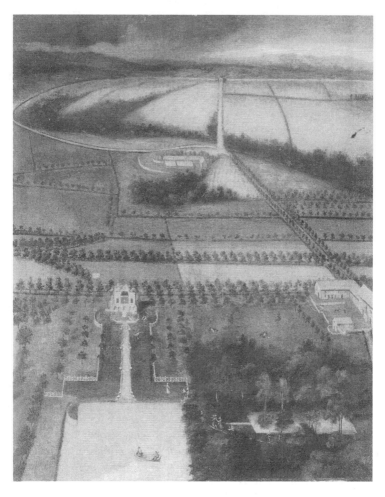

Plate 11. Unidentified Artist: *Yester House, East Lothian. View from the South* (Scottish National Portrait Gallery, Edinburgh)

Political and moral virtues are elided with aesthetics in a way which allows the landscape to be used either as a panegyric of the monarch or an attack upon those opposed to the object of the poet's admiration. It is the enemies of the king and of the order he represents who are associated with disorder or the dark side of the landscape, with craggy peaks, precipices and blasted heathland. It is perhaps fitting in a literary sense that the members of Cromwell's New Model Army were drawn disproportionately from the wastelands and woodlands of the kingdom.

The analogy between the rural estate and the state of the realm which is so frequently made in this poetry and in the country house picture reinforces the ideology of landscape in the service of absolutism. A well-managed country house and its lands form a self-sufficient world, a microcosm of the mercantilist state. The whole system is hierarchically organised, oiled by mutual co-operation between all its members, human and natural. But its harmony rests ultimately on its subordination to the care and authority of one all-powerful lord, as the harmony of its landscape depends on the lordship of the eye. The homology between the landowner's moral authority over his estate and the responsibility of the king to maintain a peaceful and harmonious kingdom is co-ordinated by the painter's or poet's eye – and ultimately that of the viewer or reader – ordering a pleasing and peaceful landscape.

Significantly one of the *landskips* that attracted the most widespread attention from poets and painters in the mid-seventeenth century was the view over the Thames at Greenwich. The focus of the perspective here was the Queen's House designed by Inigo Jones as a royal commission in 1616. In his work there and in his role as court architect to the Stuart monarchy we observe a direct link with the landscapes of the sixteenth-century Veneto and an example of ideas initiated there being refined in the service of English absolutism.

Inigo Jones: Palladianism in the Service of Absolutism

Jones was the first architect in England to achieve the status accorded to late Italian renaissance architects, of becoming more or less an

employee of the court, the official architect patronised by the Stuart queen, to whom royal commissions would naturally be awarded. Like so many of those earlier architects Jones was a man of broad and esoteric learning. He enjoyed the friendship of English poets and humanists like John Donne and Sir Henry Wotton and was closely associated with the theatre, designing stage sets for the court masques of the period, many of which, like Milton's *Comus*, took for their theme pastoral subjects thus requiring landscape settings. In the early part of his career he spent time in Italy studying at first hand the work of Italian painters and architects. During his second visit in 1613-14, immediately before fulfilling the commission for the Queen's House, Jones met and conversed with Vincenzo Scamozzi and toured the Veneto examining the Palladian palaces and villas. With Henry Wotton, then English ambassador to Venice, he made a collection of Palladio's drawings and publications. They obtained copies of *The Four Books of Architecture*, of V. Scamozzi's *Idea dell'architettura universale* and Daniele Barbaro's translation of Vitruvius with its illustrations by Palladio. Jones's intention was to introduce to England the most advanced architecture and he read deeply into late-renaissance architectural and perspective theory. His commitment to its cosmological assumptions is undoubted for Jones 'lived in a circle . . . for whom Plato's concept of universal harmony founded on numbers was still an article of belief' (Wittkower, 1974, p. 62). That he regarded Stonehenge as a ruined Roman amphitheatre and attempted to analyse its harmonic proportions is entirely in keeping with these beliefs (Summerson, 1966). The Queen's House in fact was based upon the plan offered in the *Four Books* of the Palazzo Chiericati which faces the open piazza at the eastern entrance to Vicenza. A later plan for the renovation of St Paul's cathedral in London is partly an interpretation of the motifs used by Palladio for the Basilica in Vicenza.

One of the intentions of James and Charles was to create in London a capital whose architecture was appropriate to the supposed magnificence of their rule, the equivalent of what Bernini was constructing in Rome. For this Jones as Surveyor at the Office of Works was the chosen architect. His scheme for Whitehall, if realised, would have seen the projection of absolutist control over the central public space of England. The intention of his designs and those of John Webb, his successor as Surveyor, was to impose a Palladian Roman classicism and the language of universal order across the whole area surrounding the Palace of Westminster. Royal

prerogative would have dominated architecturally and symbolically over the expression of parliamentary government. That only a tiny part of the whole project, the Banqueting Hall, was realised, because of the ability of Parliament to refuse the funds and the inability of the monarchy to provide them, itself testifies to the weakness of English absolutism. The same may be said of Jones's other great intervention in London's morphology, the square at Covent Garden which, unlike its Parisian counterpart, the Place Royale, failed to achieve its planned status as an aristocratic enclave.

Palladian Landscape and the Whig Ascendancy

With the death of Charles I and the Parliamentary interregnum Jones's Palladianism and the associated courtly ideology were equally unpopular. The restoration architects, Christopher Wren and later Nicholas Hawksmoor and John Vanburgh, employed classical motifs in their buildings but in a practical, empirical manner rather than in the theoretical urbanistic way that Jones had used them. Under Charles II to be sure, grand-manner schemes of baroque urban planning were suggested, for example the designs by John Evelyn and Christopher Wren himself for the rebuilding of London after the fire of 1666, or Wren's other proposal for an English Versailles at Winchester. But they met with strong mercantile and parliamentary opposition respectively, and their fate illustrates again the failure of Stuart pretensions to absolutism by employing perspective as a means of reducing the landscape of the capital to a personal statement of control.

However, with the ousting of the Stuart family and the establishment of a secure constitution settlement wherein a protestant Crown was firmly subordinated to the will of Parliament, the interests of both the patented peerage and the gentry and rich merchant classes were served. The success of the 'glorious revolution' provided the political conditions under which landowning and mercantile groups could, through control of the Lords and Commons, jointly direct the English (soon British) social formation towards full market capitalism.

The estate landscape whose iconography had been refined during the seventeenth century (Adams, 1979) became in the eighteenth a critical arena of cultural production, and of cultural tension between fractions of the ruling class. Its most significant new aspect was the

adoption of a set of motifs which seemed to many to mark the decisive victory in England of liberty over absolutism and of property over fiefdom. The Palladian country house and its enclosed parkland of sweeping lawns, artistically-grouped trees and serpentine lakes offers a synthesis of motifs owing their origins to a range of sources: late renaissance Italy, classical humanism, the literary pastoral and the seventeenth-century French painters in Rome. The finest of these 'landscapes', the parks at Stowe, Stourhead, Castle Howard, Chatsworth, Blenheim or The Leasowes, have come to be regarded as representative almost of the very character of the English countryside (Lowenthal and Prince, 1964, 1965). From a rather different perspective they represent the victory of a new concept of landownership, best identified by that favourite eighteenth-century word, *property*. The ideology of English parkland landscape may perhaps best be introduced by examining the design and iconography of one example, among the earliest and best-preserved of all, the garden at Rousham in Oxfordshire.

Composing Landscape, William Kent at Rousham

In 1737 General James Dormer, landowner and intimate of Lord Burlington, the supreme arbiter of good taste in early-eighteenth-century England, took up residence in his house at Rousham some ten miles north of Oxford. Attached to the house was an early-seventeenth-century walled garden with church and dovecot. Looking east from the rear of the house was a classical garden in Dutch style, a symmetrical terrace of land sloping away to the serpentine course of the river Cherwell, offering extended views from the house over gently rising land to the north east. A road leading from the house front to a bridge over the Cherwell helped define a 15 acre site, including a paddock, which formed a less formal garden area. The shape of this area was triangular, narrowing to a few yards in width at the north where it met the bridge (Figure 7.1). The royal gardener, Charles Bridgeman, had already introduced some new elements into the relationship between the house and garden to the west, including surrounding the paddock with a ha-ha, or sunken ditch, which allowed for grazing cattle to appear within the bounds of the immediate area of the house, thus uniting productive with aesthetic land uses, a point of considerable discussion in landscape debates of the eighteenth century as we shall observe. But Bridgeman's work was completely overtaken by a second design which remains very largely unaltered today as an example of *picturesque* landscape

Figure 7.1: Plan of Rousham Park, Oxfordshire, by John Bridgeman and William Kent

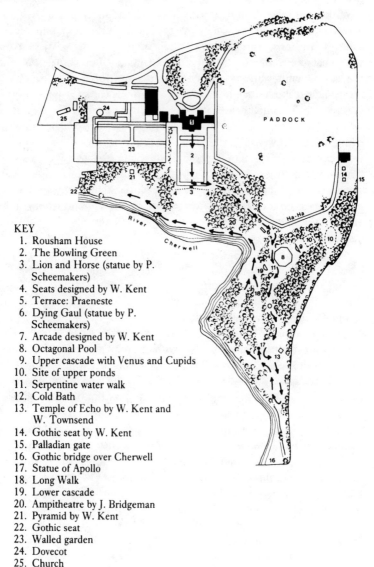

KEY
1. Rousham House
2. The Bowling Green
3. Lion and Horse (statue by P. Scheemakers)
4. Seats designed by W. Kent
5. Terrace: Praeneste
6. Dying Gaul (statue by P. Scheemakers)
7. Arcade designed by W. Kent
8. Octagonal Pool
9. Upper cascade with Venus and Cupids
10. Site of upper ponds
11. Serpentine water walk
12. Cold Bath
13. Temple of Echo by W. Kent and W. Townsend
14. Gothic seat by W. Kent
15. Palladian gate
16. Gothic bridge over Cherwell
17. Statue of Apollo
18. Long Walk
19. Lower cascade
20. Ampitheatre by J. Bridgeman
21. Pyramid by W. Kent
22. Gothic seat
23. Walled garden
24. Dovecot
25. Church
Arrows indicate the preferred direction of the garden circuit

Source: Based on a map in N. Pevsner and J. Sherwood *Oxfordshire* ('The Buildings of England Series'), Penguin (Harmondsworth, 1974).

gardening: literally the design of a garden and views from it to accord with the composition of a landscape painting.

For this second design Dormer employed William Kent, an architect and painter who had travelled extensively in Italy, attached himself to Lord Burlington as his patron and had already some experience of gardening. Like so many of his fellow English painters, the artists whose work Kent most admired in Italy were Claude Lorrain and Nicholas Poussin. The Claudian landscape, framed by coulisses and leading the eye via a series of highlights to a vanishing point at the horizon, became a formula for painting and landscape design, repeatedly copied in eighteenth-century England. Claude's popularity lasted through the century – a work of his sold for £223 15s in 1754 fetched £6,300 in 1806, and painters like George Lambert and Richard Wilson used Claudian composition and colour tones in paintings of British landscape, rendering familiar scenes in a warm Italian luminosity.

At Rousham, Kent literally recreated a Claudian landscape in the reality of lawns, trees and controlled views within and beyond the garden. His scheme produces a circuit which, when followed, presents a recurrent landscape image and composition in which the spectator participates, employing skills of associative sensibility. Beginning at the house, the primary view is determined by a wide bowling green stretching away and terminating where the land slopes steeply to the river (Plate 12). This point is marked by a centralised sculpture of a horse being attacked by lions. Woodland coulisses frame this perspective, their role emphasised by ornamental seats at the corners of the lawn. Beyond them the slope has been hollowed out to exaggerate the drop to the Cherwell, cutting out the middle ground and extending the view into the distance. In the middle distance a mill house was given stepped gables and flying buttresses to resemble a ruined chapel, and on the horizon Kent designed a completely sham arch of three tall arched lights and a decorated gable suggesting a medieval monastic ruin. Under the moist and suffused light of an English sky the scene is astonishingly effective as a living painting.

It has been suggested that its resemblance is closer to the design for a masque setting by Inigo Jones and titled 'A Peaceful Countryside' than to a Claude, because of the English rather than classical allusions made by 'Gothick' eyecatchers. But the structure of the landscape is clearly Claudian and the motifs *within* the garden are all Italian. The lion sculpture which forms the primary focus of the

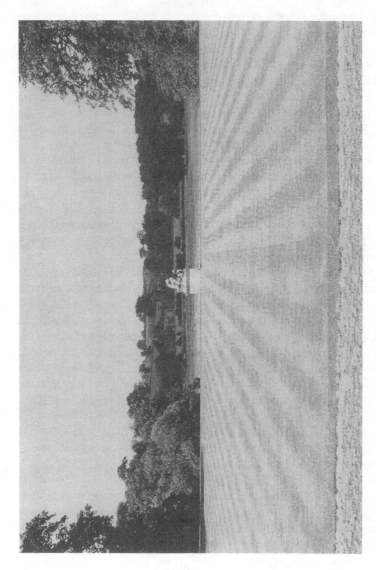

Plate 12. The Bowling Green, Rousham House, Oxfordshire

view from the house is a copy of a group in the garden of the Villa d'Este at Tivoli overlooking the flat Roman *campagna*, a favourite subject of Claude's landscapes. This combination of classical and "Gothick" allusions suggests that Kent's set piece at Rousham is a response in part to that growing demand in this nationalistic period following the Union of the English and Scottish parliaments and the defeat of France at Blenheim that pastoral poetry and art should reflect more of the reality of the English countryside (Barrell, 1980). In Horace Walpole's words, 'our ever-verdant lawns, rich vales, fields of hay-cocks, and hop-grounds, are neglected as homely and familiar objects' (quoted in Barrell, 1980, p. 7). The Gothic eyecatchers stand *outside* the garden, in the unadorned English countryside. Gothicism was a widespread and attractive literary genre which argued that a revival of western civilisation had emerged from the union of the antithetical principles of Roman authority and Gothic liberty. Its ideals fitted perfectly British nationalism and the constitutional form which had emerged from the events of 1689. Kent's use, therefore, of both classical Roman and Gothic allusions in the Rousham land-scape can be read as a statement of perfection in the English landscape – a reflection of the legitimacy of those like General Dormer who ruled over it. In the garden itself the owner revealed his own taste and educated sensibility: the eye was led out over a scene associated with the Roman *campagna*, but into an unmistakably English landscape, consciously alluding in its architectural ruins to the traditional freedoms of Britain.

Having set the first formal picture, the garden circuit continues through a series of closures in planted woodland each containing further pastoral and classical references: Venus' Vale of pools and fountains and woodland gods, a statue of Apollo, and a seven-arched structure called *praeneste*, modelled upon the Temple of Fortune at Palestrina, another favoured spot for English tourists from which they could enjoy views over the *campagna*. Between each of these wooded enclosures the garden opens out to reveal less formal views over the Cherwell to the countryside outside. In these the visitor can *compose* a personal landscape, aided of course by the surrounding associations. Nearing the north end where the garden narrows the visitor has a prospect of the medieval bridge and again of the distant eyecatchers, now differently juxtaposed into a final composed landscape. On the return lower path all views are inwards, giving new angles on the

elements of the garden such that it 'pleasingly confounds/Surprises, varies and conceals the bounds', as Pope had recommended.

The principles of the picturesque as revealed at Rousham invite the spectator to exercise individual control over space by composing landscapes through the selection of those elements which go to make up a pleasing picture of nature and excluding those which do not. In this the initial compositional rules are provided by the first view from the house and *associations* are suggested with literary, historical and geographical references and through them to moral and political ideas. The viewer thereby assures himself of his own sensibility and taste, confirming that 'all nature is a garden' which reveals the stability and perfection of English civilisation.

Kent's success was recognised by Horace Walpole:

> When the view was less fortunate, or so exposed as to be beheld at once, he blotted out some parts by thick shades to divert it into variety, or to make the richest scene more enchanting by reserving it to a further advance of the spectator's step.

But the spectator moves from this composition to create his own 'rich' and 'fortunate' landscapes as he moves through the garden. He is now become the artist, and the inversion of nature and art is complete, visual control over the actual countryside secure.

In renaissance aesthetics, from Alberti to Inigo Jones, nature contained objective principles of proportion and harmony which art, in capturing natural beauty, was obliged to follow. In Denham's landscape we saw nature as the illusion of a picture, itself an illusion of nature. At Rousham we are asked to create nature as a picture – literally and theoretically – because all is illusion. This mystification was well supported by English psychological theories in the early eighteenth century. In David Hume's words 'all reasoning is nothing but a species of sensation'. Beauty, which the renaissance theorists had taken as an objective category to be realised according to determinate rules, these Englishmen argued could be apprehended subjectively (Wittkower, 1974). Pope puts it as follows:

Those rules of old discover'd, not divis'd,
Are Nature still but Nature methodis'd
Nature, like Liberty, is but restrain'd
By the same rules which first herself ordain'd.
(Alexander Pope, 'An Essay on Criticism', 1711, lines 88-91)

Pope is putting in terms of landscape art the same principle enunciated by Shaftesbury in *The Moralist*, that nature in its original (that is, unaltered) state belongs to the divine order – a point with which Alberti would not disagree – and that man as part of nature could *experience* its beauty *intuitively* – an argument radically different from renaissance theory. Intuition is not the same as reason, so that traditional aesthetic theory was effectively undermined by the new psychology. In part this may account for the increased emphasis in painting on aerial perspective rather than linear perspective and on painterly skills rather than *disegno*, suggested by the works of Claude and Rubens. Both techniques are intended to capture mood and feeling rather than to appeal to the rational mind.

The relationship between this new aesthetic and the English political settlement is clear from Pope's lines. Nature is like liberty in the constitutional form realised by the English revolution and secured in the Whig Parliament from 1715. The Crown remains the ultimate symbolic embodiment of order and authority. It is 'natural' and can be invoked by classical allusions. But it is restrained by Parliament, the guarantor of individual liberty. The individual in the case of the eighteenth-century House of Commons means of course the member of that fluid class of gentry landowners and wealthy merchants – men of *property*. It regarded its liberty as an inheritance from the Gothic period unavailable in the lands more deeply touched by classicism, and it was also 'natural'. It could be invoked as we have seen by Gothic references, but it could also be suggested by the informal, serpentine lines of garden design which opposed the rigidities of baroque gardening as it had been developed most effectively by Le Nôtre at Versailles. Their absoluteness was read as representative of political absolutism. English liberty on the other hand threw the weight of judgement on to individual taste and sensibility, in Shaftesbury's words 'that which is dictated by the senses as opposed to the reasoning faculties; it implies the spontaneous, instinctive, imaginative, the directness of emotional experience and also the aesthetic pleasures derived from sensory response' (quoted in Wittkower, 1974, p. 199). This ideology simultaneously opened up control over nature to all men, regardless of blood, lineage and nobility, while restricting it to those who possessed the property, education and refinement to make the correct 'associations' and the land upon which to reveal their taste: in the case of Rousham to those who had undertaken the Grand Tour, knew their Claude and

appreciated this iconography of Classical and Gothic buildings and the significance of the serpentine stream which led them out of Venus' grove.

Palladianism in the Town

That General James Dormer was such a man of taste is further revealed by the appearance of his name among the subscribers to Isaac Ware's 1738 translation of Palladio's *Four Books of Architecture*. This was the first accurate version of the work available in English which also faithfully reproduced the architectural drawings of the Italian original. It followed a number of less adequate attempts which had appeared with increasing frequency in the early years of the century. One of these, the 1715 translation by Giacomo Leoni was a stimulus to Lord Burlington's Italian visit, undertaken with the intention of visiting Vicenza and studying at first hand Palladio's work. Burlington, Ware's patron, purchased there ten copies of the *Four Books*, including four first editions. His role as a patron of the arts in early-eighteenth-century England, of music, painting, gardening and above all architecture, is well known. His intention was to bring about an English renaissance along the lines laid down by Shaftesbury in his letters of 1712: the development of a national taste and a national style consonant with the constitutional perfection of England. Burlington's wide patronage and his own practice as an amateur artist made him a key figure in disseminating the style of sixteenth-century villas and town houses as the fashionable model for English building:

> After 1720 England witnessed a revolution in architectural thought that within the brief period of less than a decade completely superceded the eclectic individualism of such great architects as Vanburgh and Hawksmoor and replaced it by an Italianate, strictly neo-Palladian classicism – or better, a combination of Palladio and Inigo Jones – a style that was deftly propagated at the expense of all other traditions. (Wittkower, 1974, p. 78)

Burlington himself designed a number of major architectural pieces: General Wade's house in 1733, modelled on a Vicentine

palazzo; his own villa at Chiswick, modelled on the Rotonda; and the Assembly Rooms at York where he used the full classical repertoire for a secular, recreational building used by the provincial upper class landowners. The villa at Chiswick above all was a masterpiece of architecture and garden landscape:

> It is an immaculate synthesis of ancient and modern masters: ancient Roman planning in the sequences of rooms via the Baths and Palladio's own designs influenced from ancient planning; proportions and elemental relationships from Palladio's own designs and from two of Scamozzi's own seminal villas: Molini and Pisani. (Harris, 1981, p. 18)

Like others of the small group of Palladians, Burlington laid out gardens and an orangery, placing temples at terminating points and turning the garden into a theatrical stage.

The success of these buildings in promoting Palladianism was complemented by its acceptance by members of his coterie like Kent who together with Burlington designed Holkham Hall for the Duke of Leicester, one of the best-known propagandists for the new agriculture, and Colin Campbell, architect of Burlington's own house in Piccadilly based on the Palazzo Porto-Colleoni in Vicenza. Campbell was responsible for publishing from 1715 onwards a series of lavishly-illustrated works entitled *Vitruvius Britannicus* which eulogised buildings in the new, severe Palladian style and gave details of their plans and elevations, demonstrating their adherence to classical rules in a series of finely engraved plates. Nothing like this handbook of aristocratic taste had been published before in England and in a period of acute consciousness of social status and of competition among the wealthy for its acknowledged acquisition, the aristocratic patronage of Palladianism revealed in Campbell's work, attacking the Baroque and praising Inigo Jones, made it an effective vehicle for promoting a stylistic hegemony in establishment building. Burlington's own joint publication with William Kent in 1727 of Jones's architectural drawings, with its 400 subscribers including many key establishment figures, served to strengthen the cause. Had their joint plan for a new Houses of Parliament, which survives as a series of drawings based on the Basilica at Vicenza, been realised, Palladianism would have been inserted as the symbolic architecture of Britain at the very centre of its constitutional landscape (Plate 13).

Plate 13. William Kent: *Laid-out wall plan for the House of Commons* (British Architectural Library, RIBA, London)

But it was the publication and wide distribution of cheap builders' handbooks with simple illustrations and rules for reproducing classical forms 'made easy for the meanest capacity' that ensured the success of Palladianism as a national vernacular for the English bourgeoisie, a dominant style in provincial towns and cities from Louth to Pershore, Hexham to Blandford Forum, built to house a burgeoning professional class of town dwellers. Every builder could, and most did, purchase a manual like William Halfpenny's *Practical Architecture* (eight editions between 1724 and 1757) or Batty Langley's *Builder's Compleat Assistant* (seven editions between 1738 and 1807) as a tool of the trade. Through the medium of these books an erudite and aristocratic idea was diffused into a national style at a time when speculative building on the land leased from larger estate owners was a prime source of income for many of those initially responsible for the style. The strength of Palladianism in the landscape of English towns lasted well into the following century:

> Palladian taste represents a norm to which classical architecture in this country returned over and over again ... Neither Adam nor Soane, nor the Greek men, nor the early Gothic men ever dislodged, or attempted to dislodge, the Palladian dogma ... to entirely supercede the traditional basis provided by the books and buildings of the sixteenth-century Vicentine probably never occurred to them. (Summerson, 1969, pp. 36-7)

It is important, however, to be clear of the differences between English Palladianism and the meaning that the same motifs had held for that sixteenth-century Vicentine and his patrons. On the face of it renaissance classicism, as the fountainhead of the forms and symbols employed by the architects of absolutism's baroque fantasies, was hardly appropriate to an English ideology of naturalism, simplicity and liberty. But as Wittkower (1974) has pointed out, Palladianism was in fact taken as the complement of the emotionalist appeal to nature which was being articulated in the English landscape park often by Palladians like Henry Flitcroft who designed the park temples at Stourhead and Stowe and laid out Windsor Great Park in the 1740s (Harris, 1981). Palladio's strict adherence to a pure Roman style, originally developed in the context of Venice's search for imperial legitimation, was in eighteenth-century England associated with the imagined moral and political perfection of *republican* Rome, before the Empire. These were the ancient peoples who had also

enjoyed informal, 'natural' gardens, free from the autocratic elaborations of the grand manner. It was similarly the period before the agricultural foundation of Rome had been destroyed by its imperial policies, as recounted by Virgil in the *Eclogues*, as the English literati knew from Dryden's 1690s translation. Therefore, like Gothick, a pure classicism as represented by Palladio was entirely suited to the expression of English liberty just as naturalism in the parklands of England signified good husbandry. It is notable that neither in Burlington, nor in Campbell, nor in the pocket manuals for builders is there any discussion of architectural theory. They were a codification of rules for the disposition of spaces and ornamentation. Palladio's treatise, unlike Alberti's and others is itself relatively free of theoretical discussion, taking a decidedly practical approach. His adherence to harmonic cosmological theory may have been evident to his patrons but it held no significance for Lord Burlington and his peers. They held a different theory of beauty from Albertian principles, as we have seen, and they simply translated Palladio's measurements into English feet and inches and reproduced his motifs according to rote.

Nature and Utility in the Palladian Landscape

Significantly, a strong focus of attention among Burlington's circle was the Palladian villa. It was this form, and particularly the Rotonda – the villa most closely identified by Palladio with views over open productive countryside – that was the most copied of all the designs from the *Four Books* and which finds so many echoes in the plates of *Vitruvius Britannicus*. Neo-classicism and naturalism were first worked into a coherent ideology by a landowning aristocracy investing heavily in increasing the productive yield of their estates, whether from peasants' dues on Burlington's Irish lands, or new rotations and improved stock on Thomas Coke's Norfolk acres. The ideology of 'nature' had a dual sense: England's constitution upheld the natural rights of men to liberty, it also upheld the right to private exploitation of nature in a very practical way. John Locke saw the right to *property* as one of the natural rights of man, and this right was enshrined in parliamentary legislation throughout the century, drumming through the 1700s, in Edward Thompson's apt simile, like the hoofbeats of a landowner's hunter.

But the uses of property were a source of some dispute, indeed

attitudes toward and the use of landed property became a mode of status identification in an increasingly sharply-graded polite society. An older, Tory aristocracy who upheld what they regarded as traditional values of squirearchy defended prudent husbandry, benevolence to those who worked the estate and in general a sense of *noblesse oblige*. It was such values that they claimed were lacking in newer, parvenu landlords, often Whigs politically, who had emerged from the merchant and professional class and often had married into land. Men like Lord Cadogan and Horace Walpole were said to regard their estates as commercial enterprises, openly exploiting their tenants and happily removing them wholesale as happened at Stowe or Nuneham Courtney in order to replace their village with a grand prospect of shaven lawns and aesthetically-grouped trees denoting their new found status and power, substituting taste and sensibility for chivalry and lineage. Landscapes designed by William Kent and Charles Bridgeman for Palladian houses like Lord Cobham's at Stowe, Lord Leicester's at Holkham or Lord Harcourt's at Nuneham Courtney came under attack from conservative apologists. Best known in this context is Alexander Pope's (1731) *Epistle* to Lord Burlington in which both the Palladian style and the new landscaped garden style were subjected to savage satire. Pope appeals to those same classical references to which Burlington and the Palladians themselves paid homage, but turns them into a critique of the new fashion:

> You show us Rome was glorious, not profuse,
> And pompous buildings once were things of use.
> (Alexander Pope, 'To Richard Boyle, Earl of Burlington', 1731,
> lines 23-4)

Use was counterposed to the extravagance of new houses and parks. Such extravagance was in fact a continental abuse, to be found in Versailles, for example, and therefore to be abjured in England. True sense, Pope argues, is not the sensibility of aesthetics, but the sense of long-established patrician values:

> 'Tis Use alone that sanctifies Expense,
> And Spleandour borrows all her rays from Sense.
> His Father's Acres who enjoys in peace,
> Or makes his neighbours glad, if he encrease;
> Whose cheerful Tenants bless their yearly toil,

Yet to their Lord owe more than to the soil,
Whose ample Lawns are not asham'd to feed
The milky heiffer and deserving steed;
Whose rising Forests, not for pride or show,
But future Buildings, future Navies grow:
Let his Plantations stretch from down to down
First shade a Country, and then raise a town.
(Alexander Pope, 'To Richard Boyle, Earl of Burlington', 1731,
lines 179-90)

The landscape itself becomes for Pope the embodiment of traditional values. Reference is back into the past (his father's acres), and to the long-term future, for forests represent a generational investment. The landlord cares for his cattle and horses, allowing both access to his lawns, and his tenants regard him as a kindly father caring for their needs rather than as an employer. By contrast to this feudal fantasy Pope attacks the domineering and wasteful estate of the *nouveau riche* upon which huge expense is lavished without care for dependants and often merely auctioneered away when tastes change.

In this argument over parkland design, utility and form we can see that landscape has become in eighteenth-century England a matter of moral concern. It was emblematic of many aspects of an emerging social order in the countryside, and of responses to that order, as the British social formation shifted towards capitalist relations of production, first in the countryside, later in the factories and industrial cities. In decoding this Georgian landscape aesthetic I shall concentrate on only two themes: the relationship it poses between land and labour and that between rural landscape and the city.

Landscape and Labour

The very act of projecting the garden, conceived in the static and framed illusory space of a picture, into the working countryside beyond, had the effect of making the countryside also a picture. All nature became a garden and thus a place of recreation under exclusive control. The principle of selection inherent in both the garden and the landscape painting could therefore be applied to the rural scene generally and a form of visual denial could easily be perpetrated on it. Examining the landscape paintings of the eighteenth century, John Barrell (1980) has shown how those who actually laboured on the earth were incorporated into the pictorial

convention. From the early years of the century there was a call for works which revealed the beauties of the English scene by imposing upon it the conventions of Claude and the literary pastoral. This answered to a demand for realism and a patriotism which we noted earlier. What is intriguing is to observe how bands of light and shadow which structure Claude's aerial perspective were employed to locate images of work and leisure: the labourers in the darker bands, the leisured gentlemen in the lighter (Barrell, 1980, p. 22). Each figure or group of figures has an appropriate place within the area which can only be articulated, can only become a painting, a 'landscape' at all, by being translated into a structure by which that area is automatically and necessarily perceived as a unified, orderly, harmonious whole.

Barrell stresses the concern in the early part of the century to present labourers, however hidden, as working cheerfully in harmony with nature rather as Pope would have them. They confirm an idea of 'merry England' with prosperous farm workers, never idle to be sure, but none the less well clothed and fed. The image confirms the comforting sense of paternal responsibility on the part of the landowner whose 'cheerful peasants' toil, but in doing so bless their labour and owe their happy existence to the care of their 'lord'. The paternalist principle had been enunciated by Shaftesbury in his *Soliloquy or Advice to an Author* (1702) when he proclaimed the perfection of republican Rome: 'In a Government where the People are Sharers in Power, but no Distributors or Dispensers of Rewards, they expect it of their Princes and Great Men, that they should supply the generous Part.' Providing models of taste and providing materially for those who laboured to keep them at their ease could usefully be conjoined by the landowner in an image of nature as a garden.

During the course of the century, as England's agricultural economy became ever more closely integrated into a capitalist system, as domestic outworking came to be replaced by factory production, as population increased and as the number of agricultural workers and smallholders unable to sustain themselves without some form of charitable intervention on the part of the parish grew, so, Barrell points out, the landscape idea altered. An increasing efficiency in extracting the agricultural surplus was paralleled historically by, on the one hand an increasing demand for realism in painting the English scene, and on the other a consequent need to deal in paintings with the results of change which realism would reveal: that

the rural poor were ill-fed, ill-clothed and ill-housed and subject to a short and brutal life of unremitting toil. One obvious pictorial resolution was to show only the 'deserving poor' who, while subject to the 'natural' laws of the market which impoverished them in making others rich, nevertheless continued to find work and sustain themselves and their families, gratefully accepting the occasional charity from their benevolent betters. This produced a surge of sentimentalism in late-eighteenth-century landscape painting. Another way was to alter the structure of the landscape itself by extending the meaning of naturalism.

Thus in the work of Kent's successor as the most fashionable landscape gardener, Lancelot Brown, creator of 180 different gardens and from 1764 Royal Gardener, the distinction between the garden and the landscape beyond, still evident at Rousham, totally disappears. All obstructions to the view from the house are cleared away and vast prospects of green pastureland with carefully informal groups of trees are created. Statuary is eliminated, and the trees themselves are selected from a small range of choice: elm, oak and beech, unlike Kent's wider and more colourful choices, and the curving forms of the landscape are reflected in serpentine lakes formed by damming streams. A mere five miles from Kent's Rousham is the huge acreage of Blenheim park where the enormous pile of Vanburgh's palace and its flagged courtyard give directly on to a landscape completely devoid of human figures and occupied only by occasional grazing animals. At Chatsworth a whole valley is similarly treated. Entering it even today one is overwhelmed by the arrogant assertion of total control in the vulgar classicism of the house and the subjection of the valley floor to a lord's parkland. There is a military feel to this scale and ordering of nature, a point relevant to Blenheim's owners and not lost on some commentators. Screened by well-placed trees is the 'model' village built for the labourers who invisibly maintained this country garden. At Chatsworth it goes by the condescending name of Edensor. Former villages were not infrequently razed and a settlement less obtrusive to the view from the house built for the estate workers. This is the case in another Oxfordshire landscape garden, that of Lord Harcourt overlooking the Thames at Nuneham Courtney. Here the village was rebuilt a mile away out of sight of the house along the new London turnpike. Only the church remained on its original site, reconstructed as a classical temple to whose mausoleum-like frigidity the lowly worshippers of Nuneham were obliged to tramp in order to attend divine service. It is

a huge irony, indicative of the strength of cultural control, that these barracks are still referred to as 'model villages'.

There was of course some recognition of the real implications of such ruthless extension of domination and control over tracts of nature running to the horizon. We have already referred to Pope's early protest. With the removal at Nuneham in mind, Oliver Goldsmith, in *The Deserted Village*, lamented its implications for what he imagined to have been an easily-paced, happy and peaceful former existence for the villagers. Such complaints represent for the most part a reactionary nostalgia for disappearing paternalism – a lost stage of pastoral innocence – or a fear of future discontent brewing among the poor against a capitalist agriculture, rather than a real understanding of the historical situation under which paternalism flourished, or a siding with those dispossessed by enclosure or emparkment.

The great, self-confident parkland landscapes of the mid-eighteenth century, Lord Egremont's Petworth or Henry Hoare's Stourhead, were prospects in a commercial as well as a visual sense. Livestock grazed the lawns and the unified stands of trees that marched across their distant boundaries could realise enormous profit when mature. But the people who produced these benefits, the 60 persons, for example, permanently employed to cater for Blenheim's 2,500 acres, are entirely excluded from its 'landscape'.

Nature in the City

Georgian Britain witnessed a significant growth in the population and area of its towns and cities. Such growth was not as selective as it was to become during industrialisation in the nineteenth century. Not only London and the great colonial ports (Bristol, Liverpool and Glasgow) participated, but a wide distribution of county and country market towns whose substantial houses built for the professional classes of provincial England reveal the geographical breadth of participation in the prosperity brought by overseas trade and agricultural improvement. Possibly the most novel product of this new wealth and its spread was the boom in recreation among the gentry and professional groups. This opened up a tourist traffic into the remoter parts of the British islands, a fact of some consequence for the landscape idea as we shall see in the next chapter. It also produced the spa towns, inland resorts like Tunbridge Wells, Cheltenham, Malvern and above all Bath, and later seaside spas, most fashionably Brighton. The spa was a new kind of urban form,

built for recreation and divorced from the traditional purposes and activities calling for expression in the urban landscape: politics, trade and commerce. It is not surprising that the naturalising of the city – turning it into a garden, a 'pleasing prospect' – should have found particularly clear expression in a town like Bath which offered precisely an escape from the city proper and from civic responsibility.

John Wood the Elder, the architect most responsible for the character of Bath's townscape as the quintessential Georgian city, appears to have accepted certain Vitruvian renaissance ideas, however originally his protestantism articulated them (Neale, 1974). In Bath he wished to recreate a Roman city, complete with Forum, Gymnasium and Circus, but also to reconcile his recognition of the pagan origins of these forms with his Christianity, and to celebrate and emulate the work of the Divine Architect. His resolution of these conflicting demands is expressed in his treatise of 1741 which emphasises, as renaissance theorists had done, the symbolism of the circle and the idea of ordered civil life as the essence of the city. But these were by no means the common assumptions of his time, indeed, as Neale (1974) has shown, Wood's design for Bath was precisely a protest against the lack of civic responsibility and dignity in what he regarded as a corrupt and degenerate city and we need to place his high ideals next to his more practical speculation in urban land and buildings. Surrounded by green hills to whose contours its classicism is always responsive, its crescents and terraces facing informal swards of parkland, Bath represents the country house urbanised rather than any expression of a truly classical urban concept. In this, Bath is characteristic of English urban aesthetics in the eighteenth century, and it represents a novel reconstitution of the urban idea.

By Wood's time Palladianism was as much a vernacular in the town house as it was accepted fashion in the country house of early Georgian England. In town, too, it involved principally a set of rules to be learned and applied, in this case to façades rather than to the organisation of urban spaces conceived as a whole, as a unity. In some respects this was fitting for the urban life of a burgeoning middle class who bought the leases on London estate houses, for example, in an individual and private way. The famed discretion of the Georgian terraced house which adopts a uniform frontage with its neighbours to either side can be read as a retreat from the idea of participation in a collective civic life. By the same token, civic life as the expression of power and authority radiating from the city to the

countryside has disappeared. Rather, the city is viewed as a product of the country, or at least of a set of attitudes and values still powerfully rooted in the idea of land as the foundation of wealth and status. In a very real sense of course this was objectively so. Family fortunes were sustained and enhanced, occasionally made for the first time, through leasing out land for building: the Bedford, Portland, Portman and Eyre estates in West London, for example, or those of the Dukes of Chandos in Bath or of Lord Derby in Liverpool. Leasehold as a form of land allocation in blocks to private speculative builders militates against an overall conception of the formal character of the city, and in preserving ultimate ownership in the hands of a large landowner while creating a market in land and property, it represents a form of capitalist ownership which retains minor remnants of feudal rent.

The form adopted by the new urbanism and refined over the course of the century reflects this denial of the role of the city as an increasingly autonomous centre of capitalist accumulation, market control and ultimately production, organising the life of the countryside. The grand axes and integrated spaces of the baroque city gave way in eighteenth-century England to the curving lines of crescents and circuses, just as the axial lines of the reflecting pool of Le Nôtre's gardens had yielded to the serpentine lakes of Brown's landscapes. The urban piazza has become a park, as in the Bedford estates of West London, so that the country house is urbanised rather than, as in the case of the Venetian villa, the urban palazzo being taken into the countryside. The supreme example of this develop-ment occurs at the end of the Georgian period in the Regency development of the Marylebone estate under the plan of John Nash (Figure 7.2). The lease on this land, to the north of the growing West End, held from the Crown by the Duke of Portland, reverted in 1811. The Prince Regent wanted a residence on the edge of the city and a processional route leading to it from the ceremonial centre at St James's. This was approved by Parliament in 1813 on the grounds of improved sanitation and the route pieced together in such a way as to avoid existing large town houses like Foley House, but to slice through poorer quarters. Unlike the Rue de Rivoli in Paris, to which it was often compared, Regent Street is not a grand axis of absolute authority, rather it is a routeway between the heart of the city and open country which deploys a linked series of crescents and squares to follow a compromise path, unified by the white-painted stucco of its classical architecture: a tribute to constitutionalism.

217

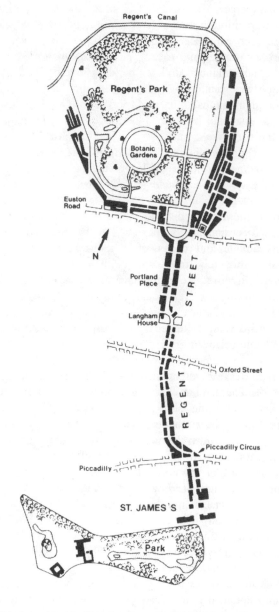

Figure 7.2: John Nash's Plan for Regent's Park and the Ceremonial Route from St James's

At its north end is Regent's Park, the original garden suburb built for the aristocracy. It was designed as a great country park surrounded by imposing terraces and planned originally to contain forty villas, each commanding its own prospect over the undulating lawns and serpentine lake of a landed estate while preserving its individual 'appropriation' of the scene, uncompromised by being overlooked (Chadwick, 1966). Although the number of villas was reduced in plan by half and in practice to no more than eight, although the national Valhalla at the centre was never built and although the park was opened to public access in 1838, it remained aristocratic in conception and use. As a German observer noted, one had to 'be a man of fortune, and take exercise on horseback or carriage' to enjoy the park, for no seats or shelters were provided (quoted in Chadwick, 1966, p. 32). Regents Park is very much a metaphor for the dominance of rural over urban values.

The social tensions produced and reflected by this urban form were real enough, and felt in polite society. Raymond Williams (1973) has shown how the construction of these great Georgian townhouses, with their necessary complement of vast numbers of poor people drawn into service by those who controlled and benefited from the vast monument to agrarian and commercial capitalism that London had become, produced an ambiguous reaction in the polite literature of the period. London's commercial power was duly fêted, its prestige and patronage properly celebrated, but at the same time a growing fear was expressed of the mass of potentially destructive people who had settled there and which not infrequently gained voice in the harsh tones of the mob, spurring Hogarth's moral indignation in etchings like *Gin Alley*, and Jefferson's in his comments on America's urban future. In urban planning, however, the social tension was evaded by treating the city as a pure form, as 'natural' and thus partaking of the virtues of the countryside rather than by integrating the design of urban space and architecture within a conception of a social utopia as had been attempted in earlier plans for the ideal city.

This evasion and the evolution of a theory of the city as a natural element finds clearest theoretical expression in French writers rather than British, although continental debts to British practice are perfectly clear. John Nash may have been the close colleague of Humphrey Repton, the turn-of-the-century's most successful landscape gardener, but it was the urban theorist M.A. Laugier who specifically acknowledges the debt to the landscape idea, quoting

approvingly the painter J.R. Cozen's *Hints on Landscape Painting* in his own urban work. But the debt to England is even deeper, for Laugier was a Physiocrat whose *Observations sur l'architecture* appeared in 1756 at the height of the physiocratic vogue for promoting England's agricultural achievement as a model for Europe. Physiocrats argued that a nation's strength rested on commercial agriculture. Quesnay, their intellectual leader, wrote in 1758:

> *Productive expenditure* is employed in agriculture, grass-lands, pastures, forests, mines, fishing, etc., in order to perpetuate wealth in the form of corn, drink, wood, livestock, raw materials for manufactured goods, etc.
>
> *Sterile expenditure* is on manufactured commodities, house-room, clothing, interest in money, servants, commercial costs, foreign produce, etc. (Quoted in Huggett, 1975, p. 91)

From this point of view the city was sterile. It could only be rendered productive through its relationship with agriculture and rural land. It had to be created *by* agriculture rather than be the organising centre for it. And from the point of view of the English landed gentry this was an entirely appropriate way of seeing the city, a product of agriculture not only in terms of providing a market for the products of their estates but also the place where land leases were arranged, the laws that secured their property upheld and where marriage and inheritance were to be secured during the 'season'.

Laugier's ideas on urban design articulate this idea of the city, making it a picturesque landscape:

> Whoever knows how to design a park well will have no difficulty in tracing the plan for the building of a city according to its given area and situation. There must be squares, crossroads and streets. There must be regularity and fantasy, relationships and opposi-tions, the casual, unexpected elements that vary the scene, great order in the details, confusion uproar and tumult in the whole. (Quoted in Tafuri, 1976, p. 4)

The city, in other words, is to be designed with the same attention paid to pleasing prospects and elements of surprise as nature itself in painting a landscape or designing a park. Co-ordination of the selected fragments is a purely visual act rather than theoretically founded as we have noted in English Palladianism, so that the regular

facades of Georgian townscape, which coexist with the often-noted lack of concern for rational disposition of rooms within the house or the appearance of the rear of terraces, is part of the same structural context that transformed the villa into the town house and the landscape park into an urban square. In Tafuri's (1976, pp. 5-6) words, 'the city falls into the same formal area as painting. Selectivity and criticism therefore signified the introduction into planning of a fragmentation that places on the same level, not only Nature and Reason, but also the natural fragment and the urban fragment'.

The consciousness of the English ruling class during the period between 1600 and 1800, when much of Europe was under absolute monarchial rule, derived in large measure from the realities of its peculiar combination of bourgeois individualism and utilitarianism with a still strong attachment to land as the basic indicator of social status and the most secure form of property. The tensions between bourgeois and feudal elements reveal themselves, for example, in the arguments over utility and conspicuous waste in the landscape park. The theory of associations and sensibility is at once individualist and strongly conformist, while appeals to the natural always suggest a rationalisation of the existing order as universally valid. But nature is very closely bound up with the idea of landscape, and landscape remains at root the creation of the outsider, a signifier of power and dominion over nature, and through nature over other men. Linear perspective, the logic of urban aesthetics and urban visual control, and the formalities of *disegno* are underemphasised in comparison to *colore* and aerial perspective, the logic of rural aesthetics and visual control over the countryside.

There is an interesting parallel to be drawn between eighteenth-century England and sixteenth-century Venice which is rendered more striking by the adoption of Venetian style in the form of Palladianism by the landed classes of England. Venice's patriciate was engaged in a fundamental transformation of economic role from mercantile to rentier activity. Many patrician families building their villas and patronising landscape painters combined substantial trading and financial investment with reorganising their agricultural estates along more profitable lines. On the surface their actions resemble those of English rentiers of the 1700s. Further, improvement in agricultural techniques was a common concern of both groups. Venetian agrarian capitalism was conducted with the practical spirit that had been applied to mercantile activity, ensuring that *commodità*

221

(the pleasurable aspects of villa life) was always related to *utilità*, just as Pope was later to demand in England. But for all these parallels there is a significant difference. While in the Veneto the urban palazzo and an urban conception of perspective and landscape was the primary model, translated into an agricultural context, in England the process was reversed so that a rural image, of 'nature', came to dominate the ideology of the city as landscape as it already dominated the countryside. In both cases the landscape idea is a vehicle for cultural production in social formations stretched between city and country, feudalism and capitalism, but the modalities of its use and the theoretical predilections that underlie it relate to the specific historical circumstances in which it was employed. In the case of Venice the urban origins of the landscape ideology fail to hide the regressive shift towards a second feudalism; in England its rural origins mask a progressive transformation into urban industrial capitalism. It is to the further elaboration of the landscape idea during the final stages of that transformation that the following chapter turns.

8

Sublime Nature: Landscape and Industrial Capitalism

In 1760 farmland constituted 47 per cent of Britain's national capital; farm buildings, stock and so on, 27 per cent of its domestic fixed capital. As a sector then, agriculture accounted for nearly three quarters of the nation's wealth while manufacturing industry represented only 7 per cent. A century later, of a greatly-expanded total, the contribution made by these two sectors had dramatically changed. Agriculture represented 36 per cent of Britain's wealth and manufacturing industry had risen to 24 per cent. Farmland's contribution alone had fallen to 21 per cent. These figures indicate something of the impact of the Industrial Revolution and of its implications for production, economic relations, and the role of land in the British social formation. The dimensions of the change wrought by industrialisation in terms of population growth, structure and distribution, urban form and social organisation, class formation and conflict are too well known to require repetition here. They were so dramatic and obvious that what is surprising is the success with which they were contained within an established constitutional, political and legal framework rather than that they brought enormous social and cultural tensions. The relative stability of the British state and its institutions in managing this transition to factory-based industrial capitalism for long lent an air of legitimacy to the conventional historiography of the Industrial Revolution as a continuous, progressive story of the nation's material prosperity and constitutional advance in which the new technology and the wealth it created appeared a triumphal act.

In recent years such a view has been challenged by studies emphasising the active involvement of ordinary people in a struggle to maintain wages, material welfare and moral values against the exploitive and alienating implications of the new form of social

organisation being forged in the factories and cities. From the perspective of historians like E.P. Thompson (1963) and those following his lead, the period has come to be regarded, in shorthand terms, as one of change from a *moral economy*, still founded on custom and attributed status as the dominant conditions of human relationships, to a *political economy*, founded upon contract and the status provided by access to capital and the means of production. Such profound changes in human relationships were bound together with the rapid penetration of new forces of production: steam power and the factory system, into critical areas of commodity production, particularly textiles and metallurgy, new transport technology in canals and railways; and the freeing of labour mobility by changes in poor relief legislation and organisation. Together these events justify the claim that the years surrounding the turn of the nineteenth century represent the culmination of England's transition into capitalism.

Outside England the political triumph of the bourgeoisie was achieved in Europe during the same years with far more revolutionary institutional change. Most obviously and influentially the revolution in France destroyed the form and legitimacy of the absolute feudal state. The Napoleonic armies undertook its destruction across the continent, from Iberia to Russia, and by the 1840s the durability of a post-feudal order in Europe was nowhere in doubt. The progress of industrial capitalism was clear, and it was assisted by new forms of state organisation.

Culture and Market Society

Despite apparent constitutional continuity these years were critical as a period of cultural revolution in Britain, as the designation 'romantic revolt', so often applied to them, signifies. In *Culture and Society 1780-1950*, Raymond Williams (1963) explores the links between romantic culture and the Industrial Revolution. He indicates five main changes at this time relating together events too commonly perceived as separate categories. These are the relationship between the producers of cultural materials (writer, poet, painter) and their audience; the attitude taken to the 'public'; the specialisation of artistic production as a subset of more general production and thus subject to similar conditions; the emergence of a theory of the 'superior reality' of art as the locus of imaginative truth; and the idea

of the artist as an autonomous, creative genius to whom a privileged status and rules of behaviour should be accorded. As the existence of a substantial and expanding middle-class audience came to constitute a 'market' for novels, poetry, paintings and engravings, so the significance of the individual patron or the collective subscription group declined. The poet or painter became a producer for this market, a professional or tradesman supplying more generalised and anonymous tastes than hitherto. At the same time what had been the mechanical arts, always produced by craftsmen for the public rather than patrons, were increasingly being located in the factories and their practitioners deskilled. The artist was becoming in effect a tradesman as the tradesman or artisan was becoming a worker, and the same market laws of supply and demand were coming to govern the products of both.

The response among poets and painters was both defensive, seeking to maintain the privileged status of their work, and offensive, attacking the alienated, mechanical operations of the new systems of production and their perceived dehumanising effects. To retain a privileged status the artist proclaimed that he worked, not for the immediately expressed demands of the market-place, the public, but for what Wordsworth called 'the People, philosophically character-ized, and ... the embodied spirit of their knowledge' (quoted in Williams, 1963, p. 51). In other words, a standard of excellence above the exigencies of popularly expressed demand was established by the artists themselves and by the *cognoscenti* of 'culture'. In appealing to it the artist was distinguished from the artisan who in manufacture increasingly obeyed certain mechanical rules of production. Critically, the artist continued to claim that his work appealed to, and expressed, eternal verities, a claim which we can trace at least back to the Renaissance. But this claim was now to be fulfilled by emphasising creative and imaginative truth, the products of unique artistic genius. This allowed a distinction to be made between that which grows naturally, the dynamic or *organic* – of which the products of genius were examples – and that which is imitated or mechanically reproduced – *manufactured*. The distinction was articulated with particular force by Thomas Carlyle in *Signs of the Times* (1829).

Romantics characteristically claimed that genius was organic, given not made, and that it produced its own rules for the creative search after an expression of imaginative truth. For this reason they attacked what they regarded as the rule-bound forms of classicism, whether expressed in the iambic pentameters and formalised language of

Augustan poetry or through the compositional structures and fixed genres of academic painting. The artist-genius could claim a revolutionary status: his creative imagination revealed the truths of common humanity against the falsity of a social order which regarded people as instruments of mechanical production. This revolutionary status could easily be carried through to support for political change as it was in varying ways by William Blake, Lord Byron and Shelley. The romantic insistence on the superiority of the organic serves to remind us that attitudes to nature were deeply implicated in this cultural revolution. Since creative artistic expression of truth was organic and society false and mechanical, the world of nature could and did take on a particular resonance, a significance which drew upon and yet transcended traditional enlightenment considerations of nature and their expression in the picturesque. A central idea thus transformed was that of the *sublime*.

The Sublime

To early eighteenth-century literati the sublime had been associated with the greatest literature of the past, with Homer, Dante, Milton, and above all the Bible. It denoted a state of mind, the highest and most serious that humans could achieve in recognising their mortal insignificance when faced with the evidence of Divine majesty – the 'awfulness' of God. Hugh Blair, a Scottish writer, protégé of Adam Smith, and member of Edinburgh's philosophical renaissance in the mid-1700s, claimed that the sublime

> produces a sort of internal elevation and expansion. It raises the mind above its ordinary state; and fills it with wonder and astonishment, which is certainly delightful; but it is altogether of a serious kind; a degree of awfulness and solemnity; very distinguishable from the more gay and brisk emotions raised by beautiful objects. (Quoted in Wilton, 1980, p. 10)

Holy fear, gloom and majesty, seriousness, infinity, exhaltation, vastness and grandeur: these are the adjectives of the sublime. Initially it inhered, not in natural objects so much as in works produced by the greatest human minds, those in almost direct contact with the Divine. Given the solemnity of the sublime, it could only be achieved in the highest artistic genres: in epic poetry, and of course

226

in God's words, inscribed in his ordained book. In painting it could be achieved, if at all, only in religious or historical works like Michelangelo's heroic panels in the Sistine Chapel. Landscape could hardly be regarded as a weighty enough subject for such matter and experience, certainly not if, in the Flemish tradition, it reproduced what Reynolds called 'the accidents of nature' – detailed empirical studies of particular locales. An ideal nature such as that found in Claude could fulfil the requirements of beauty, thus raising landscape to the level of art. Sublimity was beyond its ability to convey.

The sublime then was initially erudite and elitist in that it marked only the most elevated minds, hardly attainable by ordinary mortals who, like merchants and tradesmen, had limited time to contemplate the majestic verities of Pandemonium or the Inferno. But in the course of the eighteenth century, as the middle classes came to form an increasingly larger market for speculative writing, literature and the arts – popularised through periodicals like Addison's *Spectator* (from 1712) – the sublime was increasingly appropriated to their tastes and experience. This involved a subtle but significant change in its meaning and relations. We have already seen in Blair's words the sublime contrasted to the beautiful. The distinction was deftly defined and easily remembered. In Edmund Burke's 1757 categorisation the sublime was related to human passions of self-preservation or, in more contemporary terms, survival:

> Whatever is fitted in any sort to excite the idea of pain and danger, that is to say, whatever is in any sort terrible, or is conversant about terrible objects, or operates in a manner analogous to terror, is a source of the *sublime*; that is, it is productive of the strongest emotions which the mind is capable of feeling. (Quoted in Appleton, 1975, p. 28)

What Burke had done was to maintain the emotions associated with the sublime while altering the understanding of their source. He had removed it from the object: the great work of revelation or imagination, and given it to the human subject, not through mind but through the senses. The sublime was thereby rendered a common property of all people since, unlike mind for which we have no empirical measure by which to contradict a claim to superiority, the five senses are manifestly shared by all. Democratisation in this manner of the sublime allowed the middle classes to participate in its experience. Only later was this aesthetic of the senses itself mystified

by the notion of 'sensibility'.

But we should note also those 'passions' through which Burke claimed that the higher aesthetic experience of the sublime could be apprehended. They are those of self-preservation, survival instinct, which as Burke stresses are individual rather than social. And we should remember the intimacy between aesthetic theoreticians and the social and economic philosophers of market capitalism. Hugh Blair succeeded Adam Smith as lecturer in aesthetics at Edinburgh when the latter turned his attention to political economy. The ideology of individualist aesthetics and the passions of self-preservation wherein 'God and Nature fixed the general frame/And bade self-love and social be the same', was by no means lost on Karl Marx:

> The individual and isolated hunter and fisherman, with whom Smith and Ricardo begin . . . in no way expresses merely a reaction against over-sophistication and a return to a misunder-stood natural life, as cultural historians imagine . . . It is rather the anticipation of 'civil society', in preparation since the sixteenth century and making great strides towards maturity in the eighteenth. In this society of free competition, the individual appears detached from the natural bonds etc. which in the earlier historical periods make him the accessory of a definite and limited human conglomerate. (Quoted in Olwig, in press)

The most accessible of all the senses and the one to which so much empiricist philosophy was devoted was of course that of sight. If the sublime could be apprehended through the senses then it could be seen, not directly, but through the sight of those objects which excite the passions of self-preservation. Painting could therefore achieve sublime effects by its operation on the eye. This was originally approached by making painting the visual equivalent of the greatest episodes of history and literature. The composition of the work, its *disegno*, and the construction of the human figure could embody the exalted ideas necessary to human experience. Landscape could aspire to the same effects only if it was expressive of such ideas and not merely the record of accidental local effects. To express exalted ideas, landscape had to be generalised and humanised. In terms of the sublime Salvator Rosa rather than Claude was felt to have achieved this in his boiling clouds, precipitous chasms and rocky, clefted caves. In his rendering of the natural world he provided

that *frisson* of terror so central to the experience of the sublime. But such landscapes remained suffused with humanity, a classical or epic event still took place below the toppling cliff and nature remained in theory subservient to, and a mirror of, human action.

However, to make the step towards a sublimity inherent in the direct experience of the created world was not difficult. Indeed for an age whose ideology increasingly stressed individual experience and whose wealthy middle class had increasing opportunity to travel into the remote parts of a United Kingdom or across the Alps it was an obvious step to take. If sublime experience was to be had directly in the individual's communion with majestic natural forms, or vicariously in their poetic and artistic representation, then the elevating experience of the sublime was far more accessible than in labouring with the language of the classics or the grand cadences of Dante, Milton or King James's version of the Bible. As early as 1739 Thomas Gray was extolling the Grand Chartreuse as a sublime landscape. It expressed the immensity and infinity we associate with God: its dark, soaring mass and its vast solitudes inspired a readily-felt religious awe, a response encouraged by the medieval monastery hidden in its recesses. The literal truth of nature, of mountains and seas, of night and storm, was as inspiring as any epic. All that was needed was its realisation through the medium of art. In the course of the eighteenth century techniques were developed in painting and poetry which could achieve this.

It was a long-standing idea, related to the distinction between *disegno* and *colore* in Italian painting, that the design of a painting appealed to the intellect while its artistry struck at the emotions. This idea underlies Reynolds's academic appeal to the sublimity of the intellectual Florentine painters. As an emotional experience the sublime could best be expressed in the use of colour and medium rather than in pictorial structure. Painters like Richard Wilson and Alexander Cozens developed the skills of carefully observing and recording the details of natural forms, drawn with scientific precision, and of capturing their magnitude in vivid colour. Cozens particularly explored techniques of ink and water wash, of small hatching strokes, of mixing gum arabic and tempera with water-colours to give increased emotional force to his work (Wilton, 1980). The success of these techniques revealed that the sublime in landscape could indeed be rendered in paint, and further that this could be achieved in *plein air*, capturing the immediacy of transient natural events, with a

medium both easily transportable and readily accessible to amateur painters. These amateurs would increasingly employ drawing and painting masters to help them record their visits to the sublimities of British landscape in Wales, Derbyshire, Lakeland and Scotland (Rosenthal, 1982; Zaring, 1977; Walton, 1972). The combination of technical mastery and detailed scientific observation of the forms and processes of the natural world, and their expression in paint reached a peak in the cloud studies of Constable and in Turner's sea and storm paintings.

Parallel changes were taking place in poetry. The enormous popularity and influence of J. Thompson's *Seasons* published in the late 1720s rested in part on the vividness of their observation and description of natural details, the sense they gave of being grounded in scientific accuracy, in short, their realism. Thompson may well have stood full square in the traditional ideology of the pastoral, praising the virtues of property and dwelling on the cheerful industry of rural labourers, but his poems point towards an eventual exclusion of human society from a landscape described in the detail of its natural phenomena and the presentation of nature as an alternative moral order to that of society: 'lonely, prophetic, bearing the love of humankind in just those places where men are not' (Williams, 1963; Barrell, 1972). This too finds its fullest articulation in romantic poetry at the end of the century, in the solitary experiences of Wordsworth skating alone in the winter lakeland night, wandering lonely among spring flowers, musing in isolation on the hills above Tintern or even turning London into a natural landscape by observing its sleep, emptied of humans, in the breaking dawn.

Sublime Landscape and the Ideology of Romanticism

The changed meaning of the sublime, whereby at the beginning of the nineteenth century it could properly be found in those wild, uncultivated places untouched by an unnatural and inorganic society, was in part a cultural response to the advent of an industrial market society. Against the unnatural but apparently 'organic' growth of capital whose fertility was apparently greater than that of land, the romantic sublime proclaimed a natural and properly organic intrinsic value located in the soul of the individual – notably the poet or artist – and in the processes and phenomena of the external world, especially those which underlined human insignificance and weak-

ness: barren mountain recesses, storms, seas and night. Against the dissecting eye and analytical logic of natural science whose understanding of natural processes was increasingly underpinning the new forces of production, the romantic sublime stressed the continued existence of the divine in nature, reasoning by analogy rather than by cause.

Yet in its very critique romanticism acted in certain respects as a justification of the new order by mystifying the nature of the social relations against which it protested. Romantics accepted the detailed observational techniques of the emerging natural sciences, but employed the findings within a pre-positivist mode of reasoning, leading to metaphysical rather than strictly materialist explanation. They celebrated as strongly as any classical economist the central myth of capitalism: the 'naturalness' of the isolated individual. But in seeking to escape the alienation implied by this isolation, romantics failed to locate its origins in the new social relations of production – even as these relations affected art's own sphere of cultural production – because they could not accept society as 'organic'. Therefore no resolution was open to in the social order, it had to be found in a natural, moral order which harmonised the individual soul with unspoiled external nature.

The significance attached to landscape by romanticism related also to the changing value of land under industrial capitalism. Land's natural function in society is to produce the means of human life, a function realised collectively in production. The product of land may be unequally appropriated, as it was under feudalism, it may itself become individual property as in sixteenth-century Venice or eighteenth-century England. But even under these formations value remained in use, and increase in value came from increased potential for producing. In use-value terms it is unnatural for land to possess or increase in value without being employed productively. Thus the landscape idea in pre-capitalist formations remained attached to humanised, productive earth. Wilderness and productively barren land were culturally barren also. Pope or Goldsmith could attack unproductive parkland while celebrating the principle of property. Perspective techniques yielded the illusion of control most success-fully over humanised, cultivated lands, and it was the practical, utilitarian dimension of landscape that rendered it inappropriate to sustain the sublimity of *storia* in conventional aesthetics.

But under industrial capitalism the value of land was altered as it, together with nature and natural processes, became subject to

exchange values. It could increase in value without being productive. Indeed under industrialism traditionally productive lands could cease to be used to sustain human communities. In marginal areas like the Scottish highlands the use value of land was decreasing for its occupants, as glens were cleared and estates given over to extensive sheep rearing or deer and grouse hunting, increasing their exchange value to a few landowners and capitalists. In the coalfields and around the great cities land value rose as people left the land and it was turned out of food production and used for mining or speculative building. The sublime forces of nature – the power of the waterfall, the heat and light of combustion, the discharge of the electric storm – were being harnessed to human production. It is significant that in the late eighteenth century writers and painters could find the great furnaces and steam-belching mills of Derwentdale, Lancashire or Coalbrookdale at night 'sublime' experiences and Turner could see sublimity in views over great industrial cities. The forces which belonged naturally to the sea, the mountain and the storm were unnaturally subjected to human control and the production of exchange value. The labour employed in the conversion, in the new factories and mills, was individual and alienated, an unnatural labour given over to creating commodities for exchange rather than for use. If cultivated land, resources and labour were increasingly unnatural, nature could only exist where human society had not intervened, or at least where the appearance of non-intervention could be sustained, in the wild and unused parts of the environment.

In the analogical terms of a pre-capitalist mentality this can be explained in terms familiar from the romantic sublime. The moral order of society has been replaced by an economic order. If morality is to be discovered it must be in nature, and the increased value of uncultivated or barren land, the unnatural consequence of market forces, must stem from non-natural means. Thus romanticism seeks divinity in the mountains and sermons in stones. Wild land might in fact be a hidden location of still unalienated labour, unalienated in romantic eyes because individual rather than social and therefore unnatural. So Wordsworth praises Michael, the solitary lakeland shepherd, and the young John Ruskin sees in the crofter or peasant a man of greater natural virtue than the educated man or the city labourer. Landseer paints hugely popular pictures of 'traditional' clansmen and their families as he enjoys hunting the estates of his laird hosts. Such individuals are indeed hardly human, they are presented as products of the wilderness and will in time be replaced

in popular Victorian taste by wild landscapes bare of all recognisably human figures but filled either with costumed characters from a sentimentally idealised past or sublime creatures of the wilderness: lions and deer. The single most successful popular artist in Victorian England was in fact Sir Edwin Landseer, who depicted wild Scottish scenery, a fabricated chivalric history and noble beasts. His best selling picture, whose engraving graced the drawing rooms of countless middle-class homes well into this century was *The Monarch of the Glen*, a pastiche of the sublime: a great, male, twelve-pointed stag poised hugely over his domain as early mists rise over craggy highland peaks (Ormond, 1981).

The changing cultural interpretation of land as its value was transformed by a market economy from use to exchange is revealed in the paradox noted by Michael Rosenthal (1982) whereby, at the very period in which interest in the sublime landscape peaked in British art, there was revival of demand for pictures of productive agricultural landscapes. The love of traditional motifs of husbandry and of pleasingly ordered estates had, of course, never completely died away, but with the concern for increased agricultural productivity evident at the end of the eighteenth century by the writings of Arthur Young and others and particularly with the fear that godless revolutionary ideas of liberty and equality might be imported from France into the hay and cornfields of England this genre took on a new significance. Rosenthal claims that while in the 1780s agricultural landscapes averaged a mere 1.5 per cent of all paintings exhibited at the Royal Academy, this had risen threefold by 1792, and a similar rise was recorded during the war years of the early nineteenth century. To emphasise the productivity of the landed estate, the material comfort and cheerful acquiescence in their state of agricultural labourers, was to reassure the landowners of England of the legitimacy and success of the established order. To introduce views of ploughed fields, suitably distanced from the house, as Humphrey Repton did in his redbook landscape designs at this time (Daniels, 1981), was to celebrate a moral order which was in fact fast disappearing, while simultaneously cashing in on the rising price of grains during the war years. Conspicuous waste such as had characterised the parks of Brown and his associates was neither ideologically sensible nor economically profitable, nor was the romantic celebration of wilderness. The popularity of Stubbs' landscapes and animal paintings in which one could almost calculate the value of the thoroughbreds and relish the subservience of healthy

stable lads and trainers contrasts sharply with the lack of commercial demand for the work of John Sell Cottman who offered unpolished views of ordinary rural subjects: cottages, stone bridges, and marl pits (Holcomb, 1978). Ordinary, productive and humanised landscapes were acceptable by the market if they underwrote the idea of a successfully capitalised and profitable agrarian world, otherwise the dominant taste was for wild landscape.

The success of the sublime romantic landscape as an ideology which, while appearing to criticise industrial capitalism, in fact mystified its implications for land and human life, which proclaimed a moral order in nature while avoiding society, rested in part upon its appeal to something common in all human experience, particularly in childhood. The sense of both insignificance and fear in the face of nature's scale, particularly when displayed in full fury: in mountain masses, or whipped up in violent seas, tossed in storm or hidden in the darkness of night, is real indeed. There is enough in this experience to give an air of reasonableness to Burke's explanation of the psychology of the sublime, enough even to persuade at least one contemporary writer to accept such experience as the unmediated basis of all landscape aesthetics (Appleton, 1975). In childhood these experiences are unalienated and unreflexive and it is significant that an emphasis on childhood is powerful in romantic art. Wordsworth proclaimed the child father to the man and it was common currency that the fullest and purest communion with nature was achieved by children. Adults, to recapture it, had somehow to return to a childhood state. Now of course childhood is also a state in which symbol and referent are fused and where analogical thinking dominates. The child has no more conception of exchange value than the pre-capitalist mentality, and therefore serves as an obvious point of reference for romantic expression and is a key to its success in avoiding analysis of capitalist relations while criticising their consequences.

From Control of Land to Control of Nature

Romanticism succeeded in placing landscape and nature at the heart of cultural interest in nineteenth-century Europe. Romantic poetry affected a style of 'natural' language; water-colourists sketched and painted 'from nature'; and both poets and painters as well as 'sensitive' people from the middle classes sought out natural,

unspoiled scenes. Not only was landscape accepted as a central subject for study and commentary among progressive artists in Europe and America, but through the work of popular novelists like Walter Scott, and through cheap, mass-produced steel engravings of picturesque and romantic views, landscape appreciation had become an indicator of educated sensibility among the middle classes. They collected landscape pictures, visited the remoter parts of the British Isles, sketched and painted its scenery, and spoke with reverence of nature and things natural. The appropriate places for displaying this sensitivity became increasingly conventional. Whether in upland Britain or Alpine Europe, sublime scenes of wild nature challenged the classical ruins and great galleries of Italy as the appropriate environments for the education of taste. Trips to the Dart Valley, Snowdonia or Derwentdale, Chamonix or the Jungfrau proceeded along increasingly well-worn paths. In the drawing room they were complemented by readings from the Waverley novels or the poems of Shelley, Byron and Tennyson.

This romantic landscape, minutely recorded in its geology, flora and atmosphere, and studied with scientific care as much as it was appreciated for its sublime associations was, by nature, difficult to recreate in the design of estates and parkland. While some landowners and even some of the newly-rich industrialists like Benjamin Gott of Leeds continued to have their estates designed to replicate the organisation of the framed picture (Daniels, 1981), Humphrey Repton hesitated over the degree of detachment in the landscapes he was commissioned to create. And just as Lancelot Brown had been criticised by Richard Payne Knight at the turn of the century for the unnaturalness of his shaven lawns and controlled clumps of vegetation, so Repton's later claim that landscape gardening combined the 'luxurious imagination' of the painter with the 'practical knowledge' of the gardener was not accepted by one of the rising arbiters of early Victorian taste, J.C. Loudon, who accused Repton of ignorance on matters of science and agriculture (Daniels, 1981). The new middle class, rising on a tide of industrially-created wealth, was more anxious to display that wealth and its own sensibility in suburban gardens surrounding Gothic or Italianate villas than in the apparently cultivated but practically useless smooth lawns and picturesque clumps of the landscape park. The 'gardenesque', as Loudon called the new design, was perfectly suited to the more confined spaces of the bourgeois suburb. It depended on precise knowledge of botany and horticulture. It crowded together a

bewildering variety of species, many of them exotics brought from overseas, into dense shrubberies: private, romantic, walled enclaves which, in their 'precise, scientific, tangible, three-dimensional organization' represented an 'authentically bourgeois style' (Daniels, 1981, p. 394). They were replicated for broader, more public consumption and edification in new municipal arboreta, public parks and gardens. In a sense these were no longer landscapes since they did not direct the eye across the land but towards the details of individual plants, shrubs and trees. Indeed the *form* of the land, its topography, its relation to society – however that society might be idealised – and indeed its very shape and bounds, were all obscured by the luxuriance of vegetative life. Such parks and gardens represented not so much control over land as control over the very processes of nature, a control which reached its clearest expression in the ultimate 'gardenesque', the Victorian conservatory which displayed the green and blossoming treasures of colonial territories in an entirely artificial environment wherein land is irrelevant and natural processes depend utterly on human control.

In critical ways this shift from a landscape idea rooted in the control over land to one which denoted a far broader control over the processes and forms of nature accurately expresses something of the realities of the new social form. Once land was no longer the foundation of social production but merely one factor in it, geared along with all others to the creation and accumulation of exchange value, then it could begin to lose its privileged cultural status. Control over land was now just one dimension of control over capital which, coupled with the technology of steam and iron, was the real key to power in productive social relations. There are, to be sure, some remnants of older sets of attitudes in the status attached to land. In England the success of the older landed families in marrying into new wealth has always ensured them a certain cultural as well as political dominance. So extensive landscapes continued to complement country-house weekends. But ultimate power is located in control over the means of commodity production, not over land. This objective change is paralleled by subjective changes in the landscape idea by the mid-nineteenth century. However, such change was neither unambiguous or unidirectional and we should note a dimension of late romantic interest in nature that was less to do with mastery over it than with spiritual transcendence through nature. This dimension is apparent in the work of a number of late romantic thinkers and writers, men who were equally at home in the natural

sciences and the arts. We have commented on this approach to nature in relation to American painters of the period, but they took much of their inspiration, if not their subject matter from European thinkers and artists: the Germans Johann Wolfgang von Goethe and Alexander von Humboldt, and the English polymath John Ruskin. Their view of nature was expressed visually with the greatest force by England's most powerful landscape painter, J.M.W. Turner.

Science and Sublimity

We have observed already how painters of landscape in the early nineteenth century, particularly those who in England formed the Society of Painters in Water-colour, adopted the detailed observational techniques of the burgeoning natural sciences, geology, botany and meteorology in particular. We should recognise, too, that science at this time was still deeply influenced by religious eschatology. Geology, for example, given a powerful boost by the activities of industrial technology – mining, canal digging and later railway construction – was beginning to raise its great challenge to the Biblical interpretation of the earth's age, genesis and diluvial history. Similarly, romantic interest in the Alps stimulated the first interpretations of glacial history, in the works of de Saussure and Agassiz. Thus writers like Goethe and von Humboldt could draw upon both art and science to explore the *ur-phanomen* (the essential pattern and process of the natural world), or attempt 'a physical description of the Universe' in *Kosmos*. Goethe contributed writings on meteorology, celebrating Luke Howard's revolutionary classification of clouds, admired the botanical gardens at Padua, the earliest such scientific garden in Europe (designed by one of Palladio's patrons), and developed his own theory of colours along lines very different from those explored by Newton, lines nevertheless that depended upon acute observation (Seamon, 1979). Von Humboldt learned his natural science as an inspector of mines, matured it in expeditions into the Andes and Amazonia, and engaged directly in the promotion of botanical and zoological gardens. Yet in *Kosmos* he is willing to trace the history of landscape art and poetry as an integral part of the study. Like Goethe his project was holistic, a total understanding of the structure and order of the created universe.

Both these writers believed that in observation and description rather than in theoretical hypothesising humans could penetrate the

order of nature, the great and enduring laws by which the earth and all within it were governed. They represent the last of the great cosmologists, for soon after their monumental attempts, the botanist Charles Darwin, admirer of von Humboldt and his follower into the tropical world where painters like Church and Bierstadt had discovered the sublimities of volcanic eruptions and towering rain forests, was to return with ideas that would cleave their cosmos and separate nature and divinity.

At the very summit of Victorian confidence about human control over nature, in the decade of the Great Exhibition of Arts and Sciences held in Paxton's Crystal Palace, Darwin was to reveal mankind itself a product of nature thereby exposing a moral gulf in western understanding of nature which remains still unbridged. I shall return to this revolution when I discuss John Ruskin, the Englishman who, more than any other, strove to sustain the idea of landscape as touchstone of the moral order. First we should pause before the work of Turner, the initial stimulus to Ruskin's landscape writings and the painter who made visible the cosmos that Goethe and von Humboldt sought to understand and describe in words.

Turner began his career as a topographic draughtsman, producing conventional picturesque and antiquarian views generally for engraving in popular magazines. In his late-eighteenth-century scenes of ancient castles, great Gothic cathedrals and Alpine valleys Turner employed the techniques and assumptions of the sublime as they had been developed by painters like Wilson and Cozens. But his declared intention was to raise landscape to the level of the highest art, capable of containing and expressing the deepest human emotions and the greatest moral force. The *Liber Studiorum*, a series of mezzotints of his best early works, begun in 1805, categorises his *oeuvre* into different branches of art, using, but adding to, the conventional genres and placing different kinds of landscape like 'mountainous sublime', 'pastoral', 'elevated pastoral' alongside historical paintings in a personal hierarchy (Wilton, 1980). In Turner's eyes, and in those of his contemporaries, the route to success in raising landscape to the highest art was via realism: the foundation of painting on careful, minute, detailed and scientific study of the external world. Such observation allowed penetration into the very essence, the life force, of natural processes and it is this which comes to dominate his late pictures. Knowledge gained by observation had to be subjected to artistic and pictorial rules, particularly those of perspective. As Professor of Perspective at the Royal Academy, Turner constantly

reiterated in his lectures the importance of these rules, however dull, turgid and mechanical their acquisition. 'Without the aid of Perspective Art totters on its very foundations' (quoted in Wilton, 1980, p. 70).

But for Turner, particularly as he matured, conventional linear perspective as it had been learned from the renaissance theorists became a technique of extraordinary flexibility, as his pursuit of realism in the painting of nature led to attempts at understanding and expressing its forces from the inside rather than as a detached observer. In the landscapes and interiors of Petworth House (Plate 14), in the great sea and storm paintings of his later life and in the well-known images of Victorian manipulation of natural forces: *Rail, Steam and Speed* or *Keelman Hauling Coals By Night*, Turner searched for a new language and new techniques, breaking the conventions of realist art as then understood, by using multiple perspectives, dissolving outline and distance in an intensity of light and colour, bending forms into a vortex of force to capture nature's power and the immensities of space and distance. Ruskin recognised, even when other critics failed to, that in these works Turner always remained a realist but that this was no longer the realism of the eye as a distant, controlling observer. It was the realism of an eye that had been carried by both the body and the imagination into the actual operation of natural processes. This accounts for Turner's interest in Goethe's colour theory and his dramatic encounters with nature – having himself strapped to a ship's mast and literally passing through the eye of the storm. To press realism thus far was effectively to move beyond landscape and into the study of process rather than form or rather to create a unity of form and process, being and sight, which is at once individualist and universal rather than social. Its commentary on the human condition is pitched at the most universalised moral level. Technically Turner anticipated and lent authority to landscape painters of the later nineteenth century, notably the realists of the Barbizon school and the French Impressionists. Intellectually his was a cosmos unified by divinely-constituted natural forces in which human feeling rather than human sense provided the indication of our true place.

John Ruskin and the Failure of Landscape Morality

Turner's visual penetration of natural forces and their relations with humanity, particularly as it was expressed in the disturbing, powerful

239

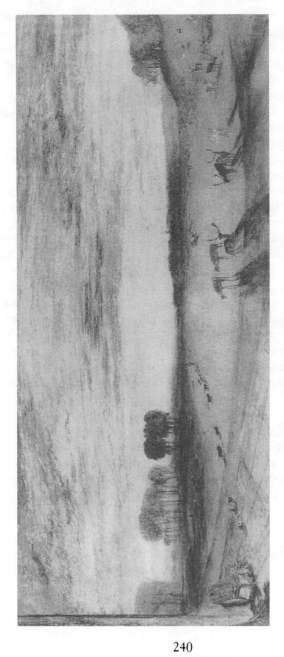

Plate 14. Joseph Mallord William Turner: *Petworth Park: Tillinton Church in the Distance* (The Tate Gallery, London)

paintings of the 1830s and 40s, was by no means easily appreciated by the viewing public. Visitors to the Royal Academy tended rather to favour in their landscapes conventional images either of an ordered and contented countryside – a denial of rural realities in the decade of machine breaking, rick burning and Captain Swing – or of grandiose, often biblical themes set against a dramatic and mannered sublime nature. However, Turner's experimentation and his vision found articulate defence in England's most prolific and influential writer on landscape, John Ruskin (1819-1900). Ruskin sought to deploy the landscape idea as the key to a moral and social analysis of the human consequences of industrial capitalism and the contradictions of Victorian political economy. In his works are revealed sharply the critical tensions between modes of thinking about the natural world in the nineteenth century, and over the appropriate place of human life and labour in that world.

Ruskin was the only son of a wealthy bourgeois sherry merchant, a self-made man with aspirations towards aristocratic society and high culture but insecure in his parvenu status, and a mother who bowed to her husband's ambitions for their son so long as he remained true to her strict evangelical faith. His education was parental and through home tutors until his admission to Oxford where close familial supervision continued. While his learning was broad it was eclectic and the dominant literature of his youth, the formation of much of his taste and assumptions, was firstly biblical and secondly romantic. The combination is significant, for while he was captivated by the romantic literature and certain of the joys of communion with wild nature – defending the moral propriety of romantic writers to sceptical Oxford tutors – he found it necessary to justify to himself the moral value of art study. It had to equal that of his rejected ecclesiastical career and thus became a pulpit for the dissemination of moral truth (Dixon-Hunt, 1982). The combination meant that for Ruskin the joy of landscape could never be purely personal, it had to have social relevance and this led eventually to his most significant contribution: the examination of relations between landscape and the social and moral conditions under which it is apprehended and expressed.

The authors and artists who formed Ruskin's tastes were headed by Walter Scott, Lord Byron and J.M.W. Turner. From all three he took a lifelong passion for wild upland scenery and from the last an interest in the elemental forces of the natural world and the perception of its forms, light and colours. Early training in drawing

was from masters closely connected with the newly-founded Society of Painters in Water-colours, the institution seeking acceptance of its medium as valid for fine art and of landscape as equal subject matter to the established genres. While Ruskin began sketching and painting with a distinct preference for the picturesque both in subject matter and style – Samuel Prout was one of his early mentors – he graduated to the more direct, less mediated response to natural scenery he detected in Turner. The liberation of the human spirit through contact with wild nature was a theme which would run through his literary and artistic experience.

This sense of liberation was keenly felt and developed in Ruskin during a series of family excursions into the conventionally picturesque regions of Britain: the Pennines, the Lake District, Wales and the Scottish Highlands. The family's first continental journey sought similar landscape and Ruskin's first view of the Alps was the crowning experience of this early romantic sensibility. The journey allowed him not only to see some of the sights which had provided the inspiration of Turner's work but equally an opportunity for Ruskin to make direct geological, botanical and meteorological observations and thus to practise fieldwork in three areas of scientific knowledge which remained a lifelong fascination. As with Goethe and von Humboldt, it was the combination of observational science, familiarity with a school of landscape art which emphasised close attention to the observed facts of the natural world, romantic attitudes to the elemental relationship between the individual and untamed nature, and a sense of evangelical truth and mission which made Ruskin's approach to landscape at once so particular and yet so relevant to the understanding of landscape in the nineteenth century.

In *Modern Painters* Ruskin argued that studied attention to the facts and forms of the natural world was central to the achievement of artistic truth and thus that the painter should be as attentive to empirical reality as the natural scientist. But the intention of such observation runs beyond science as we now understand it. It is to penetrate the 'essence' of landscape, to grasp a truth which is yielded only in the active engagement of the human subject with its object of contemplation. This could not be achieved merely by concentration on form and morphology, important as this was:

> The natural tendency of accurate science is to make the possessor of it look for, and eminently see, the things connected with his special pieces of knowledge; and as all science must be sternly

limited, his sight of nature gets limited accordingly . . . And I was quite sure that if I examined the mountain anatomy scientifically, I should go wrong in like manner, touching the external aspects. Therefore . . . I closed all geological books, and set myself, as far as I could, to see the Alps in a simple, thoughtless, and untheorizing manner, but to *see* them, if it might be, thoroughly. (Ruskin, 1856, VI, p. 475)

This idea of seeing to the essence or heart of an object is one which has been reiterated by many thinkers at different times and places but in the nineteenth century it was as we have seen directed very specifically at landscape and nature. Among others we could include the American transcendentalists Henry Thoreau and Ralph Waldo Emerson, and the English poet Gerard Manley Hopkins. Indeed one could almost imagine Ruskin's 'scientific' description of a windhover, closely observed and recorded in his diary of 1875,

I am very thankful to have seen the windhover. It was approximately at a height of eight hundred feet: but being seen over the cliffs of Gordale, I had a standard of its motion, and when it paused, it was pause absolute. No bird fixed on a wire could have stood more moveless in the sky, so far as change of place was concerned, but assuredly both wings and tail were in slight motion all the time. It had two modes of stopping, one holding the body nearly horizontal, with rapid quivering of wings, the other holding the body oblique, with very slight movement of wings and tail. Of course it stands to reason that the motion of these must be in exact proportion to the force of the wind, otherwise it would be blown back. (Ruskin, quoted in Dixon-Hunt, 1982, p. 357)

yielding Hopkins's devotional lines on the same subject written two years later:

I caught this morning morning's minion, king-
 dom of daylight's dauphin, dapple-dawn-drawn Falcon, in
 his riding
Of the rolling level underneath him steady air, and striding
High there, how he rung upon the rein of a wimpling wing
In his ecstasy! then off, off forth on swing,

As a skate's heel sweeps smooth on a bow-bend: the hurl and
 gliding
Rebuffed the big wind. My heart in hiding
Stirred for a bird – the achieve of, the mastery of the thing!
 (Hopkins, 'The Windhover', 1877; 1953, p. 30)

Subject and object are united in a single act of intentionality very
different from the aims of positive science then so actively being
promoted, which require as a prerequisite to explanation the
separation of subject and object and a focus on the causal relation
between objects. For those who take Ruskin's view, today we would
call them phenomenologists, the objectification of the scientific
procedure is alienating and the aim of their particular mode of
understanding is to overcome a personal alienation from the external
world, to replace it with a unity of feeling and meaning (Cosgrove,
1979).

But Ruskin was not satisfied with mere personal understanding
and reflection on his engagement with landscape. He acknowledged
his weaknesses as a poet or painter capable of communicating the
truth and meaning of landscape on paper or canvas. His was at once
a more theoretical and a more social concern than earlier romantics
and to understand it we need to return to his biblical knowledge and
early religious beliefs. For Evangelicals the Bible was the revealed
word of God, and thus the key to understanding His creative and
redemptive work, His intentions for human life on earth. The Bible
was a literal record of creation, the history of a chosen people and the
story of Christ's testament. Despite the challenge presented by an
advancing geology, acceptance of the Mosaic account of creation, of
the fixity of species and the recency of the earth's appearance, all
were part of an orthodoxy very closely tied to the social and moral
order of early Victorian England, as Samuel Butler's *The Way of All
Flesh* cruelly reveals. To challenge these beliefs was to threaten to
turn the world upside down. Ruskin's interest in geology, his reading
of such authorities as Lyell, Hutton and Agassiz, his membership in
the Geological Society and his friendship with William Buckland at
Oxford brought him face to face with one of the central intellectual
issues of his day.

But the Bible was also studied for a deeper and hidden truth: it
required interpretation if the real meaning of the history it contained
was to be clarified and its relevance to contemporary purposes
understood. The method of exegesis adopted by evangelical

protestants was that of *typology* (Hewison, 1976). This was a theory of types, well outlined by Ruskin himself in one of the chapters of *The Stones of Venice* (1851). Within the historical record of the Bible events and personalities serve both as universals and as equivalents of contemporary events and personalities. The Bible is therefore *symbolically* as well as literally true. By adapting this way of thinking to the picturesque artistic idea of *association* whereby the forms and features of nature were seen to embody human feelings, Ruskin was able to synthesise a theory of landscape which he outlined in *Modern Painters* and later transposed to architecture and urban landscape in his study of Venice (Cosgrove, 1982a).

Natural landscape he recognised as unquestionably beautiful and, as any reader of sublime literature would have accepted, it arouses powerful emotions of reverence in the observer, and a sense of his littleness and mortality. This sublime beauty was for Ruskin

> either the record of conscience, written in things external, or it is a symbolizing of Divine attributes in matter, or it is the felicity of living things, or the powerful fulfillment of their duties and functions. In all cases it is something Divine, either the approving voice of God, the glorious symbol of Him, the evidence of His kind presence or the obedience to His will by Him induced and supported. (Ruskin, 1895, XXXV, p. 224)

The landscape thus merited detailed empirical attention, as closely circumscribed as that of any geologist, and a penetration to its essence informed by the belief that in this essence lay its symbolising of God's intentions towards mankind. Landscape meaning was therefore by no means a personal or incommunicable thing. It was apparent to all who took pains to study and learn from it in faith and humility.

In Ruskin's cosmos there were, quite literally, sermons in stones, sermons that declared divine intention in two ways. Certain forms – shapes, lines, curves and patterns – recur throughout nature, for example the curvature of a scree slope is to be found repeated in the construction of a bird's wing and again in the shape of a beech twig and the veining of a leaf (Plate 15). These are the inward anatomy of creation and sure sign of the ideal form to which each object aspires and which is to be found in perfection only in the divinity. But there are also appropriate associations of landscape elements whose harmony provide the unity and order etched by the creator into nature and of

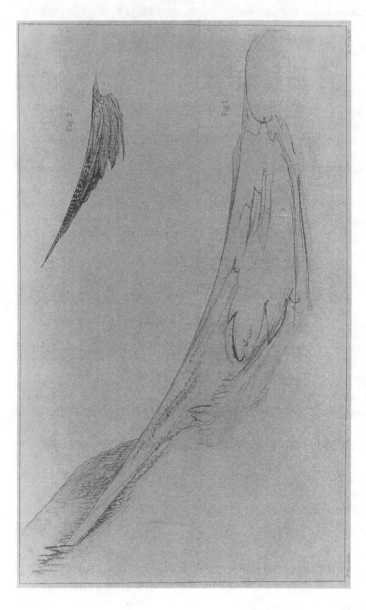

Plate 15. John Ruskin: *Debris Curvature (Modern Painters, Vol. IV)*

which all of us are intuitively aware. Thus, in limestone scenery:

> The level marshes and rich meadows of the tertiary, the rounded swells and short pastures of the chalk, the square-built cliffs and cloven dells of the lower limestone, the soaring peaks and ridgy precipices of the primaries, have nothing in common among them, nothing which is not distinctive and incommunicable. Their very atmospheres are different, their clouds are different, their humours of storm and sunshine are different, their flowers, animals and forests are different. By each order of landscape, and its orders, I repeat, are infinite in number, corresponding not only to the several species of rock, but to the particular circumstances of the rock's disposition or after treatment, and to the incalculable varieties of climate, aspect and human interference; by each order of landscape, I say, peculiar lessons are intended to be taught. (Ruskin, 1844, III, p. 39)

These lessons are moral ones. They concern the proper conduct of individual and social life. Discussing cloud formations, for example, Ruskin describes and classifies the layers and forms of clouds with an accuracy which rivals that of eminent contemporary meteorologists like Luke Howard, and proceeds to interpret them as symbols of divine mercy and justice (Cosgrove and Thornes, 1982). Clouds, he claims, mediate between the infinite void of space which reveals the certainty of God's judgement, and the changing atmosphere of the earth which similarly indicates the flexibility of divine mercy. Clouds thus exist 'to appease the unendurable glory to the level of human feebleness, and sign the changeless motion of the heavens with a semblance of human vicissitude' (Ruskin, 1860, VII, p. 133). Ruskin's is a theory of landscape in which the place and activity of the human subject are central and in which appropriate human actions are necessary to the continued harmony of the natural world.

Humans were created to live in nature, nature was designed to teach them how properly to do so. But living humans intervene in creation and in order for the humanised landscape to maintain the beauty and harmony of the natural, they are obliged humbly to observe the signs and symbols written into their world. It is no large step to recognise that while ultimately each individual holds a personal responsibility for this, it is rendered more or less possible for that individual by his moral and social environment. Ruskin, once

he directed his attention towards architecture rather than painting, found the step even easier to take since now he was dealing directly with the products of human labour, the labour of many people rather than of individuals. While *The Poetry of Architecture* (1837) concerned vernacular architecture, Ruskin's most influential writings on architecture were produced in his thirties and concentrate on public buildings: churches, palaces, monuments and, by extension, whole cities. Increasingly the nineteenth-century city became his real focus of concern and the object of the lessons to be learned from medieval architectural and social practices. Architecture was the main human contribution to landscape. It was in building that we follow and continue the creative act; an idea of course accepted by renaissance theorists but in defence of very different styles than Ruskin promoted. He argued that the forms which architecture took should not be produced intellectually through geometrical theories. Such an approach would be an arrogant elevation of the human mind to the level of God. The forms of a true architecture were those indicated in the handiwork of the supreme artist, that is in natural landscape. Therefore in vernacular building 'the material which nature furnishes, and the form which she suggests, will always render the building the most beautiful, because the most appropriate' (Ruskin, 1837, I, p. 37), and the resulting cottage or farmhouse should appear as if it were almost a product of environing nature. The worst building was that which stood out visually against the landscape, which appeared to assert human superiority over nature.

This argument was deployed by Ruskin to intervene on one side of the main aesthetic debate of Victorian architecture: the 'battle of the styles', between the supporters of Gothic and Classical architecture respectively as the national style of England. The Gothic movement and romanticism were closely related and simultaneously promoted during the period of English industrialisation. Ruskin regarded the Gothic churches and palaces of Verona and Venice as beautiful because their window lights, traceries and trefoils followed the curving, organic lines of plants and natural objects. The right angles and semi-circular vaults of renaissance architecture or the grotesques of the Baroque signalled to him a humanist arrogance. They indicated moral decadence because they proclaimed architecturally a superior human logic over the humble observation of nature. In them the builder, rather than possessing the freedom to express his joy and harmony with the world of everyday life, was constrained to follow

248

the preordained plan of the architect: he was a slave. This argument is outlined with great force in *The Seven Lamps of Architecture* (1849) and tested in the study of Venice. There Ruskin proclaimed a homology between the social order of the fourteenth-century city and the hierarchy of Gothic buildings: ordinary houses following the plan and decoration of the larger palaces just as the ordinary people accepted the government of the merchant patriciate, because they recognised its rule as just and its piety honest. The rise to ascendancy and subsequent decline of Venice as a commercial and political power at the centre of Christian Europe, Ruskin found to be accurately mirrored in its architectural history. This had important implications for industrial England:

> Since first the dominion of men was asserted over the ocean, three thrones, of mark beyond all others, have been set upon its sands: the thrones of Tyre, Venice, and England. Of the First of those great powers only the memory remains; of the Second, the ruin; the Third, which inherits their greatness, if it forget their example, may be led through prouder eminence to less pitied destruction. (Ruskin, 1851, IX, p. 17)

The final determinant of the moral quality of landscape altered by human intervention lay then in the exercise of human free will. It is the duty of every individual to observe and seek to understand the messages written by divinity into natural forms and of that individual's life and work to submit to them. But the degree to which individuals are able to fulfil this sacred duty was, Ruskin realised, heavily influenced by the society of which they are a part. He became increasingly convinced that in his own society, in nineteenth-century, capitalist England, harmony between human life, human actions and nature was not possible because people were not free. The wage labourer in an English factory whose existence depended on the endless reproduction of manufactured commodities to a specified and invariable model was alienated both from his own labour and his product. Unable to fulfil his duty to God and his fellow humans, he was as much a slave as the builders of those architectural monuments to human reason, the Egyptian pyramids or the temples of Attica and Syracuse.

Like so many of his contemporaries, Ruskin realised that this alienation and slavery was of a new kind, not sustained by chain and

leather thong but by the proclaimed suprahuman logic of the market-place. Thus he turned his attention increasingly to a critique of contemporary political economy, arguing fiercely against the utili-tarian philosophies of Adam Smith and John Stuart Mill. His criticism was founded on a belief in the intrinsic value of materials and on opposition to the idea that the value of an article of human work lay in its monetary equivalent on the market. In this of course he was close to what many other socialists in the nineteenth century were saying, and his understanding of the workings of capitalism and the processes of its development was considerably more limited than that of Marx or Engels, or even his counterpart in cultural interests, William Morris. In his attempts to resolve the problems he detected, Ruskin operated outside the general arena of emerging socialist discourse and maintained throughout a belief in the significance of art as an active force in social change. Discussions of erudite artistic symbolism combine with fiery social commentary in his letters from 1871 addressed to the working men of England: *Fors Clavigera*. As practical steps towards the establishment of a new order he organised various schemes to reintroduce unalienated work, notably the Guild of St George – a community for workers intended to have its own lands and separate economy organised along what Ruskin imagined to be the model lines of a medieval craft guild. More dramatic expressions of his belief included organising the building of a road by Oxford students and the cleaning of London streets by paid helpers.

These efforts were not intended to promote socialist equality. They combined rather an emphasis on the dignity and satisfaction of unalienated labour with a traditional Tory respect for upright leaders of men whose paternal authority was purchased by their moral stature. All people were, however, regarded as equal in the responsibility they bore to recognise and declare in their appointed tasks the perfection and beauty of created nature.

The highest form of work was art, not a thing divorced from life and valued in money, but the fullest expression of true craftsmanship and the vision which penetrated the order of nature. Inevitably Ruskin's small-scale, localised experiments were doomed to failure in the face of overwhelming capitalist social relations. They suffered the same fate as other Victorian attempts to create alternative forms of community based on an imagined social perfection. Ruskin himself saw the inadequacy of his feeble attempts to resist the tide of industrialism. In two lectures entitled *The Storm Cloud of the Nineteenth Century* written in 1884 when he had already suffered

attacks of the psychological illness that would eventually silence him, he claimed that the deterioration of climate and the pollution of the landscape of late Victorian England could be observed in a new form of cloud: 'one loathsome mass of sultry and foul fog, like smoke' (Ruskin,1884, XXXIV, p. 37), a 'plague wind' which was the material expression of moral decline in a country beset by the twin evils of industry and the market-place. It led him finally to despair of the landscape idea and of his belief in a potential harmony of human life and nature:

That harmony is now broken, and broken the world around: fragments still exist, and hours of what is past still return, but month by month the darkness gains upon the day, and the ashes of the Antipodes glare through the night. (Ruskin, 1884, XXXIV, p. 78)

Ruskin died not only wracked by his personal mental turmoil but by the sense that the vision of human perfection to be found in the contemplation and active engagement with nature which he had inherited from romanticism and refined into a social theory was false, that landscape, far from determining the moral order, could be devastated by it. In this the 81 years of Ruskin's life may be seen both as a reflection of and a commentary upon the changes that the landscape way of seeing underwent during the ascendancy of triumphant market capitalism.

Ruskin's development of the landscape idea laid particular stress on intensive, empirical study of the external world. He recognised such study as the foundation of Turner's landscapes and claimed to see it also underpinning the work of other landscapists he admired: Giovanni Bellini and Tintoretto, for example. Such study was the point of departure for anyone wishing to paint natural scenery, the work was to comply with all the requirements of science, to be 'scientifically right'. In emphasising this point Ruskin was of course following the lead of English landscapists of the late eighteenth century, particularly the water-colourists who drew upon the Flemish tradition of empiricism to challenge Reynold's Italianate classicism. But Ruskin's call for scientific accuracy was by no means an attempt to reduce painting to topographical draughtsmanship, as some critics of *Modern Painters* accused. He was perfectly clear that the purpose of such detailed observation was not to increase the store of objective knowledge or improve human control over nature. Rather he, like

Goethe and von Humboldt before him, believed that the sentient subject could not be divorced from the object of enquiry. Objects required subjects, and subjects were moral beings. All study therefore, in art and science, was concerned with the elucidation of ends or purposes, either those of the Creator, or of Nature itself, and of human life and work. It is these which are to be brought into harmony by the artist, as Turner had shown, and indeed by all who labour and thus reproduce nature and transform landscape. Only the sentient subject could penetrate the meaning of landscape. The unity assumed by Ruskin between what to us are very different modes of understanding, one scientific and objective, the other subjective and interpretative, is very significant if we are to make sense of Ruskin's idea of landscape. Effectively he was applying a form of analogical rather than causal reasoning, a mode of understanding which, as I argued earlier, is characteristic of a pre-capitalist mentality. Moreover, he was doing so at a time when such thinking in science was being undermined by Victorian positivism with its separation of subject and object and its search for causal laws modelled upon Newtonian physics.

It was the particular achievement of nineteenth-century science to elevate causal over analogical reasoning as the only valid avenue to truth about natural processes and phenomena. As ideology this mode penetrated those new 'sciences' of the Victorian age, the social sciences, and particularly the dismal science of economics. It was against the economic theories of this new science of the market-place that Ruskin unleashed his fiercest attacks, for they proclaimed moral discourse to lie outside their field of competence and promoted a model of human conduct which was entirely mercenary and a model of nature which transposed it to commodities and located their value in exchange. Today in the West we accept in large measure the assumptions of positive science and its causal reasoning as common sense, an indication of the success of its ideological hegemony. But, as I suggested in the second chapter, the shift from analogical to causal reasoning is logically related to changes in social organisation between pre-capitalist and capitalist formations. Ruskin's landscape project represents a heroic attempt to sustain the moral order implicit in the child's and in pre-capitalist conceptions of human relations with the land and nature against the economic order of industrial capitalism while deploying in his favour the findings of a science that for the most part was being used to legitimate that order. In the face of capitalist industry and its ideological expressions Ruskin's lone

project was perhaps doomed to failure. By the end of his life what reason he had left was forced to accept the death of landscape as a record of human conscience and the destruction of its inner harmonies, rather as Turner's later paintings prefigured the artistic expression of landscape's dissolution in modern art.

9

The Landscape Idea and the Modern World

It was Ruskin's despair that in industrial Britain the landscape idea could no longer sustain the burden of moral and social responsibility which his interpretation had placed upon it. Indeed, as we have seen, landscape and nature had by his time – and certainly in his own mind – become almost interchangeable categories. This 'death' of landscape was a consequence of the breadth of change in social relations, technical expertise and intellectual life that Ruskin's century had witnessed. Today, in the final decades of the twentieth century, we have to add to those changes a universe of others if we are to make sense of the landscape idea in our own world. For the landscape idea has not disappeared, rather it has again been transformed, while still sustaining enduring elements of its traditional ideological significance. True, in the field of cultural production, in painting and literature for example, landscape has not, for most of this century, been a subject of great concern to progressive artists. But it has been an enormously popular genre for more conservative painters and writers, particularly in Britain. Significantly too, some of the most radical contemporary painters are returning to landscape as a theme for their work. Landscape has certainly survived as an important area of concern for geographers, historians, designers and policy makers. As the agency of the state in allocating resources has increased within the capitalist countries, so landscape has grown in significance. In this final chapter I will examine how the landscape idea has altered with these circumstances and evaluate the extent to which landscape still sustains the ideological character which I have argued it upheld during the period of its cultural ascendancy.

The Atrophy of Landscape

It should not surprise us that at the end of his life John Ruskin felt that landscape was no longer the proper medium through which an effective comment could be made on the social, political and moral evils of his world. The Storm Cloud of the Nineteenth Century obscured far more than his own visual and mental clarity. As polluter of the skies above Brantwood or of the arcadian valleys of the Peak District, it originated in the great manufacturing cities, cities that by 1851 contained the majority of the British population. By the last decades of the nineteenth century the dominant concerns of public policy were located in these cities. The political map of England was redrawn as county and municipal boroughs and urban districts were formally separated from their rural locales. Their councils and the national state concerned themselves with housing, sanitation, public health and education, and the civic landscape of town halls, police stations, fire halls and hospitals. In the countryside the 1870s marked the end of two decades of enormous prosperity for farm owners and tenants – the 'golden age' of Victorian farming – even if it was

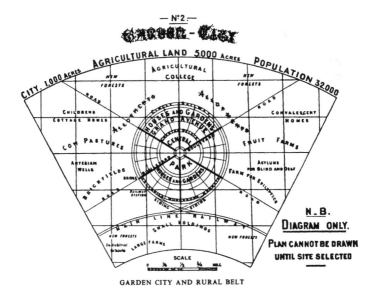

GARDEN CITY AND RURAL BELT

Figure 9.1: Plan for a Garden City Landscape by Ebenezer Howard

somewhat tarnished for the many who still were forced to emigrate from the countryside for want of work and wages. The last years of the century were decades of severe and sustained agricultural depression and misery in England, so that when Ebenezer Howard (1946) wrote his treatise on the garden city at the turn of the new century, his vision of 'a peaceful path to reform' was intended as much to relieve the poor housing, low wages and inadequate environment of rural labourers as to remove the insanitary and morally corrupt world of the massed urban proletariat. Howard's tract is of course but one indication that by the end of the Victorian age the social and environmental consequences of unrestrained industrial capitalism were regarded by many not only as intolerable, but capable of improvement and reform only through the agency of public authority in the form of planning; planning moreover that would include the design of the human environment.

Although intended to promote a liberal vision of social harmony, the formal design of Howard's new landscape (Figure 9.1), mediating country and city in its circular avenues, radiating boulevards set in parkland and centred on a great crystal palace, harks back to the proportioned, orthogonal and symmetrical form of more openly authoritarian urban landscapes. Ideal landscape and formal geometry remain inseparable in Howard's paternalist social dream, far removed from the liberating vision of more radical social critics like William Morris.

It is a measure of how far they were removed from the realities of their supposed subject matter that late Victorian representational landscape painters offered little evidence either of agricultural depression or of industrial production in their works, for example in the immensely popular paintings of John Linnell (Crouan, 1982; Jeffrey, 1983, Davie, 1983). In the 1870s Linnell continued to produce nostalgic pictures of picturesque cottages, rural swains at their doors held in poses that were borrowed from the eighteenth century and expressing an unchanged and apparently unchanging English pastoral harmony. Others, like the 'Etruscan' painters promoted a similar image of timeless Arcadia, for example Miles Birkett Foster's widely-purchased engravings *Pictures of English Landscape* (1863). These works relied upon well-tried motifs that were now a stereotype of English art and addressed to an assured urban middle-class market that had no desire for the traditional landscape way of seeing to be challenged either technically or in content.

Outside England, of course, painting was experiencing a very radical set of challenges. French impressionists, the first of the modern artists, extended the ideas of the Barbizon painters like Rousseau and Corot, heeding Turner's example and Ruskin's teaching by painting direct from nature. But unlike their immediate predecessors, impressionists like Renoir, Pissarro and Monet were not committed so much to nature as to art itself and to exploring ways in which the qualities of natural light and its often fleeting transmutations of objects could be captured on canvas. While they painted landscape and while they challenged conventional ways of seeing, it was more in terms of the technicalities of vision and paint than of seeing as the attribution and reception of meaning which Ruskin, for example, had promoted. One particular reason for this was that both ways of seeing and one of landscape painting's traditional roles as recorder of park and estate had been challenged by the invention and rapid development of photography.

The Camera and Landscape

It is conventionally accepted that the camera, a product of nineteenth-century science, optical physics and chemistry and evolving rapidly from Daguerre's early experiments in the 1830s to the sophisticated technology of lenses and picture printing available by the turn of the twentieth century, played an important role in the decline of representational painting. But the relationship between the camera and painting is more complicated than such a statement would suggest. It is certainly true that schools of art in the last decades of the 1800s laid increasing emphasis on experimentation with technique, on new ways of capturing the detail, pattern and emotional force of the external world and on expressing the inner workings of that ultimate designation of subjectivity, the human psyche. Such techniques were incorporated into an argument for the total autonomy and privileged status of the artist and the artistic experience. Art for art's sake and the uniqueness of the aesthetic as distinct from the moral, political or social were dominant themes in fin-de-siècle cultural production and also in the writings of turn-of-the-century philosophers of art like George Santayana, Benedetto Croce and Roger Frye. But photography had a closer integration with landscape, one which, for all its challenge to painting, in some respects allowed the conventional landscape way of seeing, the visual

257

appropriation of nature as commodity, to be sustained and disseminated among a population far broader than that which landscape painting had addressed. At one and the same time it gave to individual subjects the possibility of visual control over external reality, allowing them to record it for purely personal, subjective consumption, and yet to the photograph was attributed that objectivity, that scientific precision in reproducing the world which early-nineteenth-century landscapists had so eagerly sought.

It was landscape painters like Constable, Girtin and Friedrich, still bound to the conventions of linear perspective and aiming through detailed observation and recording of nature to construct an accurate representation of its forms, who provided the ground rules, the informality and directness of approach, which photography followed. Significantly Daguerre himself was a landscape painter and John Ruskin, so often a Luddite in his response to technological innovations, was an early and enthusiastic user of Daguerre's invention. The camera adopts the single viewpoint of linear perspective rather than binocular vision, its results are printed on to the flat plane of the photograph and the pictorial result is produced by the same graining and practices of paring and framing that had been developed in painting. Indeed lenses were soon being developed which aimed to 'correct the distortion' of natural perspective which the camera produces, wherein vertical lines converge, to render them parallel and thus true to the vision of single point perspective as developed in representational painting. Rather than challenging the conventions and way of seeing inherent in landscape the camera reinforced them. And yet from early on the photograph was accepted as scientific and objective, the authentic reproduction of external visible reality. Its fine grain and even surface achieved effects that luminist landscape painters had sought, of erasing the evidence of human intervention in recording nature. The photograph could therefore be distinguished from the painted record with its visible evidence of pencil, brush and knife and thus the accuracy and authenticity of the photographic record guaranteed (Galassi, 1981).

In this way the camera fulfilled a critical aim of Victorian landscape. It reinforced the authority of the personal vision and of its perspective rules as the real construction of external relations between forms. It underwrote the appropriation of the visible world to the individual, detached observer while simultaneously proclaiming in its constructional conventions the scientific objectivity and accuracy

of this vision. When we couple this technological advance and its legitimation of the landscape vision to the contemporary attack on analogical reasoning in the sciences and the elevation of causal reasoning as the only secure way to achieve accurate understanding of the forms and relations of the external world, as well as to the emergence of geography as the science of landscape, we can begin to make sense of the ambiguities of landscape which were outlined in the opening chapter.

In painting itself one initial response seems to have been to emulate the precision of the photographic image. It was for this that Ruskin congratulated John Brett and supported the aims of the Pre-Raphaelite Brotherhood. This group of English painters – John Everett Millais, Arthur Hughes, Charles Allston Collins, William Holman Hunt and others, painted landscapes which were jewel-like in their rendering of the detail, form and colour of the natural world: of plants and rocks, trees and mosses. Their desire was to achieve maximum realism but that realism did not extend to the themes of their work. The Pre-Raphaelite landscape was static. Unlike Turner's nature, it never threatens or overwhelms its human occupants, rather it exists as a vehicle for commenting upon their feelings and sentiments. In concentrating upon medieval and heavily symbolic religious iconography and on the most sentimental of contemporary subjects – a blind child unable to see the glorious rainbow, the orphaned sailor boy 'home from sea', oblivious in his grief of the blossoming loveliness of the June churchyard, the 'pretty baa-lambs', these painters challenged the camera to incorporate human sentiment into its precision, but equally turned their backs on the realities of the Victorian countryside and its environmental and social tensions, without discovering in nature the moral depth that Turner had revealed in natural forms and forces. With such vapid emotional content it is hardly surprising that Pre-Raphaelitism had little progeny other than the trite sentimentality and easy nostalgia of late Victorian landscape painting (Rosenthal, 1982). For realism, the camera and advanced printing techniques could easily and cheaply outclass the painter.

Geography from Landscape

One of the assumptions that underlay Pre-Raphaelite art, an assumption shared with Ruskin, was that accuracy of vision and

attention to the details of natural forms would yield an understanding of structure and harmony which had scientific validity. I have discussed the reliance of this view on analogical thought and the rejection of that mode in Victorian science. Photography, a product of the marriage of science and technology, both represents and reproduces an empirical, objective world. It proclaims, as does positive science, the world it reproduces to be consistent and verifiable by any observer regardless of beliefs, predilections, moral condition or personal involvement with the objects of study. A detached, objective mode of seeing and studying eases the linkage between science and technology so central to continued innovation and growth of capitalist production. By contrast, analogical thinking was consigned to the realm of primitive thought or metaphysical quackery.

The history of landscape is not unaffected by these changes. In the same period as the victory of causal over analogical thought was achieved in western understanding of nature, the study of geography was established as a distinct intellectual discipline in the schools and universities of Europe and North America. Those responsible for its promotion had little doubt that the new discipline was a science whose practices should accord with those of other positive sciences. Early geographical writers and teachers like Freidrich Ratzel, William Morris Davis and Andrew John Hebertson and the methodologists who followed them like Alfred Hettner, Richard Hartshorne and Carl Sauer, all regarded geography primarily as a positive science. It might be founded upon a pre-scientific sense of the richness and texture of the earth but in so far as the scholarly pursuit of geography aimed to understand the forms and processes of the physical world, restricting its ambit to those aspects of that world that are *visible*, physical geographers accepted unquestioningly the methods of science and the strictures of causal thinking. Physical geography's development up to this day has been consistently in the direction of greater empirical accuracy and increased deductive coherence.

But the recognition within geography that it is human intervention in the processes shaping the world we see which differentiates it into distinct areas, was fundamental from geography's earliest days as a formal discipline. As a study of the relations between human groups and their physical milieu geography assumed responsibility for that integrated vision which romantic landscape and the sense of harmony with the natural world established in the early nineteenth century, the vision which Goethe, Humboldt, Ruskin and so many of their contemporaries had struggled to achieve and express in the art of

landscape, incorporating into it the morality of the whole social process. In taking over this integrated, synthetic study of the external world but placing it firmly within the terms of reference established by positive science and causal thinking, geographical scholarship has effectively denied a place for moral discourse in its treatment of landscape.

Adopting initially a deductive path, through environmental determinism, geographers sought to establish in their science universal laws of the same stature as those of physics or chemistry in order to explain the varied patterns of human occupance. Environmentalism was subsequently rejected, less because of its moral and political implications than because of its failure as science. Its conclusions, and indeed its hypotheses, failed to stand up to empirical investigation, the logic of its causal relations was too crude. In sum, it was not sufficiently scientific. It was replaced in geography by a form of regional description and landscape classification which relied for scientific status on the morphological method discussed earlier. While in the more evocative geographical monographs this allowed expression to something of the sense of harmony between human care and the natural world upon which that care was impressed, the claim of scientific objectivity made such sensitivity either an embarrassment to methodologists and philosophers of geography or a vehicle for a reactionary geographical ideology of the land, work and folk kind which we find, for example, in German geography of the early twentieth century.

It is in the nature of the subject matter that geographers had elected to study, subject matter inherited from romantic analogical thinkers, that synthetic understanding of both human and natural processes and patterns should be addressed. The only basis upon which geographers could lay a claim to separate identity from geology or biology, anthropology or sociology was that their science offered unified understanding of the earth's surface, both physical and social. In this geography shared with photography the legacy of romantic landscape. If the camera established the authenticity of an objective, external scene but threw the burden of subjectivity on to the detached individual observer, geographical science treated the same objective, external scene according to the codified rules of causal science which relegated the subjective to the realms of private experience and to art. Geographers of course make frequent use of the camera, increasing its claim to objectivity by employing vertical air photographs of the landscape and technically replicating binocular

vision by use of stereoscopic pairs. But in both geographical and photographic landscape subject and object remain discrete and separately conceived; brought together artificially according to fixed conventions and techniques of science and art. At the historical moment when realism was challenged in painting and analogical thinking was challenged in science, the landscape idea atrophied as a moral commentary on social relations with land and with nature, to be adopted as a cold scientific concept in academic geography and public policy.

Landscape in the Twentieth Century

The ambiguities of landscape outlined in the first part of this book are more readily understood as the outcome of a long and complex historical process, deeply embedded in the changing relations within society and between society and the land, mediated through changing intellectual conceptions, religious beliefs and artistic modes of expression. Throughout this history, the landscape idea was active within a process of undermining collective appropriation of nature for use. It was locked into an individualist way of seeing which found technical expression in modes of visual composition directed to the distanced eye and which posited a human relationship with the land and nature based increasingly on exchange values. It is a way of seeing which separates subject and object, giving lordship to the eye of a single observer. In this the landscape idea either denies collective experience, as in the case of the pleasing prospect, or mystifies it in an appeal to transcendental qualities of a particular area or region, as for example in the recourse during wartime in England to an image of unchanging English countryside, a landscape reflecting the unruffled harmony of its social order. During the transition toward fully capitalist social relations the landscape idea held in an unstable union this alienated relationship with the land, alongside still powerful ideals of collective life in nature, relying as it did so upon common human experience of organic life and cyclical change in nature. Landscape was always open to appropriation by a conservative ideology of landlordship. In sixteenth-century Venice or eighteenth-century England the landscape idea was indeed seized upon as a field of ideological conflict between a conservative, aristocratic view of landholding and paternalist care on the one hand and on the other a newer, more openly exploitive, market-oriented view of property in

land. In late eighteenth-century America an attempt was made within the context of the landscape idea to create both private ownership and control over land and a community of collective moral order on that land. The attempt failed to combine mutually contradictory modes of production.

The inability to contain within the landscape idea a collective sense of the meaning of their land and place to those actively engaged in and experiencing them lies at the root of our contemporary dilemmas over planning and conserving landscapes. And planning has been at the centre of the twentieth-century response to land in western social formations. We have already noted the origins of this response with reference to Ebenezer Howard's work. In modernist movements of the inter-war period the idea of the plan was a recurrent theme. Le Corbusier, for example, in *Towards a New Architecture* (1946) captures the spirit of modernism: fascinated by the possibilities that new technology – motor cars, ocean liners, aeroplanes and airships, as well as mass-production techniques – seemed to offer for the creation of entirely man-made environments; captivated by the spirit of positivist rationalism; seeing in *The Plan* an alternative to social revolution. Corbusier's *Cité Radieuse* of 1929 and much of the 'megalandscapes' which have followed it (Banham, 1976) provide a total architectural environment, generally set in a park landscape of shaven lawns and aesthetically-grouped trees. Such a landscape appears above the imaginary future underground city projected in the film of H.G. Wells's *Things To Come* (1936). The main interest focuses on the city and the technological environment, rural space is for relaxation and aesthetic pleasure, viewed from afar, from above or from the window of a fast-moving machine. It exists perhaps to provide, in an ill-defined 'nature', a palliative to the stresses of a mechanical life. Rarely is the countryside productive, rather it is appropriated as a distanced visual delight. The separation of subject and object in our conception of the world is now a matter of accepted common sense, the formal alienation from land as use value is complete. The power of individual visual appropriation of the external world, once the preserve of a privileged few – *cognoscenti* who were also politically and economically powerful – is now open in large measure to anyone with access to camera, photographs, postcards, television or film. In such a context it is little wonder that landscape has not been a concern of modernist culture, nor a subject for progressive art in this century. Where that culture has been elitist it has sought to distance itself from such easily accessible subject

matter as landscape, exploring purely formal structures or the depths of subjectivity and abstract expression; where it has been radical it has shared with most progressive ideologies a concern with the city – the locus of history in capitalist and post-capitalist societies – the city and technology, less as landscape than as human condition.

In environmental planning itself, in Europe and North America, the idea of landscape as a distanced, primarily visual, concept has been carried alongside an untrammelled private appropriation of its exchange value, an uneasy alliance. In Britain since the 1920s and 1930s planning in the countryside has been essentially restrictive, aiming to prevent urban encroachment, 'non-conforming' developments, 'unsightly' buildings, billboards and strip architecture and to preserve an ideal of rural life. But even in the national parks, the preserves of scenic values, the increasingly few and larger landlords and tenant farmers, engaged in the nation's most exploitive, heavily-subsidised, capital-intensive and privately profitable industry, act with virtually no legislative control on their use of land. They can and do alter its appearance and indeed its material nature by hedgerow removal, field enlargement, heavy application of chemical fertiliser, the building of massed ranks of silos or animal production barracks, with no need for public approval. To this extent planning legislation, democratically enacted in the name of social progress, is inherently contradictory, even regressive.

Significantly, the conservatism of planning for the countryside, incorporating its uneasy tension between scenic values and unrestricted production for exchange, reflects the place of landscape in British cultural production over the past half-century. A form of landscape art, deeply conservative in technique and composition, has remained a predilection of British painters. Some highly imaginative artists like Paul Nash, Graham Sutherland and Bill Brandt have succeeded in using landscape to comment on the devastation and immorality of war, the moods of natural seasons and rhythms or the anthropomorphism of enduring natural forms, but in the majority of cases British landscape painting has continued in the late Victorian vein of presenting an image of unchanging rural bliss, an arcadia set in some past time when humans lived an easy and somehow 'natural' life in a village community unscathed by technology.

Raymond Williams (1973) has discussed the permanence of this image in English literature. A 1983 exhibition *Landscape in Britain 1850-1950* (Arts Council, 1983) was remarkable for the erasure from

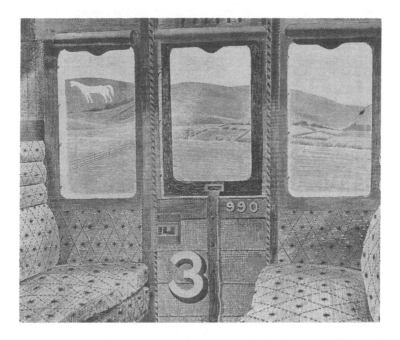

Plate 16. Eric Ravilious: *Train Landscape* (City of Aberdeen Art Gallery and Museums Collections, copyright © Estate of Eric Ravilious 1997. All rights reserved. DACS.)

the British scene it presented of tractors, farm machinery, telegraph wires, highways or breeze block and concrete farm buildings. Its view of England is perhaps best summarised in Eric Ravilious's *Train Landscape* (Plate 16) where a white horse inscribed in the chalk downland – symbol of the permanence of peaceful human occupance – is observed through the carefully-rendered windows of a well-upholstered third-class rail carriage. Unaltered English landscape, it seems to declare, is the property, the heritage, of all, even the poorest traveller, but as a framed picture, a distanced visual possession. The same message is conveyed by the unending stream of landscape posters, calendars, photographic essays, postcards and film documentaries of English landscape and in guidebooks like the *Shell Guides* of the 1940s and 1950s whose covers were designed by landscape artists like Rowland Hilder. The rate of production of these images increases, as it did during the Napoleonic Wars, in times of social and political tension. Series of books celebrating the

English pub, the village church and rural crafts, published on cheap wartime paper for mass circulation and employing the talents of such authors as Vita Sackville West and George Orwell, indicate the appeal of the genre, as does the more recent spate of nostalgic films set in a lost rural England, generally the England of the country house: *The Go Between, Brideshead Revisited, The French Lieutenant's Woman,* shot in subdued and misty tones, carrying us far away from the stresses of contemporary Britain.

The landscape painters and writers have had their visual and literary images promoted in far more forceful tones by journalistic and academic commentators. During the 1930s J.B. Priestly, C.E.M. Joad, an Oxford philosopher, and the geographer H.J. Fleure, wrote on the horrors of urban sprawl across England. Joad's titles: *The Untutored Townsman's Invasion of The Country* (1946) and *The Horrors of The Country* (1931) capture the spirit of his fierce attack on the motor car and its associated landscape of petrol stations, road houses and bypass architecture for fouling the supposed primeval peace and harmony of the English countryside. The complaint is as much social as aesthetic. Town dwellers, liberated by the car, are untutored in the polite and deferential ways of the country; country dwellers who should by rights occupy themselves in picturesque pursuits of haymaking and smoking at cottage doorways, instead are serving ice cream and petrol and plying souvenirs to the passing motorist. A firm social hierarchy is threatened, one implicit in the aesthetic image of rural England. Vaughan Cornish (1931) exemplifies how such visual ideology can sit comfortably with that of planning as well as how geography can adopt the same conventions as literary and artistic approaches to landscape. Cornish was a professional geographer, writing of the location of cities and political boundaries, lecturing and attending the Royal Geographical Society. In response to a presidential address to that Society by Sir Francis Younghusband in 1919 urging geographers to express in their writings their love of landscape, Cornish wrote a series of books and papers promoting what he referred to as 'aesthetic geography' and outlining specific techniques by which such a geography could be produced. His literary powers were by no means of the first order, his descriptions conventional and sentimental: they extolled the Sussex village, the immemorial churchyard yew, the downland fields. Cornish's work is interesting less for its inherent quality than that he was one of the very few geographers willing openly to acknowledge this aspect of the discipline and because of his detailed discussion of sight and vision

and the techniques of seeing landscape. His ideas reinforce the mode of detached, distant observation and visual appropriation, and his later role in establishing the national parks suggests how deeply the landscape way of seeing was implicated in their conception and creation. Vaughan Cornish was one of many individuals and groups who promoted the preservation of their own image of rural England, an image that landscape painters were reproducing in their works. From established bodies like the National Trust and the Council for the Preservation of Rural England, to local writers like the Powys brothers of Dorset, the themes of a disappearing English arcadia in need of protection from the forces of modernism has been a powerful and conservative one throughout the twentieth century. As always its appeal is reinforced and its ideological foundations inflected by reference to touchstones of fundamental and inalienable human experience. In this context it is worth noting the pre-war interest among landscape painters and other artists in Britain's pre-history and its landscape remnants: cairns, stone circles, megaliths; and in concrete natural forms – ancient rocks and dramatic geological structures, especially those with anthropomorphic form or having connection with pre-literate societies. Monuments like Stonehenge, Avebury and Maiden Castle attracted artists like Bill Brandt, Henry Moore and Graham Sutherland as well as schools of painters established in wild mountain or coastal regions like Pembrokeshire, Cornwall and North Devon, attracted by the scale and purity of their form and suggestions of animism, naturalism and anthropomorphism. No doubt too their distance from concerns of the present in all but the most abstract sense also had its appeal. The significance of such forms to contemporary landscape design has been promoted by G.A. Jellicoe (1966), one of the most influential and successful modern landscape architects. In a commentary on the design of the great earthen mounds which cover the reactors at the Harwell nuclear research establishment, Jellicoe draws a parallel between these megastructural monuments to ultimate control of nature for the purposes of state security, and the megaliths of ancient Britain a handful of miles to the south on the Berkshire Downs.

Set against the sustained and generally reactionary visual approach to English landscape we should note a very different set of attitudes and responses, to which in fact the term landscape seems inappropriate. The 1930s witnessed the growth on the part of working class urban dwellers, mainly in the northern industrial cities, to gain access to wild upland countryside for walking, rambling and

cycling. Institutions like the Ramblers Association, the Cycling Tourist Club and the Youth Hostels Association were not dominantly establishment-founded or sustained, nor were they mainly middle-class in membership. The most vocal advocate of the Pennine Way, the best-known of the now 1,500 miles of long-distance pathways in Britain, running the length of the Pennine Hills from Derbyshire to the Scottish border, was Tom Stephenson, raised in the Lancashire industrial town of Walley (Shoard, 1982). His case was promoted in the socialist *Daily Herald* and his actions corresponded to those of other working-class activists, attacking the privileges of large landowners who held great tracts of wild moorland and hill country inaccessible to all but their grouse-shooting friends.

In 1932 the best-remembered act of the campaign for access to the countryside took place, a mass trespass of Kinder Scout, the savage tundra upland within easy reach of millions of factory workers in Manchester, Sheffield, Derby and the host of smaller industrial settlements between them. It would be wrong to deny that such actions had their own impact on the later declaration of national parks and conserved landscapes. But significantly the intentions of people like Stephenson were not to *see* landscape, so much as to experience it physically – to walk it, climb it or cycle through it. The faculty of sight rarely seems a major concern. In Tom Stephenson's recollections as recorded by Marion Shoard he makes no reference to seeing the Pennines. 'It was just wild country, nothing at all. And the great attraction was that so easily you lost any sense of industrialisa-tion of civilisation, you felt you were alone in the world' (Shoard, 1982, p. 56). For people from environments like Manchester or Burnley in the 1930s to lose a sense of industrialisation and civilisation was not nostalgia for a lost rural England, but a gesture towards liberation, and it involved action rather than vision. As a popular folk-song of the time, 'The Manchester Rambler' puts it 'I may be a workslave of Monday, but I am a free man on Sunday.' Tom Stephenson confirms his very different attitude from Vaughan Cornish or C.E.M. Joad in his comments on the lowland southern scenery they so much admired:

> I've learned to endure lowland scenery. I realise that you can't help but admire a mountain, but to appreciate the more subtle lines of lowland landscape is more difficult – I think it has got to be acquired. (Shoard, 1982, p. 59)

It is the learned and distanced, more alienated, way of seeing, the landscape idea, that is implicitly contrasted here to a more active involvement with the land. Since 1974 every English local authority has had a statutory obligation to classify its area in terms of landscape quality, to identify those parts which are to be protected by law from alteration which might detract from their outstanding scenic beauty. The techniques by which such proposals are formulated pay scant regard to active use of the land, either by those who labour it or those who, like Stephenson, would participate actively in its rhythms for their recreation. Overwhelmingly these techniques are based on visual evidence, either that given by such 'experts' as landscape architects, artists, professional planners and other visually sensitive guardians of public taste, or of 'user-oriented studies' which frequently employ photographs of scenes as surrogates in establishing an aggregate public taste and preference for landscape (Gold, 1980), and which allow manipulation of the results by the objective statistical methods of positive science. The visual ideology of the landscape idea, atrophied from the late nineteenth century, still dominates. From positing a static visual unity and composing it within a frame by means of pencil sketch or paint we have come to the position of legislating a continued visual stasis in the landscape proposals of structure plans. We seem to find it far easier to schedule areas for preservation as outstanding landscape for those who would passively view their scenery than to delegate authority for their shaping to those who live, work or actively recreate in them – among whom those who own and make profit from the land are a tiny minority (Punter, 1982). Such preserved landscapes have in fact become a national commodity, advertised and sold abroad by the travel industry in exchange for convertible currency.

Conclusion: Insiders and Outsiders of Landscape

I have argued that landscape is a social and cultural product, a way of seeing projected on to land and having its own techniques and compositional forms; a restrictive way of seeing that diminishes alternative modes of experiencing our relations with nature. This way of seeing has a specific history in the West, a history I have outlined in the context of the long process of transition in western social

269

formations from feudal use values in land to capitalist production of land as a commodity for the increase of exchange value. Within that broad history there have been, in different social formations, specific social and moral issues addressed through landscape images. As within all significant cultural production there have been those individuals whose imaginative power has allowed them to address profoundly human needs and experiences both within prevailing conventions and, like Turner, beyond them. And underneath the ideology of sight, distance and separation implicit in the landscape idea there remains to give force to the image our own inalienable experience of home, of life and of the rhythms of diurnal and seasonal life. A contemporary artist who seeks to appeal very directly to these experiences of being inside the landscape, Richard Long, produces his work directly on and with the land – rearranging stones, leaving a human trail across the wastes of Dartmoor or the high Andes, or plastering a studio wall with an arc of Severn river mud. Entering the land rather than seeing it, he calls this land art rather than landscape. It is perhaps a sign of hope for our future cultural relations with land.

As an active force in cultural production landscape atrophied in the late nineteenth century. With the secure establishment of industrial capitalism the relationship it had long posited of a separation of individual from land and its private, personal consumption through sight, had become a way of being, experienced in urban life, intellectually defended in science and promoted in education while endlessly reinforced by the stream of visual images set before our eyes. Landscape, for all its appeal, cannot mediate the experience of the active insider and the passive outsider, as Ruskin discovered. Geographers who proclaim a human landscape concept need to recognise this as a point of departure, not a problem to be overcome, but a contradiction to be explored in its various contexts. Commenting on the writing of one of England's greatest landscape novelists, Thomas Hardy – amateur landscape painter and creator of an enduring image of Wessex – John Barrell (1982, p. 358) has stressed the impossibility of capturing 'the simultaneous *presence* of someone within the centre of knowledge . . . and his *absence* from it, in a position from which he observes but does not participate'. Such a feat is doubly impossible with the landscape idea: it originated as the outsider's perspective, it remains a controlling composition of the land rather than its mirror. Therefore,

Landscapes can be deceptive.

Sometimes a landscape seems to be less a setting for the life of its inhabitants than a curtain behind which their struggles, achievements and accidents take place. For those who, with the inhabitants, are behind the curtains, landmarks are no longer geographic but also biographical and personal. (Berger, 1976, pp. 13, 15)

271

References

Ackerman, J.S. (1966) *Palladio*. Harmondsworth, Penguin Books

Adams, J. (1979) *The Artist and the Country House: A History of Country House and Garden View Painting in Britain 1540–1870*. London, Sotheby Parke Bernet

Alberti, L.B. (1965) *Ten Books on Architecture*. (Trans. J. Leoni, 1755). Facs. London, Alec Tiranti

Anderson, P. (1974a) *Passages from Antiquity to Feudalism*. London, Verso

Anderson, P. (1974b) *Lineages of the Absolutist State*. London, New Left Books

Anderson, P. (1980) *Arguments Within English Marxism*. London. Verso

Appleton, J. (1975) *The Experience of Landscape*. London, Wiley

Architettura e utopia nella Venezia del cinquecento (1980). Milano, Electa

Argan, C.G. (1969) *The Renaissance City*. London, Studio Vista

Arts Council of Great Britain (1983) *Landscape in Britain 1850–1950*. London, Arts Council

Banham, R. (1976) *Megastructure: Urban Futures of the Recent Past*. London, Thames and Hudson

Banse, E. (1924) *Die seele D. geographie*. Brunswick, G. Westermann

Barrell, J. (1972) *The Idea of Landscape and the Sense of Place (1730–1840: An Approach to the Poetry of John Clare*. Cambridge, Cambridge University Press

Barrell, J. (1980) *The Dark Side of the Landscape: The Rural Poor in English Painting 1730–1840*. Cambridge, Cambridge University Press

Barrell, J. (1982) 'Geographies of Hardy's Wessex', *Journal of Historical Geography*, 8(4), 347–61

Baxandall, M. (1972) *Painting and Experience in Fifteenth Century Italy*. Oxford, Oxford University Press

Bazarov, K. (1981) *Landscape Painting*. London, Octopus

Berenson, B. (1952) *The Italian Painters of the Renaissance*. London, Phaidon

Berger, J. (1972) *Ways of Seeing*. Harmondsworth, Penguin Books BBC

Berger, J. (1976) *A Fortunate Man*. London, Writers and Readers

REFERENCES

Berger, J. (1980) *About Looking*. London, Writers and Readers

Blunt, A. (1973) *Artistic Theory in Italy 1450–1600*. Oxford, Oxford University Press

Bouwsma, W. (1968) *Venice and the Defence of Republican Liberty: Renaissance Values in the Age of the Counter-Reformation*. Berkeley, California, University of California Press

Braudel, F. (1972) *The Mediterranean and the Mediterranean World in the Age of Philip II*. London, Collins

Braudel, F. (1973) *Capitalism and Material Life*. (Trans. Miriam Kochan). London, George Weidenfeld and Nicholson

Braudel, F. (1982) *Civilization and Capitalism 15th–18th Centuries, Vol. II: The Wheels of Commerce*. Collins, London

Brenner, R. (1976) 'Agrarian Class Structure and Economic Development in Pre-Industrial Europe', *Past and Present*, 70, 30–75

Brenner, R. (1977) 'The Origins of Capitalist Development: A Critique of Neo-Smithian Marxism', *New Left Review*, 104, 25–93

Brown, C. (1972) *Dutch Townscape Painting*. London, National Gallery

Bunge, W. (1966) *Theoretical Geography*. Lund Studies in Geography, Series C, No. 1 (2nd ed.)

Bunske, E.V. (1981) 'Humboldt and an Aesthetic Tradition in Geography', *Geographical Review*, 72(2), 127–46

Burke, P. (1974a) *Tradition and Innovation in Renaissance Italy*. London, Fontana/Collins

Burke, P. (1974b) *Venice and Amsterdam: A Study of Seventeenth Century Elites*. London, Temple Smith

Carlyle, T. (1829) 'Signs of the Times', reprinted in Marx, L. (ed.), *The Onset of Industrialisation and America's National Goals*. Amherst College, 1965 (mimeo)

Cassirer, E. (1963) *The Individual and the Cosmos in Renaissance Philosophy*. London, Pennsylvania University Press

Chadwick, G.F. (1966) *The Park and the Town: Public Landscape in the 19th and 20th Centuries*. London, Architectural Press

Chambers, D.C. (1970) *The Imperial Age of Venice*. London, Thames and Hudson

Cipolla, C.M. (1952) 'The Decline of Italy', *Economic History Review*, 5(2) 18–24

Clark, K. (1956) *Landscape Into Art*. Harmondsworth, Penguin Books

Coles, P. (1952) 'A Note on the Arrest of Capitalism in Italy', *Past and Present*, 2, 51–4

Cornaro, L. (1935) *Della Vita Sobria: A Treatise on Temperance and Sobriety* (Trans. George Herbert). Oxford, Oxford University Press

Cornish, V. (1928) 'Harmonics of Scenery: An Outline of Aesthetic Geography', *Geography, 14,* 275–83; 383–94

Cornish, V. (1931) *The Poetic Impression of Natural Scenery.* London, Sifton, Praed and Co.

Cornish, V. (1935) *Scenery and the Sense of Sight,* Cambridge, Cambridge University Press

Cornish, V. (1937) *The Preservation of Our Scenery. Essays and Addresses.* Cambridge, Cambridge University Press

Cosgrove, D. (1979) 'John Ruskin and the Geographical Imagination', *The Geographical Review 69(1),* 43–62

Cosgrove, D. (1982a) 'The Myth and Stones of Venice: An Historical Geography of a Symbolic Landscape', *Journal of Historical Geography, 8(2),* 145–69

Cosgrove, D. (1982b) 'Agrarian Change, Villa Building and Landscape: The Godi Estates in Vicenza 1500–1600' in Ferro, G. (ed.), *Symposium on Historical Changes in Spatial Organization and Its Experience in the Mediterranean World.* Genoa, Bozzi, pp. 133–56

Cosgrove, D. and Thornes, J. (1982) 'The Truth of Clouds: John Ruskin and The Moral Order in Landscape' in Pocock, D.C.D. (ed.), *Humanistic Geography and Literature: Essays on the Experience of Place.* London, Croom Helm

Crèvecoeur, M. St-Jean de (1963) *Letters from an American Farmer and Sketches of Eighteenth-century America.* Toronto, New American Library of Canada Ltd.

Crouan, K. (1982) *John Linnell: A Centenary Exhibition.* Cambridge, Cambridge University Press

Daniels, S.J. (1981) 'Landscaping for a Manufacturer: Humphrey Repton's Commission for Benjamin Gott at Armley in 1809–10', *Journal of Historical Geography, 7(4),* 379–96

Darby, H.C. (1951) 'The Changing English Landscape', *Geographical Journal, 117,* 377–98

Davie, D. (1983) 'The Industrial Landscape in British Literature' in Arts Council, *British Landscape,* pp. 37–44

Dickinson, R.E. (1939) 'Landscape and Society', *Scottish Geographical Magazine, 55(1),* 1–15

Dixon-Hunt, J. (1982) *The Wider Sea: A Life of John Ruskin.* London, Dent

Dobb, M. (1963) *Studies in the Development of Capitalism.* Second ed., London, Routledge and Kegan Paul

Edgerton, S.Y. (1975) *The Renaissance Rediscovery of Linear Perspective.* London, Harper and Row

Eliade, M. (1959) *The Sacred and the Profane: The Significance of Religion, Myth, Symbolism, and Ritual Within Life and Culture.* New York, Harcourt, Brace and World Inc.

Finlay, R. (1980) *Politics in Renaissance Venice.* London, Ernest Benn

Fuller, P. (1980) *Art and Psychoanalysis.* London, Writers and Readers

Galassi, P. (1981) *Before Photography: Painting and the Invention of Photography.* New York, Museum of Modern Art

Geipel, R. (1978) 'The Landscape Indicators School in German Geography' in Ley and Samuels (eds.), *Humanistic Geography,* pp. 155–72

Genovese, E.D. (1972) *Roll Jordan Roll: The World the Slaveholders Made.* New York, Random House

Ginzburg, C. (1980) *The Cheese and the Worms: The Cosmos of a Sixteenth-Century Miller* (Trans. John and Anne Tedeschi). London, Routledge and Kegan Paul

Giorgetti, G. (1974) *Contadini e proprietari nell'Itala moderna: Rapporti di produzione e contratti agrari dal secolo xvi a oggi.* Torino, Einaudi

Glacken, C. (1967) *Traces on the Rhodian Shore: Nature and Culture in Western Thought from Ancient Times to the End of the Eighteenth Century.* Berkeley, University of California Press

Gold, J.R. (1980) *An Introduction to Behavioural Geography,* London, Oxford University Press

Gold, J.R. and Burgess, J. (eds.) (1982) *Valued Environments.* London, George Allen and Unwin

Gombrich, E.H. (1966) 'The Renaissance Theory of Art and the Rise of Landscape' in Gombrich, E.H., *Norm and Form: Studies in the Art of the Renaissance.* London, Phaidon, pp. 107–21

Graber, L.H. (1976) *Wilderness as Sacred Space.* Washington DC, Association of American Geographers, Monograph Series, No. 8

Green, D. (1977) *To Colonise Eden: Land and Jeffersonian Democracy.* London, Gordon and Cremonesi

Gregory, D. (1978) *Ideology, Science and Human Geography.* London, Hutchinson

Hadjinicolau, N. (1974) *Histoire de l'art et lutte des classes.* Paris François Maspero

Hale, J.R. (1968) 'Francesco Tensini and the Fortification of Vicenza', *Studi Veneziani, 10,* 231–89

Hale, J.R. (1977) *Renaissance Fortification: Art or Engineering?* London, Thames and Hudson

Hard, G. (1965) 'Arcadien in Deutchland', *Die Erde, 96,* 31–4

Harris, J. (1981) *The Palladians.* London, Trefoil Books

Harris, R.C. (1977) 'The Simplification of Europe Overseas', *Annals, Association of American Geographers*, 67(4), 469–83

Harris, R.C. (1978) 'The Historical Mind and the Practice of Geography' in Ley and Samuels (eds.), *Humanistic Geography*, pp. 123–37

Hartshorne, R. (1939) *The Nature of Geography: A Survey of Current Thought in the Light of the Past.* Lancaster, Pa., Association of American Geographers

Harvey, D. (1974) *Social Justice and the City.* London, Edward Arnold

Harvey, P.D.A. (1980) *The History of Topographical Maps: Symbols, Pictures and Surveys.* London, Thames and Hudson

Havinghurst, A.F. (ed.) (1958) *The Pirenne Thesis: Analysis, Criticism and Revision.* Boston, Heath

Heimert, A. (1953) 'Puritanism, the Wilderness and the Frontier', *New England Quarterly*, 26(3), 361–82

Herlihy, D. (1965) 'Population, Plague and Social Change' in Mohlo, A. (ed.), *Social and Economic Foundations of the Italian Renaissance.* New York, Wiley, pp. 77–90

Hewison, R. (1976) *John Ruskin: The Argument of the Eye.* London, Thames and Hudson

Hilton, R. (ed.) (1978) *The Transition from Feudalism to Capitalism.* London, Verso

Hilton, R. (1978) 'Capitalism: What's in a Name?' reprinted in Hilton, (ed.), *The Transition from Feudalism to Capitalism*

Hobsbawm, E. (1965) 'Introductory Essay' to Karl Marx, *Precapitalist Economic Formations* (Trans. Jack Cohen). New York, International Publishers

Holcomb, A.M. (1978) *John Sell Cotman.* London, British Museum

Holt-Jensen, A. (1981) *Geography: Its History and Concepts.* London, Harper and Row

Holton, R.J. (1981) 'Marxist Theories of Social Change and the Transition from Feudalism to Capitalism', *Theory and Society*, 10, 833–67

Hopkins, G.M. (1953) *Gerard Manley Hopkins: Poems and Prose.* Selected and edited by W.M. Gardner. Harmondsworth, Penguin Books

Hoskins, W.G. (1955) *The Making of the English Landscape.* London, Hodder and Stoughton

Howard, D. (1980) *The Architectural History of Venice.* London, B.T. Batsford

Howard, E. (1946) *Garden Cities of Tomorrow.* London, Faber and Faber

REFERENCES

Huggett, F.E. (1975) *The Land Question and European Society.* London, Thames and Hudson

Huth, H. (1957) *Nature and the American: Three Centuries of Changing Attitudes.* Bison Books, University of Nebraska Press

Hyde, J.K. (1973) *Society and Politics in Medieval Italy: The Evolution of the Civil Life, 1000-1350.* London, Macmillan

Ivins, W. Jr (1946) *Art and Geometry: A Study of Space Intuitions.* Cambridge, Mass., Harvard University Press

Jackson, J.B. (1964) 'The Meanings of Landscape', *Kulturgeografie, 88,* 47–51

Jackson, J.B. (1970) *Landscapes: Selected Writings of J.B. Jackson.* Amherst, Mass., University of Massachusetts Press

Jackson, J.B. (1979) 'Landscape as Theatre', *Landscape, 23(1)* 3–7

Jackson, J.B. (1980) *The Necessity for Ruins and Other Essays.* Amherst, Mass., University of Massachusetts Press

Jakle, J.A. (1977) *Images of the Ohio Valley: An Historical Geography of Travel, 1740-1860.* New York, Oxford University Press

Jefferson, T. (1785) 'Query XIX', reprinted in Marx, L. (ed.), *The Onset of Industrialisation and America's National Goals.* Amherst College, 1965 (mimeo)

Jeffrey, J. (1983) 'Public Problems and Private Experience in British Art and Literature' in Arts Council, *British Landscape,* pp. 22–36

Jellicoe, G.A. (1966) *Studies in Landscape Design,* Vol. 2. London, Oxford University Press

Joad, C.E.M. (1931) *The Horrors of the Countryside.* London, Leonard and Virginia Woolf: Day to Day Pamphlets

Joad, C.E.M. (1946) *The Untutored Townsman's Invasion of the Country.* London, Faber and Faber

Jones, P.J. (1965) 'Communes and Despots: The City State in Late-Medieval Italy', *Transactions of the Royal Historical Society, 15,* 5th series, 71–96

Jones, P.J. (1966) 'Italy' in *The Cambridge Economic History of Europe,* Vol. 1. Cambridge, Cambridge University Press, pp. 340–431

Jones, P.J. (1968) 'From Manor to Mezzadria: A Tuscan Case Study in the Medieval Foundations of Modern Agrarian Society' in N. Rubenstein (ed.), *Florentine Studies,* pp. 193–241

Klingender, F.J. (1972) *Art and the Industrial Revolution* (ed. and revised by Arthur Elton). London, Palladin

Lane, F. (1973) *Venice: A Maritime Republic.* Baltimore and London, Johns Hopkins Press

Le Corbusier (1946) *Towards a New Architecture.* London, The Architectural Press

277

Lefebvre, M. (1970) *La Revolution Urbaine.* Paris, Gallimard

Lemon, J.T. (1980) 'Early Americans and their Social Environment', *Journal of Historical Geography, 6(2),* 115–32

Levin, H. (1970) *The Myth of the Golden Age in the Renaissance.* London, Faber and Faber

Ley, D. and Samuels M. (eds.) (1978) *Humanistic Geography: Prospects and Problems,* London, Croom Helm

Lopez, R.S. (1953) 'Hard Times and Investment in Culture' in *The Renaissance: A Symposium.* New York, Metropolitan Museum of Art, pp. 19–32

Lowenthal, D. (1962–3) 'Not Every Prospect Pleases', *Landscape, 12(2),* 19–23

Lowenthal, D. (1968) 'The American Scene', *Geographical Review 58(1),* 61–88

Lowenthal, D. (1982) 'The Pioneer Landscape: An American Dream', *Great Plains Quarterly, 2(1),* 5–19

Lowenthal, D. and Prince, H.C. (1964) 'The English Landscape', *Geographical Review, 54(3),* 309–46

Lowenthal, D. and Prince, H.C. (1965) 'English Landscape Tastes', *Geographical Review, 55(2),* 186–222

Martines, L. (1980) *Power and Imagination: City States in Renaissance Italy.* New York, Vintage Books

Marx, K. and Engels, F. (1888) *Manifesto of the Communist Party.* Moscow Foreign Languages Publishing House

Marx, K. and Engels, F. (1973) *Selected Works,* Vol. I. Moscow, Progress Publishers

Marx, L. (1964) *The Machine in the Garden: Technology and the Pastoral Ideal in America.* London and New York, Oxford University Press

Masson, G. (1966) *Italian Gardens.* London, Thames and Hudson

McArdle, F. (1978) *Altopascio: A Study in Tuscan Rural Society.* Cambridge, Cambridge University Press

Meinig, D. (ed.) (1979) *The Interpretation of Ordinary Landscapes.* Oxford, Oxford University Press

Mikesell, M.W. (1968) 'Landscape', *International Encyclopaedia of the Social Sciences,* Vol. 8. New York, Crowell-Collier and Macmillan, pp. 575–80

Milward, P. (1975) *Landscape and Inscape: Vision and Inspiration in Hopkins' Poetry.* London, Paul Elek

Muir, E. (1981) *Civic Ritual in Renaissance Venice.* Princeton, NJ, Princeton University Press

Nash-Smith, H. (1950) *Virgin Land: The American West as Symbol and Myth.* New York, Vintage Books

Neale, R. (1974) 'Society, Belief and the Building of Bath, 1700–1793' in Chalkin, C.W. and Havinden, M.A. (eds.), *Rural Change and Urban Growth 1500–1800, Essays in English Regional History in Honour of W.G. Hoskins.* London, Longman

Nichols, F.D. (1976) *Palladio in America.* Milano, Electa

Novak, B. (1980) *Nature and Culture: American Landscape and Painting, 1825–1875.* London, Thames and Hudson

Olwig, K. (in press) *Nature's Ideological Landscape.* London, George Allen and Unwin

Ormond, R. (1981) *Sir Edwin Landseer.* London, Tate Gallery

Palladio, A. (1738) *The Four Books of Architecture* (Trans. Isaac Ware). Facs., New York, Dover, 1965

Panofsky, E. (1936) 'Et in Arcadia Ego: Poussin and the Elegiac Tradition', reprinted in Panofsky (1970), pp. 340–67

Panofsky, E. (1970) *Meaning in the Visual Arts.* Harmondsworth, Penguin Books

Pattison, W.D. (1957) *Beginnings of the American Rectangular Survey System 1784–1800.* Chicago, University of Chicago, Department of Geography, Research Paper, No. 50

Peters, W.A.M. (1948) *Gerard Manley Hopkins: A Critical Essay Towards the Understanding of his Poetry.* London, Oxford University Press

Pevsner, N. (1957) *An Outline of European Architecture.* Harmondsworth, Penguin Books

Pope, A. (1963) *The Poems of Alexander Pope.* A one volume edition of the Twickenham Text with selected annotations edited by John Butt. London, Methuen

Postan, M.M. (1949–50) 'Some Economic Evidence of the Declining Population of the Later Middle Ages', *Economic History Review,* 2nd series. 2, 221–46

Pounds, N.J.G. (1979) *An Historical Geography of Europe 1500–1840.* Cambridge, Cambridge University Press

Pullen, B. (ed.) (1968) *Crisis and Change in the Venetian Economy in the 16th and 17th Centuries.* London, Methuen

Punter, J.V. (1982) 'Landscape Aesthetics: A Synthesis and Critique' in Gold and Burgess (eds.), *Valued Environments,* pp. 100–23

Puppi, L. (1972) 'The Villa Garden in the Veneto' in David R. Coffin (ed.), *The Italian Garden,* Washington DC, Dumbarton Oaks, pp. 83–114

REFERENCES

Rees, R. (1980) 'Historical Links between Geography and Art', *Geographical Review*, 70(1), 60–78

Relph, E. (1976) *Place and Placelessness*. London, Pion

Relph, E. (1981) *Rational Landscapes and Humanistic Geography*. London, Croom Helm

Richter, I.A. (1952) *Selections from the Notebooks of Leonardo da Vinci*. London, Oxford University Press

Rosenau, H. (1959) *The Ideal City in its Architectural Evolution*. London, Routledge and Kegan Paul

Rosenthal, M. (1982) *British Landscape Painting*. Oxford, Phaidon

Rotondi, P. (1969) *The Ducal Palace at Urbino*. London, Alec Tiranti

Ruskin, J. (1903–12) *The Works of John Ruskin*. (Library ed.; 39 Vols., edited by E.T. Cook and Alexander Wedderburn). London, George Allen. (All subsequent references to Ruskin give the date of original publication and the volume number from the above edition)

Ruskin, J. (1837) *The Poetry of Architecture*. (1903–12, Vol. I)

Ruskin, J. (1844) Preface to the 2nd ed. of *Modern Painters*, Vol. I. (1903–12, Vol. III)

Ruskin, J. (1849) *The Seven Lamps of Architecture*. (1903–12, Vol. VIII)

Ruskin, J. (1851) *The Stones of Venice*, Vol. I. (1903–12, Vol. IX)

Ruskin, J. (1856) *Modern Painters*, Vol. 4. (1903–12, Vol. VI)

Ruskin, J. (1860) *Modern Painters*, Vol. 5. (1903–12, Vol. VII)

Ruskin, J. (1884) *The Storm Cloud of the Nineteenth Century*. (1903–12, Vol. XXXIV)

Ruskin, J. (1895) *Praeterita*. (1903–12, Vol. XXXV)

Sack, R.D. (1980) *Conceptions of Space in Social Thought: A Geographic Perspective*. London, Macmillan

Sahlins, M. (1976) *Culture and Practical Reason*. Chicago and London, University of Chicago Press

Samuels, M. (1979) 'The Biography of Landscape' in Meinig, D. (ed.), *The Interpretation of Ordinary Landscapes*, pp. 51–88

Sartori, P.L. (1981) 'Gli scrittori veneti d'agraria del cinquecento e del primo seicento: tra realtà e utopia' in *Venezia e la terraferma: le relazione dei rettori*. Milano, Giuffrè, pp. 261–310

Sauer, C.O. (1925) 'The Morphology of Landscape', reprinted in J. Leighly (ed.), *Land and Life: Selections from the Writings of Carl Ortwin Sauer*. Berkeley and Los Angeles, University of California Press, 1963

Sauer, C.O. (1941) 'Foreword to Historical Geography', reprinted in J. Leighly (ed.), *Land and Life: Selections from the Writings of Carl Ort-*

win Sauer. Berkeley and Los Angeles, University of California Press, 1963

Sauer, C.O. (1975) *Sixteenth-Century North America: The Land and Its People as Seen by Europeans*. Berkeley and Los Angeles, University of California Press

Schaefer, F.K. (1953) 'Exceptionalism in Geography: A Methodological Examination', *Annals, Assocation of American Geographers, 43,* 226–49

Schultz, J. (1978) 'Jacopo de'Barbari's View of Venice: Map Making, City Views and Moralized Geography Before the Year 1500' *The Art Bulletin, 60,* 425–74

Seamon, D. (1979) *A Geography of the Lifeworld*. London, Croom Helm

Sereni, E. (1971) 'De Marx à Lenine, La Categorie de "Formation Economique et Sociale" ', *La Pensée, 159,* 3–49

Sereni, E. (1974) *Storia del paesaggio agrario Italiano*. Bari, Laterza

Shanin, T. (ed.) (1973) *Peasants and Peasant Societies*. Harmondsworth, Penguin Books

Shoard, M. (1982) 'The Lure of the Moors' in Gold and Burgess (eds.), *Valued Environments,* pp. 59–73

Stilgoe, John R. (1982) *Common Landscape of America,* New Haven and London, Yale University Press

Summerson, J. (1966) *Inigo Jones,* Harmondsworth, Penguin Books

Summerson, J. (1969) *Georgian London,* Harmondsworth, Penguin Books

Sutter, R.E. (1973) *The Next Place You Come to: A Historical Introduction to Communities in North America,* Englewood Cliffs, NJ, Prentice Hall

Sweezy, P. (1978) 'A Critique' and 'A Rejoinder' in Hilton (ed.), (1978), pp. 33–56 and 102–7

Tafuri, M. (1976) *Architecture and Utopia: Design and Capitalist Development* (Trans. B.L. La Penta). Cambridge, Mass., MIT Press

Tafuri, M. (1980) ' "Sapienza di stato" e "atti mancati": Architettura e technica urbana nella Venezia del '500' in *Architettura e utopia,* pp. 16–39

Tagliaferri, A. (1981) 'Relazione dei rettori venete in terraferma' in *Venezia e la terraferma: Le relazione dei rettori*. Milano, Guiffrè, pp. 7–14

Taussig, M.T. (1980) *The Devil and Commodity Fetishism in South America*. Chapel Hill, University of North Carolina Press

Taylor, J.C. (1976) *America As Art*. New York, Harper and Row

REFERENCES

Thompson, E.P. (1963) *The Making of the English Working Class*. London, Gollancz
Thompson, E.P. (1975) *Whigs and Hunters: The Origin of the Black Act*. London, Allen Lane
Thompson, E.P. (1978) *The Poverty of Theory and Other Essays*. London, Merlin
Thompson, F.M.L. (1968) *Chartered Surveyors: The Growth of a Profession*. London, Routledge and Kegan Paul
Thrower, N.J. (1972) *Maps and Man: An Examination of Cartography in Relation to Culture and Civilization*. Englewood Cliffs, NJ, Prentice Hall
Tuan, Yi-Fu (1961) 'Topophilia', *Landscape, 11*, 29–32
Tuan, Yi-Fu (1971) 'Geography, Phenomenology and the Study of Human Nature', *Canadian Geographer, 15(3)*, 181–92
Tuan, Yi-Fu (1974) *Topophilia: A Study of Environmental Perception, Attitudes and Values*. Englewood Cliffs, NJ, Prentice Hall
Turner, A.R. (1963) *The Vision of Landscape in Renaissance Italy*. Princeton, NJ, Princeton University Press
Turner, F.J. (1961) *Frontier and Section. Selected Essays of Frederick Jackson Turner*, Englewood Cliffs, NJ, Prentice Hall
Turner, J.G. (1979) *The Politics of Landscape: Rural Scenery and Society in English Poetry, 1630–1660*. Oxford, Basil Blackwell
Ventura, A. (1964) *Nobilità e popolo nella societa Veneta del '400 e '500*. Bari, Laterza
Vidal de la Blache, P. (1903) *Tableau de la Géographie de la France*. Paris
Vilar, P. (1956) 'Problems in the Formation of Capitalism', *Past and Present, 10*, 15–38
von Humboldt, A. (1848) *Kosmos: A Sketch of a Physical Description of the Universe* (Trans. E.C. Otte). 2 Vols., London, Böhn
Wagret, P. (1968) *Polderlands*. London, Methuen
Wallerstein, E. (1974) *The Modern World System: Capitalist Agriculture and the Origins of the European World Economy in the Sixteenth Century*. New York, Wiley
Walton, P.H. (1972) *The Drawings of John Ruskin*. Oxford, Oxford University Press
Warner, S.B. (1972) *The Urban Wilderness: A History of the American City*. New York, Harper and Row
Waterhouse, E. (1974) *Giorgione*. W.A. Cargill Memorial Lecture in Fine Art, Glasgow, University of Glasgow Press
Weber, M. (1958) *The Protestant Ethic and the Spirit of Capitalism*. New York, Charles Scribners Sons

Whaley, D. (1969) *The Italian City Republics.* London, Weidenfeld and Nicolson

Wheatley, P. (1971) *The Pivot of the Four Quarters: A Preliminary Enquiry into the Origins of the Ancient Chinese City.* Edinburgh, Edinburgh University Press

Wilde, J. (1981) *Venetian Art from Bellini to Titian.* Oxford, Oxford University Press

Williams, R. (1963) *Culture and Society, 1780-1950.* Harmondsworth, Penguin Books

Williams, R. (1973) *The Country and the City.* London, Palladin

Williams, R. (1977) *Marxism and Literature.* Oxford, Oxford University Press

Williams, R. (1981) *Culture.* London, Fontana

Wilton, A. (1980) *Turner and the Sublime.* London, British Museum

Wittkower, R. (1962) *Architectural Principles in the Age of Humanism.* London, Alec Tiranti

Wittkower, R. (1974) *Palladio and English Palladianism.* London, Thames and Hudson

Woolf, S.J. (1968) 'Venice and the Terraferma: Problems of the Change from Commercial to Landed Activities' in Pullen, B. (ed.), *Crisis and Change,* pp. 175-203

Yelling, J.A. (1978) 'Agriculture, 1500-1700' in Butlin, R.A. and Dodgshon, R.A. (eds.), *An Historical Geography of England and Wales.* London, Academic Press, pp. 151-72

Zaring, J. (1977) 'The Romantic Face of Wales', *Annals, Association of American Geographers, 67(3),* 397-418

Zelinsky, W. (1973) *The Cultural Geography of the United States.* Englewood Cliffs, NJ, Prentice Hall

Zorzi, G. (1964) *Le opere pubbliche e i palazzi privati di Andrea Palladio,* Vicenza, Neri Pozza

Index

284

INDEX

and city 215-22; and landscape 193-4;
and Ruskin 242-5, 250-1; as subject of art
20, 22, 25-6, 34, 60, 143 *passim*; Claude
157, 227; Flanders 146 *passim*; Georgian
England 204-6, 212-15; Holland 152-5;
Venice 120-3, 125, 135, 140; control of
114, 238, 267; in golden age 166-8; laws
of 214; meaning of 41, 64; sublime 66,
185, 223-39 *passim*; *see also* science
navigators 102, 147, 162, 167, 169
Neale, R. 216
neo-classicism 210
neoplatonism 120-6, 128, 135, 140
Neptune 109-10
Netherlands *see* Holland
Neuf Brissach 156
New England 169, 185
New Model Army 196
Newton, Sir I. 237; physics 252
New York 36
Niagara Falls 185
Nichols, F.D. 181
nobility 63, 83, 89, 91; and *popolo* 73-6,
81-2, 86, 87, 107, 125; *see also popolo*
Norfolk 210
North Sea 70, 143, 155
Novak, B. 185
Nuneham Courtney 211, 214-15

Ohio river 175, 179
Olwig, K. 67, 228
opera 157
Ormond, R. 233
Ortelius 102-3, 147
Orwell, G. 266
outsider 26, 33, 38, 161, 269-71; *see also*
insider
Oxford city 199, 241, 250; county 199, 214,
244

Padovano 76, 105, 118
Padua 71, 74, 88, 114, 119, 237; Carrarese
family 76; university 109
paesaggio 22, 69, 96, 101
painting 20, 33, 59, 65, 70, 106, 178;
American 184-6; and cartography 147;
and perspective 22-7; Dutch 147; Flemish
145-50; in renaissance Italy 85 *passim*; oil
62-3, 144; Umbrian 24, 100; *see also*
landscape, Venice
Palermo 155
Palestrina, Temple of Fortune 203
Palladian country house 199, 211; geometry
133, 181-2; landscape 70, 126-35, 139,
198-206, 210-15
Palladianism 216; English 181, 198-215,
221; French 181; in towns 206-10; *see also*
Palladio, palladian
Palladians 138, 207
Palladio, A. 114, 116, 126-9 *passim*, 206-7,
210, 239; Basilica 129-31, 197, 207; *see*
also Palladian, palladianism, Vicenza, villa
Palmanova 189
Panofsky, E. 17, 160
Papacy 72, 74, 81, 107-8, 155; *see also* Pope
Papal states 80
Paris 29, 198
parkland *see* England
parks, public 236
Pascal, B. 153

pastoral 96, 140, 158, 166, 238, 256;
American 177, 183; ideology 230; literary
199, 203, 213, 215; myth 169, 171;
Virgilian 67, 122
Patinir, J. 146
Pattison, W.D. 177
Pavia 71
Paxton, J. 238
pays 28, 29
Peak District 255
peasantry 23-4, 42-3, 49, 51, 61, 63, 120,
178, 232; diet 139; English 191-2; in
Flanders 148; in Italy 76 *passim*, 119, 122,
167; proprietorship 52, 171; risings 155
Pembrokeshire 267
Penn, W. 183
Pennines 242, 268
Pennsylvania 171, 175; Avenue 183
Pershore 209
perspective 80, 85, 126, 150, 153, 176-7,
188, 197-8, 205, 231, 270; aerial 100,
104-6, 145, 155, 158, 205, 213, 258; and
city 70, 92, 94, 96-7, 112, 134, 145, 151,
157, 183, 189; and geography 30-4; and
landscape 20-7, 104, 123, 155, 194,
221-2, 238-9; garden 100, 201; linear 9,
20-7, 102, 183; maps 109, 113, 164; *see*
also Renaissance
Peru 165
Perugia 88
Perugino, P. 92
Peters, W.A.M. 13-14
Petrarch 89, 99, 120-1
Petworth House 239
Pevsner, N. 157
Philadelphia 183
photography 11, 33, 257-63
physiocracy 174, 220
Piccolomini, A.S. (Pope Pius II) 99, 164
Pico della Mirandola 102
picturesque 65, 126, 204, 226, 235, 242,
245, 266; landscape gardening 199, 220;
cottages 256
Pienza 99, 164
Piero della Francesca 96-7, 100, 104, 110,
145
Pinturicchio 88, 92
Pirenne, H. 48-9
Pissaro 257
plague 48, 49, 51, 75
planning 13, 89, 221, 256, 263-4, 268;
baroque 198; Roman 207
Plato 85, 120, 197
platonism 83, 106, 121
Pliny 99
podestà 74, 75
poesia 120, 125-6, 138-9, 158
Poland 52
Pollaiuollo, A. 100
Pope 57, 71, 112, 156, 164; *see also* Papacy
Pope, A. 204-5, 211-13, 215, 222, 231
popolo 72-6, 81-2, 89, 91, 107; *see also*
nobility
population/resource ratio 48-9, 161
Portland estate 217
Portuguese 164-5; navigation 108, 112
Postan, M.M. 48
Potomac river 182
Poussin, N. 157, 160, 201
Po Valley 78, 105, 145, 156

INDEX